STAR WARS®

1,000

COLLECTIBLES

MEMORABILIA AND STORIES FROM A GALAXY FAR, FAR AWAY

STEPHEN J. SANSWEET WITH ANNE NEUMANN

ABRAMS, NEW YORK

DEDICATION

To the literally thousands of fellow collectors and
dealers throughout the world with whom I've interacted
for more than three decades—many of whom have
become good friends—and to the next generation of
Star Wars collectors who might get inspiration, or at
least some solace, from knowing that they're not alone.

INTRODUCTION

How did I become the largest private collector of *Star Wars* memorabilia in the world? Why did I amass so much *Star Wars* stuff that a five-thousand-square-foot former hen house in semi-rural Northern California is bursting at the seams? Why collect at all, and, for heaven's sake, why *Star Wars*?

I think it all started with bubble-gum cards at Joe's Barber Shop in West Philadelphia when I was four or five years old. Because it was always first-come, first served in his one-man shop, Joe was smart about having stuff to keep kids entertained while they waited. So he had stacks of used comic books as well as the latest gum-card packs, which were usually two cents to a nickel each. License Plates! Tarzan! Funny Foldees! Davy Crockett! And the set that fed my already spacey fantasies, Target: Moon. Most of the kids ate the gum, looked at the cards, and then threw the cards into a big box for others to enjoy. With Joe's permission, I started collecting them.

Truth be told, I'm sure I inherited the collecting gene from my dad. He was a regional salesman for the American Distilling Co., a liquor purveyor, and he would come back from trips with the most incredible plastic swizzle sticks in every imaginable shape, size, and color.

Multiple Old-Fashioned glasses were stuffed with them. And our garage, which couldn't handle cars with even small fins, became the resting place for the "family" collection of *LIFE* magazines, including a number dating back to the late 1930s. My growing comic and card collections fit right in.

Then there were matchbook covers; Dixie Cup ice-cream lids with photos of celebrities; Stroehmann and Bond Bread end labels, which you carefully peeled off and pasted into a paper album to make a Hopalong Cassidy or Roy Rogers picture story; and cardboard inserts that separated levels of Shredded Wheat biscuits, which had cutouts to make a frontier town or a three-ring circus. Having little discretionary income of my own (it took years for my weekly allowance to top the twenty-five-cent level), I was never able to complete any of those sets, a severe psychological blow that likely led to my becoming that most crazed species of collector: a completist.

Books have been written about collecting, collectors, and collectibles. Psychologists have their theories about the phenomenon (my "gene theory" not being one of them). And pop-culture historians have their suspicions about when modern collecting began—perhaps

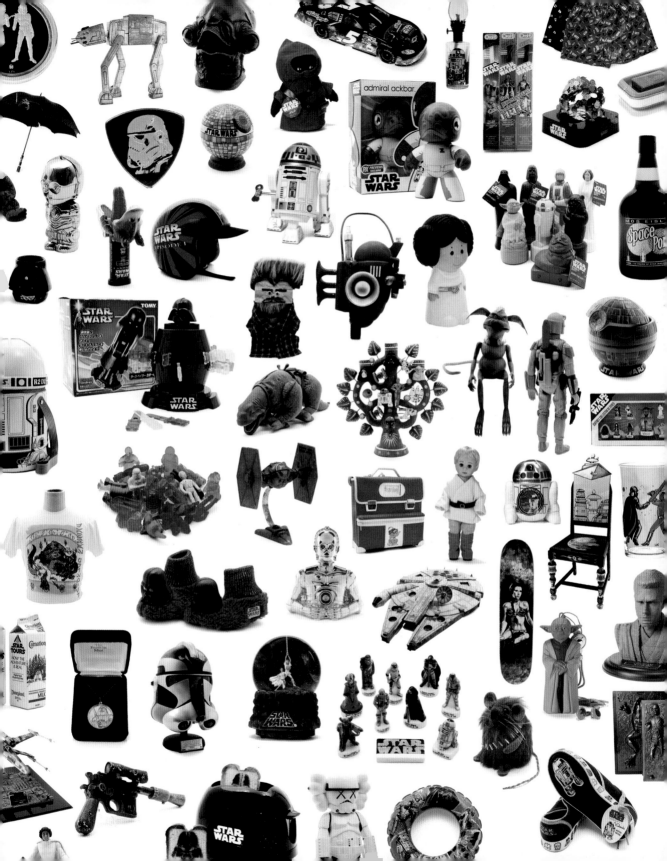

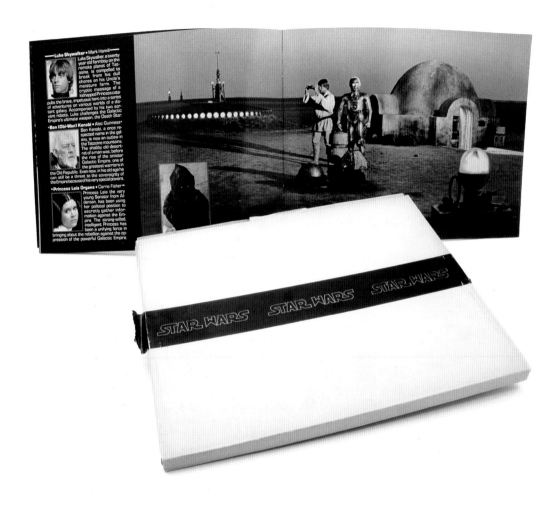

STAR WARS PROMOTIONAL BOOK

LUCASFILM/20TH CENTURY FOX
UNITED STATES, 1976

This is my very first *Star Wars* collectible, a colorful promotional brochure. It was sent to the reporter who covered the movie business in the Los Angeles news bureau of the *Wall Street Journal*, where I plied my trade as a journalist. I looked on covetously as my colleague skimmed the pages . . . and then tossed the booklet and its outer box into his wastebasket. A few hours later he left for the day, and I nonchalantly strolled over to his desk, reached into the basket, and pulled out my prize. I was thankful he hadn't had a messy lunch that day.

in 1840 with the sale of the world's first mass-market postage stamp in Great Britain, or maybe thirty-five years later when the first tobacco company started printing related series of cards along with cigarette packs, specifically to engender brand loyalty through the act of collecting.

I knew none of this in the 1950s, of course, so I guess I have to own up to the true twin demons of collecting: compulsion and obsession. Any true collector—that is, true to himself or herself—will concede at least a passing familiarity with those traits and argue that channeling them into a more socially acceptable act such as collecting is healthier than most impulses or fixations (spouses have been known to disagree).

Today, even five-year-olds talk about their "collections." I get letters from some who can barely print wanting to know how much a toy—that they or a parent just bought new at a store—is worth, and whether opening and actually playing with it will ruin its collectible value. Now *that's* scary! (My usual response: It's worth what you paid for it, and the value is more likely to decline than soar.)

It was different back in the time before *Star Wars*, before video gaming and even home video. Kids usually read comics, put together sets of trading cards, and played with toys until their early teens, when it became a sign of immaturity to do so; then the one-time treasures were handed down, given away, sold at garage sales, or simply dumped. The idea of current (and recent) objects of pop culture being collectibles—as opposed to antiques (which are considered to be at least one hundred years old)—began with trading cards and comic books. At first collected mainly by passionate fans, they developed into commodities by the early 1970s. Shops opened, newbies bought with the hope of turning a quick profit, and top-condition "grading" became important—although, for me, there's something very sad about a mint (or unread) comic book. (The concept of cards and comics as an investment crashed and burned in the two recessions of the early 1980s.)

George Lucas had no reason to expect a merchandising bonanza from his small space fantasy. With the exception of Walt Disney's Mickey Mouse, the licensing business was relatively small. The general feeling among manufacturers was that while weekly television series could be successfully licensed—from *Roy Rogers* to *Doctor Who* to *Star Trek*—movies just didn't have the staying power to be hits. The toy makers often cited the 1967 musical dud *Doctor Doolittle*, which failed both at the box office and on store shelves.

But Lucas and his team were looking for advance marketing help as much as anything, especially because 20th Century Fox was having problems coming up with the right marketing campaign, and theater owners and managers simply refused to book a movie about—as an early Fox line had it—"a boy, a girl, a universe" There were some positive signs, however. A paperback novelization from Del Rey books sold out all 200,000 copies, and a six-part serialization by Marvel Comics—despite the publisher's initial rejection of the property—went into multiple printings and sparked a huge buzz among the target audience.

Still, getting a toy company aboard proved difficult. Most solicitation letters from Lucasfilm and Fox went unanswered. At New York's annual Toy Fair International in February 1977, representatives from the two companies were literally hustled out the door of one major toy maker, Mego. But at a small company in Cincinnati, Kenner Products, the designers had read the script and seen black-and-white photos of some of the characters and vehicles—and they were hooked. Although company head Bernie Loomis didn't have high hopes for the movie, he thought it was "toyetic" enough to support a small toy line that would be introduced the following year, even if kids didn't remember the film. The contract was signed barely a month before *Star Wars* opened on May 25, and the rest is history.

Besides the fact that it was a fun-filled, action-packed, and ultimately satisfying film loved by audiences of all ages, I'm convinced that a major reason for

the huge initial success of *Star Wars* memorabilia was that supply had to chase a near insatiable demand. At first posters and T-shirt transfers were the only items available, and eventually metal jewelry appeared. Kenner managed to get out boxed cardboard puzzles and some board games, and at Christmas the company had the audacity to sell an "empty box"—a gimmick that garnered lots of publicity, most of it unfavorable. Inside the $10 sealed cardboard packet was a cardboard "stage," some stickers, and a mail-away form guaranteeing that the sender would be among the first to receive four 3 3/4-inch *Star Wars* action figures when they became available in early 1978.

My attachment to *Star Wars* was both instantaneous and deep. I had grown up devouring science fiction and fantasy novels written by masters of the form such as Isaac Asimov, Robert Heinlein, Frederik Pohl, and A. E. van Vogt; going to movies such as *Forbidden Planet* and *This Island Earth*; and watching television series like *Tom Corbett—Space Cadet*. And I grew up with the Space Age, fascinated to be part of an historic era that began with *Sputnik*.

I saw *Star Wars* at a media screening on the Fox backlot two weeks before it opened and in advance of all the hype; that added to my personal sense of discovery and excitement. I was mad for the movie. It reawakened the kid in me; at the same time, I strongly identified with the hero, Luke Skywalker, who was going through some of the same rites of passage—in a much more dramatic way, of course—that I was.

I had only recently begun to collect space toys, spurred by a front-page story I had written for *The Wall Street Journal* about antique toys, which had opened my eyes to an entire subculture. I started buying everything from 1960s Japanese battery-operated tin robots and spaceships to new toys.

The first *Star Wars* items became part of my overall space collection . . . until a few years later, when they took over like out-of-control kudzu. My very first *Star Wars* collectible was rescued from the trash. One day

I noticed a colleague who covered the movie business looking through a brochure with the words *STAR WARS* on the cover. It was the booklet that Fox and Lucasfilm sent to the folks who booked movies, and later to journalists. After he finished, he dropped it in his trash can; and when he left for the day, I "rescued" it. It was my first, but far from last, *Star Wars* collectible to be salvaged from the dumpster.

Part of my routine in the late 1970s was to hit the Los Angeles–area Toys"R"Us stores and independent shops at least once a week, looking for the latest toys. Since the adult toy-collecting mania hadn't yet started, inevitably I'd be asked how old my sons were or how many kids I was buying for. I'd mumble something, but rarely the truth. Here I was on the cutting edge of a new phenomenon, yet I was embarrassed. It just wasn't something grown men did, I believed, never stopping to think that I was a pioneer . . . after a fashion.

It didn't take long before that bugaboo that confronts every collector cropped up: Where do I put this stuff? Whether it's a closet, a spare bedroom, an empty garage, or a five-thousand-square-foot chicken coop, there's never enough room. My partner, Bob, and I lived in a fourteen-hundred-square-foot house in the hills east of Hollywood. The house was on a hill supported by metal stilts; there was no garage and very little storage space. Luckily, our wonderful neighbors had a multilevel house and offered me the use of their unfinished basement. For more than a year, as the toys came in, I took Polaroid photos of them, stuffed them in boxes, and wrapped and taped the cartons with heavy plastic trash bags, since they were going to be stored on raw earth—not an ideal location.

Soon enough, the neighbors decided to finish their basement, and I took their cue. Our one-story cantilevered house became a two-story house, with an office and toy-storage room below. And within a couple of years, it became a three-story house. Still the collection grew. One on-site storage shed eventually morphed into five off-site storage lockers.

THE OLD "MUSEUM" IN LOS ANGELES
1994–1995

The third story of my house in Los Angeles held part of the
Star Wars collection, and the rest was kept in five off-site
storage rooms. Those gray metal poles helped to support the
cantilevered house.

Star Wars merchandising had become a phenomenon. I still collected space toys, but the galaxy far, far away became my collecting focus after *The Empire Strikes Back* hit movie screens in 1980. Although the toys remained the center of attention, they weren't enough. I wanted everything—the books, comics, kids' pajamas, posters, fast-food premiums (and the containers and placemats), eating utensils, furniture, lunch boxes—you get the idea. Around the time *Return of the Jedi* was released in 1983, I realized there was an entire unexplored world of international collectibles, and I started making pen pals from Japan to Italy.

And then silence descended on the galaxy. George Lucas said he was taking a long break from *Star Wars*, and, without the prospect of new entertainment, the toys and nearly everything else disappeared from stores. Many collectors decided it was time to move on to something else; I saw it as a buying opportunity. A number of major collections came on the market—some because of divorces and the need for cash settlements—and I bought large chunks of many of them. The first *Star Wars* convention took place in Los Angeles in 1987 to mark the saga's tenth anniversary, and it brought out fans and dealers with mountains of collectibles that I never knew existed.

Over the years, other buying opportunities arose, including the chance to purchase actual props and costumes used in making the films. I traded with a few reliable international collectors and started making friends with a small community of like-minded fans. After hearing through the grapevine that Lucasfilm was interested in having a *Star Wars* collectibles price guide published, I cold-called the head of the new publishing unit of Lucas Licensing and boldly stated that if anyone were to write such a guide it should be me. "And you are . . . who?" she responded.

Star Wars: From Concept to Screen to Collectible was published in 1992. Many of today's collectors cite that book, with its anecdotes and never-before-seen photos, for getting them into collecting. Two price

RANCHO OBI-WAN RENOVATION
1998–1999

The rooms looked huge when they were empty. I couldn't imagine filling them, even as we started moving boxes in. Then came the *Star Wars* prequel trilogy.

MOVE-IN STARTS IN NORTHERN CALIFORNIA
1999

THE SAME VIEW TODAY
2009

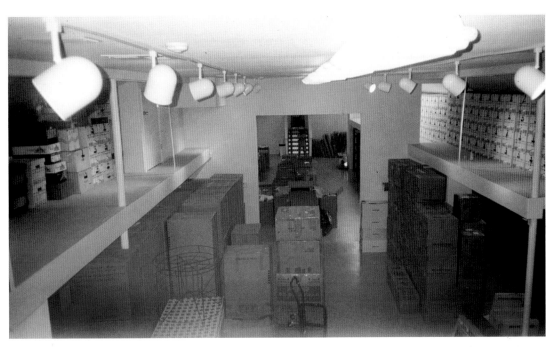

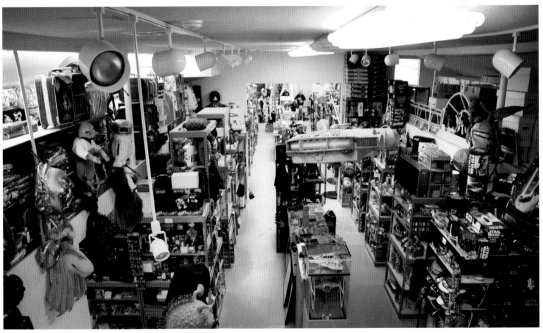

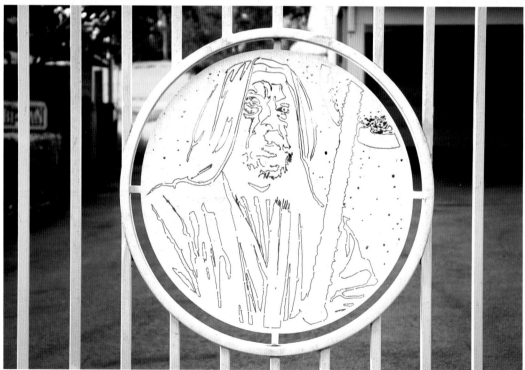

guides, fifty hours of cohosting QVC *Star Wars* Collectibles programs over six years, and another twelve *Star Wars* books followed.

And there was one other little thing. After twenty-six years at the country's preeminent business newspaper, the last nine of them as Los Angeles bureau chief, I followed my bliss—as mythologist Joseph Campbell would say—and left *The Wall Street Journal* in early 1996 to join the company that had fueled my passion for decades, Lucasfilm Ltd. My initial assignment was to act as a sort of *Star Wars* ambassador, a liaison to fellow fans, by making presentations to explain what the following year's *Star Wars* Special Edition films were all about, as well as why and how they had been changed from the originals. The Special Edition films were a twentieth-anniversary treat for fans and for George Lucas himself, who was never satisfied with the limitations he had while making the original trilogy.

Lucas Licensing also was gearing up after an eight-year fallow period. "We'll be ready for our fans when they're ready again for *Star Wars*," Licensing president Howard Roffman promised me during an interview in 1991 for my first book. Initially a trickle, the merchandise grew to a flood of biblical proportions by the time *Star Wars*: Episode I *The Phantom Menace* premiered in 1999. And, yes, I tried to buy most of it. With the advent of e-mail, the Internet, and sites such as eBay and Amazon, it became increasingly easy to track down even the most obscure items. A Jar Jar Binks automobile side-window sunshade from France? Sure, no problem!

Thankfully, by then I had left behind the storage shed, the three-story house, and the five self-store lockers. The Los Angeles–based moving company claimed ours was its second largest residential move, the largest having involved a mansion and two baby grand pianos. In searching for a house near Skywalker Ranch, space for the collection became a prime concern. After looking for nearly two months, I was getting desperate, and my real-estate agent began looking at homes that had been pulled off the market for various reasons.

And that's how I found what I came to call Rancho Obi-Wan, after my favorite *Star Wars* character. The previous owner of the former chicken ranch, located in southern Sonoma County, had turned several of the hen houses into a factory to make machinery for cabinetmakers. Unfortunately for him, the land is zoned rural/residential/agricultural, and his business was forced to close. With a lot of time and effort, we fixed up the main barn as a storage area for the collection. It is temperature-controlled, has a central-station alarm and fire system, and is surrounded by a moat filled with alligators. Well, maybe that last part is a bit of an exaggeration. The gators are fairly tame.

Because of its location, Rancho Obi-Wan isn't and can't be open to the public. Even I don't have a lot of time to spend exploring the tens of thousands of items on its shelves, which is why my friend Anne Neumann acts as collection manager. (She was also the primary photographer for this book.) She is third in a line of friends who have taken on that role, preceded by Les David and Josh Ling. Occasionally visitors will come to help reorganize or move parts of the collection, celebrate an occasion, or take a tour that I've donated to a non-profit group for a fund-raiser.

RANCHO OBI-WAN WELCOME SIGN
CHRIS TREVAS AND CHRIS REIF
UNITED STATES, 2000

This wonderful logo, based on the look of the Lucasfilm Ltd. "buckle" (the logo that looks like a 1970s embossed belt buckle), was designed for me by two artist friends, who unveiled it as a surprise. The beautifully carved wooden sign now greets visitors to Rancho Obi-Wan.

RANCHO OBI-WAN FRONT GATE
STRUCTURAL GATES
UNITED STATES, 2003

When I went scouting for a company to make a new front gate, I looked at hundreds of photos and saw that many gates incorporated art in some form. So I came up with this design using Lucasfilm-commissioned line art. Obi-Wan was then cut into the round steel plate by laser and welded to the gate frame. I had second thoughts after it was done, wondering if the portrait would act as a beacon for unwanted visitors. My fears were laid to rest after a neighbor reported that he had been asked whether the "monk" on the gate meant the property was being turned into a monastery.

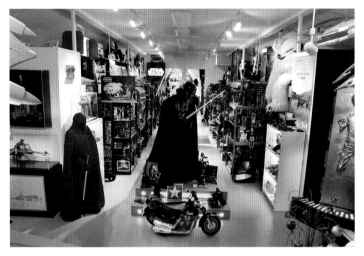

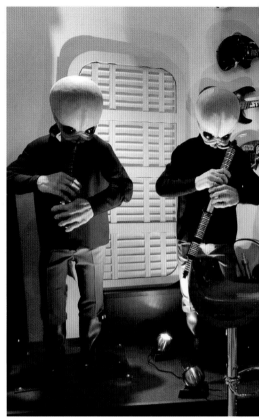

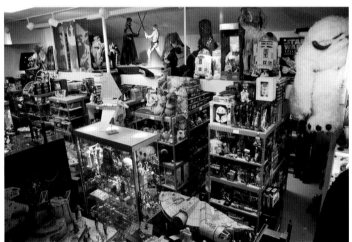

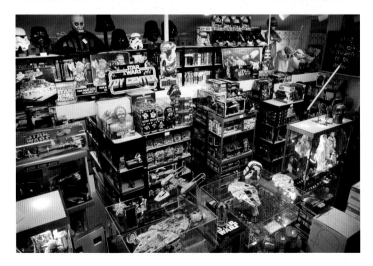

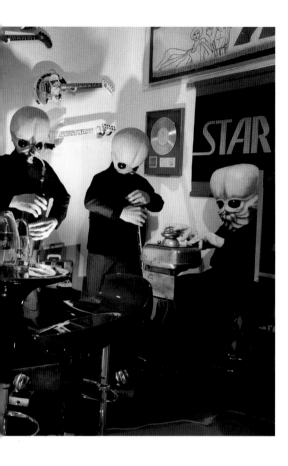

CANTINA BAND ANIMATRONIC FIGURES

MADE FOR FAO SCHWARZ
UNITED STATES, 1997

Welcome to the Mos Eisley cantina! Pull up a stool and listen to the stylings of the inimitable Modal Nodes while you sip a glass of fermented blue bantha milk. For years the band was gainfully employed—from opening until closing, on an endless loop—at the large FAO Schwarz specialty toy store in Las Vegas, where they entertained shoppers from a stage behind the soda counter. When FAO filed for bankruptcy, the band ended up as part of a live and online auction of many of the chain's fixtures. They were listed just as "alien mannequins," so there was no way to tell if they came with all the equipment necessary to get them moving and playing again—or, even if they did, whether it would be possible to hook them up again. I went for it anyway; the cost of shipping them exceeded the purchase price. When they arrived, I was delighted to discover that the man who tended to and repaired the figures in Vegas had taken them apart with the utmost care, included some instructions for reassembly, and even listed his telephone number for further advice.

Putting Humpty Dumpty back together again was way beyond my capabilities, but my handy and inquisitive friend Philip Wise volunteered, picked out the air compressor I needed, called the Vegas disassembler for some tips, designed and built the stage, and amazed us all by getting the band working again. I concentrated on getting their jackets and pants dry cleaned.

That rounded door between two of the musicians is the original door from the cantina set in Tunisia.

DARTH VADER MOVIE COSTUME AT THE ENTRANCE TO THE MUSEUM

This is the view that greets visitors to the collection at Rancho Obi-Wan, which occupies the front and back bays of the former chicken barn. Still primarily a storage facility for the ever-growing collection, the space is done up with some dramatic flare to try to give it an almost museumlike atmosphere. The imposing seven-foot Darth Vader mannequin front and center wears a mostly original costume made for *The Empire Strikes Back*, which has been pieced together from three different auctions over the years. The collection is arranged mainly by category, or type of object, and then often further broken down by movie title or era.

TWO OVERVIEWS OF THE COLLECTION

There are several questions that visitors often ask.

How much is it worth? In dollar terms, I haven't the foggiest notion and am really not sure how to figure it out, or if I even want to figure it out. Is it the sum total that I've spent on each individual item over thirty years? Or is it the current "collectible" value of everything? How do you determine a price on one-of-a-kind items? As with any collection, is there a premium attached to the objects for being part of the collection, which has so many full runs of different kinds of items?

How many individual items do you have? That's another excellent question to which I currently have no answer, but we're getting there. Anne has been inventorying and arranging the collection for several years. By the beginning of 2009 she had entered 55,352 individual items in the database—but we're not really sure what percentage of the total collection that represents. All we know is that there's much more to add; we may be only at the halfway point . . . or less.

And then there's the most difficult question of all, and the one most frequently asked: What's your favorite item? "Which one of your three kids is your favorite?" is one reply. Or another response: "Whatever arrived in today's mail!" Sometimes I'll cite a mostly original Darth Vader costume used during the filming of *The Empire Strikes Back*. Or I'll proffer an entire category, such as food-related items or things made by fans. But the truth is, I love it all.

STAR WARS LIGHT BOX

MADE FOR FAO SCHWARZ
UNITED STATES, 1996–1997

I lusted after this fiber-optic light box from the first time I saw it at FAO Schwarz's headquarters store on Fifth Avenue in New York City. FAO made a huge commitment to support *Star Wars*, tricking out full departments in its larger stores with oversize prop and vehicle replicas. I did a slide show talk at five of those stores, and about forty-five items from my personal collection went on display in the windows at the headquarters store. I kept asking who had made the box but never got a satisfactory answer. Finally, after the chain filed for bankruptcy, the box was part of a large liquidation auction. The bidding was stiff, and I paid a lot more than I thought I would, but I brought home the prize. I was even more amazed when I saw how simply and cleverly the box had been constructed, using a bundle of fiber optics, a small revolving color wheel with just two color gels, and a 40-watt lightbulb that is still shining.

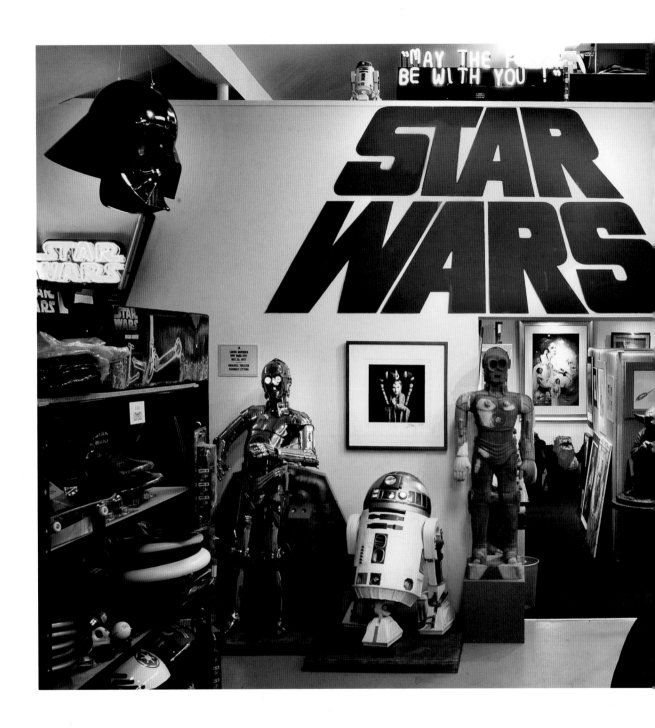

Often the story behind a collectible—what it is, how it was made, when and how I acquired it, problems connected with it such as U.S. Customs issues—is as interesting or more so than the item itself. Even a standard two-hour exploration of the collection barely scratches the surface of Rancho Obi-Wan. Hence this book, a grown-up's version of Show and Tell. Here, in fact, are some of my favorite things. I hope you enjoy the tour.

Steve Sansweet
Rancho Obi-Wan
Sonoma County, California

LOEWS ORPHEUM NEW YORK MARQUEE LETTERS
MADE FOR LOEWS
UNITED STATES, 1977

It amazes me that certain objects have survived. Something that was saved as a souvenir or because it seemed really cool to a kid can take on a new significance today, since *Star Wars* truly has become a cultural phenomenon. These are the original Fome-Cor marquee letters that graced the old Loews Orpheum theater in New York City on opening day, May 25, 1977; the Orpheum was one of only thirty-two theaters in the United States that had booked the film. Once a one-screen auditorium, it has long since been replaced by a seven-theater multiplex. I spotted these letters in the late 1980s in a small ad in a magazine that dealt with antique toys—only the second ad for anything *Star Wars* I had seen in the magazine in more than a decade. I called the phone number and talked to a nice guy in Brooklyn. He told me how he had been friends with the theater manager and that his son was "nuts" about *Star Wars*, so he asked the manager for the letters when they were replaced. They were mounted on a wall in his son's bedroom until the boy left for college. He was seeking $100 plus shipping. When they arrived at my house in Los Angeles, I realized how large they were. I had absolutely no place to display them, so they went back into the package and remained virtually forgotten behind some shelf units until I moved. Even in the new barn, I didn't think there was anyplace to put them. But one day my friend Michael suggested they might fit on the wall above the entrances to the arcade and the art gallery. The Force was definitely with us that day because, after measuring, we determined that they would fit with barely an inch or so to spare. As a bonus, they would be seen as you walked through the front entrance of the museum. Clearly, some things are just meant to be.

PLAY WITH IT

Toys were the main entry into *Star Wars* for kids more than thirty years ago, and they remain so today. A strong case can be made that toys are what started and sustained the strong attachment to the saga among today's fans and collectors. Even non-collectors and latent fans who visit Rancho Obi-Wan often ask if I can show them the particular toys that they got as birthday or Christmas gifts and still remember fondly.

It was the small scale of the first *Star Wars* action figures that paved the way for what has grown into a line of thousands of different figure and packaging variations. The standard height for boys' action figures in the 1970s had been about either eight or twelve inches. The genius of Kenner Products, after seeing the extensive variety of vehicles in *Star Wars*, was to go to a small 3 3/4-inch scale so that affordable vehicles and play sets could be made to accommodate the figures. The reduced size also allowed the initial figures to be sold for as low as $1.97 each, thus increasing the likelihood that parents would buy more than one—and that their kids would eventually beg for them all.

Other toy companies had been making small figures, but usually these were without many moveable parts or accessories and primarily targeted at preschool children, often girls. In fact, some of the first crude mock-ups done internally at Kenner were built on the bodies of rival Fisher-Price's Adventure People line. (Fisher-Price didn't add a space line until a few years after the success of *Star Wars*; its 1979 Space Commander was a clever makeover of its earlier Woodsman.)

In the years before home video, toys were a way for kids to both re-create the fantasy they had seen in the movies and to invent their own stories. Who said Chewbacca couldn't be a bad guy and pit his bow-

STORMTROOPER AND DARTH VADER KAWS VINYL FIGURES

MEDICOM TOY CORPORATION/ORIGINALFAKE
JAPAN, 2007

These are limited-edition designer vinyl toys, licensed by Lucasfilm despite their unusual appearance. The stormtrooper and Darth Vader figures were designed by KAWS and done in collaboration with a Tokyo store named OriginalFake. Only one thousand of each were made available via a lottery system, which had Japanese *otaku* (geeks) waiting in line for up to six hours. Among them, thank goodness, was my longtime Japanese *Star Wars* buddy Eimei Takeda, whom I have known through our mutual collecting mania since 1984. KAWS, a former graffiti artist from Jersey City, New Jersey, is famous internationally for his X-eyed characters.

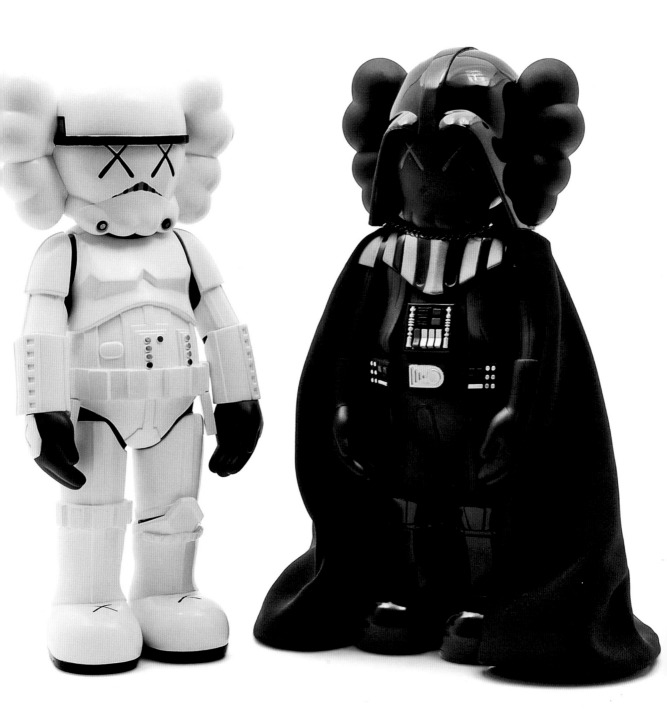

caster against Luke Skywalker's lightsaber? Or maybe Princess Leia could really show Darth Vader what she thought of him. Play patterns with toys and schoolyard role-playing games sowed the seeds for long-held memories. So years later, when it became socially acceptable for adults to start collecting the toys of their own childhood, *Star Wars* gained a renewed currency. And action figures were the center of the action.

Bernie Loomis, a toy industry veteran who was president of Kenner at the time *Star Wars* was released, conceded many years later that he had no inkling that the movie would be a hit, much less have a continuing impact on popular culture. In fact, he was sure that the film would come and go quickly, as most did, but he saw in it a "toyetic" quality that could be the basis of some products "long after the movie was forgotten." Kenner's contract, in fact, called only for one "all-family action board game" in 1977, and for six figures and perhaps three play sets in 1978. As soon as the movie opened, however, more than thirty products were rushed into development.

In retrospect, the call on the figure size seems obvious. The big success stories of the era, however, were Kenner's own twelve-inch *Six Million Dollar Man* figures, Hasbro's foot-tall G.I. Joes, and Mego's eight-inch *Star Trek, Planet of the Apes*, and superheroes lines. But if Han Solo were that big, the *Millennium Falcon* would have been five feet in diameter, would have cost hundreds of dollars, and wouldn't have fit on store shelves. In fact, Kenner eventually did make both smaller- and larger-scale *Star Wars* figures, but both lines were canceled because of the overwhelming popularity of the action figures.

Designing the initial products wasn't easy. Kenner had been given only twelve color slides to work from, so one of its first puzzles had so much "outer space" black that it was nearly impossible for kids to put together. Still, the puzzles flew off the shelves. With Lucasfilm's wishes made clear, Kenner didn't just slap *Star Wars* labels on existing products, although there were a couple of exceptions. A *Six Million Dollar Man* headset radio molded in blue plastic became Luke Skywalker's headset radio when it was remade in black. For reference, sometimes all that Kenner had were black-and-white photos that didn't show the entire character. That led to one major faux pas, which became an instant collectible. For an early Sears-exclusive Cantina Adventure Set containing four action figures, the company produced a normal-size Snaggletooth figure with a blue outfit and silver gloves and boots. Only later did designers get the information that Snaggletooth was a dwarf with a red outfit and hairy bare hands and feet. The figure was resculpted and sold on a backing card.

Due to the extensive time it takes to develop, produce, and distribute three-dimensional plastic toys, Kenner was able to get only some boxed jigsaw puzzles, a board game, and paint sets on store shelves in 1977. Unhappy over prospects of losing potentially millions dollars of holiday sales because its action figures weren't ready, Kenner marketed its Early Bird Certificate Package. This tightly sealed portfolio with a cardboard diorama and some paperwork sold for between $7 and $10. It contained a mail-away coupon that promised home delivery of the first four action figures as soon as they were ready the following year. Only about half of the 600,000 kits shipped were sold, and Kenner was the subject of some uncomplimentary news and editorial coverage for selling "an empty box." But Loomis was still happy, knowing that he had primed the pump and gotten the buzz started.

In 1978, Kenner sold 26,106,500 action figures, well on its way to selling approximately 250 million by the time the vintage line petered out in 1985, after having created 111 different basic carded figures for the United States market. For some collectors, that number is just a start. American figures were released under four main logos on backing cards, one for each movie plus the final line, Power of the Force. Then there were fifteen different card backs identified by how many action figures they showed (the number ranged

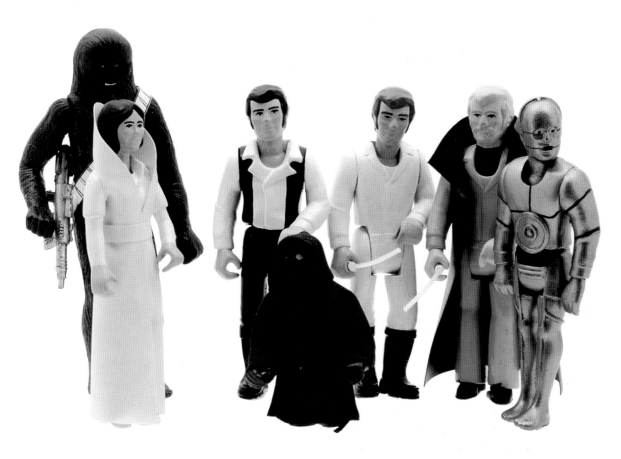

KENNER REPLICA "PROTOTYPE" ACTION FIGURES

NICK MACARTY
UNITED KINGDOM, 2006

An early photo in a print ad for Meccano, Kenner's French affiliate, indicates that many of Kenner's very first mock-ups of *Star Wars* action figures were sculpted on top of rival Fisher-Price's Adventure People, which first hit the market in 1975. They were shown to Lucasfilm officials as a proof of concept. Kenner's figures had many action features not present in the Adventure People, which were primarily for a younger audience. But in making its action figures in about the same scale as the earlier Fisher-Price figures, Kenner established an entirely new business for a licensed property. Ace customizer Nick Macarty took the fuzzy photo from the Meccano ad and built a set of "prototype" Kenner *Star Wars* figures that look amazingly like the originals. If those prototypes still exist somewhere, they haven't surfaced yet.

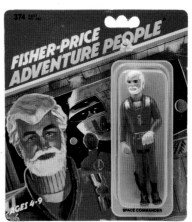

ADVENTURE PEOPLE SPACE COMMANDER ACTION FIGURE

FISHER-PRICE
UNITED STATES, 1979

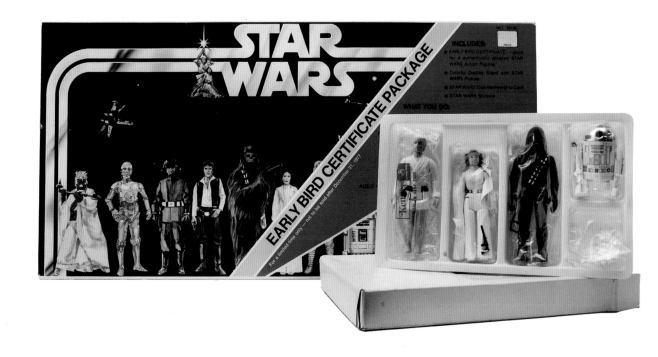

EARLY BIRD CERTIFICATE PACKAGE AND BOX OF FOUR FIGURES IN PLASTIC TRAY

KENNER PRODUCTS
UNITED STATES, 1977–1978

After the immediate and unexpected success of *Star Wars*, retailers and the public started clamoring for toys. Kenner managed to get out some boxed puzzles, paint-by-number sets, and even a board game by late fall, but despite its best efforts the company knew it couldn't ship any action figures or vehicles by the 1977 holiday season. Kenner was getting bad publicity—and even worse, it was losing the chance to rake in revenue. That's when Kenner president Bernie Loomis thought up the empty-box-for-Christmas gambit. "I couldn't deliver the toys they wanted, so I decided to give the kids a pretty picture and a promise to their parents that we'd deliver the toys as soon as possible after Christmas," Loomis said. "Everybody at Kenner tried to talk me out of it. The head guy on our advertising account flew in from New York to tell me I was crazy. The media excoriated me. But it worked."

The certificate packages, which were sealed tighter than Fort Knox to prevent in-store pilferage, contained a thin cardboard "stage" for the first twelve action figures, a few assorted pieces of paper, and a certificate redeemable by mail for the first four action figures. Some 600,000 were shipped. Nearly half went unsold and were returned by retailers. But the certificates reminded the public that Kenner *Star Wars* toys were on the way, and in the end they were considered a public-relations success—at least by Loomis.

from the original twelve to ninety-two), various promotional stickers, alternate paint schemes and other major variations on the figures themselves, multi-packs of figures, and at least a dozen international lines with their own mix-and-match variations. In their 2009 book *Gus and Duncan's Comprehensive Guide to Star Wars Collectibles*, Gus Lopez and Duncan Jenkins list 2,404 items on the twenty-one pages of six-point type that they devote to vintage action figures.

Just as location is to real estate, condition is to collecting. Many people selling carded action figures decide it's worth the cost—which can be anywhere from $20 to $250 depending on a number of variables— to get them graded and then sealed inside an acrylic case. The extra expense can be worthwhile if the figure is scarce and in great shape, since a high rating can double or triple the price that the figure will bring. Of course, the downside is that no one will ever be able to play with the toy again.

To help promote its main line of action figures and related vehicles, creatures, and play sets, Kenner developed a major television ad campaign and striking in-store point-of-purchase displays. As fans go beyond the toys themselves, they seek the displays to complement their collections. The higher-end collectors also seek prototypes, toys at early stages of production, paperwork, and even toys that were never put on the market.

It's hard to think of any item in a toy store that hasn't undergone the *Star Wars* treatment at one time or another: building toys, preschool learning toys, plush toys, die-cast toys, bicycles and other ride-ons, model kits, modeling compound, movie and slide viewers, arts and crafts, electronic games, slot-car racers, wind-ups, battery-operated toys, remote-control and radio-control toys, role-playing weapons and costumes, kites, arcade games, home video games, and, for adults, casino games. The Mr. Potato Head lineup even includes Darth Tater, Spudtrooper, and Artoo-Potatoo.

The irony of it all is that the more than $15 billion that has been spent at retail worldwide on *Star Wars* toys and other merchandise—money that helped pay for the development of Lucasfilm as a major, independent production company—came about because distributor 20th Century Fox tried to play hardball with George Lucas. In the several years between the signing of a memorandum of agreement to make the movie and the signing of the final contract just a week before filming was due to start in Tunisia, the business affairs department at Fox had done nothing but delay the process and throw roadblocks in Lucas's path. That forced him to use his own money from the unexpected financial success of *American Graffiti* to fund most of the preproduction expenses of *Star Wars*, which got him closer to the starting gate and gave him the upper hand in the final negotiations. Rather than hold out for a higher salary for writing and directing the movie, as Fox expected, Lucas held out for more control. In the end, he got what he wanted the most: sequel rights and 50 percent of the merchandising pie, which was later expanded to include all licensing rights and royalties. If *Star Wars* had opened and closed quickly, those rights would have been worth nothing. George Lucas was happy to take that risk.

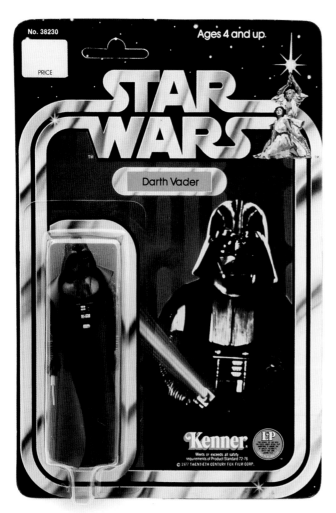

DARTH VADER 3 3/4-INCH ACTION FIGURE

KENNER PRODUCTS
UNITED STATES, 1978

These are the figures that launched a multibillion-dollar line of toys, one that is as popular today as it was more than thirty years ago when first conceived. The so-called 3 3/4-inch-scale action figure—as opposed to the 8- or 12-inch figures more common at the time—helped smaller toy maker Kenner Products vault into the big leagues. By scaling down the size of the figures, Kenner was able to produce multiple vehicles, play sets, creatures, and other accessories that broadened the line and expanded kids' play patterns. With the figures originally priced as low as $1.97 each at some stores, kids quickly decided that they had to have them all and didn't hesitate communicating that to their parents. These first twelve figures, in as good a condition as possible on sealed cards, are the heart of most advanced *Star Wars* collections—and a goal for beginners.

DEATH SQUAD COMMANDER 3 3/4-INCH ACTION FIGURE

KENNER PRODUCTS
UNITED STATES, 1978

"Death Squad Commander" has such a unpleasant connotation, especially for a movie appealing to all ages. But that was the name assigned to this character at the time of the initial release and through the first release of this figure on a card with an *Empire Strikes Back* logo. Then it was changed to the much more politically correct "Star Destroyer Commander."

3 3/4-INCH ACTION FIGURES

KENNER PRODUCTS
UNITED STATES, 1978

(Left to right, top to bottom)
Luke Skywalker
Ben (Obi-Wan) Kenobi
Han Solo
Princess Leia Organa
Chewbacca
Artoo-Detoo (R2-D2)
See-Threepio (C-3PO)
Stormtrooper
Sand People

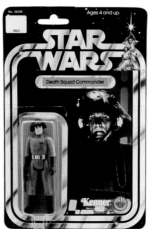

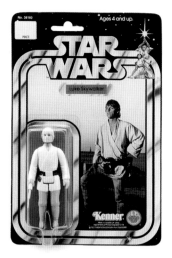

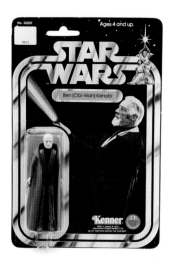

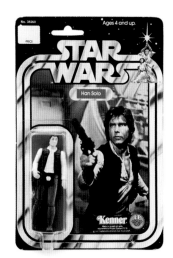

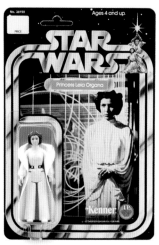

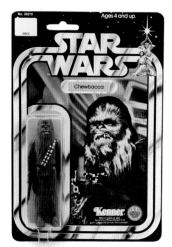

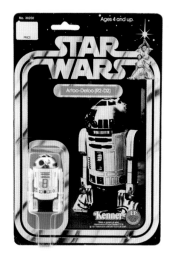

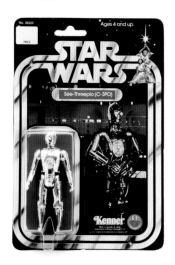

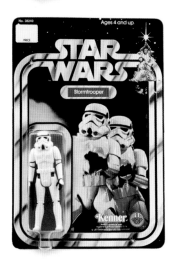

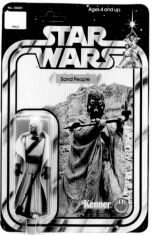

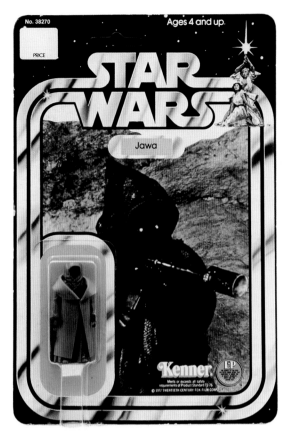
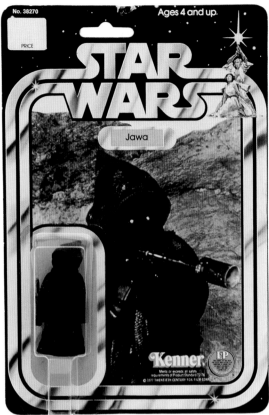

VINYL-CAPE JAWA 3 3/4-INCH ACTION FIGURE

KENNER PRODUCTS
UNITED STATES, 1978

This was the one that almost got away. The Jawa was barely half the size of other figures, yet it was priced the same. It came dressed in a vinyl cape—just like Darth Vader, Obi-Wan Kenobi, and others. But the photo clearly showed a richer-looking cloth cape. So in order to make sure that the figure sold, Kenner produced only a limited number of Jawa figures with the vinyl cape (above left) and switched in mid-production to a tiny cloth cape (above right). Of course, because of its scarcity, it's the vinyl-cape figure that is highly sought. Sometime in the early 1980s, after having opened and displayed my original twelve *Star Wars* figures, I decided to buy another set on the card, in mint condition. I drove to the shop of a dealer friend, Sunnie Ballard of Sunnie's Funnies. He had assembled a full set for me for the princely sum of $215 (quite laughable now). But he also had something else he wanted to show me, and he pulled this carded Jawa out from below the counter. "Ever

seen one of those?" he asked, a smile on his face, knowing the answer would be no. "Is it for real?" I asked. "Yep, it's a variation." That was the first time I had heard the word "variation" used in reference to a *Star Wars* figure, but certainly not the last. "Really rare, too!" So I asked how much he wanted for it. "For you, forty-five," he said. I quickly calculated that I was already running very low on cash (he didn't take credit cards and I didn't have my checkbook). Besides, I thought that was a lot of money for a figure that looked a lot cheaper than the one I had just bought. So I said no, thanked him, and left the store. As I got to my car, my inner collector stopped me. "Don't be a fool," he said. I checked my wallet again—just enough. So I went back to the shop and closed the deal. Sunnie didn't seem surprised. Today, given the pristine condition of the card, my $45 purchase is likely worth more than $2,000. Sometimes it pays to listen to your inner voices—or were they my midi-chlorians?

CLOTH-CAPE JAWA 3 3/4-INCH ACTION FIGURE

KENNER PRODUCTS
UNITED STATES, 1978

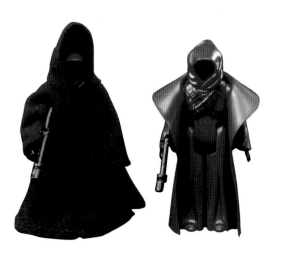

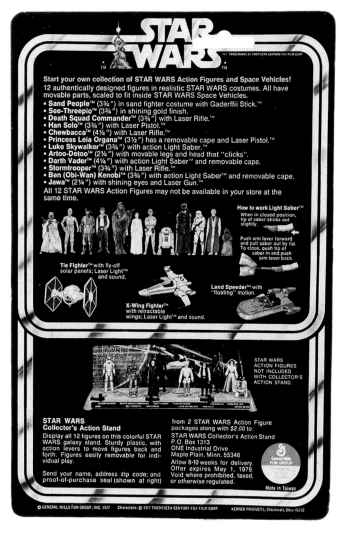

**CLOTH-CAPE AND ORIGINAL
VINYL-CAPE JAWAS**

KENNER PRODUCTS
UNITED STATES, 1978

**ORIGINAL TWELVE-BACK CARD FOR
3 3/4-INCH ACTION FIGURES**

KENNER PRODUCTS
UNITED STATES, 1978

The original twelve-back cards (so named because they include
the first twelve *Star Wars* action figures) also show the first
three vehicles and a plastic action-figure "stage."

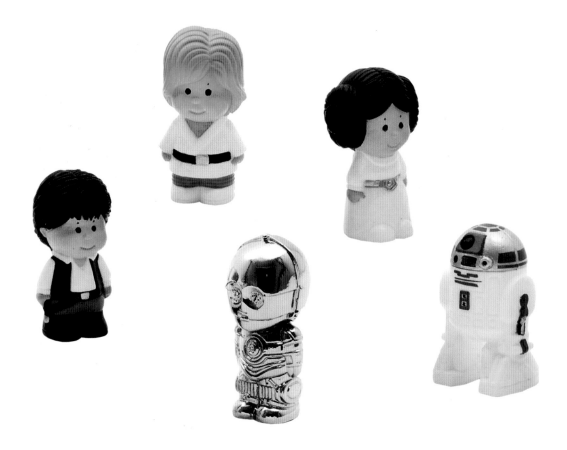

REPRODUCTION KENNER PROTOTYPE STAR TOTS

NICK MACARTY
UNITED KINGDOM, 2006

Early in the development of the *Star Wars* line, Kenner designers came up with the idea of a preschool line called Star Tots, based on its successful Tree Tots toys and play sets. Early sketches exist of ten different characters, and prototypes were produced of at least half of those. Kenner craftsmen also built in wood a Star Tot—scaled landspeeder and an X-wing fighter in which to place the figures. But it was an idea whose time was not to come for about twenty-five years, when Hasbro introduced a similar, but updated and more action-oriented, line called Galactic Heroes. That line became a runaway success among both children and older collectors. I spotted four of the prototypes and the two vehicles on the shelf of a Kenner employee when I was doing reporting for my first *Star Wars* book in 1991; I desperately wanted to call him afterward to see if he had any interest in selling them. But being a *Wall Street Journal* editor at the time, my sense of journalistic ethics—separating work and personal lives—prevented me from doing it. Big mistake. They eventually ended up in someone else's collection.

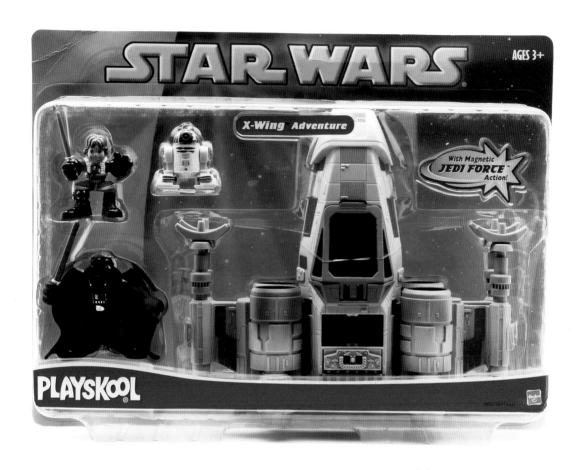

FIRST VERSION OF GALACTIC HEROES

HASBRO/PLAYSKOOL
UNITED STATES, 2004

This is the twenty-first-century version of the Star Tots line proposed in the late 1970s. It has been extraordinarily successful. The first time George Lucas spotted a full display of them at New York's Toy Fair International, a trade show, he seemed mesmerized and examined them for a full ten minutes.

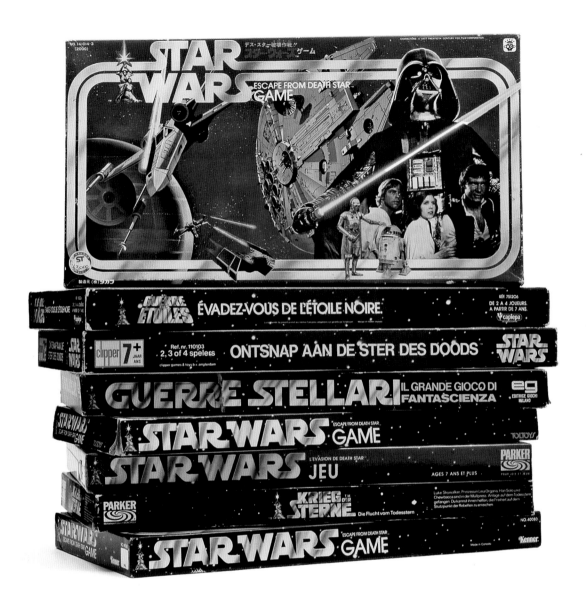

ESCAPE FROM DEATH STAR BOARD GAMES

KENNER PRODUCTS
EIGHT COUNTRIES, 1977–1978

One of the first *Star Wars* products out the door was the
Escape from Death Star game. Relatively easy to produce
and play, it became a worldwide staple, as seen in this stack
from Kenner and its affiliates in (from the top) Japan, France,
the Netherlands, Italy, Australia, Canada, Germany, and
the United States.

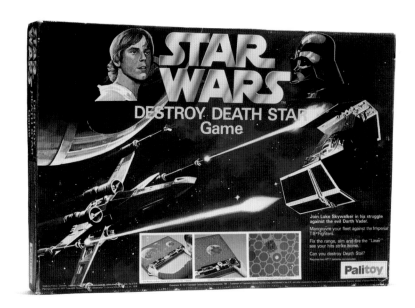

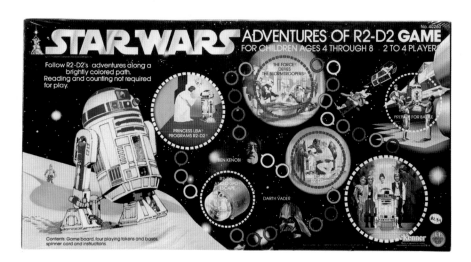

DESTROY DEATH STAR ELECTRIC
BOARD GAME

PALITOY
UNITED KINGDOM, 1978

Talk about exciting technology! Plug this game in, and the
playing field vibrates. And that's about it. The box is a lot cooler
than the game field itself.

ADVENTURES OF R2-D2 BOARD GAME

KENNER PRODUCTS
UNITED STATES, 1979

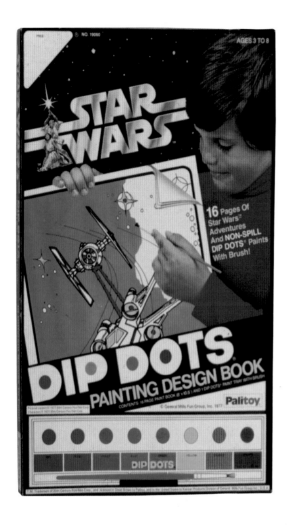

DIP DOTS PAINTING SET

KENNER PRODUCTS
UNITED STATES, 1977

DARTH VADER INFLATABLE BOP BAG

KENNER PRODUCTS
UNITED STATES, 1977–1978

CHEWBACCA INFLATABLE BOP BAG

KENNER PRODUCTS
UNITED STATES, 1979

JAWA INFLATABLE BOP BAG

KENNER PRODUCTS
UNITED STATES, 1979

ARTOO-DETOO (R2-D2) INFLATABLE BOP BAG

KENNER PRODUCTS
UNITED STATES, 1977–1978

What kid wouldn't want to knock down the Dark Lord of the Sith? And you could make a case for swatting a Jawa or two for droidnapping our friends R2-D2 and C-3PO. But punching out our heroes R2 and Chewbacca? What could those toy guys have been thinking?

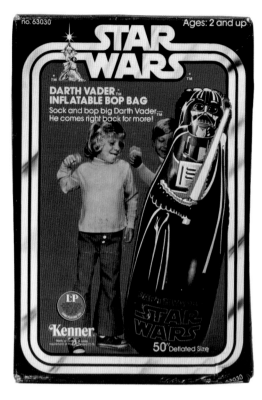

no. 63030 · STAR WARS · Ages: 2 and up

DARTH VADER™ INFLATABLE BOP BAG

Sock and bop big Darth Vader™! He comes right back for more!

Kenner

50" Deflated Size

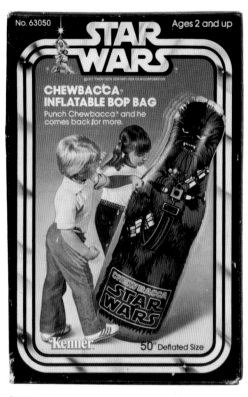

No. 63050 · STAR WARS · Ages 2 and up

CHEWBACCA™ INFLATABLE BOP BAG

Punch Chewbacca™ and he comes back for more.

Kenner

50" Deflated Size

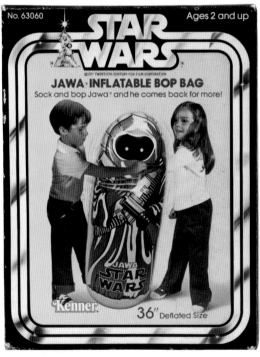

No. 63060 · STAR WARS · Ages: 2 and up

JAWA™ INFLATABLE BOP BAG

Sock and bop Jawa™ and he comes back for more!

Kenner

36" Deflated Size

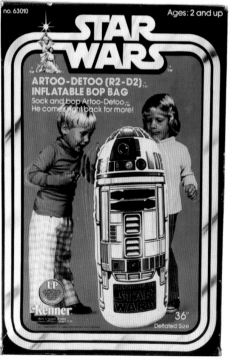

no. 63010 · STAR WARS · Ages: 2 and up

ARTOO-DETOO (R2-D2)™ INFLATABLE BOP BAG

Sock and bop Artoo-Detoo™! He comes right back for more!

Kenner

36" Deflated Size

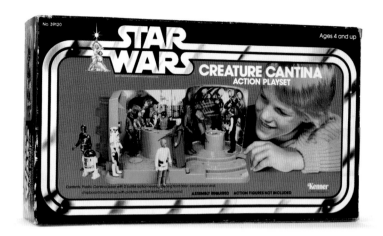

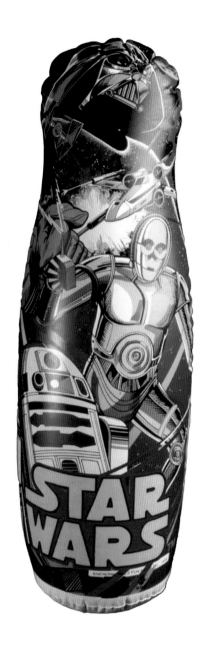

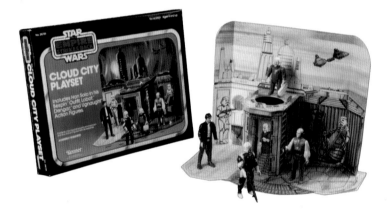

CREATURE CANTINA 3 3/4-INCH-SCALE PLAY SET

KENNER PRODUCTS
UNITED STATES, 1979

Among the vintage Kenner toys most fondly recalled by today's adult collectors were a number of different play sets that had let them as kids re-create part of the action of the movies or develop their own stories with their collection of action figures. The cantina, of course, was one of everyone's favorite scenes in *Star Wars*, with its bizarre assortment of alien creatures. Just remember, "No droids allowed!"

CLOUD CITY 3 3/4-INCH-SCALE PLAY SET

KENNER PRODUCTS
UNITED STATES, 1980

MULTI-CHARACTER BOP BAG

TAKARA
JAPAN, 1978

In Japan, you got the opportunity to knock down multiple characters, but of course they always bounced back.

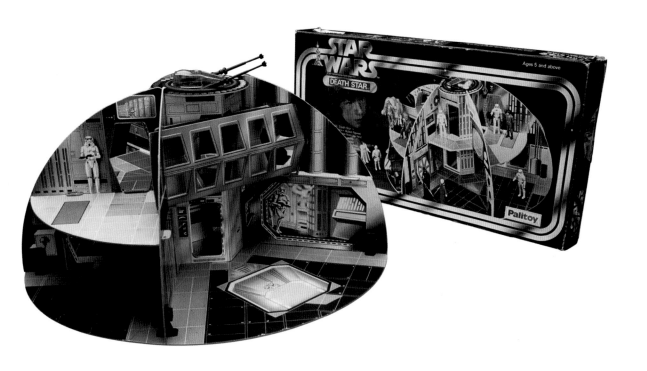

DEATH STAR 3 3/4-INCH-SCALE PLAY SET
PALITOY
UNITED KINGDOM, 1978

Designed in the United Kingdom, this colorful chipboard play set was quicker and cheaper to manufacture than Kenner's version, and it sold in a much more compact box. Kenner's was a plastic slice of a three-level Death Star section with multiple play features, which was advertised in the 1978 Sears Wish Book for $17.87. While the Kenner Death Star Space Station was sold in the United States and Canada, the exceedingly cool, assemble-it-yourself Death Star from Palitoy was also sold in slightly different versions and under different brand names in France, Australia, New Zealand, and Canada (the only country to sell both). Without the Internet, most American collectors had never heard of this beautiful toy until the early 1990s, and then the race was on. That drove the price sky high—well above $500 in excellent condition; because the set is printed cardboard and it is too heavy for the flimsy card-stock box, finding one in even decent shape these days is a challenge. The set features a pass-through elevated walkway, a laser cannon on top, and a chute leading down to a trash compactor with a wall that you push to compact the trash—and possibly your action figures.

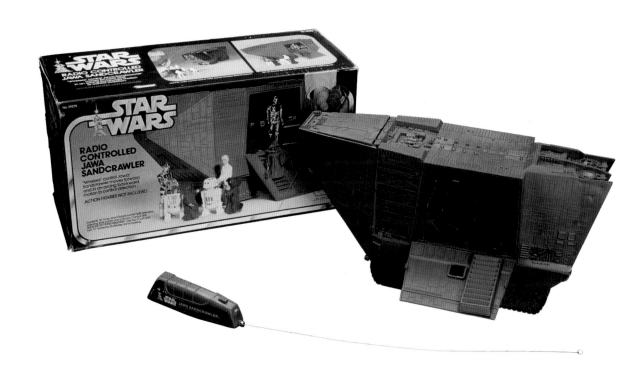

RADIO CONTROLLED JAWA SANDCRAWLER
3 3/4-INCH-SCALE VEHICLE

KENNER PRODUCTS
UNITED STATES, 1979

In the early years of the *Star Wars* merchandise phenomenon, there were a number of aspirational toys—too expensive for every parent to be able to buy, but most assuredly in the hands of at least one kid on the block (undoubtedly the scion of the first neighborhood family to have a color television set too). The radio-controlled Jawa sandcrawler was one of those toys. It wasn't a major vehicle in the first movie, and it didn't have weapons you could fire or lots of secret compartments to explore. But there was something decidedly cool and a bit mysterious about it, and when Kenner released one that could actually move—well, say no more.

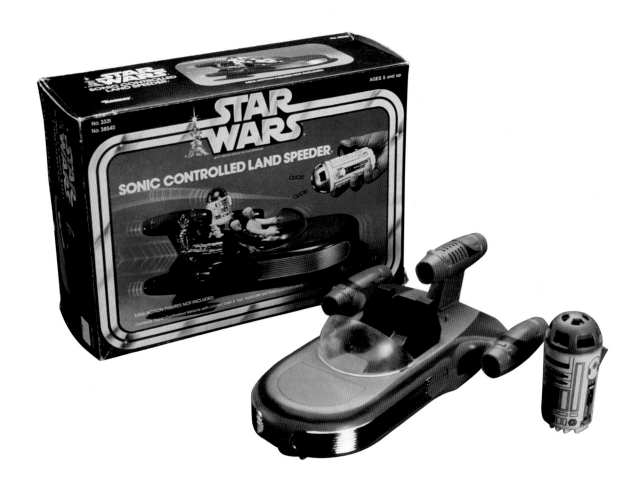

SONIC CONTROLLED LANDSPEEDER
3 3/4-INCH-SCALE VEHICLE

KENNER PRODUCTS
UNITED STATES, 1979

Department-store exclusives have long played a role in marketing hot toys. The store commits to buying all of a special product in order to attract customers, and the manufacturer gets an assurance of extra marketing and advertising. For collectors of vintage *Star Wars* toys, there are few more iconic than this JC Penney-exclusive landspeeder, which was produced in very limited quantities and was available mainly through its Christmas catalogue. Moving under battery power, its "sonic control" consisted of an oversize R2-D2 clicker, much like an expensive version of the clacking metal "crickets" that have annoyed generations of parents. Sold for around $30 new, this toy mint in the box now commands prices north of $2,000.

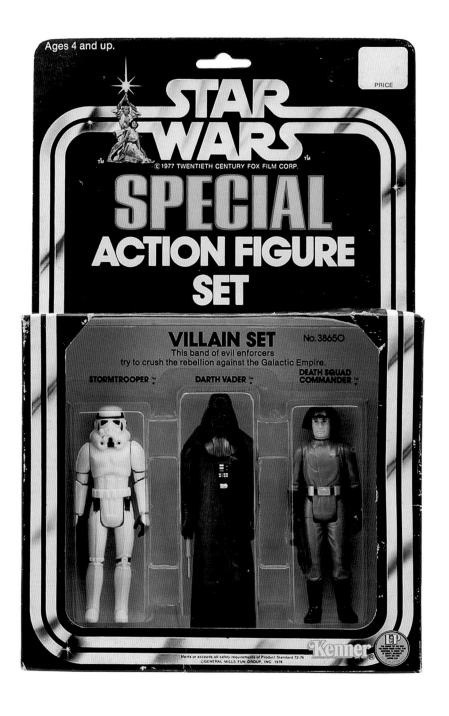

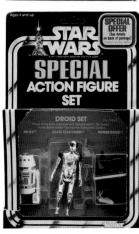
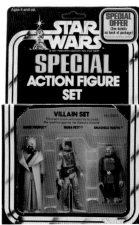
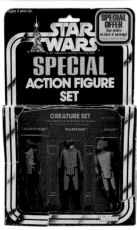

3 3/4-INCH ACTION-FIGURE
THREE-PACK SETS

KENNER PRODUCTS
UNITED STATES, 1978–1979

In the rarefied atmosphere of top *Star Wars* action-figure col-
lectors, the series of sixteen different action-figure multi-packs
issued for *Star Wars* and *The Empire Strikes Back* are among
the most sought. These were sold exclusively through a few
department-store chains at holiday time, and most collectors
didn't even know they existed until the 1990s. Some sets
seem to be scarcer than others and rarely surface for sale.
Kenner mocked up some special sets for *Return of the Jedi* and
showed them in its brochure for department-store buyers, but
they were never produced. As with any collectible, condition is
an essential component of price. But condition is more impor-
tant to some collectors than others. I once traded one of my
sets in pristine condition for two sets (a replacement and one
I didn't own) that were merely in excellent condition. I now have
all but two of the sets and have just about given up looking for
them at a decent price. A few years ago, a complete set of all
sixteen three-packs in excellent condition changed hands
for $40,000.

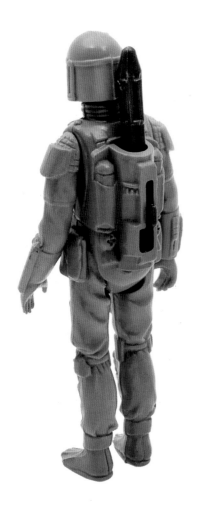
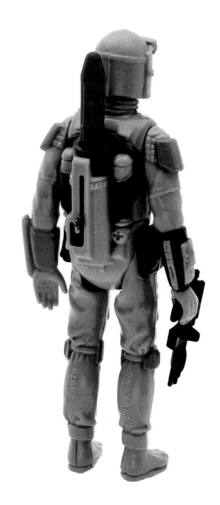

ROCKET-FIRING BOBA FETT
UNPRODUCED PROTOTYPES: L-SLOT (LEFT)
AND J-SLOT

KENNER PRODUCTS
UNITED STATES, 1979

These two figures are among the holiest of grails, and therein lies a tale familiar to most collectors of vintage Kenner *Star Wars* action figures.

The bounty hunter Boba Fett, who wore the coolest costume and was one of the most mysterious characters in the original movies, was first introduced in a short animated segment of 1978's televised *Star Wars Holiday Special*. Fett would go on to make a huge impact from a small role in *The Empire Strikes Back* and become a fan favorite.

While changes to toys happen all the time in the development process, the Boba Fett action figure was unique in the *Star Wars* line because the version as first planned was touted as a mail-in promotional offer. For many months it was widely advertised and appeared on other *Star Wars* toys, featuring its spring-loaded, missile-firing backpack—one of the first really

cool action features for a toy as small as an action figure. But a few months after the promotional campaign was launched, rival Mattel Toys issued a product recall of toy vehicles from the television series "Battlestar Galactica" because similar missiles led to choking incidents in young children, thus leading to a change in product safety rules.

The initial all-blue plastic preproduction samples had already been sent to Kenner headquarters. A small red missile fit loosely in the bounty hunter's jet pack and could be fired easily by moving a protruding red plastic tab. In the hope that the missile-firing feature could be salvaged, the designers decided to remake the slot in the backpack with a "lock," basically extending the L shape into a J shape. A hundred or so of the by-then fully painted versions were sent to Kenner for testing, and most were destroyed in the process. Executives realized that nothing could save the feature because the size of the missile itself was a problem.

The company quickly put stickers over all advance packaging and signage touting the missile-firing feature, remade the figure's back, and sonically welded all missiles inside the jet pack. None of the missile-firing versions were ever released to

NOTE TO CONSUMERS

Originally our STAR WARS™ Boba Fett™ action figure was designed to have a spring-launched rocket. The launcher has been removed from the product for safety reasons. If you are dissatisfied with the product, please return it to us and we will replace it with any STAR WARS™ mini-action figure of your choice.

Thank you for your support.

BOBA FETT™ IS . . .

A fearsome, intergalactic bounty hunter who was introduced in the November 1978 Star Wars television special, "A Wookie Holiday". He pretended to befriend Han Solo™ Luke Skywalker,™ Chewbacca,™ C-3PO™ and R2-D2™ while secretly plotting with Darth Vader™ to trap the Rebel Alliance. Boba Fett™ will also play a major role in the next Star Wars movie, "The Empire Strikes Back".

Kenner

the public, and only a handful survive, making these two figures rare indeed. Still, there are any number of fans who claim that they did indeed receive a missile-firing Fett in the mail. Inevitably, however, when asked to show it they report burying it in the yard of a former house, burning it, or watching their dog eat it.

ROCKET-FIRING BOBA FETT APOLOGY
(FRONT AND BACK)

KENNER PRODUCTS
UNITED STATES, 1979

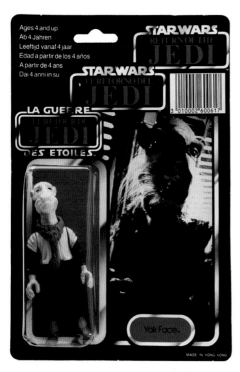

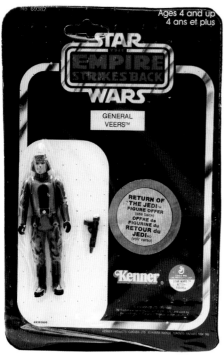

YAK FACE 3 3/4-INCH ACTION FIGURE

PALITOY
EUROPE, 1984

Of course you remember Yak Face. No? But he was in the background for at least three or four seconds of screen time in *Return of the Jedi*. Yak Face was supposed to be Kenner's ninety-third and last action figure in the *Return of the Jedi* line in the United States, but, because production was delayed, he never made it. Instead, Yak Face was released mainly in Europe (where the movie opened months after the domestic release) on so-called Tri-Logo cards (English, French, and Spanish). A few years later, a toy dealer in Germany who was selling me high-end robots threw one in a package because he knew I liked *Star Wars*. Never having seen one before, I got excited and asked if he could find more of them. I didn't know that by then they were on clearance all over Europe. I got them for something like $2 each and resold them for $5, not realizing that if I had been willing to sit on my discovery for a few years, I could have gotten 100 times that much.

GENERAL VEERS 3 3/4-INCH ACTION FIGURE EXCLUSIVE TO SEARS

KENNER (CANADA)
CANADA, 1981

I searched for this General Veers action figure for years—partly because it looked so cheap. It was a bonus packed inside the large plastic Imperial Walker, or AT-AT, just for Sears Canada. The United States version merely used a generic name on the card: AT-AT Commander. Here we have his proper name: General Veers. So even though the back of this card is blank, and the figure is held in place with nasty, hole-punctured shrink wrap instead of a tidy, hard-plastic bubble, the scarcity of this Canadian toy makes it worth about twenty times its American counterpart.

3 3/4-INCH BOXED ACTION FIGURES

POPY
JAPAN, 1980

These action figures, packaged inside sealed plastic bags made by Kenner Products in Hong Kong, take on added value when in boxes produced strictly for the Japanese market. Popy made fifteen of *The Empire Strikes Back* action figures, part of a broader line of World Heroes. I found these in a toy store I visited regularly in the Little Tokyo neighborhood of Los Angeles. I asked the friendly owner if she could get more, but she said all her other shipments had been seized by U.S. Customs because they were "gray" imports, meaning that Popy didn't have the right to sell them beyond Japan.

REBEL TRANSPORT 3 3/4-INCH-SCALE VEHICLE

KENNER PRODUCTS
UNITED STATES, 1982

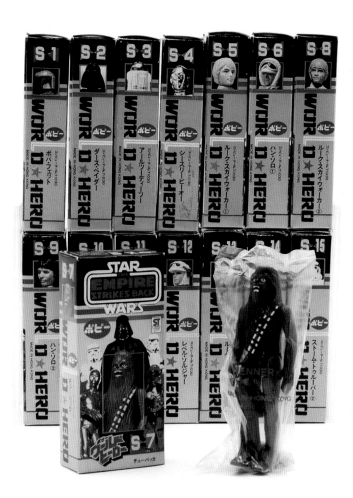

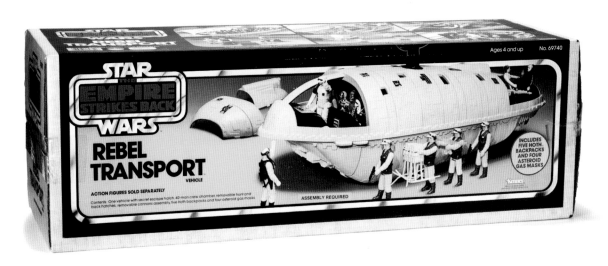

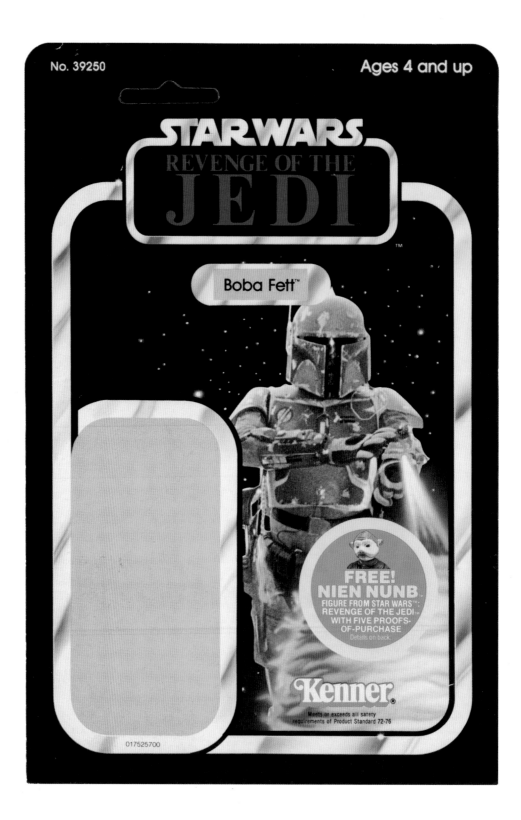

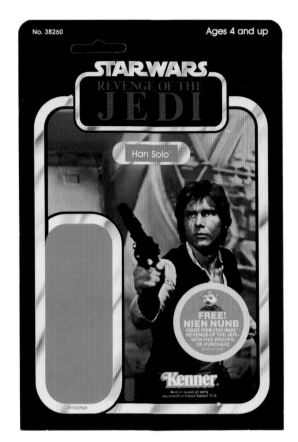

"REVENGE OF THE JEDI" UNUSED ACTION-FIGURE CARD BACKS

KENNER PRODUCTS
UNITED STATES, 1982

As fans know, the title of 1983's *Return of the Jedi* was long reported as "Revenge of the Jedi." 20th Century Fox issued an advance movie poster with that title in late fall 1982, and licensees with long lead times started printing it on packaging and other material. But just a few months before the movie's release came the announcement that Jedi just don't seek revenge. Actually, behind the scenes, George Lucas originally had titled his movie "Return" but producer Howard Kazanjian convinced him that the word wasn't strong enough, so it was changed early in the production process. But Lucas was never totally on board. Lucasfilm did some focus groups in November 1982 to determine which was the most effective title. If the saga were to continue with the good-versus-evil theme it had delivered to date, then "Return," rather than "Revenge," would be more effective in communicating that message, the report concluded, supporting Lucas's instincts. Kenner had already designed and printed stock of action-figure backing cards with the "Revenge" logo. While most were destroyed, enough seeped into collectors' hands to make a fascinating artifact of what is probably the best-known movie-title change in history.

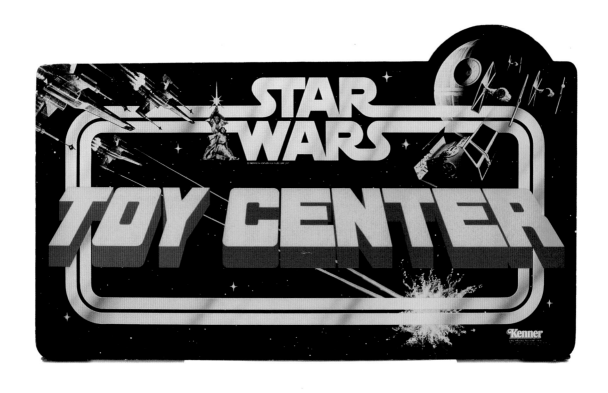

STAR WARS TOY CENTER DISPLAY

KENNER PRODUCTS
UNITED STATES, 1977–1978

Part of the fun in putting together a collection of nearly anything is providing some context that shows how, where, or when an object was sold or used. A great way to do that is by trying to acquire related POP—in-store, point-of-purchase displays. The cardboard and metal signage, and some three-dimensional displays, for vintage Kenner toys are among the most desirable. I picked up a number of these pieces in mint condition at a once-in-a-lifetime auction in Las Vegas. The parents of the collection's owner had run a toy store for years, and they always got two displays—one of which they put aside for their son, who loved *Star Wars*. Collectors flew in from all over the world to bid. After the auction was over I realized that they accepted only cash. I had a sinking feeling until some dealer friends, who knew the auctioneer, vouched for the non-bouncing nature of my checks.

STAR WARS ACTION FIGURES "COLLECT ALL 79" DISPLAY

KENNER PRODUCTS
UNITED STATES, 1983

THE EMPIRE STRIKES BACK DISPLAY

KENNER PRODUCTS
UNITED STATES, 1981

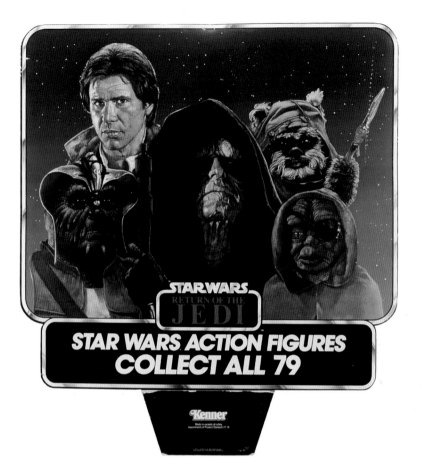

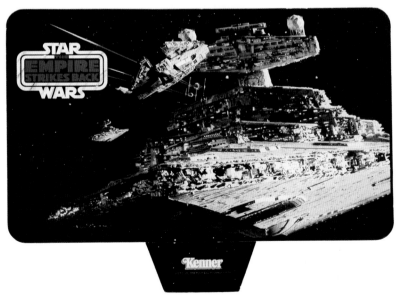

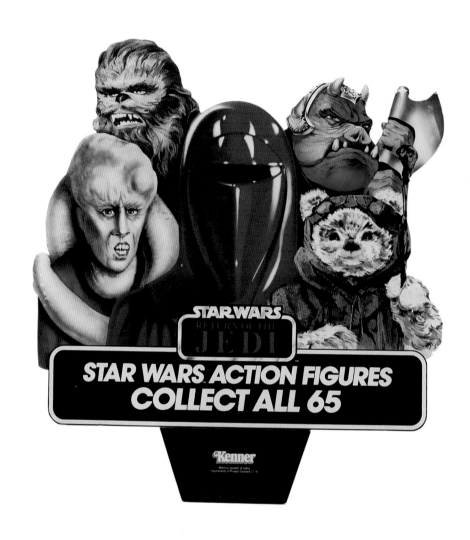

STAR WARS ACTION FIGURES "COLLECT ALL
65" DISPLAY

KENNER PRODUCTS
UNITED STATES, 1983

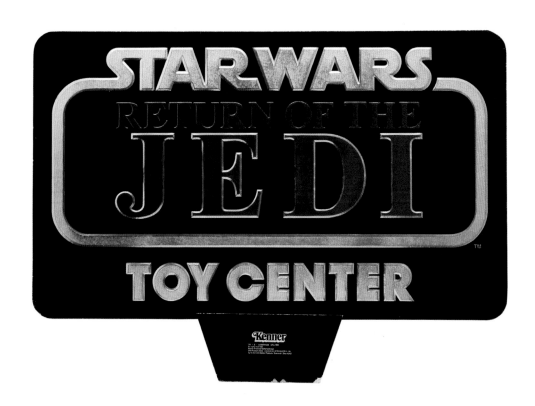

RETURN OF THE JEDI TOY CENTER DISPLAY

KENNER PRODUCTS
UNITED STATES, 1983

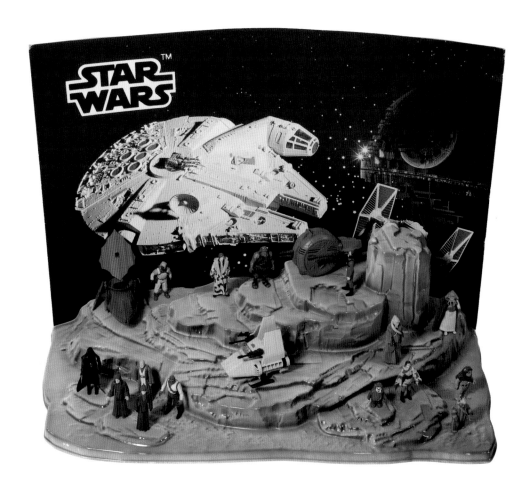

RETURN OF THE JEDI STORE DISPLAY

KENNER PRODUCTS
GERMANY, 1983

This large display was used to promote the sale of *Return of the Jedi* action figures in both Germany and the United Kingdom, hence only the *Star Wars* logo was used, not any additional verbiage that would have to be translated.

GARGAN 3 3/4-INCH ACTION FIGURES
RYAN SHAW, HASBRO, KENNER (LEFT TO RIGHT)
UNITED STATES, 2003, 2008, 1984

Yarna D'al Gargan couldn't even be called a tertiary character in the saga. The six-breasted humanoid woman was seen as a background dancer in Jabba the Hutt's palace in *Return of the Jedi*. She didn't get a full name and background story until years later. Still, Kenner Products put her on a list of action figures to be produced in the 1985 line. She was sculpted and made into a first-stage plaster proof-of-concept prototype (shown here on the right, without her arms and with her small feet broken off). The sculpted model was then taken to the stage of developing an action figure with moveable legs, arms, and head . . . and nothing more. The fully realized vintage-look action figure on the left was sculpted from scratch by customizer Ryan Shaw. Gargan was one of the few vintage-line figures taken this far into development and not produced. After all, how do you integrate the character into a play pattern? Nothing happened to her in the movie. She isn't particularly exotic-looking. Finally, nearly twenty-five years later, Hasbro gave the collectors' world

the gift of a beautifully sculpted Yarna D'al Gargan carded action figure in 2008. The collectors yawned. Even though the figure was produced in relatively small numbers, it quickly fell into the dreaded category of "peg warmer," meaning that while most of the other figures in the line sold out, poor Yarna remained hanging on the pegs in near solitude.

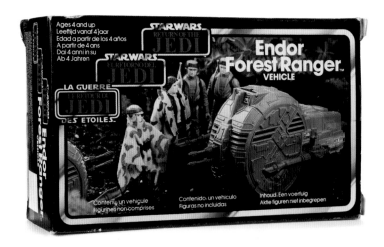

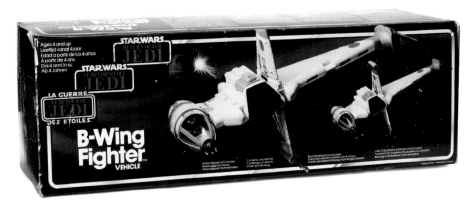

ENDOR FOREST RANGER 3 3/4-INCH-SCALE MINI-RIG

MECCANO
FRANCE, 1983

So-called mini-rigs were an important part of Kenner's business. They were small vehicles at relatively inexpensive price points that could fit one action figure. Most of them were never in any *Star Wars* movie, but they were cleverly designed with style elements that made them seem to be vehicles that existed just off screen.

B-WING FIGHTER 3 3/4-INCH-SCALE VEHICLE

MECCANO
FRANCE, 1983

The Tri-Logo concept of packaging in three languages came and went with the release of *Return of the Jedi* in 1983. It meant that one box design could fulfill orders in the United Kingdom, France, and Spain. Tri-Logo action figures, once considered inferior to American examples, have taken on a certain cachet in recent years as collectors seek out packaging variations. In addition to the logos in three languages, the boxes carry warnings and other information in German, Dutch, and Italian.

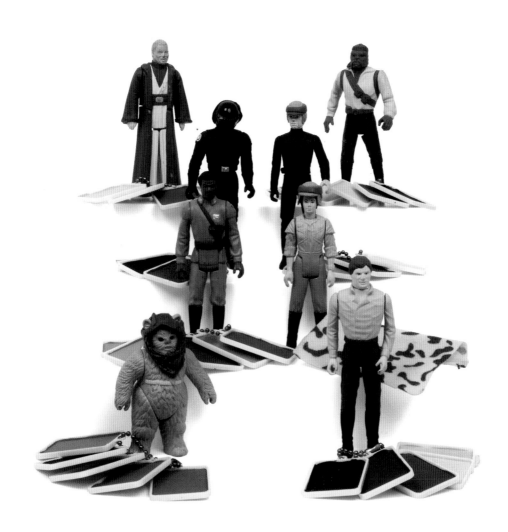

THE POWER OF THE FORCE SERIES
PREPRODUCTION PAINT MASTERS

KENNER PRODUCTS
UNITED STATES, 1984

An action figure goes through many stages before it finally gets
into the hands of a child or collector: reference work, design
and engineering drawings, sculpting, and much more. These
figures are paint masters, hand-painted at Kenner headquarters,
then in Cincinnati, Ohio. The figures, along with small plastic
trays—one for each color of paint used—were sent to factories
in Asia as master samples to be followed. The paint masters
were then returned to Kenner headquarters along with the
initial batch of figures so they could be carefully checked.

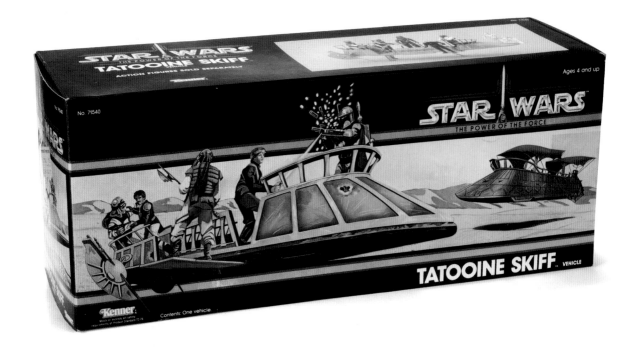

TATOOINE SKIFF 3 3/4-INCH-SCALE VEHICLE

KENNER PRODUCTS
UNITED STATES, 1985

The most-sought after—and least produced—packaging variation in the vintage Kenner toy line was called The Power of the Force. This is an excellent example in a near-pristine sealed box.

ACTION FIGURES AND VEHICLE MULTI-PACKS

PARKER BROTHERS
GERMANY, 1985

Packaging variations excite lots of collectors, even when they already have exactly the same toys. In these 1985 German examples—one keeps the figures on their original cards and the other adds a small vehicle—the only real difference is the front and back overlay and the plastic bubble. For some collectors, that's worth thousands of dollars because they were among the few items sold in Germany that used a translated version of the American logo for The Power of the Force. I have a few different versions in my collection, although I did have one more until I got a call out of the blue offering me an astonishing price: five-hundred times more than I had originally paid. I'm a firm believer that if someone really wants something more than I do—appreciably more—then they are meant to have it.

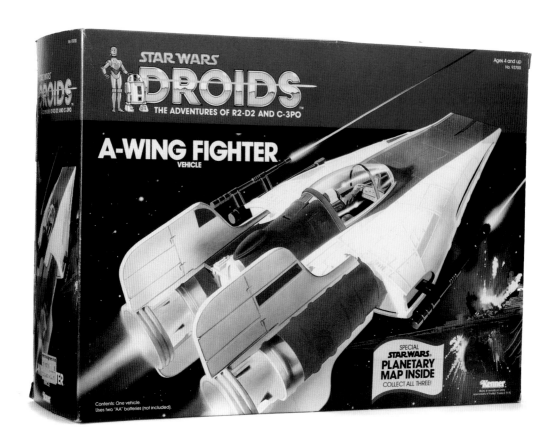

A-WING FIGHTER 3 3/4-INCH-SCALE VEHICLE

KENNER PRODUCTS
UNITED STATES, 1984

This is one of the few vehicles branded with the new look of the short-lived *Star Wars: Droids* animated television series, which lasted just one season.

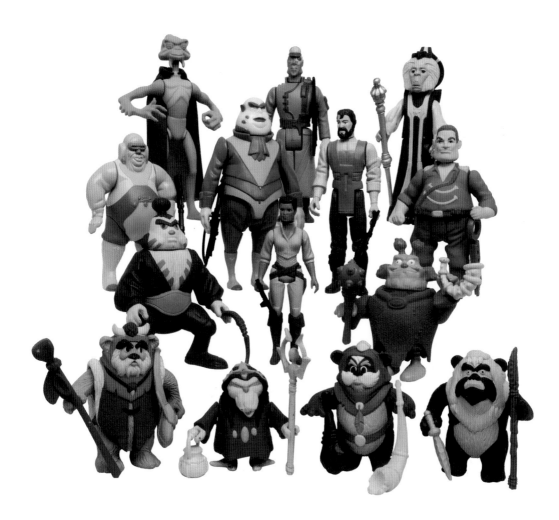

EWOKS AND DROIDS ADVENTURE HOUR
UNPRODUCED 3 3/4-INCH ACTION FIGURES

KENNER PRODUCTS
UNITED STATES, 1986

The first animated *Star Wars* series was the *Ewoks and Droids Adventure Hour*, which started airing on ABC-TV in 1985. It was actually two separate half-hour shows, one featuring the Ewoks, first introduced in *Return of the Jedi*, and the other featuring R2-D2 and C-3PO and the adventures they had before the events of the original *Star Wars* movie. *Star Wars: Droids* lasted only a season; the time and expense it took to produce it didn't make continuing the show feasible. *Star Wars: Ewoks* played one more season after being retooled for a younger audience. Kenner introduced a small line of Ewoks and Droids animated-style action figures in 1985, and showed the figures above in its 1986 Toy Fair catalogue for retailers. But the line was dropped before production began on the fourteen new characters.

This is a complete, hand-painted set of the preproduction figures with all of their accessories. I bought it from someone who said he got it from one of the original engineers on the

project. It was missing one accessory, the scepter of Mon Julpa, the character in the upper right. Unbelievably, a collector buddy had two of them and sent me his spare at no charge. *Star Wars* collectors are some of the friendliest and most giving people I have ever met.

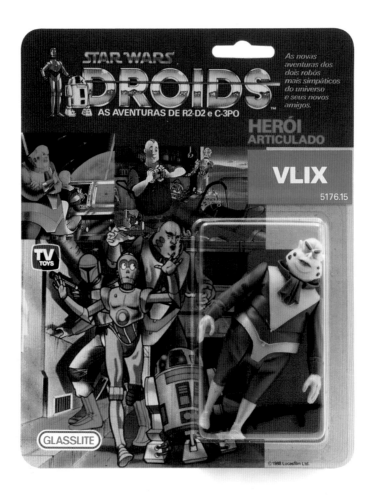

REPRODUCTION CARDED GLASSLITE VLIX FIGURE

POON WAI KIONG
SINGAPORE, 2008

While I have many stories of smart or prescient purchases—even those that seemed overpriced at the time—I bought this reproduction to remind me of the One That Got Away.

Vlix was a minor bad guy in the *Star Wars: Droids* animated half-hour that ran in 1985, twinned with *Star Wars: Ewoks*. Kenner released eighteen new animated-style figures in 1985, but sales were mediocre. It had planned to release fourteen new figures in 1986 but canceled them before production got under way. However, in 1988 the Brazilian toy company Glasslite produced, under sublicense from Kenner, a small line of *Star Wars* action figures. Surprisingly, one of them was the previously unproduced Vlix. It took many (pre-Internet) years for word of the anomaly to make its way to American collectors. One night I got a call from a collector friend. He had a carded Vlix figure that he was selling. Was I interested? By then, I had paid a hefty amount to get a complete set of the preproduc-

tion Ewoks and Droids figures, but still, it sounded interesting. "How much?" I asked. "$800," he said. Yikes! Given that I already owned the figure, I thought that was pretty expensive for a piece of cardboard. So I passed. Of course, it turned out that this was by far the rarest carded action figure ever produced for the mass market—and the price just soared. A very nice carded Vlix is reputed to have changed hands for $12,000. So when I saw this reproduction Vlix on a reproduction card, I decided to buy it, not to fool anyone, but to remind me that no one consistently makes the right decisions as a collector—and that certainly includes me.

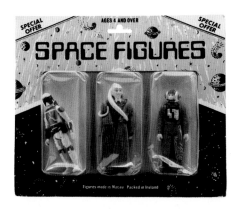

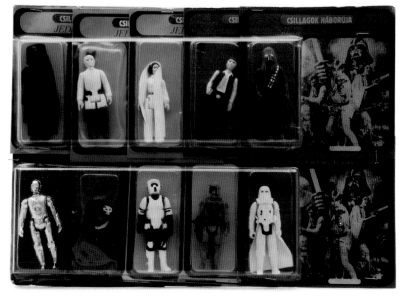

SPACE FIGURES "SPECIAL OFFER" THREE-PACK

KENNER (FIGURES ONLY)
UNITED STATES, 1985

Bootleg? Well, not exactly. These are actual Kenner action figures, but that certainly isn't *Star Wars* packaging. The story is that Kenner, stuck with a large quantity of figures as the *Star Wars* craze started winding down in the mid-1980s, gave two million of them to a charity with the understanding that they'd be given away to kids, thus giving the company a tax write-off. But the charity turned around and sold the lot to a middleman who packaged them in Ireland and resold them for pennies on the dollar to United States retail chain KB Toys Inc. Kenner was shocked to discover that its new *Star Wars* figures were competing with its older ones—three of which sold for about the same price as one new one.

HUNGARIAN BOOTLEG ACTION-FIGURE DISPLAY PACK

UNKNOWN
HUNGARY, C. 1984

In some countries, Mexico for one, you can tell if a movie has staying power by the quantity of bootleg toys. No bootlegs = turkey. Judging by the number of *Star Wars* counterfeits over the years, the saga has worldwide popularity. Take this set of ten cheesy bootlegs from Hungary, made from the original action figures, hastily painted, and poorly packaged. This happens to be a special stapled-together window display in excellent condition. I purchased this from dealer friends at a Los Angeles toy show in the mid-1980s for $125. It was mostly out of boredom and a sense of desperation, since I hadn't found anything cool to buy in weeks. Today it is said to be worth at least $5,000. Even I find that absurd.

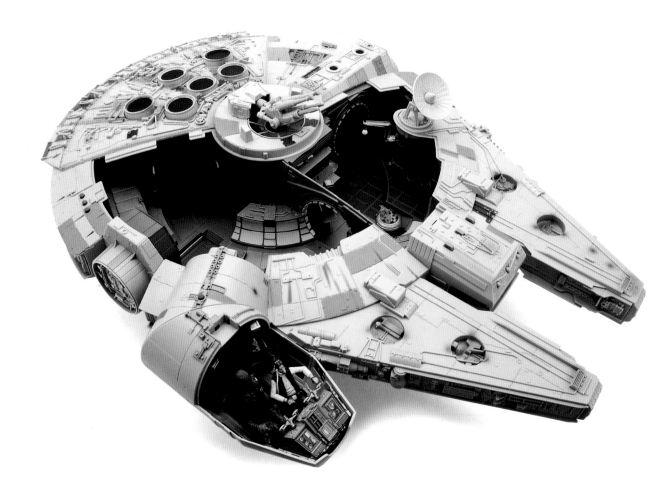

MILLENNIUM FALCON VEHICLE/PLAY SET

HASBRO
UNITED STATES, 2008

In the halls of Hasbro, the project was code-named BMF, and it's still called that internally and by fans: the "Big *Millennium Falcon*." And while a large team helped foster it along, it was mainly the result of one man's dream and passion. Mark Boudreaux, a University of Cincinnati industrial design major, started at Kenner in a work-study program just as the *Star Wars* line was being launched. Mark worked on the first version of the *Falcon* toy that came out in 1979, a year after the initial wave of action figures hit. A somewhat upgraded version of the most famous ship in the saga was released around two decades later using the same tools, or steel molds, as the original. But those molds were just about shot. Boudreaux and the *Star Wars* design team just couldn't imagine a *Star Wars* line that would never again include Han Solo's ship, so they came up with an audacious idea: a nearly three-foot-long toy about the size of the original ILM model—and twice the size of the original toy—filled with all the electronics that could never have been done

in the 1970s. To their relief, management agreed to make the sizable investment, and the toy was released to near-universal acclaim in the fall of 2008. It includes things such as light-up headlights and loads of vehicle and weapon sounds (engine boost, cruise mode, fly-by, and firing cannons); an opening, light-up cockpit that can fit up to four figures (the entire ship is capable of flying eighteen figures to a faraway galaxy); secret smuggling compartments; recorded lines from the movies; missile launchers; and enough other goodies to keep kids and adult fans occupied for hours. To Luke Skywalker the *Falcon* may have looked like a "piece of junk," but Captain Solo's retort was never truer: "She may not look like much, but she's got it where it counts, kid."

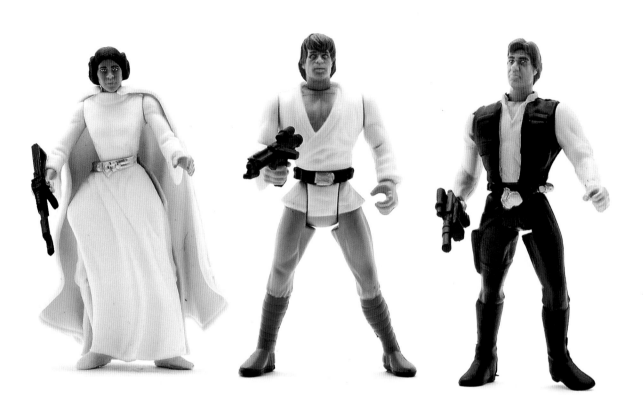

ACTION FIGURES

HASBRO
UNITED STATES, 1995

(Left to right)
Princess Leia
Luke Skywalker
Han Solo

Having disappeared from store shelves for nearly a decade, *Star Wars* action figures made their much-awaited return under new corporate parent Hasbro in 1995. There had been some behind-the-scenes discussion about the look of the relaunched figures, but Hasbro made a strong case to Lucasfilm that kids had grown used to, and demanded, the buffed-up, muscular look of lines such as Masters of the Universe. So Lumbering Luke, Monkey-face Leia, and Han Solo-flex appeared—and fan derision quickly followed. It was a good lesson for Hasbro. They learned a simple truth: *Star Wars* fans want as close-to-movie accuracy as possible for the characters. The company's sculpts have gotten better year after year, and today the line is recognized as one of the best in the business.

C-3PO AND DARTH VADER 3 3/4-INCH-
SCALE ACTION-FIGURE CARRYING CASES:
FIRST SHOTS AND PACKAGING TESTS

KENNER PRODUCTS
UNITED STATES, C. 1983

To test new tools—the hard metal that is cut to act as a mold
for tens of thousands of the same pieces—toy companies
press samples out of whatever plastic is handy and plentiful, re-
gardless of the final color of the actual product. The gold-plated
Vader case, on the other hand, was a packaging test to see how
the vacuum-metallized coating on a yet-to-be produced C-3PO
case would stand up under strenuous real-world conditions.
The company sent out at least one hundred of the gold cases
to different locations, then had them shipped back to its
Cincinnati headquarters to examine how they withstood the
shipping process. Later, a number of the used cases showed
up at local flea markets. This one is clearly and permanently
marked on the back: $2.00.

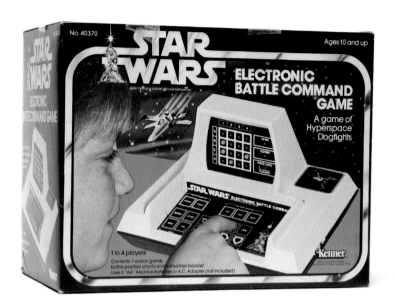

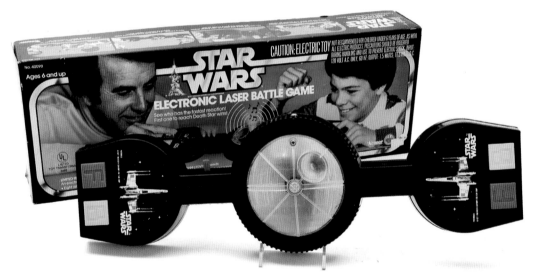

ELECTRONIC BATTLE COMMAND GAME

KENNER PRODUCTS
UNITED STATES, 1979

High tech for its time, this early electronic game was a variation on Battleship. You could play against the machine or up to three other players.

ELECTRONIC LASER BATTLE GAME

KENNER PRODUCTS
UNITED STATES, 1978

Whereas fast-acting, superbly rendered three-dimensional characters await your every command on the latest gaming platforms, in 1978 this simple beeping LED game was state of the art. Toy makers were slow to introduce electronics into their lines, for the most part, because of cost considerations.

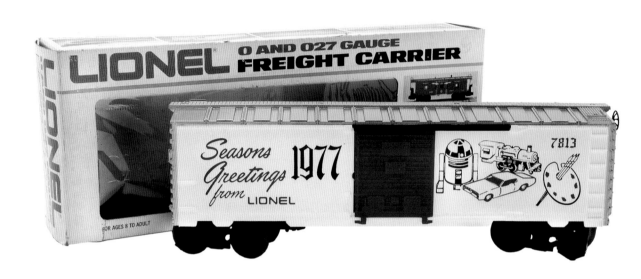

FREIGHT CARRIER "SEASONS GREETINGS 1977"

LIONEL
UNITED STATES, 1977

What's R2-D2 doing on a boxcar? Famous toy-train maker Lionel was subcontracted by Kenner Products to make a *Star Wars* slot-car racing set. Presumably giddy from this coup, Lionel added R2-D2 to its annual limited-edition Christmas gift boxcar.

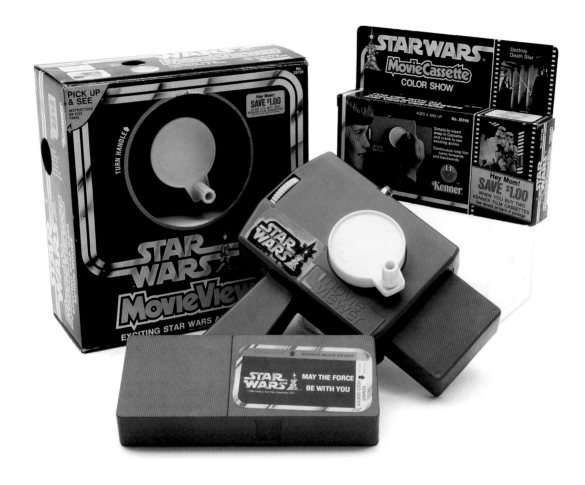

MOVIE VIEWER AND CASSETTES

KENNER PRODUCTS
UNITED STATES, 1978

In the years before home video, when the only way to see *Star Wars* was to return to the theater or buy a Super 8 projector, hand-cranked movie viewers provided an alternative—although not a great alternative. The image, when you could see it, was tiny and scratchy, "scenes" were drastically cut, and you had to talk to yourself if you wanted sound. Of course, none of that stopped me from haunting toy shops for nearly a year, trying to find all six different cartridges.

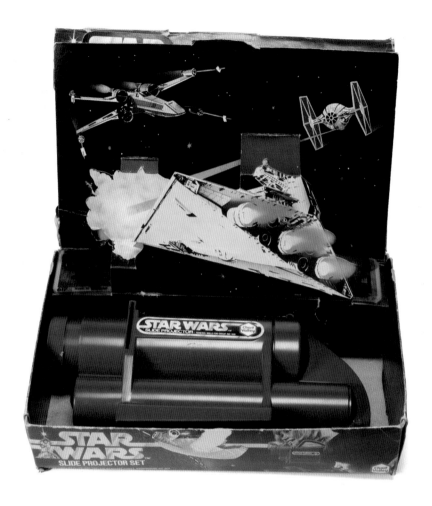

SLIDE PROJECTOR SET

CHAD VALLEY
UNITED KINGDOM, 1978

Simple film-strip and slide projectors could once occupy a
child's time. The projectors from the United Kingdom, Australia,
and France used kid power to move the action along. The
projectors needed to be very close to a wall, and even then
their images were fuzzy because the "lens" was just a cheap
piece of clear plastic. The British projector box has a wonderful,
unexpected pop-up display when the box is opened. Today's
replacement for these simple toys: a $2,500 twenty-inch-tall,
motorized R2-D2 DVD system with surround sound that can
project quality videos on a screen of up to eighty inches. One
positive review called it "nerdtacular."

GIVE-A-SHOW PROJECTOR

TOLTOYS
AUSTRALIA, 1978

MINICINEX CASSETTE FILM PROJECTOR

MECCANO
FRANCE, 1978

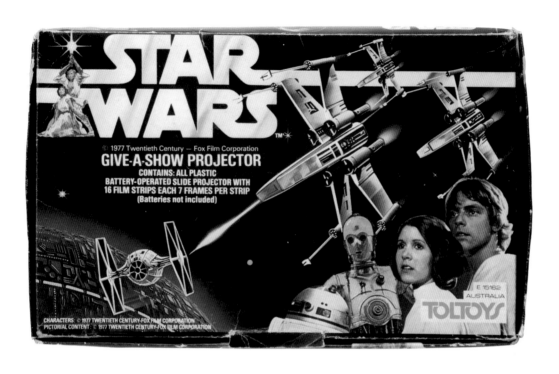

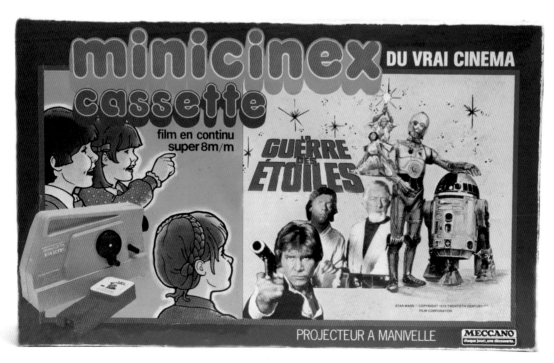

R2-D2 15-PIECE PUZZLE

TAKARA
JAPAN, 1978

This small item from Japan represents, in a way, the work at Rancho Obi-Wan. Like the puzzle with its fifteen squares (not counting the logo), the property has fifteen "collection" areas: receiving, auxiliary storage, office, library, comics and magazines, card room, poster room, the museum itself, arcade, art gallery, four lofts, and an additional "back barn" with three thousand square feet of storage. For years pieces of the collection have been moved from one room to another, sometimes arriving in the same place over and over only to be moved again. The goal is simple: put the picture back together. Put all the comics in the comic room, all the displays in the same area, all the Pepsi products on one rack, underwear with underwear, and so on. A box could be found in a remote corner revealing items missing for years. Or perhaps precious items have been buried in the course of moving the puzzle pieces around. At the height of a promotion or right after a convention, so many new items arrive that moving the puzzle pieces seems impossible. Yet every day the picture becomes more complete.

EARLY *STAR WARS* PUZZLE

KENNER PRODUCTS
UNITED STATES, 1977

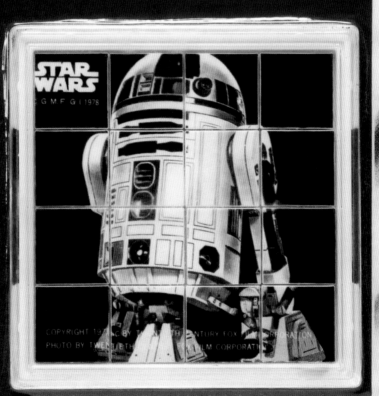

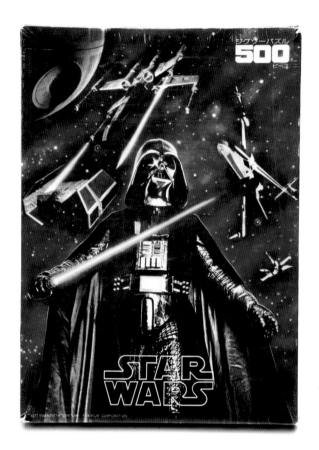

DARTH VADER 500-PIECE PUZZLE

TAKARA
JAPAN, 1977

SPACE BATTLE 730-PIECE PUZZLE

TAKARA
JAPAN, 1978

DARTH VADER MINIATURE 60-PIECE PUZZLE

TAKARA
JAPAN, 1978

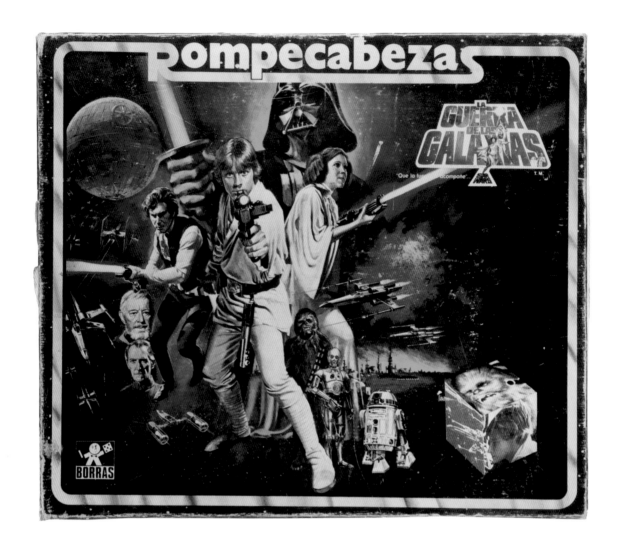

POSTER COLLAGE BLOCK PUZZLE

BORRAS
SPAIN, 1978

In Spanish, the word for puzzles translates literally as "broken heads," and some of them truly will have you knocking your head against a wall.

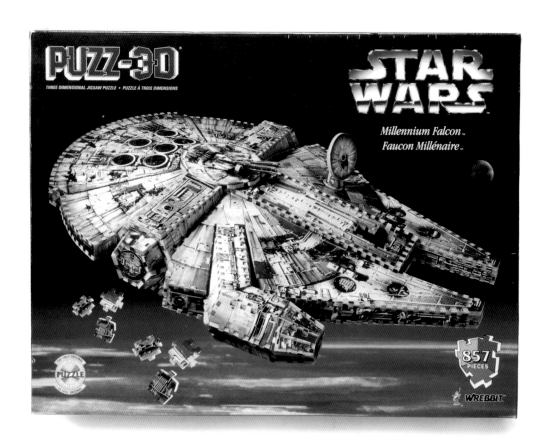

C-3PO AND R2-D2 PLASTIC CUBE PUZZLE

DALMAU CARLES
SPAIN, 1986

MILLENNIUM FALCON PUZZ-3D

WREBBIT
CANADA, 1995

Those aren't pieces of the *Millennium Falcon* floating off into space on the cover of this three-dimensional puzzle; they're just to show that the puzzle solver can create an actual object. The *Falcon* was followed by a nifty R2-D2 with a small sound chip.

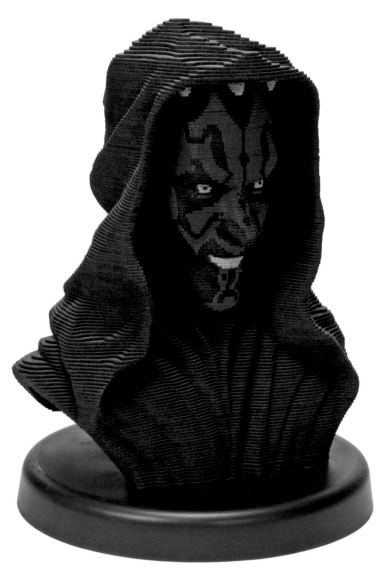

DARTH MAUL 3-D SCULPTURE PUZZLE

THE REALLY USEFUL GAMES COMPANY LTD.
UNITED KINGDOM, 1999

When put together correctly, these challenging puzzles form
an extraordinary cardboard sculpture made of individual,
stacked pieces. If all else fails, each piece is numbered (not
consecutively) on the underside, and there's a cheat sheet that
should alleviate any frustration.

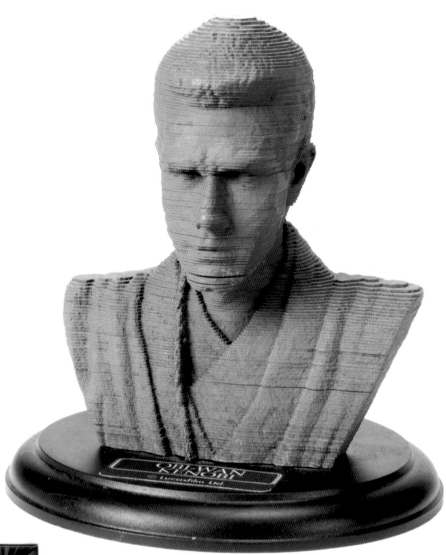

**OBI-WAN KENOBI MINIATURE 3-D
SCULPTURE PUZZLE**

THE REALLY USEFUL GAMES COMPANY LTD.
UNITED KINGDOM, 1999

**HEROES/VILLAINS MONTAGE CIRCULAR
JIGSAW PUZZLE**

CHARACTER GAMES LTD.
UNITED KINGDOM, 2002

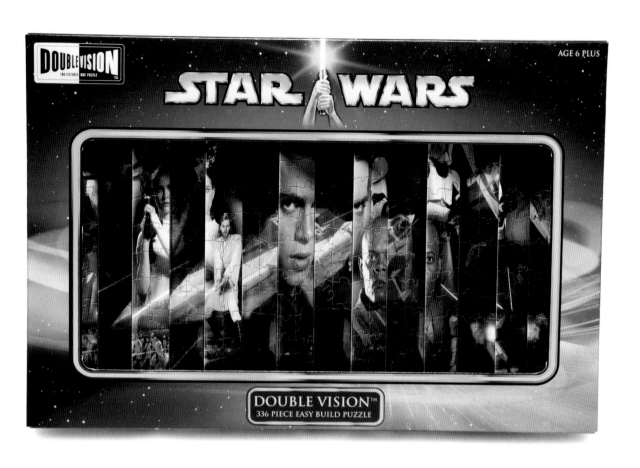

HEROES AND JEDI STARFIGHTER "DOUBLE VISION" PUZZLE

CHARACTER GAMES LTD.
UNITED KINGDOM, 2002

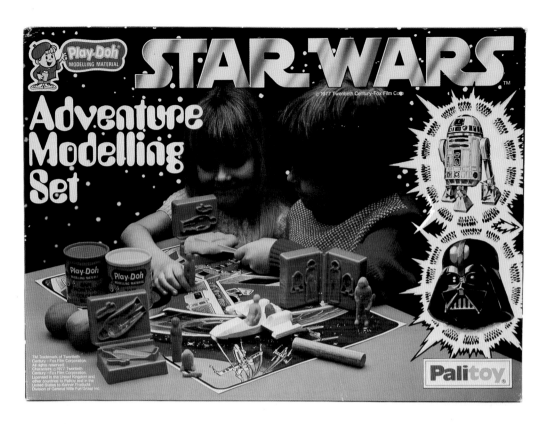

PLAY-DOH ADVENTURE MODELING SET

PALITOY
UNITED KINGDOM, 1978

Play-Doh, a colorful children's nontoxic and reusable modeling compound, was tied to the *Star Wars* franchise from the start. The sets usually contained a couple of tubs of Play-Doh, molds (R2-D2, Princess Leia, Luke Skywalker, and Darth Vader), a vehicle or environment piece (here a small X-wing fighter), and a colorful plastic play mat. Because the prequel movies were considered to be for an older audience, Play-Doh vanished from the *Star Wars* scene—but not forever.

PLAY-DOH STAMPERS

PLAYSKOOL / HASBRO
UNITED STATES, 2009

Once children came back to the galaxy with the weekly animated series *Star Wars: The Clone Wars*, could Play-Doh be far behind? This mini-set of Anakin Skywalker and his Padawan, Ahsoka Tano, comes with two three-ounce cans of Play-Doh compound. The figures have a stamp pattern under their feet to make a three-dimensional image in a circle of Play-Doh. Released at the same time was a set with R2-D2 and Obi-Wan Kenobi. As the package reminds kids three and older, "Fun to play with, but not to eat."

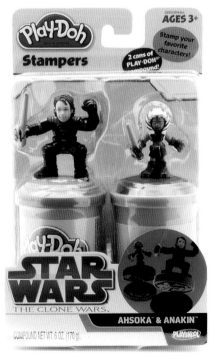

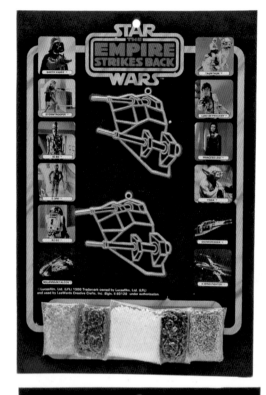

THE EMPIRE STRIKES BACK SUN CATCHERS

LEEWARDS CREATIVE CRAFTS INC.
UNITED STATES, 1980

With the exception of model kits, crafts haven't been plentiful for *Star Wars* fans. These sun catchers, or make-your-own faux stained-glass ornaments, therefore caused quite a buzz when they were introduced—not to mention a considerable stink in the kitchen when you baked your plastic crystals at 375 degrees for fifteen to twenty-five minutes. Thirteen different sun catchers were produced in limited quantities, including bounty hunter IG-88, Princess Leia, and two versions of the snowspeeder, with either one or two vehicles included.

R2-D2 (ARTOO-DETOO) STUFFED TOY
WITH SOUND

KENNER PRODUCTS
UNITED STATES, 1977

One of Kenner's very first toys was this plush R2-D2 with an embedded squeaker that made it sound very much like a dog toy. Everybody loves R2, and it was a big seller—although no one knows how many were chewed up by dogs. The Chewbacca plush toy looks like a shaggy dog, at least a bit. That's fitting, since the character, a faithful companion to rogue pilot Han Solo, was based on George Lucas's Alaskan Malamute, Indiana. (The name was saved for later use.)

CHEWBACCA STUFFED TOY WITH
BANDOLIER STRAP

KENNER PRODUCTS
UNITED STATES, 1977

CHEWBACCA HAND PUPPET

REGAL TOY CO.
CANADA, 1978

In 1978 a small, independent toy maker in Canada got a sublicense from the General Mills Fun Group (Kenner) to make plush toys based on R2-D2, a Jawa, and Chewbacca. Regal was a door-to-door catalogue seller similar to Avon or Tupperware. The nature of this business model meant only very limited numbers were produced, and only a handful exist in collections today. In fact, so few of these have surfaced it is debated whether the hand puppet was actually mass-produced or if only sales samples exist. The nearly three-foot-tall Chewbacca is also highly coveted because of its look and size. Regal took two Chewie bandolier straps from the smaller plush toy, attached them together, and produced a longer strap for its large toy. There were many more of the sweet-looking Jawas and R2-D2s sold.

JAWA PLUSH TOY

REGAL TOY CO.
CANADA, 1978

CHEWBACCA LARGE STAND-UP PLUSH TOY

REGAL TOY CO.
CANADA, 1978

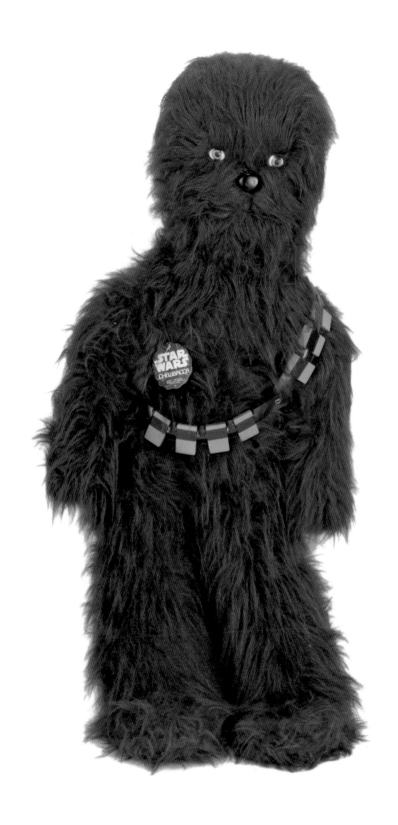

NIPPET THE EWOK PLUSH TOY

PALITOY
UNITED KINGDOM, 1983

PRINCESS KNEESAA THE EWOK PLUSH TOY

KENNER PRODUCTS
UNITED STATES, 1983

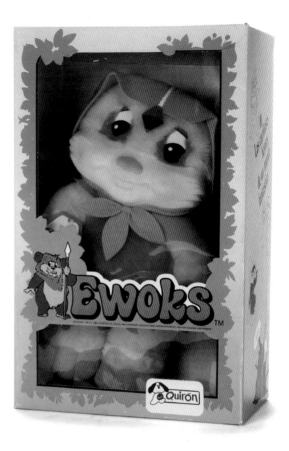

WICKET THE EWOK AND PRINCESS KNEESAA
PLUSH TOYS

QUIRON
SPAIN, 1986

Kids in Europe took more to the animated adventures of the
Ewoks and the Droids than American youngsters. One reason
is that the animated series got more prominence in many
foreign countries in the mid-1980s because there were fewer
broadcasting outlets. That led to some exclusive merchandise,
especially in Spain and France. Among the best Spanish items
were these two large plush Ewok dolls, in the forms of "stars"
Princess Kneesaa and Wicket, as well as Droids and Ewoks
multisided plastic block puzzles.

EWOK SMALL PLUSH TOYS

KENNER PRODUCTS
UNITED STATES, 1983–1984

There was a problem turning the fierce and fearsome Ewoks—
the diminutive heroes who helped the Rebels defeat Imperial
forces in *Return of the Jedi*—into toys. At least most of them
looked fierce in the film, since the creature costumers ran out
of time to make the Ewok face masks capable of showing dif-
ferent moods or emotions. For the toy line, however, they were
cute and cuddly, almost like teddy bears.

BABY EWOK IN BASKET PLUSH TOY,
UNPRODUCED PROTOTYPE

KENNER PRODUCTS/HASBRO
UNITED STATES, 1994–1995

When Kenner renegotiated its licensing agreement with
Lucasfilm in 1994, by which time Kenner was owned by Hasbro,
it faced some stiff competition from other major toy compa-
nies. In the end, three companies made detailed presentations,
some with prototype products in hand that were made either
in-house or by small outside development companies or
freelancers. The Ewok baby in a basket, which might be more
fright-inducing than cute, was either done around that time or
shortly afterward.

**WAMPA PLUSH TOY,
UNPRODUCED PROTOTYPE**

KENNER PRODUCTS / HASBRO
UNITED STATES, 1994–1995

**BANTHA HAND-PUPPET PLUSH TOY,
UNPRODUCED PROTOTYPE**

KENNER PRODUCTS / HASBRO
UNITED STATES, 1994–1995

**DEWBACK HAND-PUPPET PLUSH TOY,
UNPRODUCED PROTOTYPE**

KENNER PRODUCTS / HASBRO
UNITED STATES, 1994–1995

These plush toys would surely have evoked squeals of delight from children—and collectors—if they had been produced. They take two iconic beasts of burden from *Star Wars* and one scary beast from *The Empire Strikes Back* and turn them into clever playthings. The green dewback, seen mainly as transportation for Imperial stormtroopers on Tatooine, and the almost Rastafarian-looking bantha used by fierce Tusken Raiders and others, have been turned into soft hand puppets. While neither got much screen time in the original film, they have populated novels and comics, and are familiar to fans. The wampa was at the center of action at the beginning of *Empire*. It was the beast that grabbed Luke Skywalker from the frozen Hoth ice field and hung our hero upside down in his icy "meat locker," keeping Luke fresh for his next meal. Skywalker, using his newly acquired Jedi powers, managed to escape and chop off one of the beast's arms. The plush wampa, however, couldn't appear friendlier.

BATTLE BUDDIES PLUSH-TOY SHELF DISPLAY BOX

HASBRO
UNITED STATES, 2004

No, that's not the Cowardly Lion from *The Wizard of Oz* on the right. Would you believe Chewbacca?

PLUSH-TOY ARCADE GAME PRIZES

TAKARA
JAPAN, 1992

These small plush figures helped teach non-Japanese collectors the word *kawaii*, the Japanese culture of cuteness. Not made for direct sale, the plush toy could be obtained only by pouring yen into an arcade game and using a remote steering mechanism to get a clawlike contraption to pick one up and drop it into the prize slot. In Japan, the "kawaiification" of the *Star Wars* brand has been unstoppable.

UNPRODUCED PLUSH-TOY PROTOTYPES

HASBRO
UNITED STATES, C. 1996

When Hasbro started making its line of small *Star Wars* plush "Buddies," Lucasfilm decided that the masked characters looked fine, but the heroes with faces came across as neither fish nor fowl—not accurate enough and yet not enough of a caricature. So the initial prototypes of Luke, Han, and Obi-Wan were rejected. The Tusken Raider was produced, but in a somewhat different style.

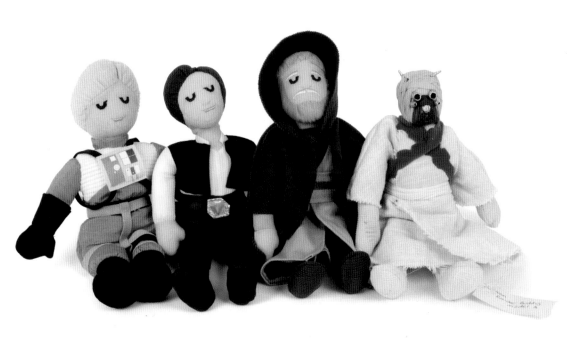

95

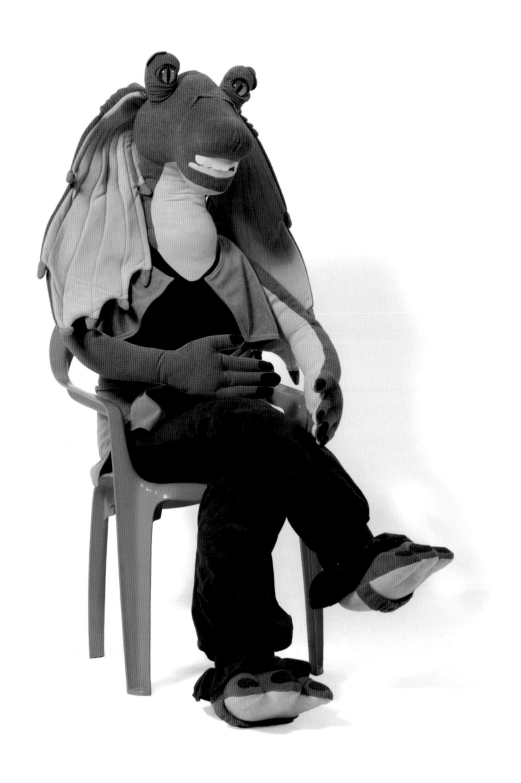

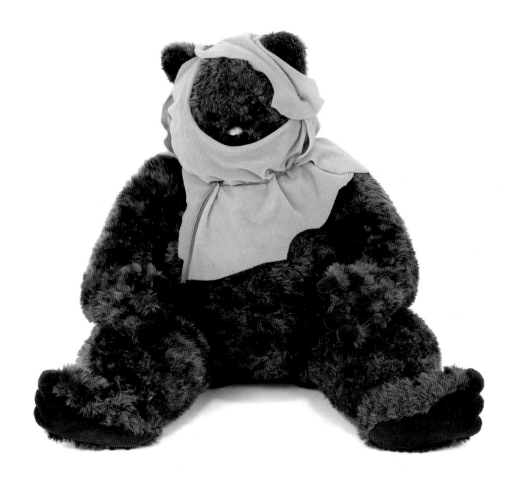

JAR JAR BINKS JUMBO PLUSH TOY

APPLAUSE
UNITED STATES, 1999

Let's face it. Some older fans hate the character of Jar Jar
Binks, the goofy Gungan introduced in Episode I *The Phantom
Menace*. Others find him endearing, and younger kids—for
whom he was created—absolutely love him and his antics.
He often acts like a silly kid, and they can relate. This four-foot-
tall plush Jar Jar was made in very limited numbers for sale
exclusively at FAO Schwarz. He seems ready for a serious
chat on metaphysics, the state of the world economy, or
perhaps whoopee cushions. The straps under his feet allow a
kid to insert his or her own feet and walk Jar Jar around like
a giant puppet.

TWO-FOOT-TALL EWOK PLUSH FIGURE

DOUGLAS TOYS
UNITED STATES, 1997

Bigger and certainly softer than most Ewoks in *Return of the
Jedi*, this large plush toy was a special, limited premium from
Frito Lay, which, along with its parent company, PepsiCo, were
the major promotional sponsors of the *Star Wars* Trilogy
Special Edition releases in early 1997.

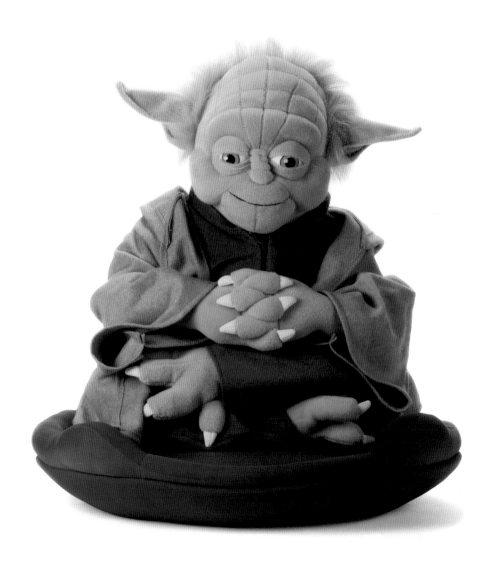

PLUSH YODA ON "HOVER CHAIR"

CLINTON CARDS
UNITED KINGDOM, 2005

AHSOKA TANO SMALL PLUSH-TOY PROTOTYPE (LEFT) AND PLUSH TOY (RIGHT)

COMIC IMAGES
UNITED STATES, 2008

Lucasfilm is understandably protective of the *Star Wars* brand, and part of that can be seen in the quality of the merchandise its licensees produce. Lucas Licensing needs to give its stamp of approval and expertise at every step along the way: pitch, concept design, prototypes, and often preproduction samples. In comparing these three early samples with the finished products, it is easy to see major changes in coloring, style, and even shape.

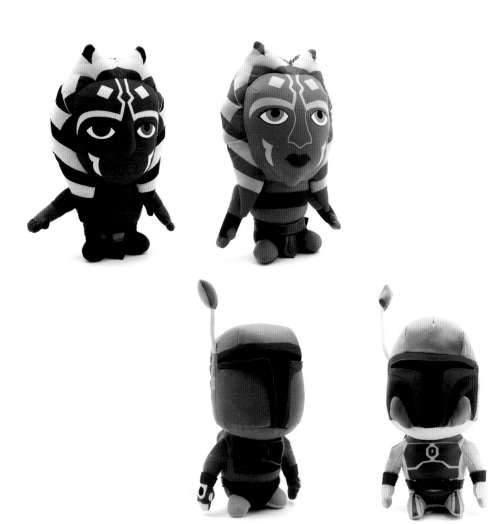

**BOBA FETT SMALL PLUSH-TOY PROTOTYPE
(LEFT) AND PLUSH TOY (RIGHT)**
COMIC IMAGES
UNITED STATES, 2008

**GENERAL GRIEVOUS SMALL PLUSH-TOY
PROTOTYPE (LEFT) AND PLUSH TOY (RIGHT)**
COMIC IMAGES
UNITED STATES, 2008

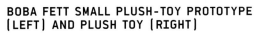

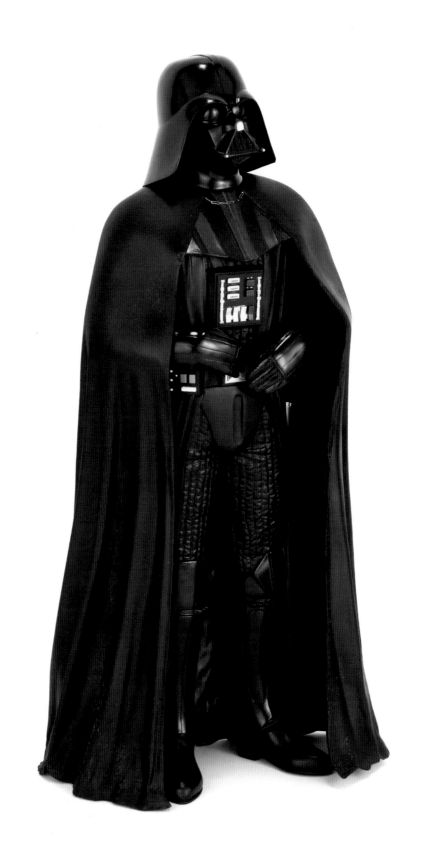

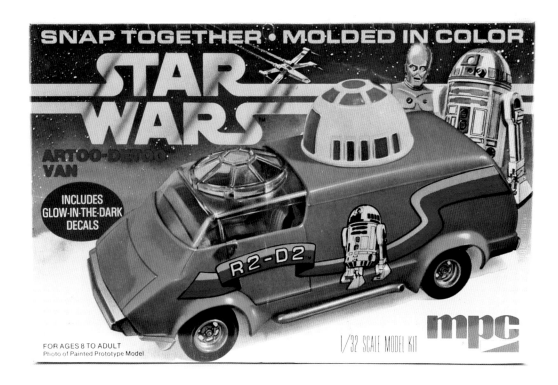

DARTH VADER VINYL MODEL KIT

REDS INC.
JAPAN, 1993

This Japanese-made three-foot-tall Darth Vader "model kit" has nothing to assemble or even paint. How that qualifies as a kit is beyond my comprehension. Also, it was sold as a limited edition of just five hundred, which quickly sold out. So the company produced another five hundred a year later. That seemed to me to violate the trust of collectors, who were told there would only ever be five hundred pieces. But the company said it had done no wrong because the two versions were different. I defy anyone to point out even a single difference; I sure can't.

R2-D2 VAN MODEL KIT

FUNDIMENSIONS
UNITED STATES, 1978

Customized vans were hot in the 1970s, but it's hard to believe that this concept was ever approved, much less made and sold. There is also a toy version and an electric slot-car racer. Does anyone remember how red-hot slot-car racing used to be?

YODA AND MACE WINDU VINYL MODEL KIT

KOTOBUKIYA
JAPAN, 2002

Model kits became a moribund business in the United States
starting in the mid-1990s, but they stayed strong in Europe
and in Japan, where today's *Star Wars* kits originate. These
prepainted vinyl models, which feature high-quality sculpts and
ease of assembly, have become very popular among collectors.

SANDTROOPER SERGEANT VINYL MODEL KIT

KOTOBUKIYA
JAPAN, 2004

STAR WARS

ARTFX

CLASSIC *STAR WARS* SERIES
SANDTROOPER
1/7 Scale Pre-painted Soft Vinyl Model Kit
1/7 Scaleソフトビニール製 塗装済み組み立てキット

Limited to 1000 KOTOBUKIYA ホビーショップ コトブキヤ限定

サンドトルーパー サージェント
限定版

SNAP FIT
切り取り加工・接着剤不要

SUGGESTED AGES 15 AND UP

⚠ **WARNING:**
CHOKING HAZARD-Small Parts
Not for children under 3 years of age.

CAUTION : Product contains functional sharp edges (or points). Exercise care during unpacking and assembly.

103

STAR WARS CD-ROM PAPER MODEL KITS

INNER BRAIN
JAPAN, 1999

These boxed kits have sheets of card stock that are cut out,
folded, and glued together to make the vehicles shown on the
box. A CD-ROM contains images and details about each vehicle.
Someone else cut and assembled the paper *Millennium Falcon*.
I would never have the patience or the set of skills needed.

MILLENNIUM FALCON PAPER MODEL KIT

INNER BRAIN
JAPAN, 1999

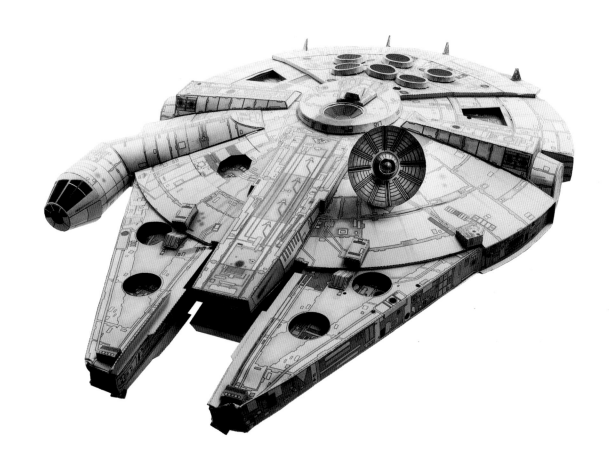

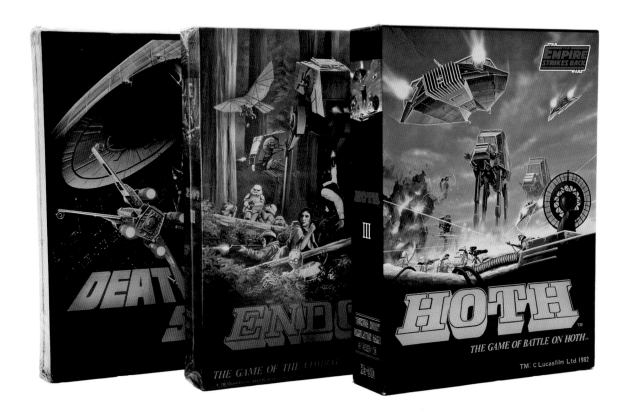

HOTH, ENDOR, AND DEATH STAR ROLE-PLAYING BOARD GAMES

TSUKUDA CORPORATION
JAPAN, 1983

These very complex Japanese role-playing games have absolutely no visual appeal once the boxes are opened.

EWOK GAMES FOR YOUNG CHILDREN

VOLUMETRIX
FRANCE, 1986

These French games, based on Ewok books and the animated
television series, all have an educational component.

ABORDA TU NAVE ESPACIAL, CONQUISTA EL ESPACIO Y DESTRUYE LA ESTRELLA DE LA MUERTE.

LUCHA CONTRA LAS FUERZAS DEL MAL Y CONVIERTE A LUKE SKYWALKER EN UN CABALLERO JEDI

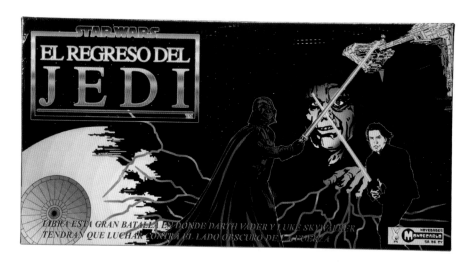

LIBRA ESTA GRAN BATALLA EN DONDE DARTH VADER Y LUKE SKYWALKER TENDRÁN QUE LUCHAR CONTRA EL LADO OBSCURO DE LA FUERZA

STAR WARS: A NEW HOPE BOARD GAME

NOVEDADES MONTECARLO
MEXICO, 1997

THE EMPIRE STRIKES BACK BOARD GAME

NOVEDADES MONTECARLO
MEXICO, 1997

RETURN OF THE JEDI BOARD GAME

NOVEDADES MONTECARLO
MEXICO, 1997

WAR BOARD GAME

GROW JOGOS
BRAZIL, 1999

This board game is unusual since it was made only for
the Brazilian market. Over the years Brazil has had the most
active licensing program for *Star Wars* of any country in
South America.

DARTH VADER AND R2-D2 POP-UP KIKIIPPATSU GAMES

TOMY
JAPAN, 2002

Kikiippatsu is a Japanese word that roughly translates to "Caution! Danger ahead!" But the object of the game is the same as similar games from a lot of countries: When the "hot" lightsaber is pulled, Darth Vader pops up and you lose. With R2-D2, when the correct wrench is yanked, Luke Skywalker's lightsaber pops up from R2-D2's dome, thus saving the day.

IG-88 (BOUNTY HUNTER) LARGE-SIZE ACTION FIGURE AND PRETOOLING PROTOTYPE

KENNER PRODUCTS
UNITED STATES, 1980

The last and least produced of Kenner's vintage line of large action figures (sometimes cautiously called dolls for boys) was the bounty hunter droid IG-88, one of the motley crew assembled by Darth Vader in *The Empire Strikes Back*. Here the finished toy stands next to a pretooling prototype that is marked to show where several gaps and seams will be closed before the final steel tool is cut.

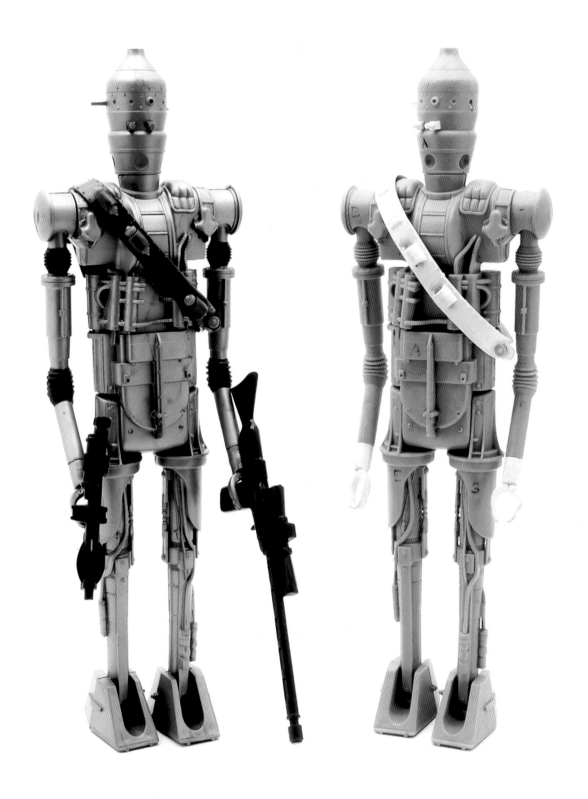

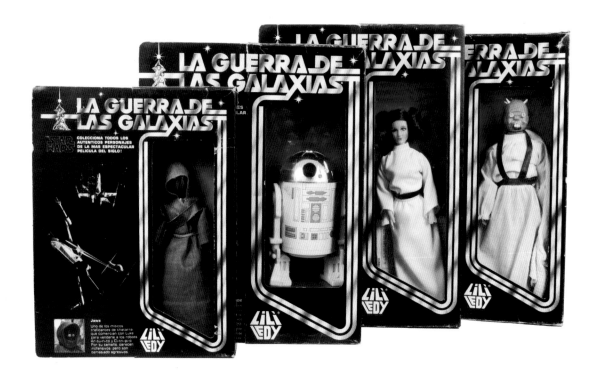

12-INCH FIGURES

LILI LEDY
MEXICO, 1978

Lili Ledy of Mexico was Kenner's only worldwide affiliate to produce entirely different versions of Kenner's 12-inch figure (or doll) line. Kenner's large R2-D2, for example, was molded three-dimensional plastic. Lili Ledy simply upsized the 3 3/4-inch action figure and used a large paper label for R2's body. And the figure of the Tusken Raider, or Sand Person, was unique to Mexico. A small cache of these figures was found in a warehouse more than a decade ago, causing a collectors' feeding frenzy.

LARGE FIGURES

TAKARA
JAPAN, 1978

(Left to right, top to bottom)
Chewbacca
Stormtrooper
Darth Vader
C-3PO

Among the distinctive items produced by the Japanese toymaker Takara in 1978 were four carded 7- to 8-inch action figures, twice the size as those in the United States. Besides their unusual look, the figures are known for a slight glitch on the first printing of the figure cards. "Stormtrooper" was transliterated as "Stoom Trooper" and added to all the initial cards, as if it were a generic slogan or logo for *Star Wars* characters. Vintage Japanese items have become highly sought collectibles all over the world.

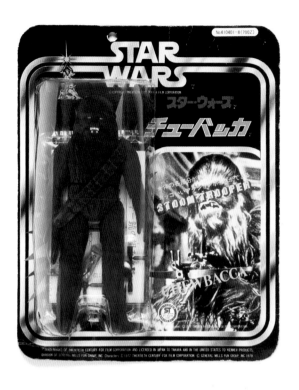

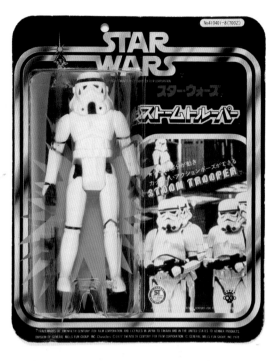

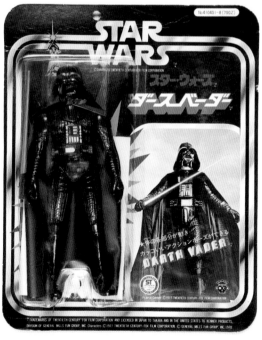

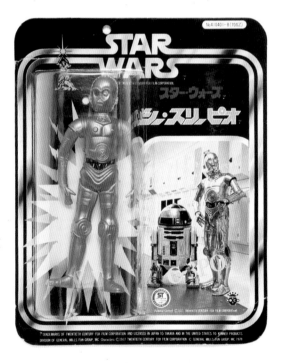

PRINCESS LEIA, HAN SOLO, AND LUKE SKYWALKER DOLLS

MADAME ALEXANDER
UNITED STATES, 2003

Famous doll maker Madame Alexander finally found its way to the Force in 2003, producing this set of six-inch dolls for FAO Schwarz. Turning the iconic trio into baby dolls with eyes that closed when you laid them down was a gamble. Many fans thought they were cute; others found them somewhat creepy.

QUEEN AMIDALA DOLLS WITH CELEBRATION AND SENATE CHAMBER GOWNS

ROBERT TONNER DOLL CO.
UNITED STATES, 1999

These magnificent porcelain dolls of Queen Amidala came with elaborate layers of clothing—but no instructions or photos showing how to dress them. Because most *Star Wars* collectors are guys, perhaps doll maker Robert Tonner assumed that they all still lived at home and their mothers could help them. Another problem: the hair pattern made it impossible to install Amidala's "forehead tiara." After months of agitation by some fans, Tonner agreed to replace the heads with corrected versions. I will concede that my first attempt to dress Amidala made her look like she had just lost a pro wrestling match. Thankfully, female help was only a phone call away.

commander gree™

SAN DIEGO COMIC CON INTERNATIONAL

MIGHTY MUGGS
made from 100% recycled awesome

STAR WARS®

87926 AGES 6+

MIGHTY MUGGS LANDO CALRISSIAN

HASBRO
UNITED STATES, 2008

Based on the growing success of designer vinyl toys, Hasbro
launched a line of *Star Wars* Mighty Muggs. These immediately
popular toys, made of recycled plastic, look at the saga
characters in a playful new way.

MIGHTY MUGGS ADMIRAL ACKBAR

HASBRO
UNITED STATES, 2008

MIGHTY MUGGS COMMANDER GREE

HASBRO
UNITED STATES, 2008

DARTH VADER UTILITY BELT ROLE-PLAY SET

KENNER (CANADA)
CANADA, 1977

Without any three-dimensional toys to sell in 1977, Kenner Canada thought it had a good idea: Slap *Star Wars* logos on some schlocky plastic guns, belts, and what passed for lightsabers; package them in three character styles; and call them Utility Belts—all apparently without approval. As soon as Lucas Licensing saw them, executives ordered them off the market. That, of course, has made this sad trio very scarce and very valuable.

LUKE SKYWALKER UTILITY BELT ROLE-PLAY SET

KENNER (CANADA)
CANADA, 1977

PRINCESS LEIA ORGANA UTILITY BELT ROLE-PLAY SET

KENNER (CANADA)
CANADA, 1977

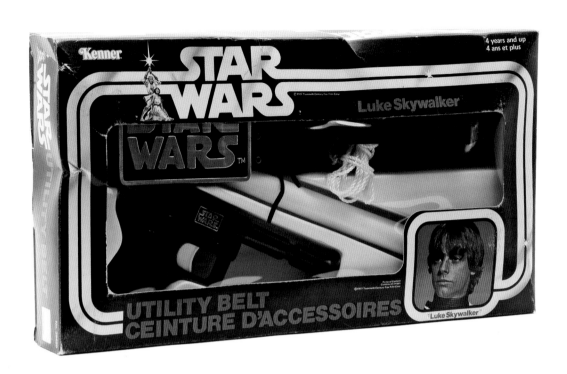

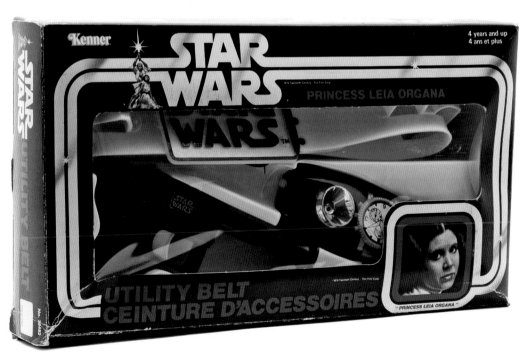

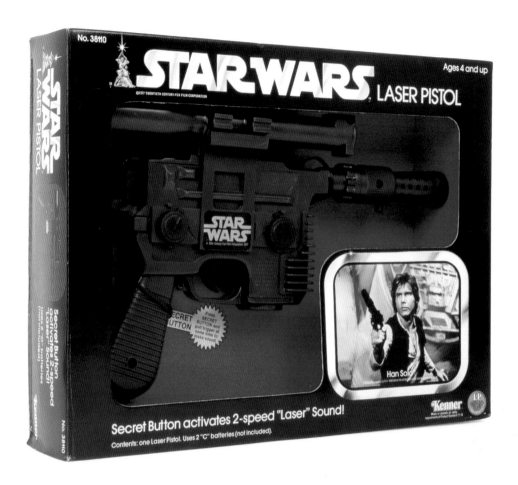

ROLE-PLAY LASER PISTOL

KENNER PRODUCTS
UNITED STATES, 1978

I identified with the more "sensitive" Luke Skywalker. But a majority of males today say Han Solo was their guy, and this is the accessory that did a lot of his talking. He's a scoundrel, a rascal, in it for the adventure and the money—and, in the end, he's the one who gets the girl. (Not that Luke should even have had a semi-romantic kiss with a young lady who turned out to be his sister.)

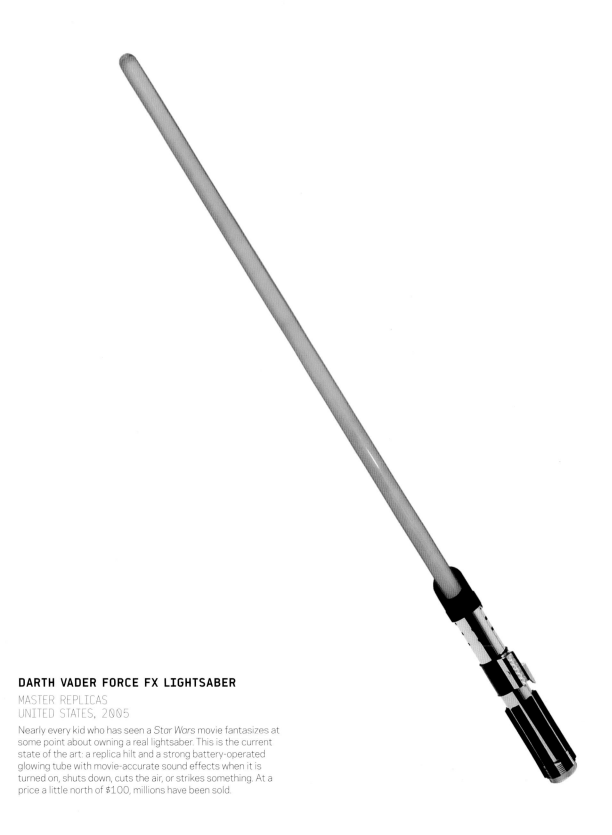

DARTH VADER FORCE FX LIGHTSABER

MASTER REPLICAS
UNITED STATES, 2005

Nearly every kid who has seen a *Star Wars* movie fantasizes at some point about owning a real lightsaber. This is the current state of the art: a replica hilt and a strong battery-operated glowing tube with movie-accurate sound effects when it is turned on, shuts down, cuts the air, or strikes something. At a price a little north of $100, millions have been sold.

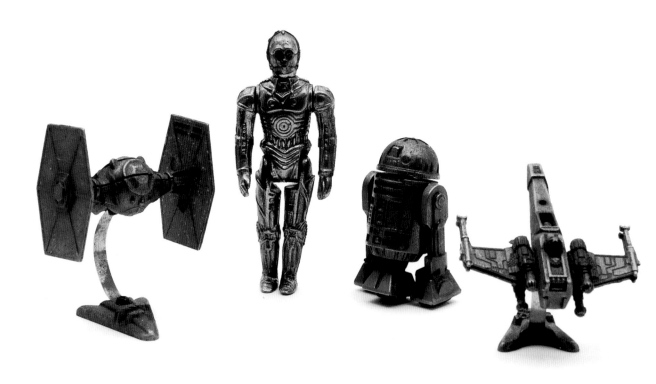

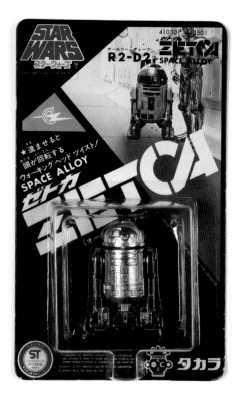

ZETCA SPACE ALLOYS

TAKARA
JAPAN, 1978

This unusual set of small "space alloy" droids and vehicles was produced in fairly small quantities and is difficult to find today, even in Japan. The toys all have some moving parts despite their size, and they display well in the tiny Japanese apartments in which many collectors live. The hardest piece to find is the landspeeder. The ones out of the package are very dear to me. I had admired them in the home of a neighbor, a fellow lover of science fiction and movies. Mike Minor, in fact, was art director of the movie *Star Trek: Wrath of Khan*; he helped with my second book, a 1980 photo guide to science-fiction toys and models. We set up a makeshift photo studio in his basement, and in five minutes he could transform a bare tabletop into a strange planet or a shimmering galaxy, and never repeat himself. It was likely the first book to feature current *Star Wars* toys as collectibles. After Mike died, his partner gave me the Zetcas, telling me that he knew Mike would have wanted me to have them.

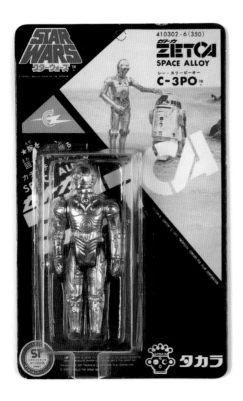

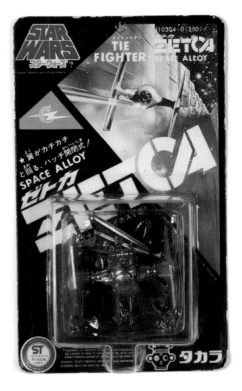

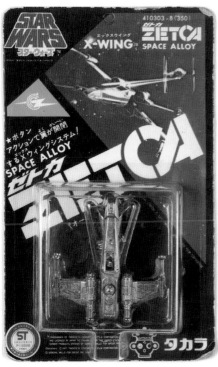

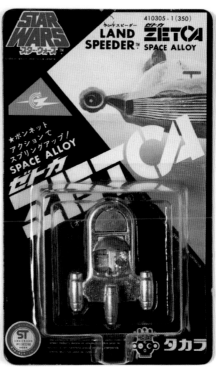

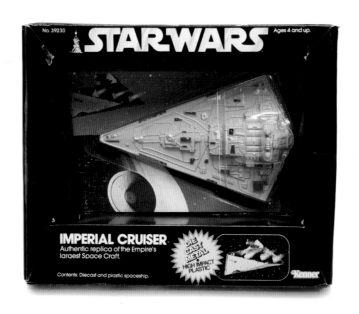

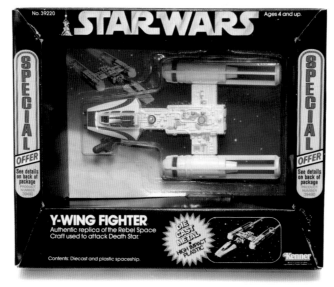

IMPERIAL CRUISER DIE-CAST VEHICLE

KENNER PRODUCTS
UNITED STATES, 1979

Y-WING FIGHTER DIE-CAST VEHICLE

KENNER PRODUCTS
UNITED STATES, 1979

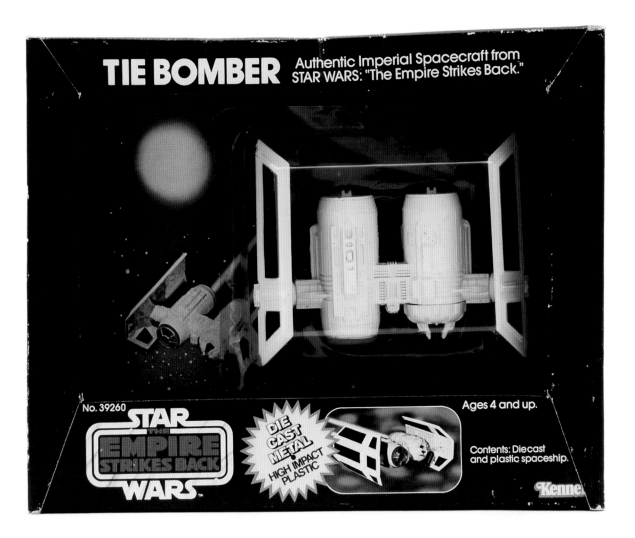

TIE BOMBER DIE-CAST VEHICLE

KENNER PRODUCTS
UNITED STATES, 1980

Whereas all of the other die-cast vehicles Kenner produced for
Star Wars and *The Empire Strikes Back* were fairly abundant
and can be purchased today in excellent condition for around
$50 each, the TIE bomber is a major exception. It was sold
only by JC Penney, was produced in smaller quantities, and
arrived late on store shelves. That scarcity can raise the price
of this collectible to twenty times that of the others. I'm happy
that I never gave up looking for it. I eventually found one buried
under the more common die-cast toys in a post-Christmas
clearance bin.

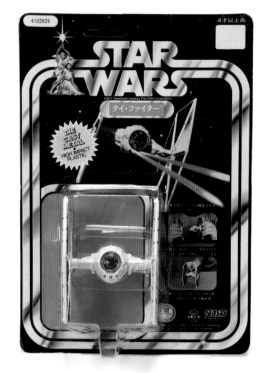

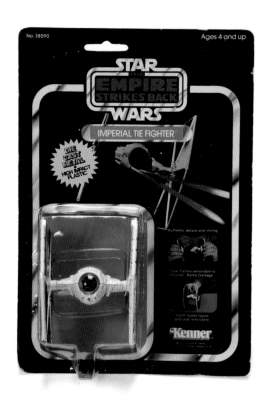

No. 38590

Ages 4 and up

STAR WARS
EMPIRE STRIKES BACK

IMPERIAL TIE FIGHTER

DIE CAST METAL HIGH IMPACT PLASTIC

Authentic details and styling

Solar Panels removable to simulate Battle Damage

Darth Vader figure and seat removable

Kenner

TIE FIGHTER DIE-CAST VEHICLES

KENNER PRODUCTS
UNITED STATES, 1978–1980

To non-collectors, these five toys look alike. In fact, the toys are exactly the same. But the cards they're attached to are different enough to make for a collectible variation. The first United States *Star Wars* card without the word *Imperial* in front of *TIE Fighter* was changed during production. It stayed that way when it was rereleased with a logo for *The Empire Strikes Back*. Because of its more limited run, the English/French card for Canada never made it to a second version. The card for the Japanese market has some English copy, but the majority of the copy is in Japanese.

TIE FIGHTER

KENNER PRODUCTS
UNITED STATES, 1978

IMPERIAL TIE FIGHTER

KENNER PRODUCTS
UNITED STATES, 1978–1979

TIE FIGHTER

KENNER (CANADA)
CANADA, 1978

TIE FIGHTER

TAKARA/KENNER
JAPAN, 1978

IMPERIAL TIE FIGHTER

KENNER PRODUCTS
UNITED STATES, 1980

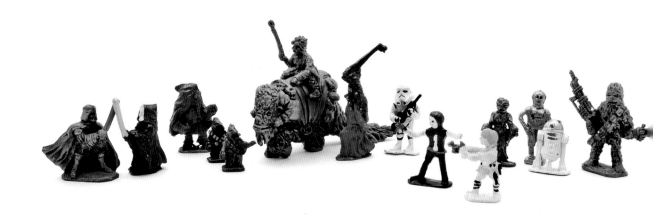

METAL FIGURINES

HERITAGE (STAR TREK GALORE)
UNITED STATES, 1977

Counterfeit and bootleg *Star Wars* toys are not a recent phenomenon. Lucasfilm and its licensees have been plagued by unauthorized merchandise since the first movie premiered more than three decades ago. Counterfeits—which aim to look as close to licensed merchandise as possible, down to the inclusion of a copyright line—are fairly rare. But opportunistic bootlegs, especially from poorer countries where the look may sometimes be more important than the quality, are something the company constantly battles. Bootlegs were numerous in the early years, partly because of a huge demand that wasn't being met immediately as licensees began gearing up. Especially prevalent in the early days were lightsaber rip-offs under more than a dozen different names. But if you ask a collector about the granddaddy of bootlegs, he or she would probably cite a set of fifteen or so small metal gaming figures, which came in both pewter color and hand-painted versions. Supposedly made by a company called Heritage, they were boldly

and widely advertised in popular science-fiction and monster magazines by a Florida company called Star Trek Galore, which is still in business but under a different name. The figures are somewhat crude and rough, the paint jobs not very skillful, and the price not inexpensive. But they represented the first three-dimensional figures available for the breakthrough movie. Star Trek Galore probably got one of the first-ever "cease and desist" letters from Lucasfilm and 20th Century Fox, but the company shipped product for many months. A few years later, another bootlegger copied these illegal figures and sold them in a reduced-size set in blue plastic cases. No, there really is no honor among thieves.

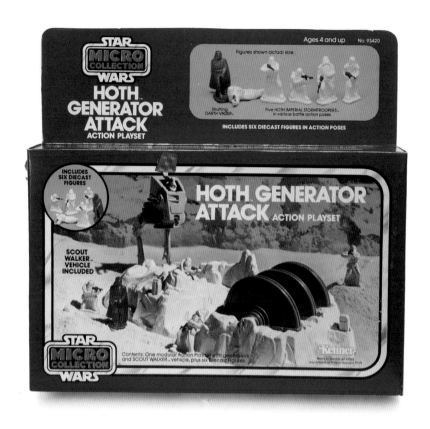

MICRO COLLECTION HOTH GENERATOR
ATTACK ACTION PLAY SET

KENNER PRODUCTS
UNITED STATES, 1982

The various play sets that make up the Kenner Micro Collection
are highly sought after today. Unfortunately, the cool-looking
line laid an egg when it was introduced in 1982 as a series of
plastic environments and vehicles with painted die-cast figures.
The problem was the size. Kenner had so quickly and broadly
established its larger 3 3/4-inch-scale as the gold standard
that parents refused to shell out for what they perceived as
a replication of the existing line in miniature. Kenner's original
concept was to do static scenes that eventually would be taken
from all three movies, but that was tweaked to add play value
to the environments and make several of them interconnect,
spurring additional purchases. The small metal figures were
posed, but no parts moved. Several additional sets had reached
production stage and a Jabba the Hutt environment had been
developed for the release of *Return of the Jedi*, but the line
was terminated. Prototypes and quantities of unreleased metal
figures have since made their way to collectors.

MICRO COLLECTION *MILLENNIUM FALCON*

KENNER PRODUCTS
UNITED STATES, 1982

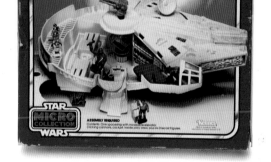

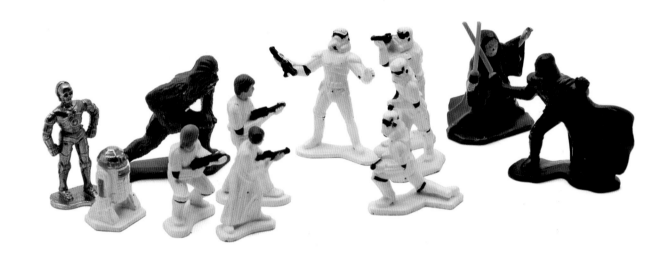

MICRO COLLECTION FIGURINES
KENNER PRODUCTS
UNITED STATES, 1982

C-3PO ACTION MASTERS AND PROTOTYPES

KENNER PRODUCTS/HABSRO
UNITED STATES, 1994

When Kenner Products resumed making *Star Wars* toys
in 1994, first out of the factory door were small die-cast
metal figures called Action Masters. While most figures were
sculpted on a one-to-one basis, droids like C-3PO sometimes
got the two-up treatment to achieve more detail; the double-
size figure would then be reduced using a pantograph-like
device. The old-gold droid was the one sold at retail. The shiny
gold version was a mail-away premium and is much more rare.
I sent away for two of them. Neither ever arrived. I made sure
that my unhappiness reached the upper levels of the company,
and I eventually received my MIA treasure.

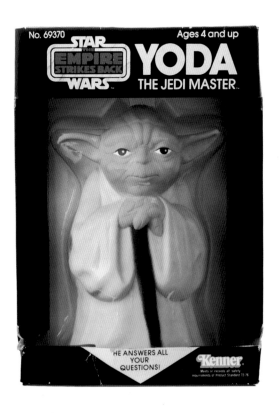

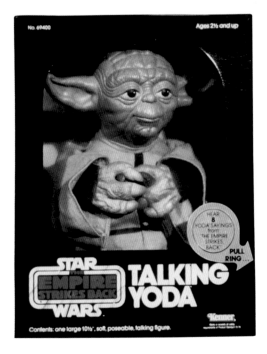

YODA THE JEDI MASTER FORTUNE TELLER

KENNER PRODUCTS
UNITED STATES, 1981

"He answers all your questions!" Hmm. So certain he is?

TALKING YODA UNPRODUCED PROTOTYPE AND BOX

KENNER PRODUCTS
UNITED STATES, 1981

This was the first unproduced *Star Wars* toy I encountered as a collector. Years later I picked up the bright green prototype head of the prototype figure and a photo of the planned box. I bought it from a constantly updated list printed by a Florida toy dealer; it was just sheer luck that I had sent away for the current list and was one of the first to get it. Two of the talking Yoda dolls were listed, and I bought mine for $500. When I told my Japanese friend Eimei about it, he wanted one too. So I called the dealer back. But by that time he realized he had a small treasure and doubled the asking price. I practically slammed the phone down in anger. But Eimei said he still wanted it, so I reluctantly bought it for him.

It's a simple but brilliant toy. The plush body hides a pull-string voice box with a needle and a plastic record that contains eight of Yoda's phrases from *The Empire Strikes Back*. I couldn't understand why such a cool toy was never produced after having come so far. I imagined all kinds of strange reasons: maybe Frank Oz didn't like the quality of his voice, or product-safety managers were afraid tots would pull off the ring at the end of the string and swallow it. The real reason was sad but understandable: price point. "We all loved the toy," a longtime Kenner official told me. "And we had it to show the retailers, but they wouldn't buy it because we already had two items at the same price point, and they thought those would sell better." Years later I discovered that there were at least half a dozen different prototypes of Talking Yoda, including one that was made totally from hand-painted fabric.

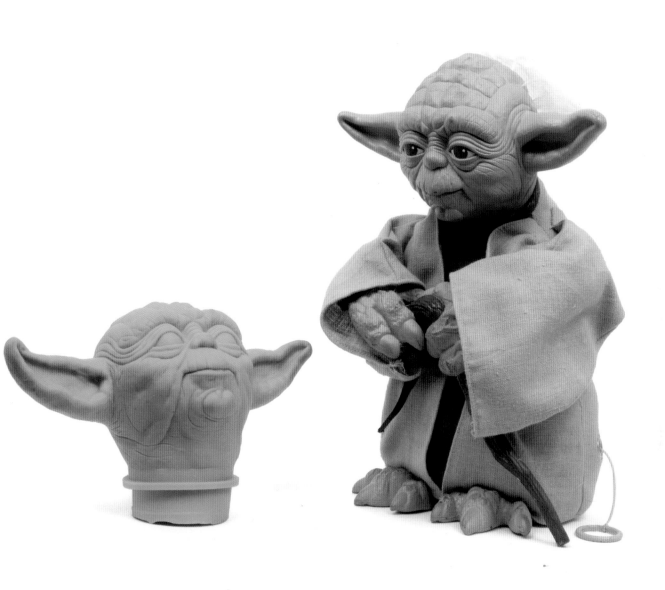

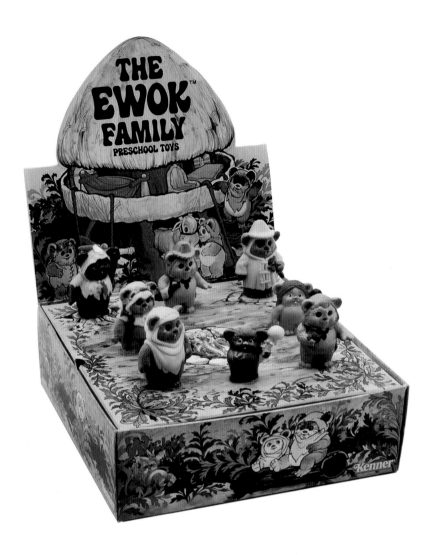

THE EWOK FAMILY FIGURINES SALESMAN'S DISPLAY

KENNER PRODUCTS
UNITED STATES, 1984

There were movie-realistic Ewok figures, cartoonlike Ewok figures, and later animated versions from the weekly TV series *Star Wars: Ewoks*. This salesman's sample for the first dedicated preschool *Star Wars* line helped introduce the tribe to retailers. The line lasted about a year.

SIT'N SPIN

KENNER PRODUCTS
UNITED STATES, 1984

Hard to believe, but there are some hard-core fans of a certain age who detest the Ewoks. I was an invited guest at one small convention in 1998, and my parting gift was a plush Ewok tied to the middle of a spinning plastic dart board, darts included. I think all naysayers should be tied onto Wicket the Ewok Sit'n Spins and then twirled for hours until they become as goofy as, well, an Ewok.

EWOK TEACHING CLOCK PRESCHOOL TOY

KENNER PRODUCTS
UNITED STATES, 1984

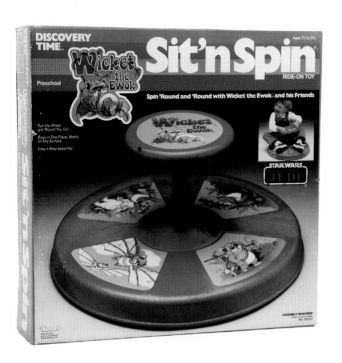

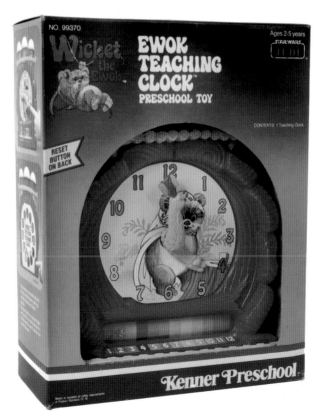

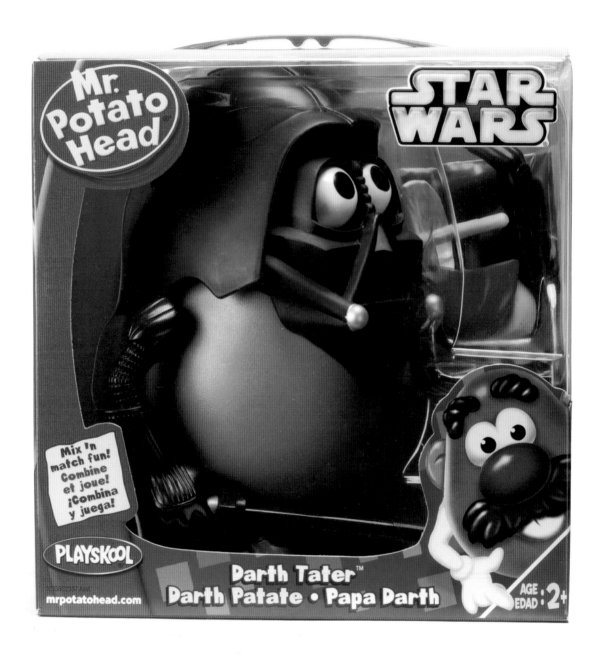

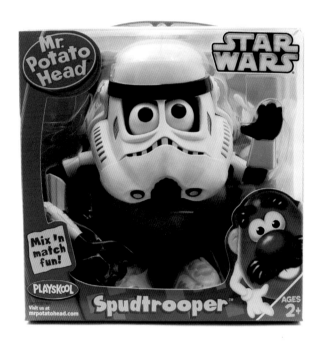

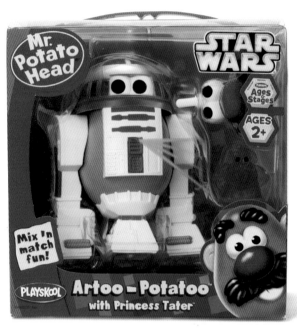

DARTH TATER MR. POTATO HEAD

HASBRO / PLAYSKOOL
EUROPE, 2005

Hasbro hit a home run with its merger of two iconic characters: Darth Vader and its own Mr. Potato Head. There was just something about the joining of the evil Vader with the guileless Mr. Potato Head. Naming the toy "Darth Tater" made for irresistible copy in newspapers and magazines and on television. Based on the public's initial response, Hasbro quickly increased the magnitude of its production, but it still had to chase demand. When Darth Tater hit the shelves, he was snapped up instantly. His popularity led to a line extension with characters such as Spudtrooper and Artoo-Potatoo with Princess Tater. Hasbro copywriters had fun with the box copy too. Darth Tater spouts the infamous line, "Together we shall rule as father and spud," while Spudtrooper warns, "Freeze! Or I'll mash you!"

SPUDTROOPER MR. POTATO HEAD

HASBRO / PLAYSKOOL
UNITED STATES, 2005

ARTOO-POTATOO (WITH PRINCESS TATER)
MR. POTATO HEAD

HASBRO / PLAYSKOOL
UNITED STATES, 2006

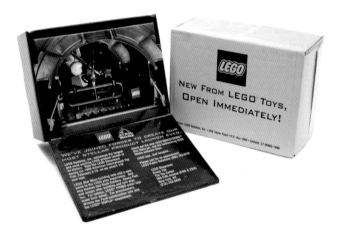

(Top)

NEW YORK TOY FAIR INTERNATIONAL 2005 VIP GALA INVITATION

LEGO SYSTEMS INC.
UNITED STATES, 2005

(Bottom left)

NEW YORK TOY FAIR INTERNATIONAL 1999 INVITATION

LEGO SYSTEMS INC.
UNITED STATES, 1999

Invitations to special limited-attendance events are very collectible, few more so than this one from LEGO. Since most invitations are on paper or card stock, the two hundred people who received this three-dimensional piece announcing the first showing of the new LEGO *Star Wars* toy line at New York's Toy Fair International in February 1999 certainly took notice. When flipped open, it plays a *Star Wars* theme and shows off its mini LEGO Luke Skywalker battling his evil dad, none other than Darth Vader. Six years later, LEGO used a transforming Anakin-Skywalker-into-Darth-Vader toy as its invitation to a Toy Fair VIP Gala.

(Bottom right)

LEGO EVENT BRICKS

LEGO SYSTEMS INC.
UNITED STATES AND UNITED KINGDOM, 1999–2008

LEGO Systems took on *Star Wars* as its first licensed brand in 1999. It was a match made in heaven. The LEGO look for vehicles and characters made it accessible to youngsters, while also appealing to the kid in many older collectors. The promotion-minded company sometimes prepares special event bricks, examples of which include these four (clockwise from top left): a special *Star Wars* Fireworks event at LEGOLAND in Windsor (United Kingdom), *Star Wars* Celebration I, and *Star Wars* events at LEGOLAND California in 2005 and 2008.

X-WING FIGHTER SHELF DISPLAY

LEGO SYSTEMS INC.
UNITED STATES, 2000

LEGO has long been known for its enticing retail shelf displays of prebuilt models that show potential customers what the final product will, hopefully, look like. This piece, for the higher-end X-Wing Fighter Ultimate Collector Series building set, adds a soupçon of cleverness: It consists of only one-half of the model and uses a mirrored backdrop to complete the illusion.

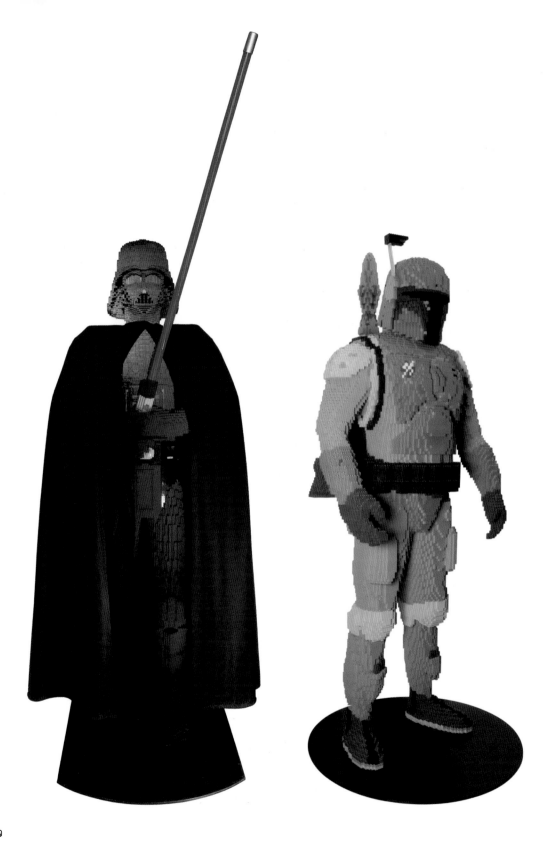

DARTH VADER LEGO LIFE-SIZE STATUE

LEGO SYSTEMS INC.
UNITED STATES, 2002

LEGO Systems' large models of characters, creatures, or things built from regular LEGO bricks and permanently fastened together travel from store to store to be used as point-of-purchase displays. But these pieces are never sold. So there was quite a stir when FAO Schwarz, the famous toy retailer, made a special deal with LEGO to build and sell three seven-foot-tall Darth Vader statues and, a year later, two Boba Fetts. The excitement died quickly when collectors saw the price: $10,000 each. One day, a few years after they were introduced, I got a call from a friend who was visiting FAO's Las Vegas store. "The LEGO Vader is marked down 50 percent," he told me excitedly. That was still too much for my budget. But just a week later I got a call from Ruby, a delightful lady who had long been my "personal shopper" at the Vegas store. She told me the manager wanted the Vader out of the store, and it was now marked down 80 percent. Sold! The lesson, of course, is that sometimes it pays to wait even on a very limited collectible, especially if you really can't afford it. Weeks later, when Vader arrived, I discovered his lightsaber didn't light up, although his soundtrack worked just fine. It had happened on one of the other two Vaders, I was told, and a technician was sent out to fix it. My LEGO source couldn't remember if that was the statue purchased by Joey Fatone or Michael Jackson. No technician showed up at Rancho Obi-Wan, but about a month later a special bulb arrived in the mail all the way from Germany.

BOBA FETT LEGO LIFE-SIZE STATUE

LEGO SYSTEMS INC.
UNITED STATES, 2003

"48 HOURS OF THE FORCE" LEGO MURAL

LEGO SYSTEMS INC.
UNITED STATES, 2005

For *Revenge of the Sith*, many Wal-Mart stores had giant tents in their parking lots promoting "48 Hours of the Force." Inside were displays of new merchandise for sale, samples of M&M'S, games, and a table where kids could help assemble this LEGO mural, brick by brick. LEGO helpfully provided a full-color "cheat sheet" to aid assembly.

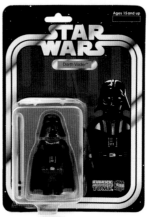

BOBA FETT KUBRICK

MEDICOM TOY CORPORATION
JAPAN, 2003

Japanese Kubrick mini-figures have become popular in the last
few years, either carded for special events or in small, sealed
boxes containing one of six different figures. With luck, you might
get one of the two "secret" and very limited figures per series.
But wait! If you don't know what's inside each box, then you might
have to buy dozens to get a full set of all eight. Exactly.

SANDTROOPER KUBRICK

MEDICOM TOY CORPORATION
JAPAN, 2004

DARTH VADER KUBRICK

MEDICOM TOY CORPORATION
JAPAN, 2005

COMMANDER JORG SACUL KUBRICK

MEDICOM TOY CORPORATION
JAPAN, 2006

You've never heard of Commander Jorg Sacul? Spell the last
name backward and you'll get a pretty good clue to who he
is. The name was first used on a Hasbro action figure sold
exclusively at *Star Wars* Celebration II in 2002 in Indianapolis.
I plead guilty to coming up with the not-quite-clever-enough
name. After the boss said we could use him as the subject of
an action figure, I wanted a name that wouldn't give away the
secret immediately but would be fairly obvious within a minute.
I also took a first stab at writing the Commander's "back-story."
Lucas Licensing president Howard Roffman, who has worked
at the company since 1980, was gentle as he reworked it to
perfection.

HAN SOLO IN CARBONITE CHAMBER KUBRICK

MEDICOM TOY CORPORATION
JAPAN, 2007

SPIRIT OF YODA KUBRICK

MEDICOM TOY CORPORATION
JAPAN, 2008

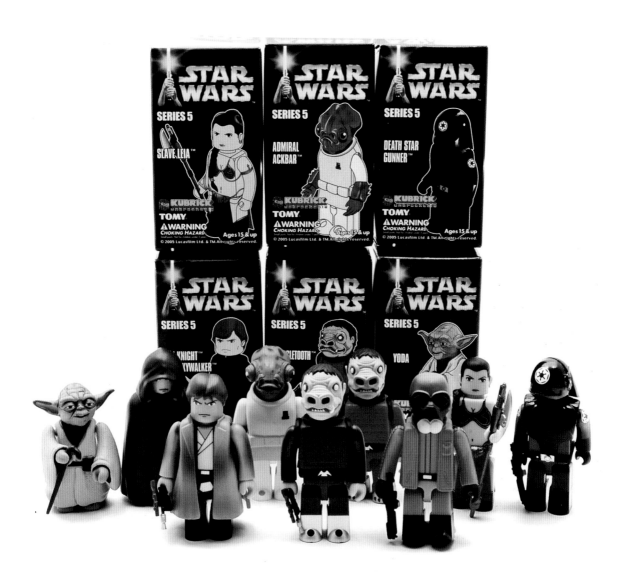

KUBRICK SERIES 5
MEDICOM TOY CORPORATION
JAPAN, 2005

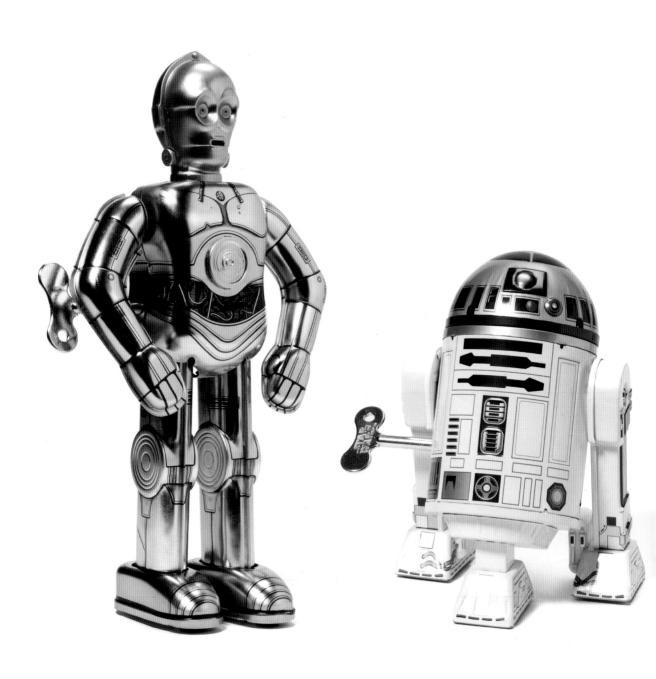

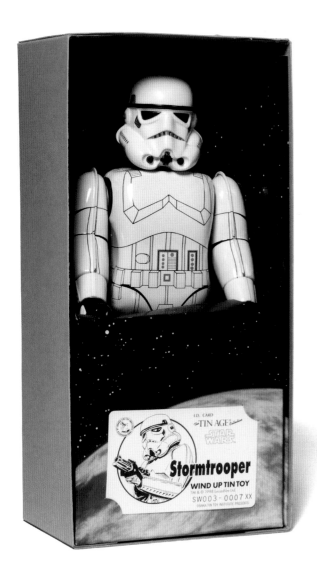

C-3PO WIND-UP TIN TOY

OSAKA TIN TOY INSTITUTE
JAPAN, 1997

C-3PO and R2-D2 make some sense as beautifully lithographed, wind-up tin toys. But Darth Vader, a stormtrooper, and the bounty hunter Boba Fett? Yet somehow they all work. Their naïve charm springs from classic, post–World War II Japanese wind-up tin toys of robots or spacemen.

R2-D2 WIND-UP TIN TOY

OSAKA TIN TOY INSTITUTE
JAPAN, 1999

STORMTROOPER WIND-UP TIN TOY

OSAKA TIN TOY INSTITUTE
JAPAN, 1998

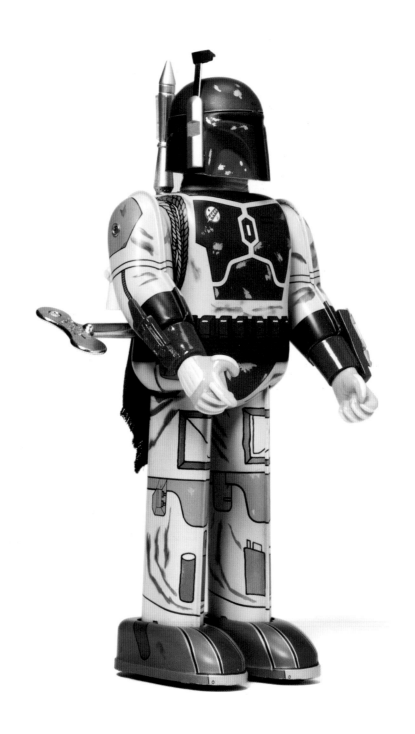

BOBA FETT WIND-UP TIN TOY
OSAKA TIN TOY INSTITUTE
JAPAN, 1998

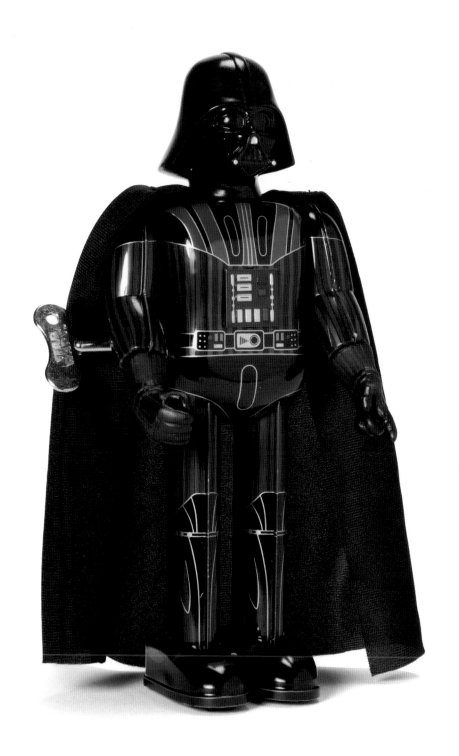

DARTH VADER WIND-UP TIN TOY
OSAKA TIN TOY INSTITUTE
JAPAN, 1997

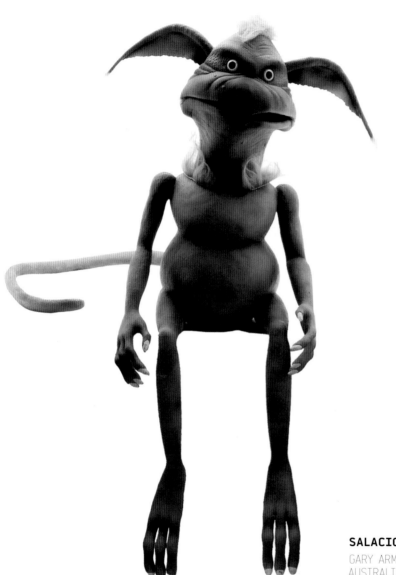

SALACIOUS CRUMB HAND PUPPET

GARY ARMSTRONG
AUSTRALIA, 1996

Jabba the Hutt's cackling Kowakian Monkey Lizard, the annoying Salacious Crumb, was made from scratch out of rubbery latex by Gary Armstrong, an Australian friend and professional prop builder. Gary made Salacious and several complete creatures (heads, hands, and feet) for a large convention of Star Walking, an unofficial Australian fan club. Just like in *Return of the Jedi*, Salacious is a puppet, although far less complex than the movie one: just insert your arm and move his mouth with your hand. Salacious was a prop in a television show taped at Rancho Obi-Wan for the Sci-Fi Channel, which featured filmmaker Kevin Smith narrating an hour of *Star Wars* fan films. Smith had a very animated conversation with his hand, at that point flapping the lips of Mr. Crumb.

MILLENNIUM FALCON CRDL MAGNETIC SCULPTURE

CRDL FOR GALOOB
UNITED STATES, 1997

Remember those CRDL magnetic sculptures that were all the rage in the early 1980s? A strong magnet in the base let the user manipulate small, shaped metal pieces as a stress reliever—an executive toy, supposedly. The only *Star Wars* CRDL was this promotional item given away at New York Toy Fair by the Galoob showroom to tout its decidedly nonmagnetic MicroMachines. Only two hundred were produced.

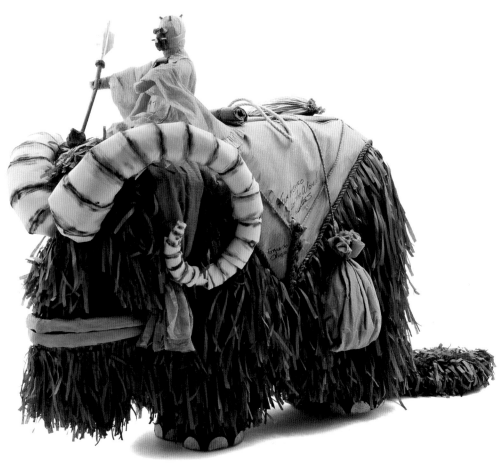

BANTHA PIÑATA

FERNANDO OLVERA
MEXICO, 2004

This incredible bantha piñata—designed after the beast of burden seen briefly in *Star Wars: A New Hope*—is truly one of my favorite pieces. It shows the passion, skill, and inventiveness of *Star Wars* fans, something found all over the world. Not that I'd ever let anyone swing a bat at this baby, but you can easily lift the saddle to drop in the traditional candy or small toys. It won first prize in the piñata category in a large crafts contest at the Official Mexican *Star Wars* Fan Club convention in Mexico City. I waited nearly fifteen minutes for the creator to come pick up his piñata and prize. Finally Fernando Olvera arrived with his wife. I introduced myself, told him how much I admired his creation, and asked if he would sell it to me so I could display it and have hundreds or thousands of people admire it. He seemed hesitant; I thought perhaps he was thinking how much he could wring out of me. It was just the opposite. "I don't know," he said. "How can I set a price? It cost me just a few dollars for the material and some of my time." I quickly responded: "Ah, but it is your artistry that I would be paying for. How about $100?" His wife poked him in the ribs and said in a stage whisper, "Take it!" Which Fernando was happy to do.

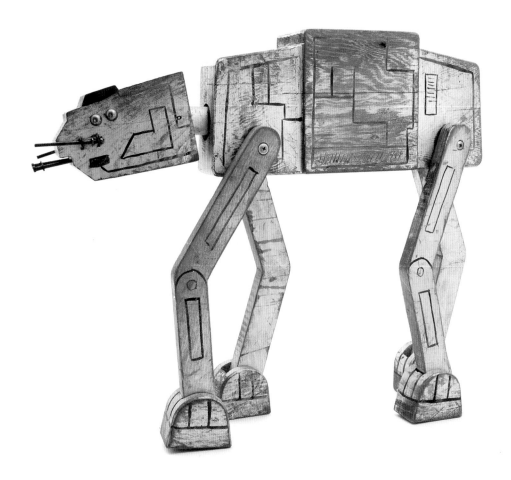

AT-AT WOODEN FIGURE

FAN-MADE
UNITED STATES, C. 1980–1981

A friend picked this up for me at a flea market many years ago for the princely sum of $10. The seller had no clue about its history, so I supplied one. There was a kid somewhere in Southern California who absolutely loved *The Empire Strikes Back*. That's all he talked about around the house, the neighborhood, and the schoolyard. And all he dreamed about for months was getting a spanking-new Kenner All Terrain Armored Transport (aka AT-AT or Imperial Walker) for Christmas. But things were tight that year, and the $30-plus cost was beyond his parents' reach. Instead, Dad made this incredible piece in his workshop, using flexible connections so that the legs could go back and forth, the feet could stay flat, and the neck could sway just like in the movie. Penny nails filled in for chin guns. As a final touch, since the sides couldn't open, two holes were carefully drilled in the top so that stormtrooper action figures could be placed aboard. Regardless of how close my story tracks to reality, this is a true piece of *Star Wars* folk art.

R2-D2 WIND-UP

TAKARA
JAPAN, 1978

Whereas Kenner produced a conventional R2-D2 action figure with a paper label for its body, Japan's Takara made one with a molded three-dimensional body—and it walked. George Lucas and others at Lucasfilm loved it and strongly suggested that Kenner sell it in the United States. Afraid of cannibalizing sales of the version it was already shipping, Kenner officially responded with a polite "No," but let its Canadian affiliate import a few thousand and put them on a backing card the same size as that of the rest of the line. Canada was the only place in the world to get that version.

ASTROMECH DROIDS WITH LIGHTSABER REMOTE CONTROL

TOMY
JAPAN, 2005–2008

If you're not really into *Star Wars*, you may know only R2-D2. But in the comics, books, and even in the backgrounds of the movies themselves, there are scores of barrel-shaped "astromech" droids, something that the Japanese toymaker Tomy took advantage of in making these tiny remote-control versions of R2 and his fellow droids.

30TH ANNIVERSARY 3 3/4-INCH ACTION FIGURE PROTOTYPE PACKAGING

HASBRO
UNITED STATES, 2007

Packaging is essential to make a toy stand out among thousands of other toys on the shelves. Lucasfilm and its licensees also develop an overall "line look" so that consumers can spot *Star Wars* merchandise quickly, no matter what it is or where it is placed in a store. This was an early design for the 2007 30th Anniversary Collection. The light blue strip is actually a separate piece of thin but tough plastic integrated within the card. The final packaging kept the basic look and shape intact, but it became one piece of cardboard. The coloring was changed to red and black. A year later, however, the blue-and-white color scheme was adopted, although the packaging design was totally different.

ARCADE MACHINES

HANKIN, DATA EAST, SEGA, WILLIAMS ELECTRONICS
AUSTRALIA, UNITED STATES,
1981, 1993, 1997, 1999

From left to right are the four major pinball machines produced
for the saga. The earliest, made in Australia, has an infinity
mirror as part of the back glass. The other pinball games were
made in the United States. The Episode I game is an amazing
combination of pinball and video game, but unfortunately it was
the last pinball of any kind made by Williams, which decided
there was much greater profit in making gambling devices.

STAR WARS SLOT MACHINE

JPM INTERNATIONAL LTD.
GERMANY, 1997

The first *Star Wars* slot machine was built in the United King-
dom for use in Germany. It uses small metal slugs embossed
with a TIE fighter on one side. To advance and score, the player
needs to line up fruit across the middle of the spinning wheels
or get three X-wing fighters to show up anywhere in the nine
slots; that sets off the upper chase around the circle, until you
land on STOP and Darth Vader tells you off—in German, of
course. It's more chilling if you don't understand the language.

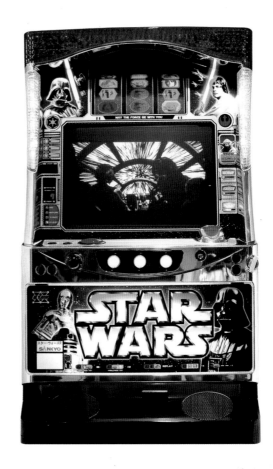

PACHINKO PARLOR GAME

SANKYO
JAPAN, 2008

Sankyo is one of the leading electronic game makers in the world. Its *Star Wars* Fever line of games combines the old upright pinball game of *pachinko* (using steel ball bearings and a nail-studded vertical playfield) with the latest in electronics, movement, lights, and high-definition technology. This machine uses clips from the movies but features newly animated anime-style *Star Wars* characters. It is as much fun to watch as it is to play. Gambling is illegal in Japan, although you wouldn't know it after stepping into a noisy, smoky, and crowded *pachinko* parlor. The player "rents" balls, and the object is to amass many more, which are then traded in for token gifts. Coincidentally, nearby there is always a small business that will buy the gifts in exchange for a fixed amount of yen.

PACHISLO PARLOR GAME

SANKYO
JAPAN, 2008

A *pachislo* machine is similar to an electronic slot machine.

SANKYO *STAR WARS* FEVER GOLF GIFT SET

SANKYO
JAPAN, 2008

Sankyo made this gift set to promote its new *pachinko* machine. In golf-crazy Japan, having *Star Wars* golf balls, ball markers, a ball scoop, and a Darth Vader golf towel could do nothing but improve your game.

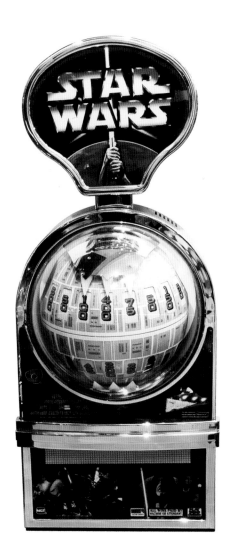

SLOT MACHINE TOPPERS

INTERNATIONAL GAME TECHNOLOGY
UNITED STATES, 2005–2007

There is little that says more about older fans still loving *Star Wars* than casino slot machines. It is illegal to own a current or recent slot machine without a very-difficult-to-obtain gaming license. But these are merely the tops of some recent machines and don't contain any software or hardware related to the actual gambling mechanisms. They were found on eBay.

WEAR IT

The images from a promotional short filmed in 1977 are seared into my consciousness. It's a brief scene of young men and women in their late teens and early twenties dancing to *Star Wars* disco music. They all have long hair, and they are wearing bell-bottom jeans and *Star Wars* T-shirts. They're in a room whose walls are covered by *Star Wars* posters, and the women are wearing *Star Wars* jewelry. It's a good reminder that the movie was both an overnight sensation and a long-lasting cultural phenomenon, a rare combination.

Another filmed moment, a black-and-white television commercial from 1980, evoked various reactions: desire, if you were a kid; isn't that precious, if you were a young mom; and creepiness, if you were a teenager or adult male. It was a spot for Union Underwear's *Star Wars* Underoos. With cheap production values by today's standards, the spot featured a bunch of boys and girls prancing around in various styles of *Star Wars* Underoos, singing and emoting as if they were part of a privileged class. Truly cringe-worthy, it clearly worked since Underoos are remembered fondly by fans of a certain age. Taking questions from a *Star Wars* Trivial Pursuit game, one online forum moderator challenged members to see how quickly they could answer.

MODERATOR: What was visible through Darth Vader's armor as he lifted the Emperor over his head?
DARK KNIGHT: His *Star Wars* Underoos. (Real answer: His skeleton.)

Over the years there have been boxer shorts for men (usually satin) and even a few pair of young girls' panties made for Episode I (sold in the United Kingdom). But Underoos remain top-of-mind. Possibly to capitalize on the parent-child *Star Wars* bond, saga Underoos returned to the shelves in late 2008, but only in young boys' sizes.

Undergarments are just the beginning. Licensees have been only too happy to provide shirts of every type; trousers, shorts, and belts; pajamas and robes; raincoats, windbreakers, and snowsuits; gloves and scarves; socks, cloth handkerchiefs and neckties; watches and jewelry from plastic to sterling silver and 24-karat gold;

OFFICIAL 501ST LEGION PATCH
501ST LEGION
UNITED STATES, 2000

sandals, shoes, shoelaces, and boots; sweaters and sweatshirts; purses and wallets; and caps, hats, and tuques. There was an attempt to interest couturiers in designing gowns inspired by the fantastic fashion statements that Natalie Portman wore as Queen Amidala in Episode I, but the timing proved wrong. Still, there was a special runway show of prequel outfits during New York Fashion Week in February 2006.

Costumes are big business too. The saga was the perfect fodder for Halloween at the time of the original trilogy, and it has become so again since 2005 with the release of *Revenge of the Sith* and the *Star Wars: The Clone Wars* television series. The costumes have ranged from inexpensive vinyl coveralls and thin plastic masks to high-end near-replicas sold at around $1,000. Talented seamstresses could use McCall's or Butterick patterns to make their own. And in recent years, even costumes for babies and dogs have been licensed. Fans show their creativity by making costumes that either look like they're right off the set or that trigger smiles, like the blocky *Star Wars* LEGO figure costumes that have appeared at some conventions. There is even an Elvis Trooper and a (Sherlock) Holmes Trooper in the 501st Legion fan group. Still, the simple early costumes evoke nostalgia. One Canadian friend has worn old, stretched Ben Cooper costumes to Halloween parties for a couple of years in a row, but we won't be sharing photos of him in this book.

The number of different T-shirt designs produced worldwide in more than three decades easily exceeds five thousand and is probably twice that amount. For the release of the animated movie *Star Wars: The Clone Wars* in 2008, Wal-Mart alone carried thirteen exclusive kids' shirts.

Most restricted "cast and crew" gear falls into the clothing category, made for and sold to (or occasionally given to) members of the movie crew, the visual effects specialists at Industrial Light & Magic, or the artists at the JAK Productions art department, who worked on the prequel trilogy. The vintage ILM material shows

MARC ECKO CUT & SEW STORE DISPLAY

MARC ECKO ENTERPRISES
UNITED STATES, 2008

This glossy, mounted poster was a display at a Marc Ecko store in Las Vegas. Ecko, a pop-culture-maven-turned-entrepreneur, has always loved *Star Wars*, and his license has resulted in more than 100 pieces of trendy clothing. Despite appearances, the line unfortunately does not contain ladies' lingerie with a matching clone trooper helmet.

PIT DROID COAT RACK STORE DISPLAY

MADE FOR FAO SCHWARZ
UNITED STATES, 1999

With Lucasfilm's blessing, the funny pit droids from *The Phantom Menace* were made into solid clothing racks for the large *Star Wars* shops at several FAO Schwarz specialty toy stores. Unlike the pit droids in the movie, however, you can't punch this one in the nose and watch it quickly fold up into a much smaller size. When a Lucasfilm manager heard that some large FAO stores were selling these store displays to collectors, she immediately put an end to the practice because they weren't licensed objects and Lucasfilm didn't collect any royalties on them. Luckily, mine was already on a truck that had left Las Vegas.

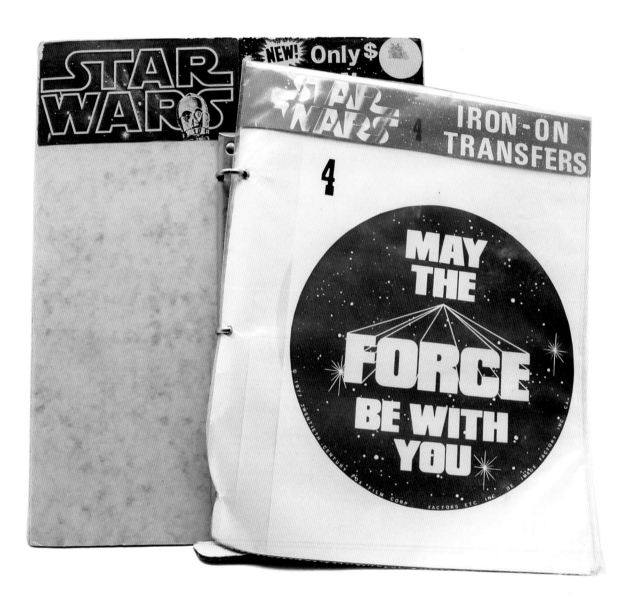

a wicked sense of humor and is the most in demand, along with the actual protective clothing worn by the crew. This includes the sub-zero snowsuits and parkas worn in Finse, Norway, while shooting scenes on the "ice planet Hoth" for *The Empire Strikes Back*, or rain suits used by the *Return of the Jedi* crew during the Ewok planet scenes shot in a redwood forest in Northern California, under the code name "Blue Harvest." While there are only a few items for each of the original movies, the prequels produced a lot more. By Episode III, producer Rick McCallum gave each department permission to produce its own souvenir clothing as long as the designs passed muster. As a result, there were more than fifty different shirts, jackets, vests, caps, and hats made, some in multiple colors. Clearly it was an entrepreneurial venture.

The problem for a serious collector is how to organize a ton of clothing, much less how to display it. In a database, how do you describe a white Yoda character T-shirt to make it distinguishable from the seventy-two other white Yoda character shirts? Shirts frequently don't include a year of copyright and often don't even have the manufacturer's name if the hang-tag is missing. The only sure way is to photograph everything because, for most people, visual memory is a lot stronger than descriptive memory. With probably more than one hundred thousand individual items in my collection, it is rare that I will buy a duplicate of something I already have once I have seen and handled the first object. Of course, I often forget my name and telephone number, but the really important memories persist.

The best way to display a full costume is to drape it over a mannequin. In large cities, used mannequins are fairly easy to find for a little more than $100. Cloth-covered mannequins with bendable limbs will set you back more than $500, but their flexibility allows for life-like poses. You can stuff cotton wadding or old pillows into some costumes, as I do with my giant fan-made wampa suit, and buy inexpensive foam wig stands for masks and helmets. Or you can just wear everything. I have a friend who wears a different *Star Wars* T-shirt every day of the year. I've never asked, but maybe he just hates to do laundry.

EARLY T-SHIRT TRANSFER DISPLAY
FACTORS INC.
UNITED STATES, 1977

The 1970s were a strange time for many reasons. In pop-culture history it was the beginning of the era when you paid for the right to advertise a movie, an event, or a product on your chest. Make-your-own-T-shirt shops bloomed like cherry blossoms in Japan. And one beneficiary was *Star Wars*. It seemed like everyone wanted to wear a *Star Wars* shirt. Factors Inc., which had made a name for itself by selling a million Farah Fawcett posters in a very short period, picked up the *Star Wars* license and ran with it, producing scores of transfers, T-shirts, posters (Darth Vader quickly overtook Ms. Fawcett in the numbers game), and other memorabilia. The speed with which the company got product out the door was amazing. Of course, that resulted in occasional boo-boos, such as the ubiquitous badge, tote bag, T-shirt transfer, and more that proclaimed "Darth Vadar Lives." That merchandise is not rare—the misspelling was never corrected.

HAN SOLO T-SHIRT

FACTORS INC.
UNITED STATES, 1977

DARTH VADER T-SHIRT

FACTORS INC.
UNITED STATES, 1977

CHILD'S JACKET (FRONT AND BACK)

BRIGHT RED GROUP
UNITED STATES, 1977

This early jacket has the infamous misspelled "Darth Vadar
Lives" patch on the front but a correctly spelled "Darth Vader"
transfer on the back.

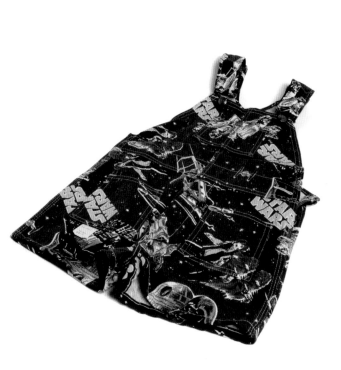

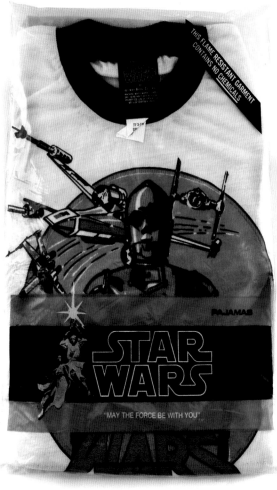

CHILD'S SUNSUIT

LIBERTY TROUSER
UNITED STATES, 1977

The sunsuit was part of a small line of heavy denim shorts, trousers, and overalls for kids in either a blue or brown *Star Wars* pattern.

CHILD'S PAJAMAS

WILKER BROS.
UNITED STATES, 1977–1978

GIRLS' PAJAMAS

ST. MICHAEL FOR MARKS & SPENCER
UNITED KINGDOM, 1999

Our adorable models Iris and Alex sport British-made girls' pajamas. Because the demographics for the saga run heavily male, there has been very little made specifically for girls, young or older.

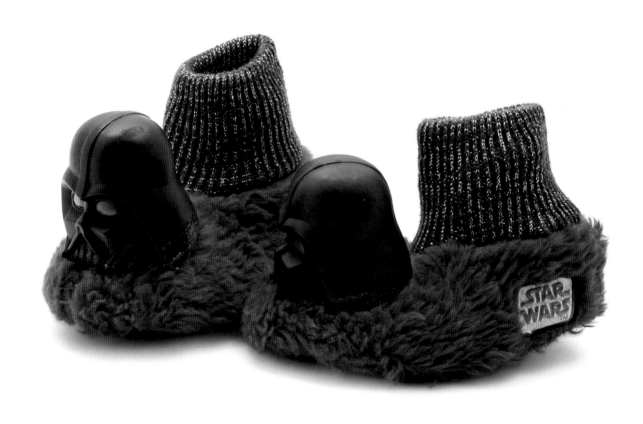

DARTH VADER SLIPPERS

UNKNOWN
TAIWAN, 1977

A prime example of how evil can be made cute.

R2-D2 AND C-3PO TENNIS SHOES

CLARKS
UNITED STATES, 1977–1978

STAR WARS SILVER AND BLACK R2-D2 SHOES

CLARKS
UNITED STATES, 1977–1978

Clarks had a broad line of shoes available for *Star Wars* and through the beginning of the era of *The Empire Strikes Back*. While some had characters and logos all over them, others were merely suggestive of the movie, such as these crepe-soled R2-D2 models with large stars on the arch.

CLARKS SHOES FOR KIDS STORE DISPLAY POSTER

CLARKS
UNITED STATES, 1977

***THE EMPIRE STRIKES BACK* SHOES FOR KIDS STORE DISPLAY POSTER**

CLARKS
UNITED STATES, 1980

***STAR WARS* BY CLARKS STORE DISPLAY**

CLARKS
UNITED STATES, 1977–1980

JAR JAR BINKS SLIPPERS

KIDNATION INC.
UNITED STATES, 1999

The only thing that could make these even better is if Jar Jar's
tongue were sticking way out.

JAPANESE STORMTROOPER FLIP-FLOPS
CONVERSE
JAPAN, 2005

The Converse stormtrooper flip-flops are far too cool to break
out of their background. In Japan, the packaging is sometimes
even more important than the product.

R2-D2 THERMAL UNDEROOS

UNION UNDERWEAR
UNITED STATES, 1980

Few of today's fans who grew up with *Star Wars* can forget the incessant black-and-white television commercials in the 1980s for *Star Wars* Underoos. They featured a bunch of young boys and girls in their Underoos, jumping up and down and singing an ode to the two-piece underwear with a tune that was hard to get out of your mind. Printed on the inside of the package was a certificate that made the wearer a Jedi; it must have been official because it was signed by Yoda.

PRINCESS LEIA UNDEROOS

UNION UNDERWEAR
UNITED STATES, 1981

LUKE SKYWALKER FLIGHT SUIT UNDEROOS

UNION UNDERWEAR
UNITED STATES, 1981

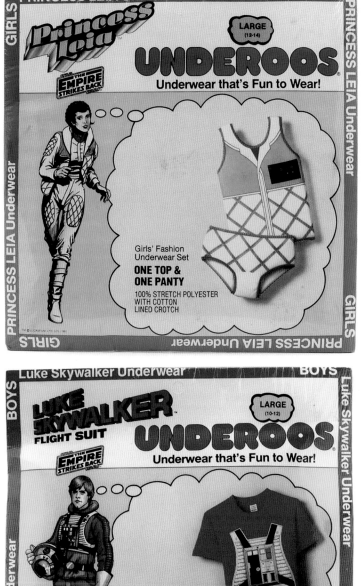

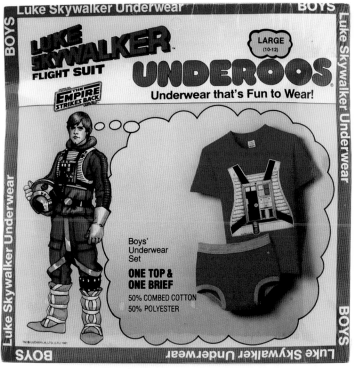

STAR WARS LOGO JESTER'S CAP

FRESH CAPS
UNITED STATES, 1996

We're not sure if this is really a jester's cap or the manufacturer's attempt to make wearers look like Twi'leks with swinging lekku. If you understand that, welcome to true *Star Wars* geekdom.

YODA CAP

THINKING CAP CO.
UNITED STATES, 1980–1981

Thousands of *Star Wars* hats and caps have been made around the world for more than three decades, yet this has been my favorite from the time it first appeared. Thinking Cap made it in two versions, with shorter ears for its child's cap.

DARTH VADER CHILDREN'S GLOVES

SALES CORP. OF AMERICA
UNITED STATES, 1983

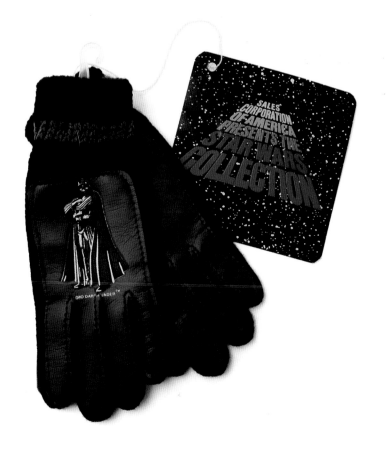

MEN'S SATIN BOXER SHORTS
C&A
FRANCE, 2005

JAR JAR BINKS SATIN LOUNGING ROBE
COAST
AUSTRALIA, 1999

PRINCESS LEIA CEREMONIAL NECKLACE

LAPPONIA JEWELRY OY
FINLAND, CONTINUOUS FROM EARLY 1970s

This is the sterling silver necklace that Princess Leia (Carrie
Fisher) wears in the medal ceremony at the end of *Star Wars*.
Well, it is and it isn't. It is not the actual necklace that she wore,
but a duplicate—not a "replica." Designed by the Finnish artist
Björn Weckström and produced by Lapponia Jewelry OY before
filming ever started on *Star Wars*, the design is called "Planetoid
Valleys." It's part of a collection of seventeen pieces called the
"Space Silver" collection that Weckström started designing in
the late 1960s, inspired by the first manned space flight, by
Russian cosmonaut Yuri Gagarin. Perhaps the name inspired
the film's costumers to buy or borrow one of the necklaces.
The design is still available for sale today, along with a
matching bracelet.

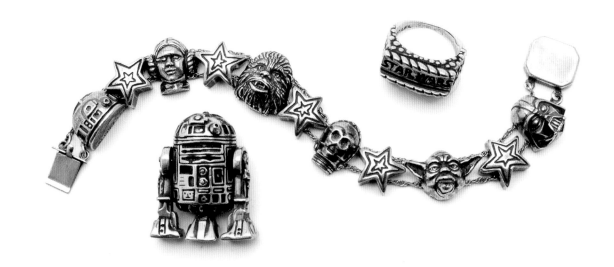

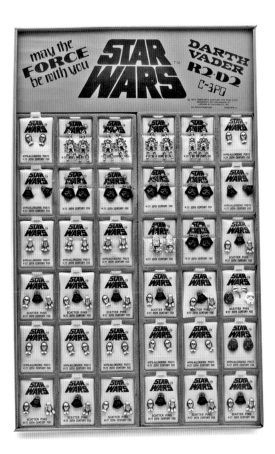

STAR WARS STERLING SILVER JEWELRY

NEIMAN MARCUS
UNITED STATES, 1997

Sold exclusively by Texas-based Neiman Marcus in 1997, this seldom-seen sterling silver jewelry was priced for adults, not children. The simple *Star Wars* ring and the nicely sculpted R2-D2 pin are fine pieces. But it is the *Star Wars* charm bracelet that really stands out, since it may be the only such bracelet produced for the saga since a kid's bracelet in 1977. The subtly depicted heads (or the top, in R2-D2's case) of six major characters are interspersed with stars—so no one will ever forget the film's title.

CHARACTER JEWELRY SHELF DISPLAY

WEINGEROFF ENT
UNITED STATES, 1977

One of the first licensees to get three-dimensional products into stores was Weingeroff Ent, which produced a broad range of inexpensive jewelry in 1977, mainly using Darth Vader, Chewbacca, R2-D2, C-3PO, a stormtrooper, and an X-wing fighter. Among its many lines: earrings (pierced and clip-on), necklaces, charm bracelets, stickpins, tie tacks, rings, and barrettes. The necklaces were my first purchase of three-dimensional *Star Wars* items. I had spotted them immediately on the check-out counter of a Spencer Gifts mall store. Once I saw that they had moveable parts I was hooked. Then I had an internal debate over whether I could buy six ladies' necklaces without being embarrassed. My growing *Star Wars* lust settled the debate, and as I was paying for them, I muttered, "My girl-friend is really going to like these." The cashier looked up at me briefly and gave a knowing nod of the head. She wasn't fooled for a moment.

THE EPIC BEGINS .1 OZ. .999 GOLD COIN NECKLACE

RARITIES MINT INC.
JAPAN, 1987

The uniqueness of *Star Wars* products sold in Japan took an interesting twist in 1987 when Rarities Mint in the United States made twenty-four different silver and gold coins in six different designs and four different weights. But Japan was the only country where a twenty-fifth variation was available: a one-tenth-ounce gold coin made into a necklace.

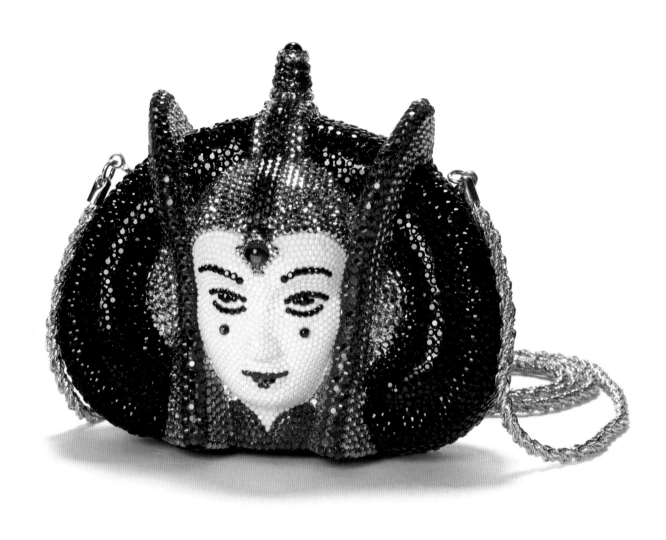

QUEEN AMIDALA CRYSTAL HANDBAG

KATHRINE BAUMANN COLLECTIBLES
UNITED STATES, 1999

This magnificent bejeweled minaudière (a small ornamental case carried as a handbag) was made in a limited edition of seventy-five by Katherine Baumann for FAO Schwarz. The exterior is covered with Swarovski crystal beads. With the pieces initially priced at $2,100, the store misjudged the market by a big margin. They finally sold out when FAO reduced the price by 80 percent. The handbag remains an impressive creation.

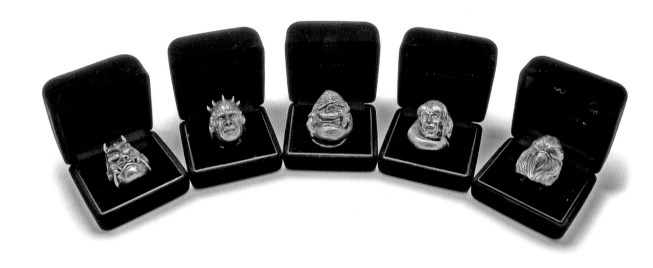

FIVE CHARACTER RINGS

JAP INC.
JAPAN, 1997–1999

JAP Inc., a Japanese company on the cutting edge of pop culture, made a series of very large sculpted rings—most in silver—of characters from the original trilogy, Episode I, and Episode III. They might look good on someone who needs a size 10XL glove, but they dwarf most fingers and hands. However, the sculpt on each one is near perfect, as can be seen in this selection of five rings (from left): Gamorrean guard, Darth Maul, Jabba the Hutt, Bib Fortuna, and Chewbacca. They might also be near-lethal weapons in—or on—the wrong hands. The rarest piece in the line is a 18-karat gold C-3PO head ring. Limited to just fifty, they were priced at $2,000 each. I told my friend Eimei not to buy one for me; it was just too expensive. "Ah, but you must have," he said. "You are the *collector*." We went back and forth on the issue; he considered it his role to try to make sure I had every *Star Wars* item produced in Japan—using my money, of course. A few months later he told me regretfully that the limited edition had sold out. I thought I was safe until months later when he called again. "Big coincidence," he said. "I was at a show and sat next to the president of JAP, and he said he had found one more gold ring and would sell it to you for half price, so I bought it." All of which proves, I guess, that even when you try to limit yourself as a collector, there can be forces that conspire against you.

18-KARAT GOLD C-3PO RING

JAP INC.
JAPAN, 1997

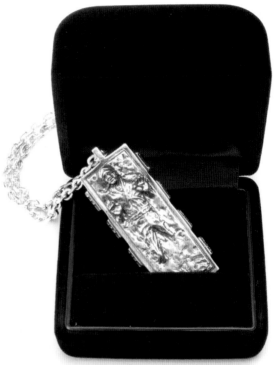

DARTH VADER, STORMTROOPER, AND BOBA FETT RING SET

JAP INC.
JAPAN, 1997

These silver rings have been colorized.

HAN SOLO IN CARBONITE STERLING SILVER NECKLACE

JAP INC.
JAPAN, 1997

The only piece of licensed jewelry from JAP Inc. that is not a ring is this Han in Carbonite necklace.

C-3PO BELT BUCKLE PROTOTYPE

UNKNOWN
UNITED STATES, 1976–1977

This painted plaster casting was a prototype for a possible
early C-3PO belt buckle that was never produced.

BRASS BELT BUCKLE STORE DISPLAY

BASIC TOOL & SUPPLY CO.
UNITED STATES, 1977

Among the first items licensed in 1977 were these brass
belt buckles made in the San Francisco Bay Area. They went
perfectly with the wide leather belts that held up oh-so-
fashionable bell-bottom jeans. Another company, Leathershop
Inc., was also licensed to make almost exactly the same
buckles at the same time.

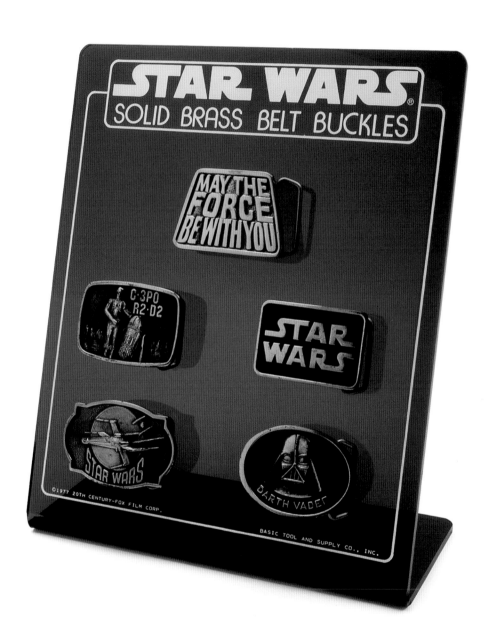

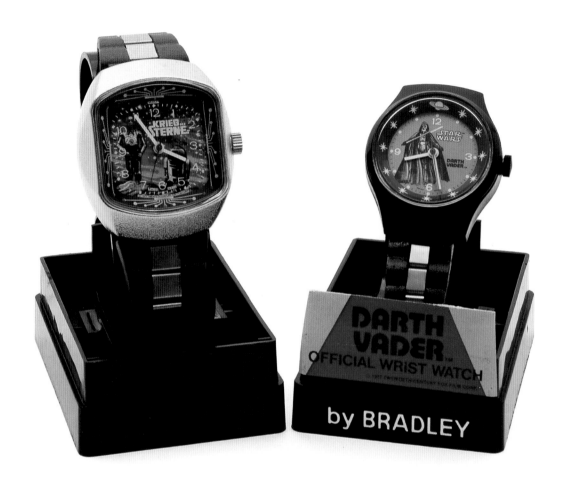

C-3PO AND R2-D2 WATCHES

GSX
JAPAN, 2007–2008

These beautiful and subtle watches pay homage to the two main droids of the *Star Wars* saga, the only characters that appear in all six movies. They are designed—and priced—for adults.

BOBA FETT WATCH WITH MANDALORIAN DOG TAG AND RESIN BOX

FOSSIL
UNITED STATES, 2002

GERMAN AND AMERICAN WATCHES

BRADLEY TIME
GERMANY (LEFT) AND UNITED STATES, 1977–1978

These early watches represent the vanguard of the hundreds of timepieces that were produced all over the world for all six *Star Wars* movies. Most of the vintage-period watches were made for kids. As the audience matured, watches were increasingly made for adults by companies such as Fossil in the United States and GSX in Japan.

FAN CLUB BADGE SET

OFFICIAL *STAR WARS* FAN CLUB
UNITED STATES, 1978–1979

Membership had its privileges in the Official *Star Wars* Fan Club. One was that you could purchase exclusive items, such as this fourteen-piece movie badge set, including an unusual badge carrying a photo of George Lucas.

FAN CLUB "RECRUITER" BADGE

OFFICIAL *STAR WARS* FAN CLUB
UNITED STATES, 1981–1982

You could win a "Rebel Recruiter" badge or T-shirt if you signed up some Rebels as members of the fan club.

DARTH VADER AND R2-D2 COUNTER DISPLAYS

CASTOLINE
MEXICO, 1997

These two counter displays made especially for Sears Mexico show most, but not all, of the myriad pins developed by Castoline for the *Star Wars* Special Editions. They were first available at a convention sponsored by the Official Fan Club in Mexico.

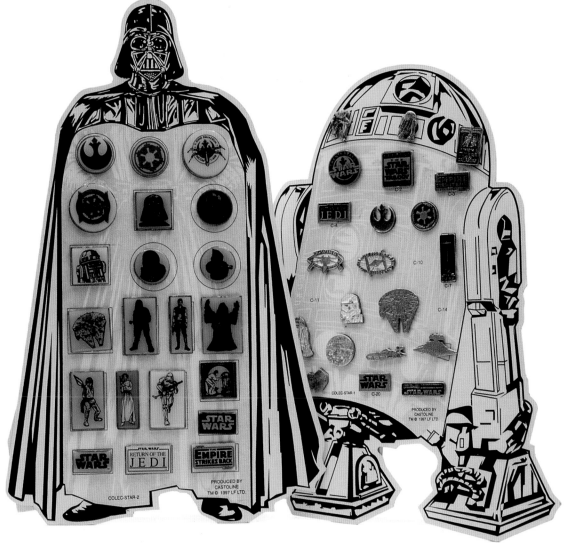

SILK NECKTIES

WATASHO
JAPAN, 1998

Whereas most of the polyester ties sold in the United States had large, gaudy patterns, many of the Japanese ties had more subtle overall patterns whose *Star Wars* theme wouldn't even be recognizable unless you looked closely. Then again, Japan produced some big, bold designs, too.

EPISODE I NECKTIES

RALPH MARLIN
UNITED STATES, 1999

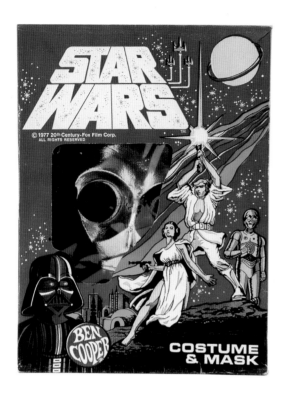

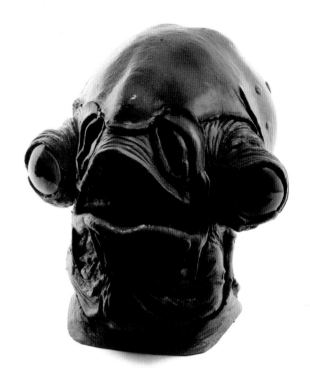

"STORM TROOPER" CHILD'S COSTUME

CRONER
AUSTRALIA, 1980

This Australian costume is the same as the Ben Cooper costume from the United States, but the box art makes all the difference. While the American costumes were in a generic box, some artist with little reference material must have come up with this bizarre-looking "storm trooper" that clearly didn't go through the Lucasfilm vetting process before it was released. The Darth Vader costume box isn't nearly so far astray, but a bit scary nonetheless.

DARTH VADER CHILD'S COSTUME

CRONER
AUSTRALIA, 1980

"STORM TROOPER" COSTUME INSERT

CRONER
AUSTRALIA, 1980

C-3PO CHILD'S COSTUME AND BOX

BEN COOPER
UNITED STATES, 1977–1978

With all the creatures and droids parading before our eyes in the film, *Star Wars* became a bonanza for a number of costume and mask companies.

ADMIRAL ACKBAR OVER-THE-HEAD MASK

DON POST STUDIOS
UNITED STATES, 1982

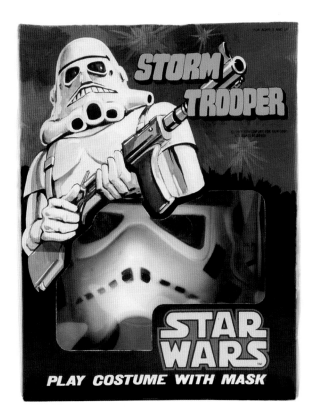

STORM
TROOPER

© 1977 20TH CENTURY-FOX FILM CORP.
ALL RIGHTS RESERVED

FOR AGES 3 AND UP

STAR
WARS™

PLAY COSTUME WITH MASK

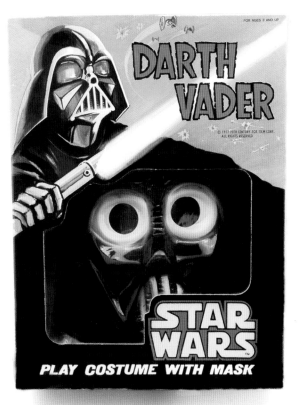

DARTH
VADER

© 1977 20TH CENTURY-FOX FILM CORP.
ALL RIGHTS RESERVED

FOR AGES 3 AND UP

STAR
WARS™

PLAY COSTUME WITH MASK

CRONER ©1980 TWENTIETH CENTURY-FOX FILM CORP.

STAR
WARS

STORM TROOPER

● MADE OF FLAME RETARDANT VINYL
● ONE PIECE TOPPER ONLY
● WELDED SEAMS FOR GREATER STRENGTH
COSTUME AS SHOWN

ONE SIZE ONLY (3-10)

CRONER TRADING PTY. LTD. AUSTRALIA

MADE IN TAIWAN

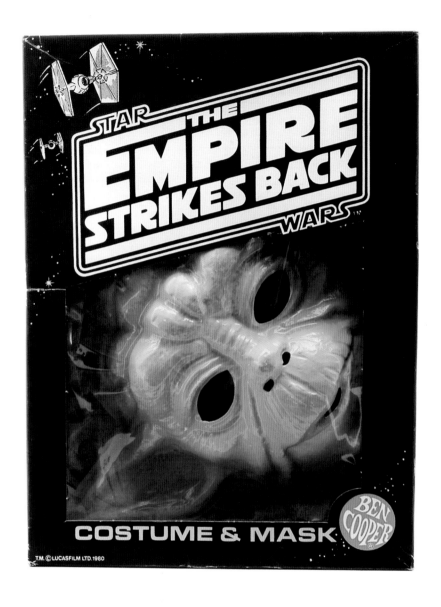

LUKE SKYWALKER JEDI KNIGHT CHILD'S COSTUME

ACAMAS TOYS
UNITED KINGDOM, 1983

It's always difficult to portray a living person in a line of children's costumes. This British Luke Skywalker costume is a rare exception.

IMPERIAL STORMTROOPER CHILD'S COSTUME

ACAMAS TOYS
UNITED KINGDOM, 1983

YODA CHILD'S COSTUME

BEN COOPER
UNITED STATES, 1980

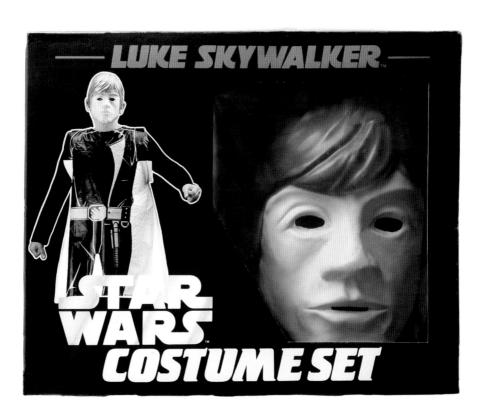

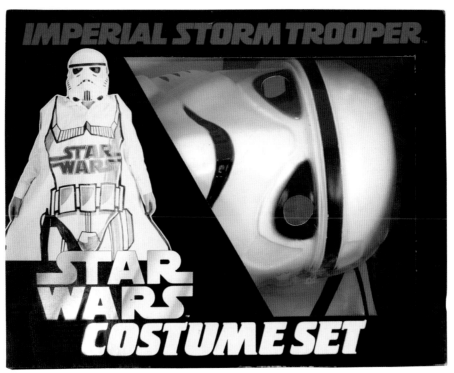

ADULT QUEEN AMIDALA COSTUME

RUBIE'S COSTUME CO.
UNITED STATES, 1999

In the original *Star Wars* trilogy, most of the costumes looked like sackcloth—deliberately, since the galaxy was under the thrall of an oppressive regime. But the prequels had incredibly elaborate costumes, none more so than those for Queen and later Senator Amidala. For *The Phantom Menace*, Rubie's, which normally makes low-priced kids and adult costumes, delivered this astonishing high-end Amidala gown, trimmed in fake fur. It even has lighted pods near the bottom, just like the costume in the movie.

IMPERIAL GUARD COSTUME

LISA YANKEY
UNITED STATES, 2003

The Imperial Guard does nothing but looks fantastic on screen. Trying to duplicate the costume, however, is tricky because there is so little good photo reference and lots of debate over the correct shade of the guard's cape. I dug up as much background material as possible and paid for the fabric; Lisa Yankey and her husband Jeff—both members of the 501st Legion— did the hard work.

WAMPA COSTUME

JUAN ROBERTO MENDEZ
MEXICO, 2004

This humongous wampa ice creature is head of security at
Rancho Obi-Wan. When it arrived at the office one day, several
colleagues decided to try it on; there was even a photo of the
wampa playing table tennis posted to the official website,
starwars.com, for a caption-writing contest. But as the day
wore on, the wampa got a little rambunctious and made a run at
Web writer Bonnie Burton, who adopted her best look of terror
for the camera.

The costume, which looks a bit like a shaggy Greek flokati
rug, was assembled with a lining of newspaper pages by Juan
Roberto Mendez, a talented Mexican fan; it won first prize in
the costume contest at a 2004 convention in Mexico City.
Even more amazing, he remained inside of the costume for
most of the day. He also built full-size Ewoks covered with rab-
bit fur. Sadly, Roberto died in his sleep at the age of thirty from
a congenital heart problem. He was mourned by his *Star Wars*
friends all over Mexico, one of whom wrote me, "Roberto was
buried with his medal of first place from Encuentros 2004 for
his wampa outfit, and with one of his handmade Ewoks."

PRINCESS LEIA (SLAVE GIRL) PET COSTUME

RUBIE'S COSTUME CO.
UNITED STATES, 2005

This is my own precious "Princess" Lucca, wearing the canine Princess Leia Slave Girl outfit. She also could have been Darth Doggy, Yoda, or Leia in her original chaste white gown. There are now also *Star Wars* baby costumes.

CHEWBACCA, LEIA, YODA, JAWA, AND DARTH VADER COSTUME PATTERNS

McCALL'S
UNITED STATES, 1981

LUKE AND LEIA COSTUME PATTERNS

BUTTERICK
UNITED STATES, 1997

501ST LEGION PATCHES

501ST LEGION
WORLDWIDE, 1997–2009

The 501st Legion, the largest grassroots *Star Wars* fan organization in the world with more than four thousand members in the United States and nearly forty other countries, sprang from the fertile imagination of one South Carolina fan, Albin Johnson. In recovery for a year from an automobile accident that cost him his left leg, Johnson was caught up with the news of the upcoming *Star Wars* Trilogy Special Edition. When he returned to work as a network administrator, he and a buddy began talking about cool stormtrooper costumes, and one thing led to another.

"I remember marching into the shabby little movie theater where they were showing [*Star Wars*]," Johnson recalls. "I was nervous as hell; you couldn't see anything in that helmet, and it was so uncomfortable. Would this thing even look real? Am I making an idiot out of myself? But the fans ate it up."

Thanks to the Internet, the 501st (the name just "sounded good") was born. Today, the men and women who "troop" attend events together, visit children's hospitals, and raise money for charities. The 501st quickly attracted Lucasfilm's attention; after some due diligence, the company warmly welcomed the group as part of the extended family.

In a little more than a decade, the fantasy of one fan has led to a world of joy for not only 501st members but also the millions of people who have seen them in person or on numerous television shows. For example, a 501st "Rockettes" line hoisted "Star Trek"'s William Shatner at the start of the American Film Institute's Life Achievement Award show for George Lucas. With Lucasfilm's permission, the 501st makes patches, challenge coins, and other merchandise that is traded or sold only at cost and only to the membership. The foreign-looking words on many of the patches are from a faraway galaxy. The alphabet is Aurebesh, which, conveniently, can be translated into English without a Rosetta stone.

(Opposite, clockwise from left)

DJIBOUTI OUTPOST PATCH

DJIBOUTI, C. 2005

SPANISH GARRISON PATCH

SPAIN, 2006

SAUDI ARABIA PATCH

SAUDI ARABIA, 2003

NORTHEAST REMNANT (NEW YORK/NEW JERSEY) PATCH

UNITED STATES, 2006

(Above, clockwise from top left)

SAN DIEGO SQUAD PATCH

UNITED STATES, 2006

FEMTROOPERS PATCH

UNITED STATES, 2006

FRENCH GARRISON FIFTH-ANNIVERSARY PATCH

FRANCE, 2007

REVENGE OF THE SITH PREMIERE PATCH

UNITED KINGDOM, 2005

(Opposite, left to right, top to bottom)

FLORIDA GARRISON TENTH ANNIVERSARY PATCH

UNITED STATES, 2007

HOLMES TROOPER PATCH

UNITED STATES, 2007

NORTH TEXAS SQUAD PATCH

UNITED STATES, 2008

MICHIGAN SQUAD PARADE PATCH

UNITED STATES, 2007

R2-KT PATCH

UNITED STATES, 2007

ISRAEL OUTPOST PATCH

ISRAEL, C. 2003

(This page, top to bottom)

GARRISON CARIDA (PENNSYLVANIA) MUMMERS PARADE PATCH

UNITED STATES, 2008

OLD LINE GARRISON (MARYLAND/ WASHINGTON D.C.) PATCH

UNITED STATES, 2007

ICELANDIC OUTPOST PATCH

ICELAND, C. 2005

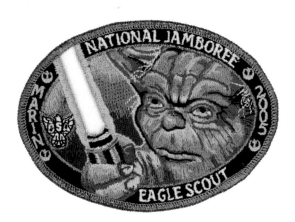

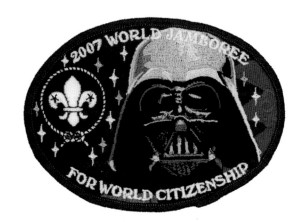

2001 JAMBOREE PATCH

BOY SCOUTS OF AMERICA, MARIN COUNCIL
UNITED STATES, 2001

Lucasfilm sometimes also allows Boy Scout groups to use *Star Wars* characters to help raise funds.

2005 JAMBOREE: EAGLE SCOUT PATCH

BOY SCOUTS OF AMERICA, MARIN COUNCIL
UNITED STATES, 2005

2005 JAMBOREE: SEA SCOUT SHIP PATCH

BOY SCOUTS OF AMERICA, OCCONEECHEE COUNCIL
UNITED STATES, 2005

2007 JAMBOREE: FOR WORLD CITIZENSHIP PATCH

BOY SCOUTS OF AMERICA, MARIN COUNCIL
UNITED STATES, 2007

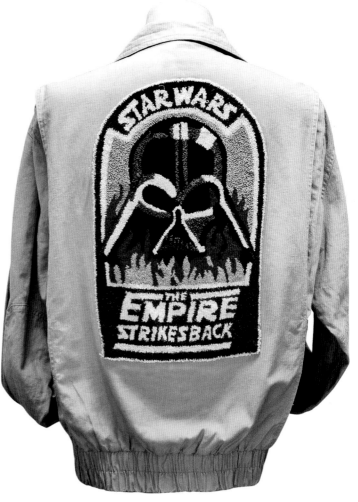

THE EMPIRE STRIKES BACK "VADER IN FLAMES" LATCH HOOK JACKET

MITCH MITCHELL
UNITED STATES, C. 1980–1981

I met Mitch Mitchell and his then-wife at the *Star Wars* 10th Anniversary convention in Los Angeles in 1987. They were both hard-core collectors, the first husband-and-wife team I had ever met who were equally passionate about the hobby. A few years later I got a call to let me know the couple was splitting up and needed to sell most of their collection. Mitch sent me a bunch of photos and I bought a number of items, including Virginia license plates embossed with names like DAGOBAH. However, there were three homemade embroidered jackets that I really admired—except too much work had gone into them and they weren't for sale. Flash forward more than two decades when, out of the blue, I got an e-mail that started, "You won't remember me but . . ." It was Mitch, and I most definitely remembered him. He was packing up to move and wanted to give some of his more personal items a good home. He sent me not only the three jackets at no charge but also some wonderful hand-carved wooden *Star Wars* model vehicles he had made for his then-young son. They are all now displayed at Rancho Obi-Wan. Mitch is another wonderful example of how truly amazing my fellow *Star Wars* collectors are.

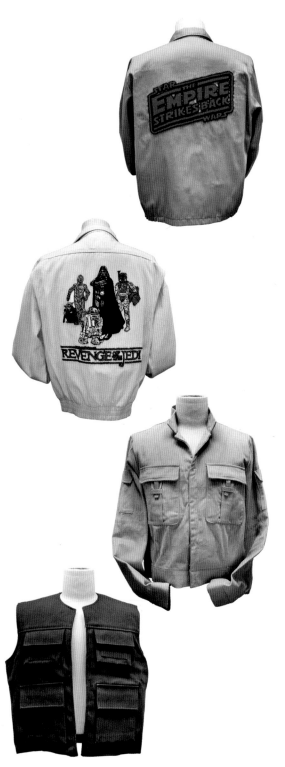

THE EMPIRE STRIKES BACK LATCH HOOK JACKET

MITCH MITCHELL
UNITED STATES, C. 1980–1981

REVENGE OF THE JEDI LATCH HOOK JACKET

MITCH MITCHELL
UNITED STATES, C. 1983

LUKE SKYWALKER JACKET

OFFICIAL STAR WARS FAN CLUB
UNITED STATES, C. 1982

What could be better than to dress up like Luke Skywalker in his intergalactic Eisenhower jacket or Han Solo in his natty black vest? It was possible thanks to the Official Star Wars Fan Club, run in the early days by Lucasfilm itself.

HAN SOLO VEST

OFFICIAL STAR WARS FAN CLUB
UNITED STATES, C. 1983

STORMTROOPER HELMET REPLICA

GUIDON MESSIKA FOR THE GERMAN GARRISON,
501ST LEGION
GERMANY, 2006

The German Garrison of the 501st Legion, the worldwide Star Wars costuming and service organization run by fans for fellow fans, presented this incredible helmet to me as a gift just prior to the 2007 Tournament of Roses Parade in Pasadena, California, marking the start of the thirtieth anniversary of the release of Star Wars. George Lucas had come up with the idea of having a presence in the more-than-a-century-old New Year's Day parade, in large part to honor the good work of the 501st. Lucas encounters members of the group at nearly every award ceremony, speech, or premiere he attends. At his request the company's marketing team recruited more than two hundred Legion members from around the world, all dressed in their own costumes as stormtroopers, clone troopers, snowtroopers, biker scouts, Imperial officers, and other characters, including one Darth Vader. It was an incredible event made even more special by the camaraderie of Star Wars fans, hailing from from Brunei to France to Mississippi, and the amazing Grambling State Tiger Marching Band. Hundreds of people gave up their New Year's holiday for the three days of hard practice that led to Lucasfilm's "Star Wars Spectacular," an astounding sight snaking its way down Colorado Boulevard and across millions of television screens. None of us there will ever forget it, and this is the best souvenir I can imagine.

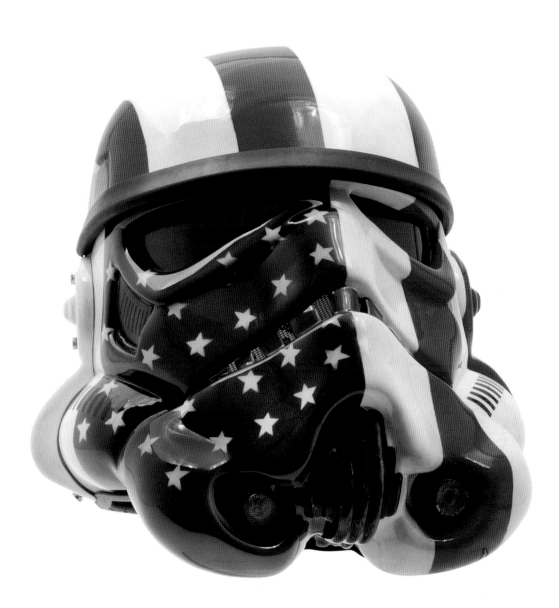

HAN SOLO FIGHTS GREEDO T-SHIRT

WONDER WORKS
JAPAN, 1999

No one can ever know for certain, but it's a safe bet that well over ten thousand different *Star Wars* T-shirt designs have been produced and sold all over the world in just a little more than three decades. But of all the commercial T-shirts in the world, I would place these and similar ones from Wonder Works at the top of my list. Their melding of iconic *Star Wars* characters and events with a classic Japanese painting style is sublime. The company produced a similar series of high-end rayon shirts with different art.

DARTH VADER AND STORMTROOPERS T-SHIRT

WONDER WORKS
JAPAN, 1999

JABBA'S DUNGEON T-SHIRT

WONDER WORKS
JAPAN, 1999

YODA VOLCANO T-SHIRT

WONDER WORKS
JAPAN, 1999

DARTH VADER RAYON SHIRT

WONDER WORKS
JAPAN, 1999

"LEIA" T-SHIRT

MARC ECKO
UNITED STATES, 2007

Pop fashion icon Marc Ecko is a huge *Star Wars* fan, so it was only a matter of time before he tried his hand at cool *Star Wars* T-shirts, hoodies, and jeans. Within two years he had produced more than one hundred different items for his Cut & Sew line, often using embroidery, rhinestones, or sewn-on patches. As part of a regular TGIF event that Lucasfilm hosts for employees, Lucas Licensing put together a faux fashion show with volunteers assigned various Ecko clothing. Imagine my great surprise when they picked me to wear a very plain black-on-black T-shirt with a very simple phrase: "*Star Wars* Changed My Life."

"STONETROOPER" T-SHIRT

MARC ECKO
UNITED STATES, 2007

"MASTER YODA TATTOO" T-SHIRT

MARC ECKO
UNITED STATES, 2007

"TATTOO TROOPER" T-SHIRT

MARC ECKO
UNITED STATES, 2007

HOLIDAY HOODIE AND DARTH VADER JEANS

MARC ECKO
UNITED STATES, 2008

"DRINK COCA-COLA" *STAR WARS* T-SHIRT

COCA-COLA CO.
JAPAN, 1978

An early premium, this shirt was part of Coca-Cola's major promotional tie-in with *Star Wars* in Japan.

"*STAR WARS* CHICKS" T-SHIRT

MADE FOR *STAR WARS* CHICKS
UNITED STATES, 2000

Sometimes Lucasfilm will give fan groups like the *Star Wars* Chicks permission to produce a limited number of items such as T-shirts to raise money for charity. In fact, the Chicks were one of the first groups to ask to do so.

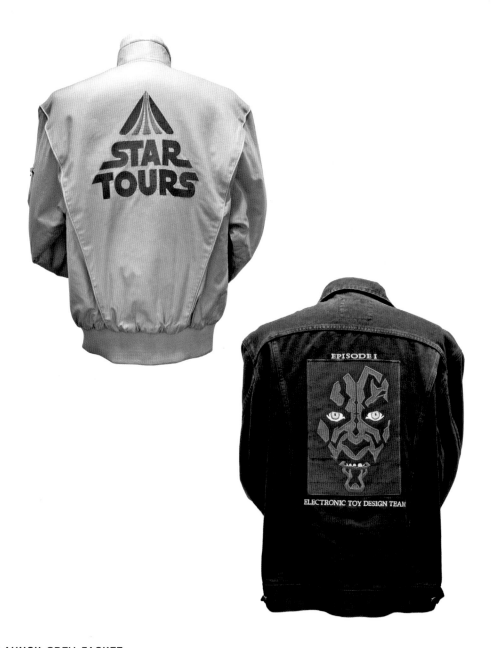

STAR TOURS LAUNCH CREW JACKET

WALT DISNEY COMPANY
UNITED STATES, 1986

Jackets for special events or other limited purposes aren't
generally available to the public. Examples shown here include:
the crew jacket for the Disney team that helped to open the
Star Tours ride in January 1987; the jean jacket for the Tiger
Electronics design team, which worked on toys for *The
Phantom Menace*; and the "cast and crew" jacket for the
opening of Disneyland's Jedi Training Academy.

TIGER EPISODE I ELECTRONIC TOY DESIGN
TEAM JEAN JACKET

TIGER ELECTRONICS
UNITED STATES, 1997

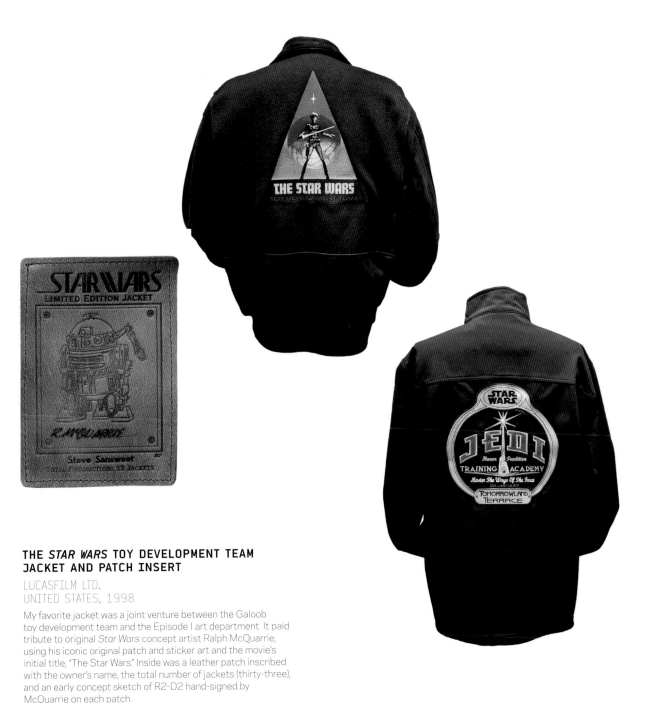

THE *STAR WARS* TOY DEVELOPMENT TEAM JACKET AND PATCH INSERT

LUCASFILM LTD.
UNITED STATES, 1998

My favorite jacket was a joint venture between the Galoob toy development team and the Episode I art department. It paid tribute to original *Star Wars* concept artist Ralph McQuarrie, using his iconic original patch and sticker art and the movie's initial title, "The Star Wars." Inside was a leather patch inscribed with the owner's name, the total number of jackets (thirty-three), and an early concept sketch of R2-D2 hand-signed by McQuarrie on each patch.

JEDI TRAINING ACADEMY CAST AND CREW JACKET

WALT DISNEY COMPANY
UNITED STATES, 2006

DARTH MAUL MOTORCYCLE HELMET PROTOTYPE

SHOEI
JAPAN, 1999

Shoei and Taira Racing, both well-known names in the production of gear for motorcyclists, produced a limited line of helmets, heavy leather jackets, and racing gloves. There were fifty jackets, one hundred helmets, and five hundred sets of gloves produced for each of the three designs. The Episode I helmet is a prototype.

DARTH VADER MOTORCYCLE HELMET

SHOEI
JAPAN, 2001

STORMTROOPER MOTORCYCLE HELMET

SHOEI
JAPAN, 2001

BOBA FETT MOTORCYCLE HELMET

SHOEI
JAPAN, 2001

MOTORCYCLE GLOVES

TAIRA RACING CORPORATION
JAPAN, 2001

**JEREMY BULLOCH IN BOBA FETT
MOTORCYCLE JACKET**

TAIRA RACING CORPORATION
JAPAN, 2001

Vintage Boba Fett himself, actor Jeremy Bulloch, tried on the
full outfit while visiting Rancho Obi-Wan.

DARTH VADER MOTORCYCLE JACKET

TAIRA RACING CORPORATION
JAPAN, 2001

STORMTROOPER MOTORCYCLE JACKET

TAIRA RACING CORPORATION
JAPAN, 2001

BOBA FETT MOTORCYCLE JACKET

TAIRA RACING CORPORATION
JAPAN, 2001

STORMTROOPER

DARTH VADER

Boba Fett

THE EMPIRE STRIKES BACK CAST AND CREW T-SHIRT

LUCASFILM LTD.
UNITED STATES, 1978

After actual props or costumes used in the making of a *Star Wars* movie, the next most precious collectibles are cast and crew items: shirts, jackets, photo collections, paperweights, or other three-dimensional objects. Shirts, the most plentiful, often feature the same art or logo that was used to identify film cans or other property during the making of the movie, such as this early "Vader in flames" art from concept designer Ralph McQuarrie. While the basic design stayed the same, it varied for different uses. For example, the embroidered patch that appeared on crew jackets was later adopted by the Official Fan Club for its members. Some of the cleverest designs came from the wags at Industrial Light & Magic, who worked long and hard to make the visual effects in *Empire* even better than those in *Star Wars*. One of the first shirts—made when the movie was still known only as "*Star Wars* II"—was created by the night crew at ILM. Another shirt, "Sound People . . . or

Worse," was a sly reference to the terrifying Tusken Raiders, or Sand People, of the first movie. My favorite, however, blends *Star Wars* with the public's perception at that time of Marin County, where ILM was based. The front of the shirt, with the words "*Star Wars*, Marin Unit," shows an undressed Darth Vader sprawled out in a redwood hot tub with a smoke in one hand, a glass of wine in the other, and a rubber ducky floating nearby. As the back of the shirt attests, "The Empire Lays Back."

"*STAR WARS* II" NIGHT CREW T-SHIRT

LUCASFILM LTD.
UNITED STATES, 1978

"SOUND PEOPLE . . . OR WORSE" T-SHIRT

LUCASFILM LTD.
UNITED STATES, 1978

***STAR WARS* MARIN UNIT T-SHIRT**
(FRONT AND BACK)

LUCASFILM LTD.
UNITED STATES, 1979

INDUSTRIAL LIGHT & MAGIC T-SHIRT

LUCASFILM LTD.
UNITED STATES, 1980

INDUSTRIAL LIGHT & MAGIC T-SHIRT

LUCASFILM LTD.
UNITED STATES, 1980

"I HOLD UP UNDER PRESSURE" YODA IN STRAIGHTJACKET T-SHIRT

INDUSTRIAL LIGHT & MAGIC
UNITED STATES, 1981

"REVENGE OF THE JEDI" CREATURE SHOP T-SHIRT

LUCASFILM LTD.
UNITED STATES, 1981

EPISODE III AUSTRALIAN LIGHTING CREW T-SHIRT (BACK)

LUCASFILM LTD.
UNITED STATES, 2003

CREATURE SHOP
CREW

ART FOR CREW T-SHIRT

LUCASFILM LTD.
UNITED STATES, 1984

Some critics complained that the fierce Ewok warriors in
Return of the Jedi—whose primitive fighting skills bested the
technological prowess of the Galactic Empire—were too cute
and cuddly. So in 1984, when Lucasfilm produced a TV movie
based on the Ewoks (released internationally as a theatrical
film), Phil Norwood, an animator at ILM, created this original
artwork for a crew T-shirt. Needless to say, it was quite popular.

"EWOKS: DAMN RIGHT WE'RE CUTE!!!"
T-SHIRT

LUCASFILM LTD.
UNITED STATES, 1984

EPISODE III PLASTER DEPARTMENT JACKET
(FRONT AND BACK)

LUCASFILM LTD.
UNITED STATES, 2003

EWOK MASK REPLICA

PROP STORE OF LONDON/TOM SPINA
UNITED KINGDOM AND UNITED STATES, 2007

Using original fabric "fur" and leftover eyes, nose, and mouth pieces from the British workshop of Stuart Freeborn, the creature maker for the original saga, American prop maker extraordinaire Tom Spina fashioned this mask for the Prop Store of London, which in turn gave it to me.

EWOK STEVE

PROP STORE OF LONDON/TOM SPINA/KATHY PILLSBURY
UNITED KINGDOM AND UNITED STATES, 2007

The complete Ewok costume, including the hood, was made for me by Los Angeles fan and costume expert Kathy Pillsbury. I dressed in it for the opening ceremony of *Star Wars* Celebration IV in Los Angeles in May 2007. I must have impressed someone. Mayor Antonio Villaraigosa asked to have his photo taken with "the guy in the hairy suit" so that he could show his kids.

CHEWBACCA WALT DISNEY WORLD APPEARANCE MASK

DON POST STUDIOS
UNITED STATES, 1999

Don Post Studios, which made masks that were used in some movies, became an early Lucasfilm licensee, producing over-the-head masks and helmets at various price points. Walt Disney World also hired the company when it upgraded the look of its *Star Wars* walk-around characters. This solidly built Chewbacca mask allows Disney cast members to open and close the mouth, which is very handy if they can do the Wookiee growl.

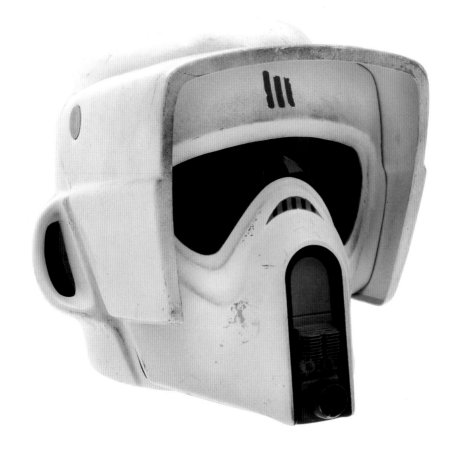

BIKER SCOUT HELMET PROP

LUCASFILM LTD.
UNITED STATES, 1981–1982

One of the iconic helmets from *Return of the Jedi*, this particular biker scout helmet was damaged during production and disposed of. You can see the cracked lens. I'm fond of telling people that this belonged to the poor Imperial scout who crashed headlong into a giant tree on the Forest Moon of Endor. The truth is, nobody knows. Typically, there are five or six duplicate costumes and hand props made for the major characters in a movie. In case one is damaged or not wearable every day, there are backups so that an expensive production doesn't have to stop in its tracks. For a piece like this, there might be a 50 percent overage. The basic shape of the helmet is sculpted in clay; then molds are taken and the pieces vacuum-formed. Detail pieces are added, the mask is painted, and decals are applied. Each single piece is coded with a number and other information. In this case, the letters "BH" appear, for "Blue Harvest"—the cover name used by the *Jedi* production team to throw anyone off their scent when filming in the United States.

"BLUE HARVEST" RAINCOAT

LUCASFILM LTD.
UNITED STATES, 1982

Another "Blue Harvest" item, this rain slicker, along with matching yellow trousers, was part of the crew gear for shooting in one of the northernmost spots in California, next to Rockefeller Forest, a state park near Crescent City. The actual location was a privately owned area of tall redwoods that became the Forest Moon of Endor, home of the Ewoks.

NORWAY FILM CREW SUIT

LUCASFILM LTD.
NORWAY, 1979

This was another item on my wish list for years. It is the cold-weather gear used by the crew shooting *The Empire Strikes Back* on and near a glacier in Finse, Norway. The shoot was plagued by terrible snowstorms and bitterly cold temperatures. This particular outfit was worn by Geoff Glover, the director of photography for the Norwegian Unit. No, he didn't go out to the glacier without boots; I have only his thick woolen socks.

EAT IT OR KEEP IT

There really is no such thing as a *Star Wars* "taste" when it comes to licensed food products. And some of the most obvious things have never been licensed. Where, for example, is Aunt Beru's blue milk, the most famous edible in the entire saga? I once made my own to sip on camera. Unfortunately, I followed the Easter egg dye manufacturer's instructions exactly; I can assure you that although it looked great, even a small amount of vinegar blended with milk is not a pleasant taste.

Licensed food products and quick-serve restaurant tie-ins are as much or sometimes even more about promotion than making top dollar from royalties. Putting 25 million cereal boxes with *Star Wars* graphics and collectible premiums inside on breakfast tables every morning for a few weeks can add up to plenty of impressions targeted to the core audience. The fact that Kenner Products was owned by the General Mills Fun Group Inc. at the time that the first movie was released helped make it possible to get General Mills cereal packaged with *Star Wars* premiums on the shelves before the end of 1977. Because George Lucas insisted on healthy alternatives to the cereal that kids favored—such as Count Chocula and Franken Berry—the promotion started with Cheerios before expanding to the sugary cereals.

Star Wars opened in most foreign countries at least six months after its American premiere, allowing much more time to put licensing deals in place for products that would come out coincident with the openings. And because of shorter lead times, many of those products were food related. Candy, cookies, and ice cream were among the favorites. The United Kingdom favored its cherry and lemon Chewbars, Lyons Maid ice cream, and Mallow Shapes candy. The latter consisted of character-shaped heads in a colored marshmallow candy. I first came across samples of these tasty treats in a musty carton I was going through in the Lucasfilm product archives in 1991, while researching an earlier book. There, at the very bottom of the flotsam and jetsam, was a plain white box marked "Samples." Inside were what looked like petrified shrunken heads of Darth

CREAM OF JAWA SOUP POP ART

D. MARTIN MYATT
CANADA, 2001

Who says that Andy Warhol is the only one who can reinterpret an everyday can of soup? My friend Dave Myatt used to do an online fan comic strip about Jawas. This is one offshoot, made just for fun.

Lorta Phanble's

CONDENSED

Cream of
Jawa
SOUP

NET WT.
10 ¾ OZ
(305g)

Vader, C-3PO, and some indescribable characters. Nearby was a petrified bird, but that's another story.

Nearly all of the food products had in-pack or on-pack premiums, sometimes as simple as masks, cards, or small standees to cut out. The idea was that you always had to buy multiple packages to complete the series. In one 2009 promotion with Frito Lay Mexico, bags of salty snacks were packed with cool collectible cards from *The Clone Wars* movie and TV series. The only problem: the set consisted of ninety cards. That pretty much set the record, although there were more difficult sets to put together, especially the twelve stickers that came in bags of Harper's Dog Chow in Australia.

Sometimes the food *was* the collectible, such as Sonric's bubble gum from Mexico that had character "trading cards" printed on the gum slabs themselves. The chocolate Jar Jar "Easter bunny" from Canada was another; it has managed to stay yummy-looking on my shelf for a decade. In the case of *Star Wars* pasta shapes from the United Kingdom, I decided that emptying the cans would be a good idea, once one started to bulge and another began to leak. The Japanese liquid curry and vegetables remains in its vacuum-sealed packs, and the sealed Eskimo ice cream pack had only a filler for display purposes, never real ice cream. I must admit to having shellacked about a dozen character cookies from 1983 Pepperidge Farm boxes, but alas, they eventually deteriorated. Some people have suggested enclosing food items in blocks of acrylic, but the very process would likely ruin the object to be deified—unlike Malaysian scorpions, which survive the same process intact.

In addition to cereal, candy, and salty snacks, the original trilogy prompted many items: bacon, hot dogs, peanut butter, and canned spaghetti in Canada; baked beans, sausage, cheese wedges, and yogurt in the United Kingdom; crisp bread sticks in Japan; mustard in France and Germany; and Wonder Bread and a small run of Orchard Hill Farms TV dinners with a *Star Wars* snipe on the box front in the United States. Playing with *Star Wars* toys is one thing, but consuming *Star Wars* on a regular basis is transubstantially different. I don't want to get into a quasi-religious area, but why do fans consume *Star Wars* character-shaped pasta pieces or ice pops in the form of battle droids? Does a Jar Jar Binks milk chocolate "Easter bunny" taste better than the rabbit kind? No, but it's fun to eat, certainly.

Quick-serve restaurant tie-ins were launched all over the world starting in 1977 with Burger Chef and Burger King in the United States. Most have involved kids' meals, small toy giveaways, and often sweepstakes with a major grand prize such as a special *Star Wars*–decorated Hummer. There are usually plenty of banners, point-of-purchase displays, and in-store posters and window decals, which become collectible after the promotion ends. However, some folks don't want to wait until the end of the promotion and try to help themselves to the outdoor merchandising during the wee hours. That became a major problem when Burger

FRANKEN BERRY STRAWBERRY CEREAL
GENERAL MILLS
UNITED STATES, 1977

A cautionary tale: Make sure you remove the premium at the time of purchase, when the product is still fresh. A dealer friend once gave me a tightly sealed, fifteen-year-old box of Franken Berry cereal promising (artificial) strawberry-flavored frosting and the always-delightful marshmallow bits. The box also contained a *Star Wars* sticker. I already had the full set, but I needed the empty box and figured I could use the extra sticker for trading. (The package is often scarcer and more valuable than the premium.) But when I carefully opened the box and then the sealed wax bag inside, there was no cereal—only a dense, one-inch layer of a reddish-purple goop at the bottom. The sticker, inside a cellophane bag, was mired in the goop like some saber-toothed cat or mammoth stuck eons ago in Los Angeles's La Brea Tar Pits. Sorry, but Franken Berry is no longer available.

CRAZY COW CHOCOLATE FLAVOR CEREAL
GENERAL MILLS
UNITED STATES, 1977

COUNT CHOCULA CHOCOLATE FLAVOR CEREAL
GENERAL MILLS
UNITED STATES, 1977

COCOA PUFFS CHOCOLATE FLAVOR CEREAL
GENERAL MILLS
UNITED STATES, 1977

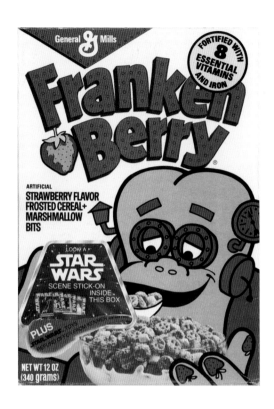

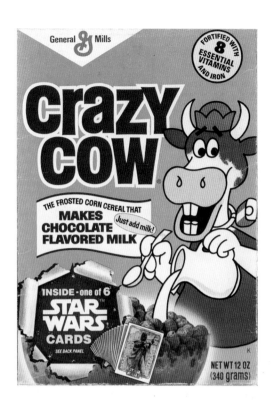

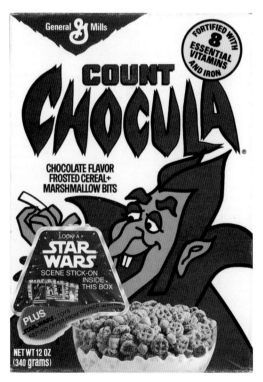

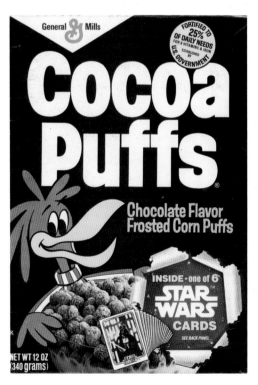

236

King restaurants featured oversized, inflatable Darth Vader busts on their roofs for the opening of *Revenge of the Sith*. Instead of normal tie-downs, Burger King used heavy chains and locks—and mostly succeeded in keeping the Vaders in place until the campaign's end.

Store displays, beyond those made for fast-food promotions, are a major part of *Star Wars* collecting. They are usually attractive but ephemeral, gone almost before you can ask for them. Some store managers are more accommodating than others, putting a person's name and telephone number on the back of a display and calling when it's ready to be removed. Others lie through their teeth. "Oh, we can't give these away," they'll say. "Lucasfilm comes to collect them all." Sometimes young collectors are told that "George Lucas himself demands these back." Those are the displays that mostly were trashed years ago with the few surviving pieces ending up today on eBay.

Perhaps the most inventive campaigns in the food category have come from the world's leading soft drink producers, the Coca-Cola Company and PepsiCo. For the original trilogy, Coke partnered with fast-food companies to do premiums (posters, collectible cards, and al-

CORN FLAKES CEREAL WITH MASK
KELLOGG'S
AUSTRALIA 1980

(Left to right, top to bottom)
With Boba Fett Mask
With Bossk Mask
With C-3PO Mask
With Chewbacca Mask
With Darth Vader Mask
With Luke Skywalker Mask
With Stormtrooper Mask
With Yoda Mask

These eight different boxes of Kellogg's Corn Flakes from Australia were made to promote the release of *The Empire Strikes Back* in 1980. Each one has a character mask to cut out and wear. What makes them special is that they are unassembled, unglued box flats, as pristine as they day they were printed. Also, it is practically unheard of to do eight distinctly different package designs for the same product. But most important, these designs have a certain naïve, storybook quality that is unusual for the saga. And while many of the major characters are portrayed, we are stopped by the strange green creature called only "Bounty Hunter"; later given the name Bossk, he has about thirty seconds of screen time, mostly in long shots. The boxes are also special for their recipes. Who wouldn't want to whip up a batch of Boba Fett treats or See-Threepio cookies, both made with Kellogg's Corn Flakes?

bums) and glasses; mini-markets handed out several series of collectible plastic cups; and many theaters offered collectible cups and pitchers along with a sweepstakes.

PepsiCo upped the ante with an exclusive worldwide deal tied to the Special Editions and Episode I. It covered soft drinks, Frito-Lay salty snacks, and all three of its Tricon unit's restaurants: Taco Bell, KFC, and Pizza Hut. In the United States there were twenty-four different Pepsi cans to collect, each bearing a character photo and one word that, when put together correctly with the other cans, formed a "secret message." Actually, they formed three sentences: *Anakin breaks free but may face new enslavement. The Jedi triumph but their future is clouded. One menace is destroyed but another lurks nearby.* Sort of like three *Star Wars* fortune cookies, eh? Four styles of gold-colored Yoda cans, randomly inserted in soda cartons, could be turned in for elaborate *Star Wars*–themed $20 checks and a fifth Yoda-style can. Some fans didn't realize until it was too late that the collectible value of most of the cans they sent in was far more than $20—as was the uncashed check. The Japanese market, as is often the case, was in a category by itself. Suntory Ltd., the large whisky and non-alcoholic beverage maker, is Pepsi's master franchisee in Japan. Its character bottle-cap covers and display stages, along with numerous premiums, are probably the most creative *Star Wars* promotion ever produced anywhere.

As a collector, I find it hard to keep for posterity *Star Wars* apricot juice from Spain, cheese from the United Kingdom, or soda and liquid tea from China. But I can keep what nearly everyone else throws away: the packaging. And three-plus decades of *Star Wars* packaging from around the world, from products used every day, starts to explain how the movies became such a global pop-culture phenomenon; why it is still easy, for example, for an editorial cartoonist to use the image of Darth Vader to immediately connote evil. Even those benighted souls who haven't seen any of the movies likely know what the Dark Lord of the Sith represents.

STORAGE
Keep frozen until required.

SERVING INSTRUCTIONS
Thaw at room temperature before serving.
Twinkies can be eaten partly frozen if preferred.

FREE OFFER
Kids — cut out the card opposite and collect
the set of five great scenes from "The Empire
Strikes Back". Swap with your friends. To
receive your "Empire" badge, cut out and
collect two badge illustrations appearing on
the back of these packs.
Post to P.O. Box 14-347
Panmure, Auckland,
together with the
coupon below and a
stamped self-addressed
envelope.

Closes 1 June 1981

Please rush me a FREE
Empire Strikes Back Badge. I have
enclosed two badge illustrations and a stamped
self addressed envelope.
(Send to Empire Strikes Back Promotion,
P.O. Box 14-347, Panmure, Auckland)

NAME

ADDRESS

Marketed by General Foods
Corporation N.Z. Ltd.
Auckland, New Zealand.
Made under licence for ITT Continental Bakery Company

TWINKIES BOX (FRONT AND BACK)
GENERAL FOODS
NEW ZEALAND, 1980

BANANA BITZ CEREAL
NATURE'S SOURCE
SOUTH AFRICA, 1997

These unusual cereal boxes from South Africa contained
metal "Star Wars coins" as premiums.

CHOC BITZ CEREAL
NATURE'S SOURCE
SOUTH AFRICA, 1997

MALLOW BITZ CEREAL
NATURE'S SOURCE
SOUTH AFRICA, 1997

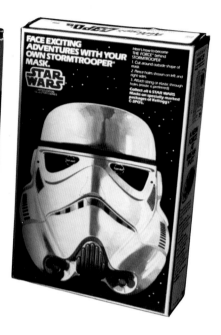

C-3PO'S CEREAL

KELLOGG'S
UNITED STATES, 1984

An updated, more realistic version of cardboard cut-out masks came on box backs of C-3PO's cereal, the first cereal to be specially made and branded with a *Star Wars* name. According to the box, it was a "crunchy honey-sweetened oat, wheat, and corn cereal." No offense, Kellogg's, but to me it tasted like sweetened cardboard. For some reason the nuggets were shaped like the numeral 8. Thanks to all the box variations, I ended up with something short of a metric ton of the cereal, which I carefully repackaged in large paper supermarket bags and gave to little Eddie Hansen, who loved *Star Wars*. His mother, who welcomed the contribution but hadn't realized how much I was bringing over, told me later that Eddie insisted on a full bowl every morning for months. However, it seemed like the cereal was multiplying behind closed pantry doors so she started tossing out three times as much as he ate every day when Eddie left to catch the school bus.

DECODER DISCS

KELLOGG'S
AUSTRALIA, 1983

Digging out an in-pack premium can be immensely satisfying for a child—or a collector. You don't have to wait the inevitable six to eight weeks after you've sent away a coupon, checking the mail every day until finally "it" arrives . . . and by then you may even have forgotten what "it" is. Of course, the name of the game is to put together a full collection in as mint shape as possible. These "Picture Name Decoder Discs" were packed inside boxes of Kellogg's Corn Flakes and Rice Bubbles in Australia. The idea was to scratch off the rectangle on the front of the disc and match it with symbols on the box's side panels to win one of 2,620 "fantastic" *Return of the Jedi* toys. If you weren't an instant winner, you could tear off the bottom part of the disc and enter a sweepstakes. The catch, of course, was that you had to destroy the disc to do that. Today, a complete mint set of the sixteen discs is worth far more than even the best toy in the contest.

C-3PO'S STORE DISPLAY STANDEE

KELLOGG'S
UNITED STATES, 1984

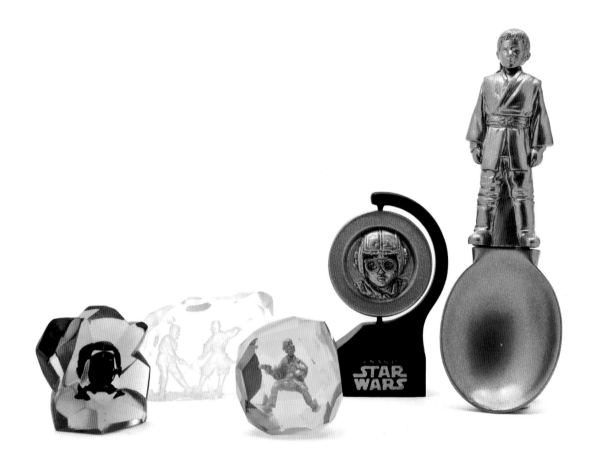

CEREAL SPOON PREMIUMS

KELLOGG'S
EUROPE, 1999

These cereal spoons with *Star Wars* character handles were an in-pack premium in several European countries to promote Episode I. The sculpts, which were done at twice their final size, were amazingly accurate, especially for such a low-cost disposable end product. The Lucas Licensing manager who was doing the product approvals liked them so much that he asked the manufacturer if it would be possible to get a painted version of the "two-up" set. The manager was kind enough to give me these small but beautiful works of art when he left the company.

CEREAL SPOON PREMIUM PROTOTYPES

KELLOGG'S
EUROPE, 1999

CEREAL SPOON PREMIUM PAINTED PROTOTYPES

KELLOGG'S
EUROPE, 1999

CEREAL PREMIUM PROTOTYPES

KELLOGG'S
EUROPE, 1998

The list of initial ideas for in-pack, in-store, or mail-away pre-miums must include ten to twenty times the number of items eventually produced. Sometimes licensors disapprove, some-thing turns out to be too expensive to produce, or designers just come up with better ideas. Many ideas were whittled down for the pan-European Kellogg's promotional tie-in with Episode I in 1999. These are a few of the items that made it all the way to the prototype stage. The two-piece spoon of young Anakin Skywalker was produced, but with an entirely different sculpt. The colored crystals were also made, but instead of a metal character locked inside, the final versions were thinner and just etched. The spinning disk, which seemed to merge images when twirling at high speed, was a nonstarter.

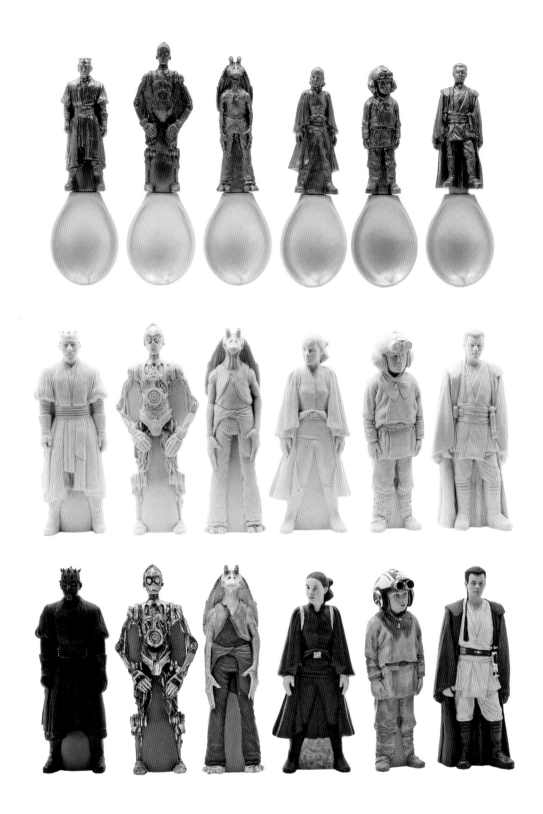

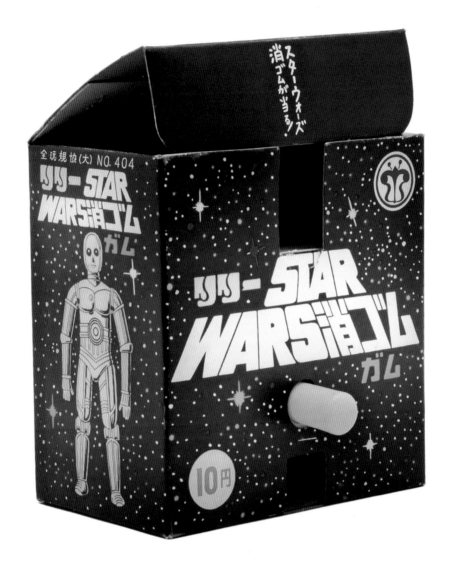

STAR TOURS MILK CARTONS

CARNATION
UNITED STATES, 1987

Carnation has long been a promotional and in-park partner with Disneyland in Anaheim, California. So when the *Star Wars*–inspired ride Star Tours first opened in January 1987, Carnation milk cartons in Southern California touted the news.

GUM AND ERASER PRIZE DISPENSER

LILI
JAPAN, 1978

Give ten yen to the shopkeeper and get a spin on this apparently unauthorized, simple cardboard "vending machine." By turning and pulling the yellow plastic handle, you get one gum ball. If it's orange, well, enjoy it. If it's blue, you get to go for another piece. But if it's red, you get your pick of a small *Star Wars* eraser from the top compartment of the box.

MASKS

LYONS MAID
UNITED KINGDOM, 1978

(Left to right, top to bottom)
Stormtrooper
C-3PO
Chewbacca
Darth Vader

These funky British masks came with Lyons Maid ice cream.
Lyons also made *Star Wars* chocolate iced lollies with
chocolate-flavored coating and sugar balls. Yum!

MALLOW SHAPES CANDY

H. W. STEWART
UNITED KINGDOM, 1978

By the time I uncovered samples of these candies, some
twenty years after they were made, Darth Vader's head and all
the others had hardened into shriveled bricks.

PROMO

PAULS

POPSICLES

STAR WARS

ASSORTED FLAVOURS

STAR WARS

10 PACK

780ml.

ICE CONFECTION

INGREDIENTS:
CANE SUGAR, FOOD ACID,
VEGETABLE GUMS,
FLAVOURS, COLOURS,
WATER ADDED.

ARTIFICIALLY COLOURED
AND FLAVOURED.

STORE AT OR
BELOW -18°C

USE BY

PAULS

POPSICLES

STAR WARS

AUSTRALIAN UNITED FOODS
62 MONTAGUE RD
STH BRISBANE QLD 12103
PRODUCT OF AUSTRALIA
REG NO 223

ADMIRAL ACKBAR
TOLTOY'S ACTION FIGURE
SEE SIDE OF PACK FOR DETAILS
EXCLUSIVE OFFER!

POPSICLES

STAR WARS

PAULS

© T.M © Lucasfilm Ltd. (LFL) 1983. All rights reserved.
Australian United Foods, authorized user.

POPSICLES

STAR WARS

PAULS

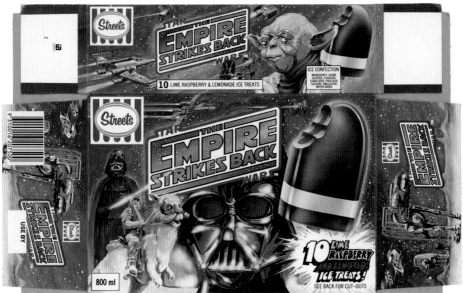

ICE CREAM BOX

AUSTRALIAN UNITED FOODS
AUSTRALIA, 1983

This series of frozen-confection boxes and wrappers from
Australia has a look akin to early stone-litho movie posters.
They are highly sought after by collectors.

ICE CREAM BOXES

STREETS ICE CREAM
AUSTRALIA, 1978, 1980

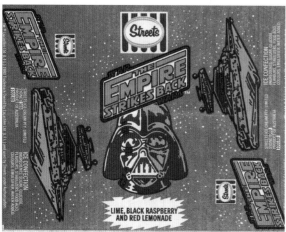

RASPBERRY AND PINEAPPLE WATER ICE WRAPPER

STREETS ICE CREAM
AUSTRALIA, 1978

PETERS ORANGE ICY-POLE WRAPPER

AUSTRALIAN UNITED FOODS
AUSTRALIA, 1983

LIME, BLACK RASPBERRY, AND RED LEMONADE ICE CONFECTION WRAPPER

STREETS ICE CREAM
AUSTRALIA, 1980

PETERS LEMONADE ICY-POLE WRAPPER

AUSTRALIAN UNITED FOODS
AUSTRALIA, 1983

PAULS LEMONADE POPSICLE WRAPPER

AUSTRALIAN UNITED FOODS
AUSTRALIA, 1983

PAULS LIME POPSICLE WRAPPER

AUSTRALIAN UNITED FOODS
AUSTRALIA, 1983

PAULS RASPBERRY POPSICLE WRAPPER

AUSTRALIAN UNITED FOODS
AUSTRALIA, 1983

PAULS PINE ORANGE POPSICLE WRAPPER

AUSTRALIAN UNITED FOODS
AUSTRALIA, 1983

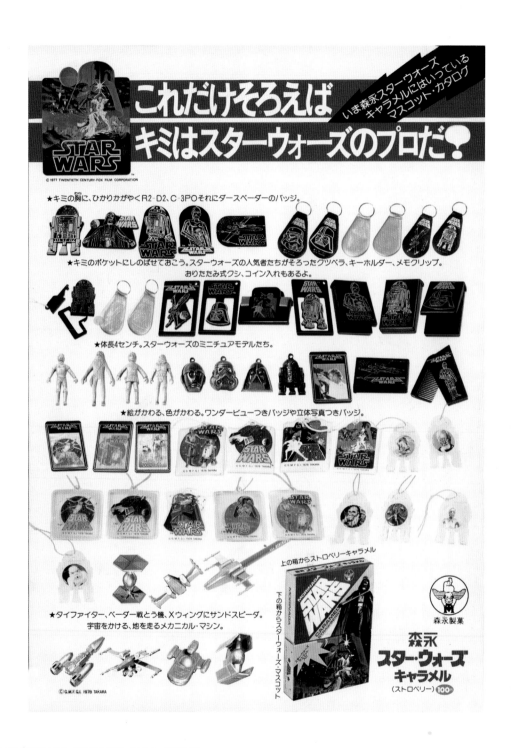

MORINAGA/TAKARA PREMIUM SELL SHEET

MORINAGA
JAPAN, 1978

FOOD SNACKS WITH PREMIUMS

MORINAGA
JAPAN, 1978

In Japan, it seems, it's not about the food but the premium inside. Once, perhaps, the snack was king. By the late 1970s, they were coequal. In recent years, you have to search hard in a toy package to find the two baby-aspirin-sized mints that justify the toy's sale in food stores. This colorful line of products from Morinaga, with premiums by Takara, shouted *Star Wars*: packages of rice snacks, bread sticks, and caramel candy hid well over one hundred different premiums, if you take color differences into account. There were card-stock and plastic bookmarks, tiny pill or candy boxes, combs, badges, pins, plastic figures, assemble-it-yourself vehicles, all kinds of soft and hard plastic tags, paper clips, and metal charms. Everything was sealed, of course, so even after buying one thousand snacks a hard-core collector could still be missing many pieces.

POSTER BOOKMARK PREMIUM

MORINAGA
JAPAN, 1978

DROIDS BOOKMARK PREMIUM

MORINAGA
JAPAN, 1978

ESCAPE POD BOOKMARK PREMIUM

MORINAGA
JAPAN, 1978

DARTH VADER BOOKMARK PREMIUM

MORINAGA
JAPAN, 1978

STAMP STICKER PREMIUMS

MEIJI SEIKA
JAPAN, 1978

This full set of thirty stickers eluded me for decades. I had picked them up little by little. Packaged with snack food, they were rolled into tight cylinders and extremely difficult to unroll and flatten. One day in 2008 I was in a small but packed *Star Wars* collectibles store near Tokyo and found the full set for sale. It wasn't cheap, I had run out of yen, and the consignment shop didn't accept credit cards. But the manager sensed my disappointment—or did he sense that another sucker wouldn't be around for a while?—and agreed to keep it until my next trip to Japan in three months. He met me at *Star Wars* Celebration Japan and we closed the deal.

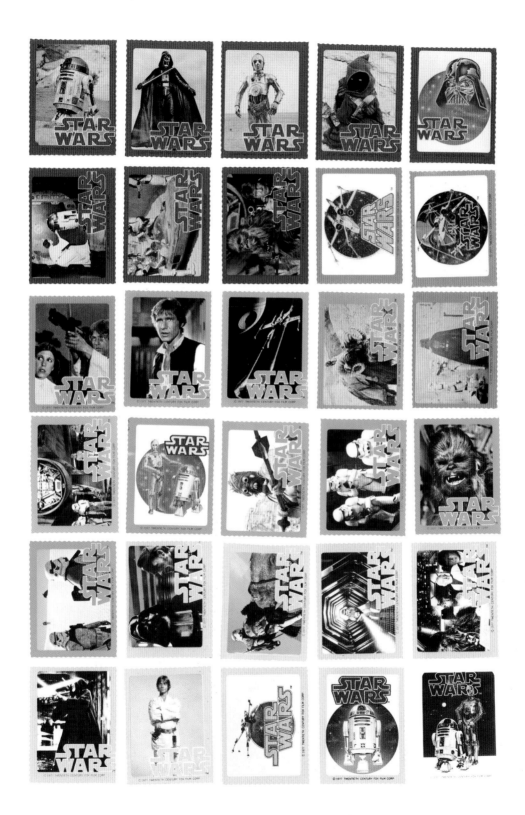

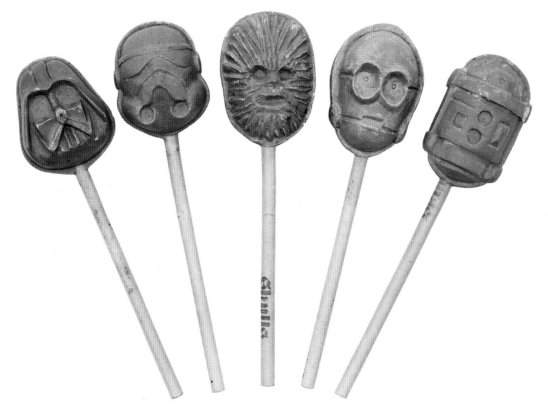

LOLLIPOP RESIN PROTOTYPES

CANDY PACKERS
AUSTRALIA, 1980

LOLLIPOP SALES FLYER

CANDY PACKERS
AUSTRALIA, 1980

For a collector, it's great to find paperwork that goes along with
a collectible. In this case, I had long owned a sell sheet from
Australia for *The Empire Strikes Back* lollipops. I certainly never
thought I'd come across the still-wrapped candy decades later.
Instead I uncovered something far better: the original resin
replicas that Candy Packers cast out of the lollipop molds to
test the molds and gain final approval for the product.

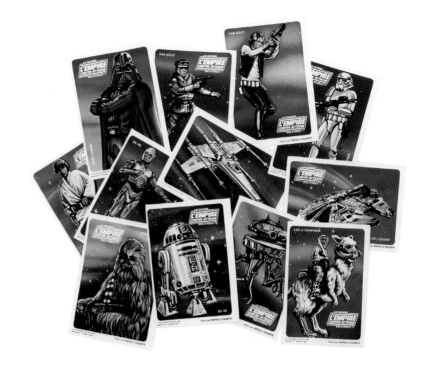

STAR WARS COOKIES STORE DISPLAY

PEPPERIDGE FARM
UNITED STATES, 1983

PLASTIC VACUFORMED CARD PREMIUMS

CERALIMENT LU BRUN
FRANCE, 1980

This beautiful set of fifteen vacuformed, three-dimensional plastic cards came as premiums in boxes of French Papou and Palmito biscuits. In good condition, they are rare even in France. The art from *The Empire Strikes Back* was unique to this set. It's fascinating to see that the French were still using the original spellings of names for the first film: Dark Vador, Luc Skywalker, Yan Solo, D2-R2, Z-6PO, and my all-time favorite, Chiquetaba.

COLLECTOR DISCS

YORK
CANADA, 1980

These were available under the lids of York peanut butter, protected by a paper insert.

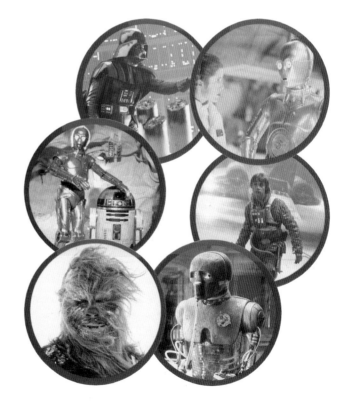

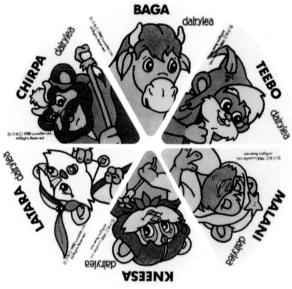

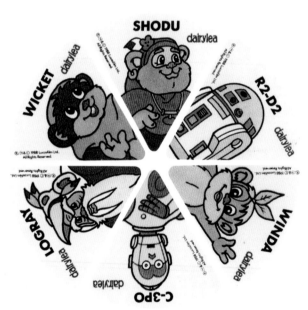

CHEESE WEDGES

DAIRYLEA
UNITED KINGDOM, 1980, 1988

CHEESE WEDGE COLLECTIBLE LABELS

DAIRYLEA
UNITED KINGDOM, 1988

CHEESELICIOUS JAR
PARMALAT DAIRY & BAKERY INC
CANADA, 2002

Somehow "*Star Wars*: It's Cheeselicious" just doesn't do it for me.

MUSTARD GLASSES

AMORA
FRANCE, 1983

(Left to right, top to bottom)
Darth Vader and Stormtroopers
Yoda and Luke
Ewok and Chewbacca
Darth Vader and Luke

We have no idea whether it was industrial espionage or a harmonic convergence, but in 1983 mustard makers in both France and Germany sold their products in jars that became *Star Wars* glasses once emptied.

MUSTARD GLASSES

HENGSTENBERG MUSTARD
GERMANY, 1983

(Left to right, top to bottom)
Darth Vader and Royal Guards
Leia, Han, and Droids
C-3PO and R2-D2
Yoda
Ewoks

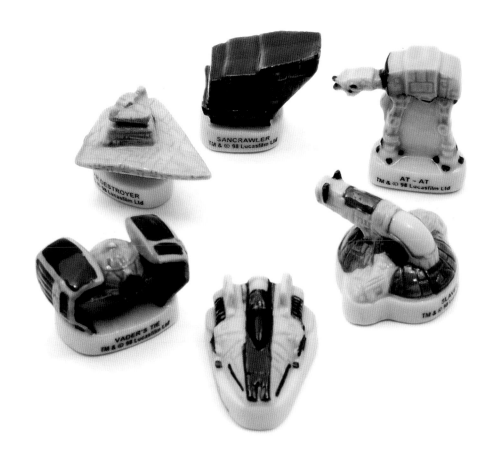

EPIPHANY CAKE FIGURINES

ARGIDAL
FRANCE, 1998 (ABOVE AND OPPOSITE TOP)
FRANCE, 2005 (OPPOSITE BOTTOM)

The Catholic celebration of Epiphany, also known as the Day of the Three Kings or Twelfth Night, includes many traditions. One really sweet one, especially in France and French-influenced Louisiana, is the baking of the *galette des rois*, or Kings' Cake, with a bean or a small trinket hidden inside. The one who finds the object in his or her slice is crowned king (or queen) of the feast. Bakeries all over France sell small ceramic *fèves* to place inside the cake. Often it's a baby Jesus—or a Star Destroyer. These small representations of *Star Wars* characters and vehicles have been sold in France for more than a decade. Sometimes they come with a cardboard "crown."

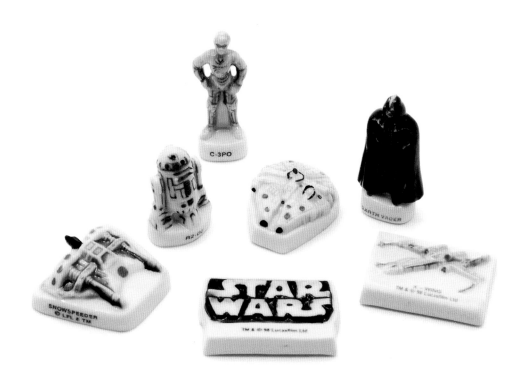

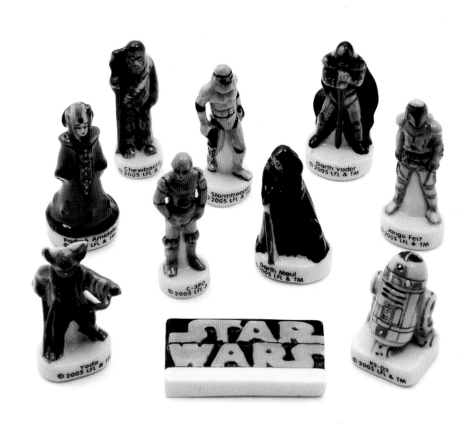

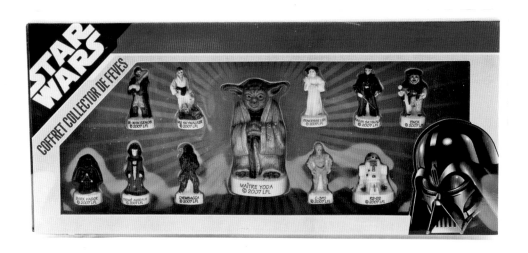

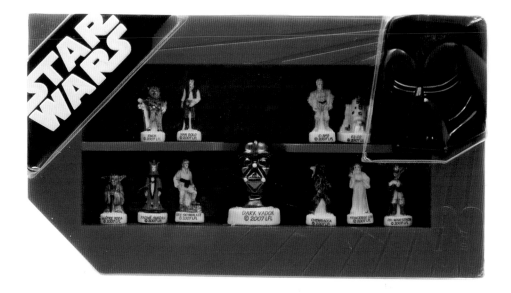

30TH ANNIVERSARY EPIPHANY CAKE FIGURINE SETS

ARGIDAL
FRANCE, 2007

BUBBLE-GUM SLAB "TRADING CARDS"

SONRIC'S
MEXICO, 1997

A variation on bubble-gum and trading cards, these printed slabs of Mexican gum are the trading cards.

STAR WARS and all associated
elements © 1997 Lucasfilm
Ltd. All Rights Reserved

LUKE SKYWALKER

STAR WARS and all associated
elements © 1997 Lucasfilm
Ltd. All Rights Reserved

PRINCESS LEIA

STAR WARS and all associated
elements © 1997 Lucasfilm
Ltd. All Rights Reserved

YODA

STAR WARS and all associated
elements © 1997 Lucasfilm
Ltd. All Rights Reserved

BOBA FETT

STAR WARS and all associated
elements © 1997 Lucasfilm
Ltd. All Rights Reserved

DARTH VADER

STAR WARS and all associated
elements © 1997 Lucasfilm
Ltd. All Rights Reserved

R2D2

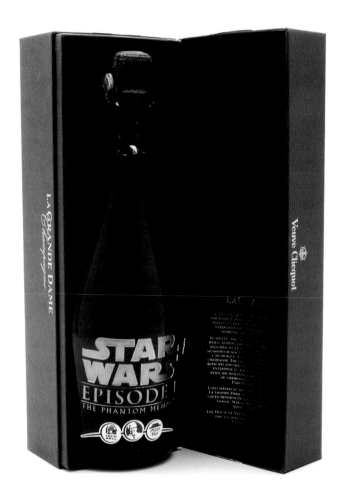

MOS EISLEY SPACE PORT

STAR WALKING INC.
AUSTRALIA, 1998

To celebrate its tenth anniversary in 1998, the unofficial *Star Wars* fan club in Australia, Star Walking Inc., had a pun-derful time silkscreening bottles of "Mos Eisley Space Port" for its adult members.

ENGRAVED CHAMPAGNE BOTTLE

MADE FOR PEPSICO
UNITED STATES, 1999

Nothing says love more than a $100 bottle of La Grande Dame champagne engraved with *Star Wars*: Episode I *The Phantom Menace*, and the logos of Pepsi, Frito Lay, Taco Bell, KFC, and Pizza Hut. These were gifts to the Lucasfilm marketing team from the PepsiCo *Star Wars* marketing team following the conclusion of a broad-based promotional program for Episode I across nearly all PepsiCo brands.

CHOCOLATE CANDY BAR RESIN PROTOTYPES

CADBURY'S
UNITED KINGDOM, 1999

As part of the approval process for perishable items, companies need to show designs and nearly completed products to Lucas Licensing for approval. Changes are noted, prototypes are sent back to the company, and new pieces are made. These are resin versions of Cadbury's chocolate bars for Episode I, which were sold in the United Kingdom and elsewhere in Europe, along with the brass casting used to make the final mold for the Jar Jar Binks bar. The date on the back of one piece indicates it was made just a little more than three months ahead of the opening of *The Phantom Menace*.

JAR JAR BINKS "EASTER BUNNY"

LES CHOCOLATS VADEBONCOEUR
CANADA, 2000

No one would ever mistake Jar Jar Binks for the Easter Bunny, or a bunny of any kind. But just in time for Easter, this large maker of chocolate Easter bunnies and other holiday treats came out with a hollow milk chocolate Jar Jar Binks bust. Since the object itself is food, this is one case where I ignore my own rule to immediately dispose of all food that comes into my collection. The box stays closed, there are no nibbles or holes that I can see, and the chocolate hasn't even started turning white after nearly a decade.

MOLDED *STAR WARS* CHARACTER CHOCOLATES
MADE FOR FAO SCHWARZ
UNITED STATES, C. 1998

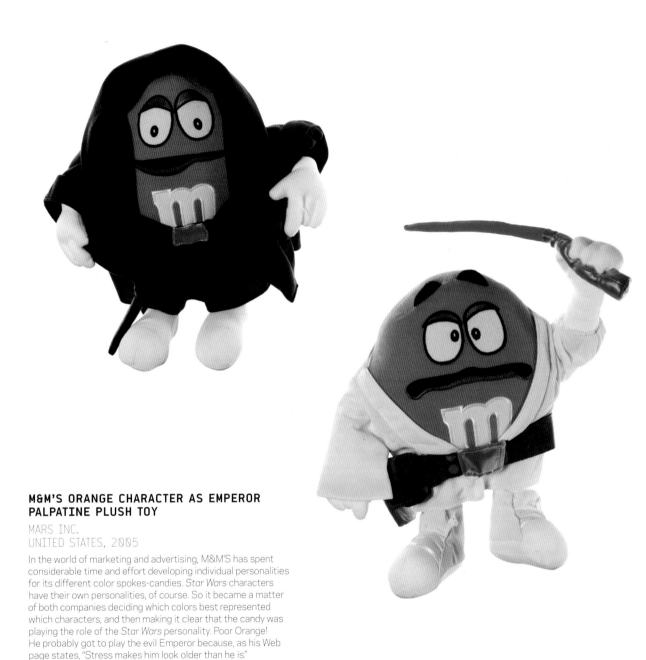

M&M'S ORANGE CHARACTER AS EMPEROR PALPATINE PLUSH TOY

MARS INC.
UNITED STATES, 2005

In the world of marketing and advertising, M&M'S has spent considerable time and effort developing individual personalities for its different color spokes-candies. *Star Wars* characters have their own personalities, of course. So it became a matter of both companies deciding which colors best represented which characters, and then making it clear that the candy was playing the role of the *Star Wars* personality. Poor Orange! He probably got to play the evil Emperor because, as his Web page states, "Stress makes him look older than he is."

M&M'S ORANGE CHARACTER AS LUKE SKYWALKER PLUSH TOY

MARS INC.
UNITED STATES, 2005

Wait a second! If Orange is Emperor Palpatine, how can he also be Luke Skywalker, the Emperor's polar opposite? Well, perhaps because Orange "thinks everyone is after him. (He's probably right!)"

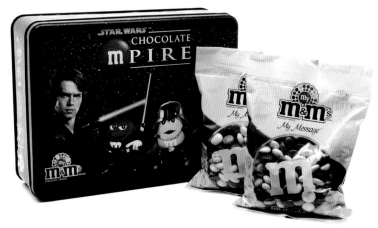

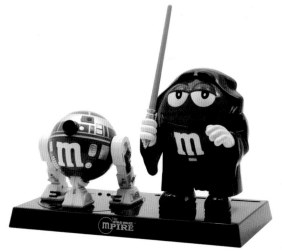

7-ELEVEN SHELF TALKER FOR M&M'S PROJECTION CLOCK

MARS INC.
SINGAPORE, 2005

CHOCOLATE "MPIRE" TIN BOX WITH CUSTOMIZED M&M'S

MARS INC.
UNITED STATES, 2005

The tin box was free. All you had to do was make an online purchase of $50 worth of customized M&M'S. My candies all say "Rancho Obi-Wan."

R2-D2 AND OBI-WAN KENOBI M&M'S PROJECTION CLOCK

MARS INC.
SINGAPORE, 2005

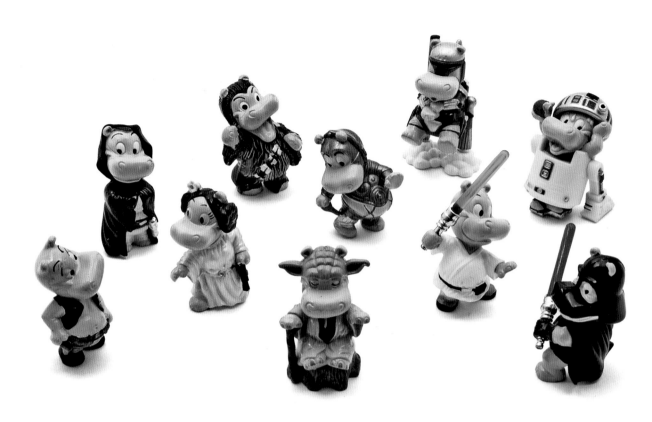

STAR WARS HAPPY HIPPO FIGURINES

FERRERO
GERMANY, 2002

Ferrero makes Kinder Eggs, those small chocolate-covered plastic capsules filled with toys that delight children all over the world—except in the United States. The FDA apparently believes that American children are stupid enough to swallow the capsule and toy as well as eat the chocolate. Ferrero has dressed its Happy Hippos as everything from Looney Tunes to Disney characters. Its *Star Wars* promotion mixed classic and Episode II characters.

DARK LASER HAPPY HIPPO CHASE FIGURINE

FERRERO
GERMANY, 2002

This all-black version of the Darth Vader Happy Hippo was a rare "chase" figure.

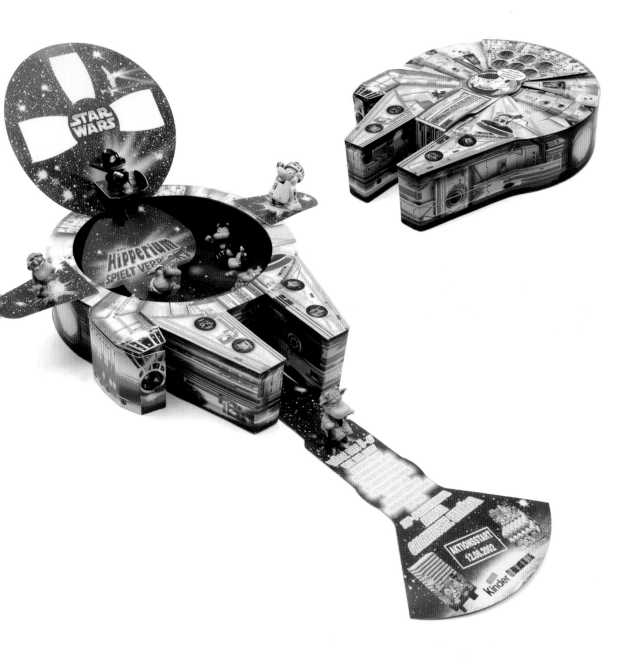

MILLENNIUM FALCON SALESMAN'S SAMPLE

FERRERO
GERMANY, 2002

To help sell its line of *Star Wars* Happy Hippos, Ferrero
produced this cardboard salesman's sample in the shape of
the *Millennium Falcon*. Open all of the flaps and the ten
characters pop into view.

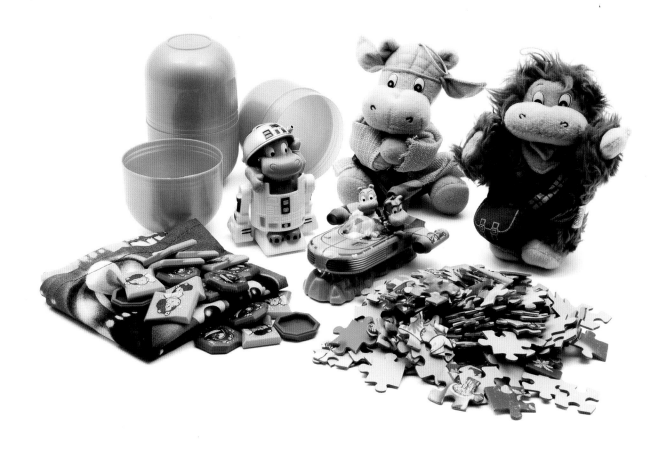

LARGE HAPPY HIPPO KINDER EGG SURPRISES

FERRERO
GERMANY, 2002

For the year-end holiday season, Ferrero made these large Kinder Eggs filled with plush toys, a puzzle, a game, a floating landspeeder, and a pull-back R2-D2.

AUBACCA (HIPPO CHEWBACCA) PLUSH DOLL

FERRERO
GERMANY, 2002

LUKE EIWALKER INFLATABLE STORE DISPLAY FOR *STAR WARS* HAPPY HIPPOS

FERRERO
GERMANY, 2002

LIGHT-UP *STAR WARS* HAPPY HIPPO DISPLAY

FERRERO
GERMANY, 2002

PASTA SHAPES IN TOMATO SAUCE CANS

HEINZ
UNITED KINGDOM, 1999

British kids were a lot luckier than American youngsters when Episode I came out. They could have their parents buy Heinz pasta in tomato sauce shaped like Jar Jar Binks, Darth Maul, and a Naboo starfighter—although if they were heated too long, they all sort of looked alike. There were also cans with holographic foil labels. Tip to collectors: empty all food cans and bottles, or one day you'll wake up to quite a nasty surprise.

BACON PACKAGE

SCHNEIDER'S
CANADA, 1977–1978

R2-D2 and bacon? Now what's that all about? The back of the package promotes a sweepstakes with one hundred prize packages of Star Wars toys. Schneider's also packaged hot dogs with the same promotion.

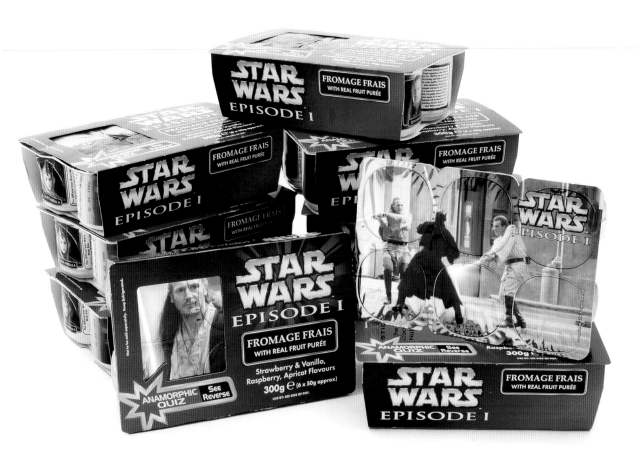

FROMAGE FRAIS WITH FRUIT PURÉE
SIX-PACKS

MD FOODS
UNITED KINGDOM, 1999

I seem to have more strange adventures with *Star Wars* food products than just about anything else. No offense to the manufacturer or British tastes, but I found this dessert inedible. I was quite excited to find these in the supermarket near my friend Elaine's house in London, until I realized how many different varieties of packaging and stickers there were. After visiting several markets and believing I had all ten varieties—sixty little cups of a dessert with a French name—I brought them to Elaine's kitchen and carefully peeled off the sticker, stuck in a spoon, and had my first taste of—Yecch! Good thing I was standing over the sink. It tasted like gelled flour, basically what it was. So I proceeded to open and empty three thousand grams of this stuff down Elaine's sink, flushing with water as I went along. Along about pack six or seven I noticed the water wasn't going down the drain as quickly, so I turned up the pressure. I did manage to finish, but the sink was rebelling. As a kid I remember making creatures in school out of papier-mâché, and the "glue" that held the shredded newsprint together was a mixture of . . . flour and water. Uh-oh! To make a long story short, I agreed to pay for the plumber.

FISH FLAKES PACKETS

NAGATANIEN
JAPAN, 1999

I was writing about these food packages and almost committed a faux pas, or maybe even an international incident. I had been told they were fish flakes, so naturally I assumed that this was aquarium food for goldfish or similar species. The gist of the paragraph highlighted the fact that there was *Star Wars* fish food in Japan. But a little voice told me to double check. Actually, it was Lucasfilm's licensing agent in Japan, Takeshi "Ken" Ogawa. I had just mentioned it to him in passing, and he gave me a strange look. "Fish food?" he asked. "I don't remember licensing fish food." I dug up my research material and Ogawa-san set me straight: It was fish-flavored flakes to season rice.

EPISODE I "VILLAINS" CURRY

NAGATANIEN
JAPAN, 1999

EPISODE I "HEROES" CURRY

NAGATANIEN
JAPAN, 1999

EPISODE I CURRY PREMIUM DISKS

NAGATANIEN
JAPAN, 1999

CHICKEN AND OTHER FOOD PACKAGING
AND PREMIUMS

LE GAULOIS
FRANCE, 2005

The last time I was at a *Star Wars* fan convention in Paris in 2008, I was introduced on stage as *L'homme froussard*, or the Chicken Man. Even more embarrassing, half the large audience knew exactly what my hosts meant by that. My previous visit three years before had been consumed with shopping, but not for normal toys or collectibles. I haunted supermarkets and small grocery stores in pursuit of chicken—and a whole lot more. One of France's largest food companies, Le Gaulois, was doing an Episode III promotion. It had a set of twenty-eight different *Star Wars* magnets and a second set of the same design, but on stickers. As important to me was the packaging; after

all, how many different varieties of chicken could there be? Dozens, I discovered, in the frozen food and refrigerated cases: plain, fried, roasted, barbecued, cordon bleu (with subvarieties), with all kinds of sauces, in quiche, and so on. And not just chicken entrées. There were fresh sandwiches, pizzas, Mexican food, lunch meat. All in all, I collected eighty-seven different packages, and I'm sure some eluded me.

Of course, when you have no means of refrigerating or freezing items in your tiny hotel room, your mastery of the language is just so-so, and none of your French friends wants to take the unwrapped food, there is just one option. Every morning before I left the room, I would open as many packages whose contents could be stuffed into the petite wastebasket. I have no idea what the cleaning lady thought, since she probably hid when she saw me coming. I'd then clean out the packages in the bathroom with soap and water as best I could. It was a decidedly more difficult task than crushing pounds of potato chips in my hotel room in Melbourne in order to get all of the bags and premiums for the *Star Wars* Special Edition in 1997—although the room in Australia was left with the distinct smell of cooking oil.

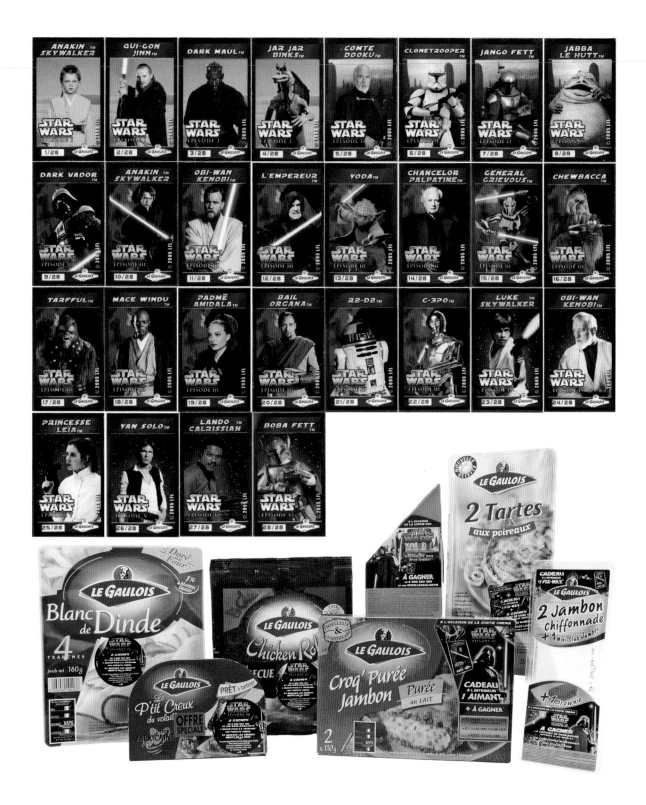

281

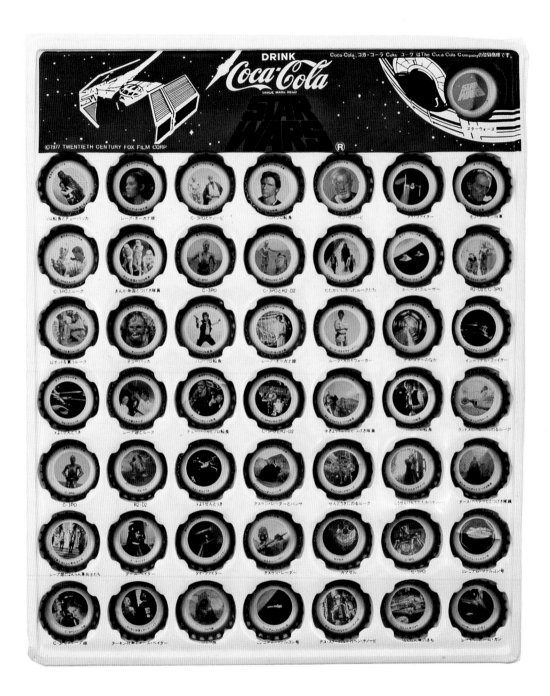

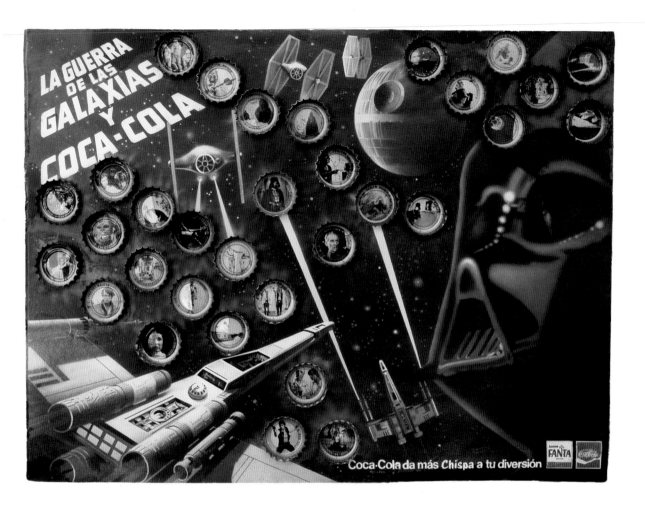

La Guerra de las Galaxias y Coca-Cola

Coca-Cola da más *Chispa* a tu diversión

BOTTLE CAP CROWN SET

COCA-COLA CO.
JAPAN, 1978

Completing any serial collection gives a hard-core collector a feeling of elation. Sometimes all the pieces are acquired at once; sometimes it can take years of worldwide searching to turn up one last piece. No matter how impossible a task seems, few passionate collectors are willing to give up. This 1978 collection of fifty *Star Wars* Coca-Cola bottle caps—or crowns—with photos from the movie and one logo, meant that collectors had to either drink hundreds of bottles of Coke or have good trading buddies. There were also caps that could be turned in for small amounts of cash; not surprisingly, those don't turn up very often. The thin plastic tray was an in-store premium.

BOTTLE CAP CROWN SET

COCA-COLA CO.
MEXICO, 1977–1978

The thirty-two-cap set in Mexico was at least smaller than the one in Japan. Collectors had to paste each cap onto an inexpensive cardboard sheet, few of which have survived complete, much less in good shape.

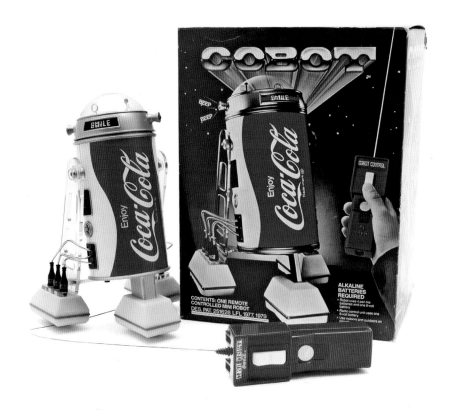

COBOT

CREATIVE SYSTEMS GROUP FOR COCA-COLA CO.
UNITED STATES, C. 1982

Originally built in the late 1970s as a large-size R2-D2-type radio-controlled robot that could roam supermarket aisles and promote Coca-Cola and related brands, the Cobot became so popular and garnered so much publicity that eventually about 275 were made and shipped to Coke bottlers around the world for promotional use. Then someone came up with the idea of making a miniature version, a branded toy that could be sold alongside Coke products for around $25. But Lucasfilm, which hadn't interfered with the full-size Cobot, objected. Its licensee Kenner had a radio-controlled R2-D2, and officials believed Cobot was an infringement on both that license and on the design patents for R2-D2. Rather than go to court, the two sides struck a compromise. Coke would make and sell no more than 1,000 Cobot toys and offer them only in three test markets. Lucasfilm's design patent would be noted on the toy and its packaging, and the company would receive a royalty on all sales. An even rarer version, sold by Foodland Markets in Atlanta, featured a Foodland grocer graphic over the Coke can. Cobots—big and little—rarely come up for sale these days.

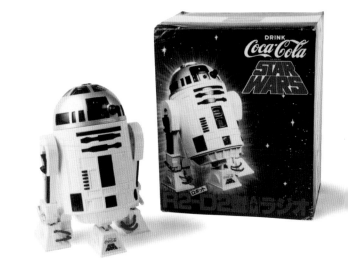

R2-D2 RADIO PREMIUM

COCA-COLA CO.
JAPAN, 1978

This radio in the form of R2-D2 was a premium in the large Coke promotion for *Star Wars* in Japan.

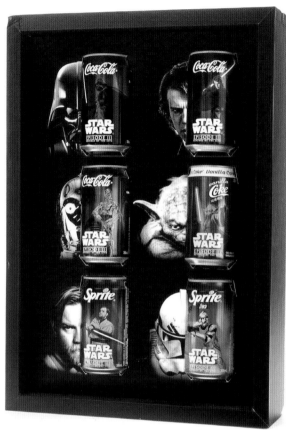

SIX-CAN DISPLAY BOX
COCA-COLA CO.
HONG KONG, 2005

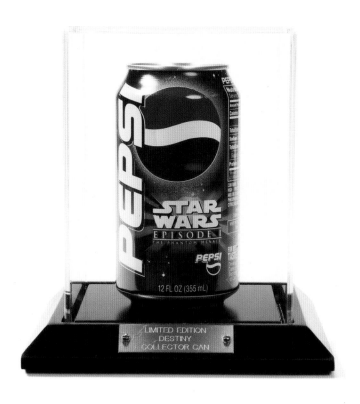

DESTINY COLLECTOR CANS

PEPSICO
UNITED STATES, 1999

When PepsiCo first announced that it had a worldwide promotional deal with Lucasfilm across all of its brands, starting with the 1997 Special Edition releases and continuing through Episode I, its press release stated the deal was valued at $2 billion. That was not cash to be spent, but the theoretical value of impressions—that is, a single instance of an ad or image being displayed. PepsiCo counted in that figure its *Star Wars*-branded soda cans and bottles, snack bags, and store display material, as well as paid advertising. The Special Edition releases were a test bed for a huge campaign for Episode I. And the company did pull out all the stops: special collector cans of Pepsi; randomly hidden gold-color Yoda cans across all of its brands, some of them painfully difficult to find; full-size mannequins of Darth Maul, Jar Jar Binks, Yoda, and Watto distributed to supermarkets across the United States, to be awarded in local sweepstakes; game pieces in packages of Frito Lay snacks; promotions and sweepstakes in Pizza Hut, KFC, and Taco Bell chains; and television advertising by the ton.

YODA GOLD PRIZE CANS

PEPSICO
UNITED STATES, 1999

DARTH MAUL LIFE-SIZE STATUE
PEPSICO
UNITED STATES, 1999

EPISODE I BOTTLE CAP COLLECTION STAGE
SUNTORY/PEPSI
JAPAN, 1999

Some of the most creative promotional products ever done for *Star Wars* have come from Suntory, the giant beverage company that is the Japanese licensee for all Pepsi drinks. For all three prequels it produced millions of bottle-cap covers of *Star Wars* characters, as well as large plastic stages—representing *Star Wars* locations—to display them all.

ATTACK OF THE CLONES BOTTLE CAP COLLECTION STAGE
SUNTORY/PEPSI
JAPAN, 2002

DEATH STAR II BOTTLE CAP COLLECTION STAGE
SUNTORY/PEPSI
JAPAN, 2005

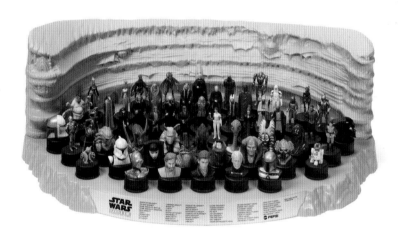

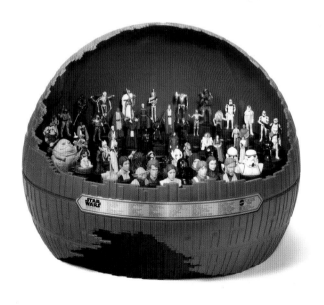

R2-D2 REFRIGERATED DISPENSER PREMIUM

SUNTORY / PEPSI
JAPAN, 2005

This amazing device dispenses soda cans with the push of a button. It chills off very quickly after plugging it in, producing cold sodas in only about fifteen minutes.

R2-D2 DVD PLAYER PREMIUM

SUNTORY / PEPSI
JAPAN, 2005

R2-D2 FRICTION TOY PREMIUM

SUNTORY / PEPSI
JAPAN, 2006

DARTH VADER STEAM HUMIDIFIER PREMIUM

SUNTORY / PEPSI
JAPAN, 2006

Yes, this Darth Vader steam vaporizer exhales moist air from its mouth.

MTT CAN COOLER CARRYING CASE

SUNTORY / PEPSI
JAPAN, 2000

This Suntory/Pepsi can cooler carrying case comes in the form of an MTT landing ship carrying battle droids as can covers.

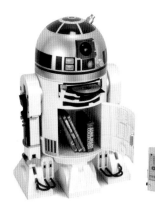

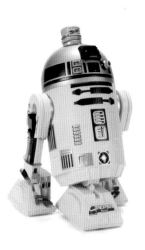

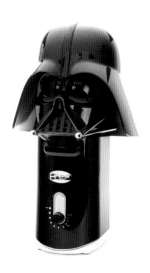

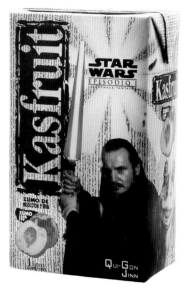

KASFRUIT ORANGE AND PEACH DRINK CARTONS

PEPSICO
SPAIN, 1999

RED BULL CAN COLLECTION

RED BULL GMBH
THAILAND, 2005

Red Bull, an energy drink that has some fans at Skywalker Ranch, did promotions in several countries, including this set of cans in Thailand. It also sponsored a Formula One racer in the Monaco Grand Prix with an Episode III paint job.

R2-Q5 PEPPER MILL

HEART ART COLLECTION LTD.
JAPAN, 2007

R2-R9 SOY SAUCE BOTTLE

HEART ART COLLECTION LTD.
JAPAN, 2007

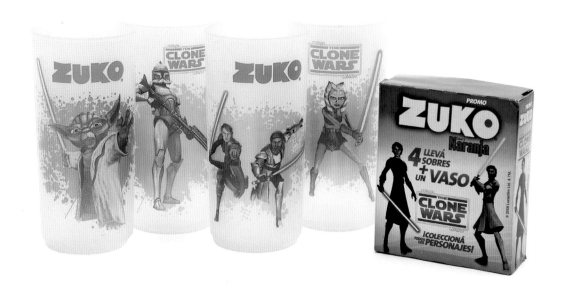

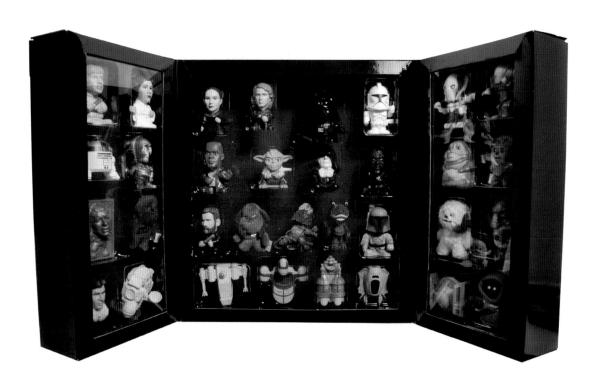

ZUKO NARANJA ZINC REMEDY

CORPORA TRESMONTES
ARGENTINA, 2008

Mom says to take zinc at the first sign of a cold. How handy to have it come packed with a glass from *Star Wars: The Clone Wars*. In the early 1990s there were also vitamins shaped like *Star Wars* characters in the United States.

SUPER D TOYS EXECUTIVE DISPLAY

BURGER KING
UNITED STATES, 2005

DARTH VADER TOASTER

MADE FOR STARWARSSHOP.COM
UNITED STATES, 2008

It is hard to believe that it took until 2008 for a toaster that burned the image of the Dark Lord of the Sith onto a piece of sliced bread to make it to market, albeit in limited numbers. The first batch sold out at StarWarsShop.com after news of the toaster spread like wildfire to fan, gadget, and pop-culture sites.

LOOK AT IT

Everything that's part of a collection is an object to look at, of course. But many items are made specifically to be displayed and admired. Other pieces once served a function—such as the making or marketing of a movie or the manufacturing of a product—and have a different use now that their first mission is complete. Still others are made to be collectible in a series, such as trading cards, or they are limited-edition, even rare, objects of art. It's important to define "limited," however; one licensee who made tin boxes containing tin trading cards years ago defined limited as "only 49,999 boxes produced."

This chapter contains the most disparate grouping in the book, from mass-produced objects to one-of-a-kind props, artwork, and fan-made bits and pieces. Some things have no apparent intrinsic value at all, while others could sell for $1,000 an ounce. In the collector's eye, however, most are treasures, to be shared with all but parted with only reluctantly. In that I feel a kinship with the late Forest J. Ackerman, the man who coined the term "sci-fi," the ultimate fanboy until his death at ninety-two in December 2008. Ackerman, a writer and onetime literary agent was, as a 2003 *Los Angeles Times* profile put it, "perhaps the great-est science fiction collector of all time, but outside of fandom, his name is virtually unknown." He influenced many in Hollywood today, either through the magazine he founded, *Famous Monsters of Filmland*, or the collection housed in his "Ackermansion" in the Los Feliz hills of Los Angeles. Ackerman didn't hoard and hide his collection like some; he opened his house nearly every Saturday to all comers, sharing his marvelous accumulation of props, memorabilia, and more than fifty thousand books and pulp magazines. Sometimes items would be stolen, and as he got older he had to sell much of his collection to provide for the twenty-four-hour nursing care that he needed. But he was a collector to the end.

Another collector who shares is George Lucas. He has the most amazing movie-poster collection I have ever seen, and a great deal of it is hanging in the hallways and offices of Lucasfilm's three major

GENERAL GRIEVOUS QUARTER-SCALE PREMIUM FIGURE
SIDESHOW COLLECTIBLES
UNITED STATES, 2005

facilities in the San Francisco Bay Area. The collection is composed of predominantly oversized international posters from the silent-film era through the 1970s. Clearly the artwork is what inspires Lucas's purchases, not the "importance" or impact of the movies, although one often tracks the other. Sometimes I'll stop in front of a poster I've passed a hundred times and just take a minute or two to appreciate it.

Many of the standout or most unusual posters from the original Star Wars trilogy come from countries where the films were released many months or years after their American debuts, and they departed from the sanctioned American designs. That was true in Japan, where Japanese artists usually redid the posters, and in Eastern Europe both before and after the break-up of the Soviet Union. The posters from Poland, Hungary, and Russia are the most unusual of all.

Sculpture, maquettes, and fine art generally had to wait until the first generation of Star Wars collectors grew up, entered the workforce, and had some disposable income—a lot of disposable income, in the case of $15,000 to $18,000 bronzes. There are the one-of-a-kind commissions that graphic artists accept at comic conventions and one-of-a-kind surprises that artist friends do just to bring a smile to your face. Those pieces are priceless. And you never know where you're going to spot that next must-have treasure. It could be at the employee art show at the annual holiday party, or at a charity auction to which a talented Lucasfilm artist has donated a piece. Perhaps it's a small sculpture a fan hands you before a lecture, or a wooden re-creation of an iconic Star Wars character that wins first place in its category at a Mexico City Star Wars convention.

Talent, creativity, and a passion for Star Wars infuse the fan-made art, models, and three-dimensional constructions in my collection. Whether the artists live in London, the Netherlands, Ukraine, Japan, Mexico, Australia, or North Africa, all were inspired by a galaxy far, far away. Maybe it's an "underground" artist who is making a commentary on how he views the capitalist system, or a fan who magically transforms a piece of paper with a few folds to create a character or vehicle from the saga. My British buddy Nick Macarty creates wondrous toys that never were but probably should have been. And Antonio Diaz, a Mexican actor and playwright, makes the most incredibly complex models out of sheets of tin or aluminum.

Large displays made for stores find a second life in collections such as mine. Whether they are oversize three-dimensional pieces like a six-foot-by-four-foot Millennium Falcon with flashing laser cannons or four-foot-tall cardboard displays made for a weekend promotion at four hundred Wal-Mart stores, they become part of an ever-changing exhibit devoted to showing the immense contribution made by one series of movies to worldwide popular culture.

While I've already dismissed the canard that Lucasfilm demands displays be returned or trashed, there is one firm example of a government agency that did. In issuing Star Wars stamps in 2007, the United States Postal Service made several displays. The best was a large three-dimensional floor standee with a full-size C-3PO and R2-D2 with blinking lights—a true collector's dream. There were several of them in Los Angeles at the Star Wars Celebration IV event where the stamps were introduced and sold. At the end of the show a lot of collectors were waiting around, hoping to snag

"REVENGE OF THE JEDI" POSTER PROTOTYPE
DREW STRUZAN FOR PENCIL PUSHERS INC.
UNITED STATES, 1982

If the Pentagon were willing, I bet I could come close to filling all 17.5 miles of its corridors with one copy of every Star Wars poster and point-of-purchase display made in the last three decades. My personal collection of posters alone has grown to more than three thousand, most stored in large flat files. They break down into four categories: theatrical release, event, commercial, and promotional/advertising. Today, most movie posters are photographic, eschewing the sometimes fantastic art that graced posters of yore. The trend toward photographic posters was starting around the time the first Star Wars trilogy was released, accompanied by a major cutback in the different versions available in terms of both size and alternate art. But George Lucas insisted on artwork for the posters of the Special Edition releases in 1997 and for the main posters for each of the prequel movies. The images were all painted by renowned poster artist Drew Struzan, who did the artwork for the famously recalled "Revenge of the Jedi" poster. This is an even rarer, near-final concept version of the released poster.

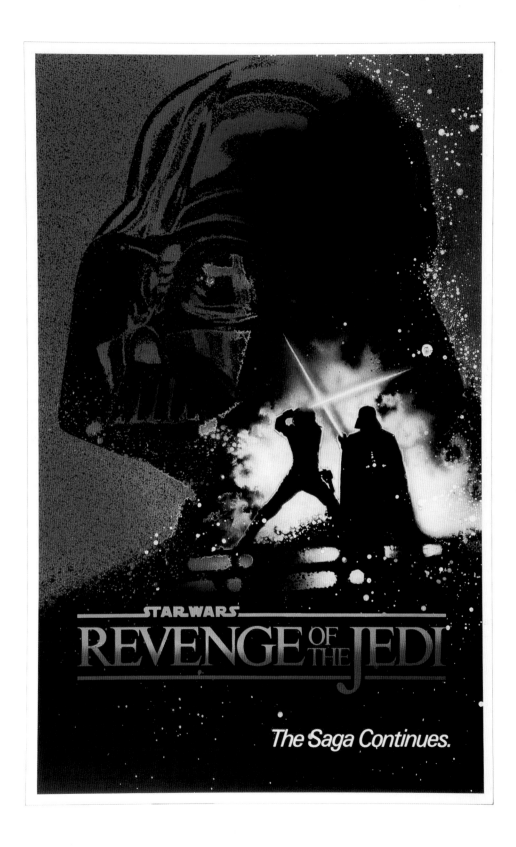

a display; but to their horror, and despite their pleas, the postal employees thoroughly trashed every one of them. They said they had no choice. Sure enough, the back of each standee had a neon-pink sticker that said it was the sole property of the Postal Service and must be destroyed after use by order of the Postmaster General. If anyone doubted that, my friend Gus has a bizarre story. One large standee somehow "escaped" and was for sale on eBay. Gus was the high bidder when the seller suddenly ended the auction. A few days later Gus got a call from an FBI agent who assumed Gus won the auction since his user name was still listed as top bidder. "The guy was very apologetic and said he usually hunted terrorists," Gus said later. "But for some reason he couldn't fathom, he had been assigned to track down this theft of government property." You really can't make up stories like that.

Events always produce collectibles, and the more you're involved with the occasion, the more special they are. The "*Star Wars* Spectacular" at the Tournament of Roses Parade on January 1, 2007, was seen by tens of millions of people around the world but directly experienced by just a few hundred who will never forget it. George Lucas had fond memories of family visits to the annual parade, one of California's oldest public traditions, and thought it would be a great way to honor the men and women of the 501st Legion, an international costume and service organization of *Star Wars* fans, while kicking off the year in which the saga would celebrate its thirtieth anniversary. The entire small but enthusiastic Lucasfilm marketing team pitched in for ten months of concerted work leading up to the week after Christmas. My particular role was to figure out how to select the two hundred or so stormtroopers and other costumers from all over the world who, along with the

Grambling State University Tigers Marching Band, two floats, and other costumed characters would make the five-mile march down Colorado Boulevard. The early highlight for many was when George showed up unannounced at the welcoming dinner on the first night and cheered everyone along by assigning them the task of "conquering the galaxy." My personal thrill was being able to complete the entire march dressed as an Imperial officer, along with my marching colleagues Mary Franklin and Kayleen Walters, both of whom looked a darn sight better than I did.

Finally, a word of caution about the *Star Wars* props market. Very few authentic *Star Wars* movie props are available to collectors. A large number of the costumes and props for the original movies were rented from specialized vendors and given back after filming, only to be sold years later. Others were tossed because they were broken or superfluous. But many pieces being offered for sale as authentic props are strongly believed to be bogus by many in the prop-collecting community. Certificates of authenticity are worth about the price of the sheet of paper they're printed on. The same goes for the majority of autographs sold via online auction sites; they're bogus, too.

THE EMPIRE STRIKES BACK RELEASE POSTER

MIROSLAW LAKOMSKI FOR LODZ
POLAND, 1983

International release posters—especially those from Eastern Europe—were often wildly different from the standard United States release posters. While *The Star Wars Poster Book* (2005) covers many of them, this one and those on the following spread are recent acquisitions. It's doubtful that any of these posters were submitted in advance for approval by Lucasfilm.

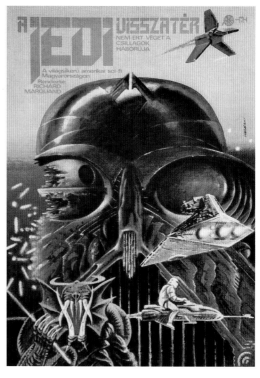

STAR WARS RELEASE POSTER

MOKEP
HUNGARY, 1978

THE EMPIRE STRIKES BACK RELEASE POSTER

MOKEP
HUNGARY, 1980

RETURN OF THE JEDI RELEASE POSTER

HELÉNYI TIBOR (ATTRIBUTED) FOR MOKEP
HUNGARY, 1984

"ROCK HEAD" *STAR WARS* RELEASE POSTER

YURI BOKSYOR (ATTRIBUTED), MAKER UNKNOWN
RUSSIA, 1990

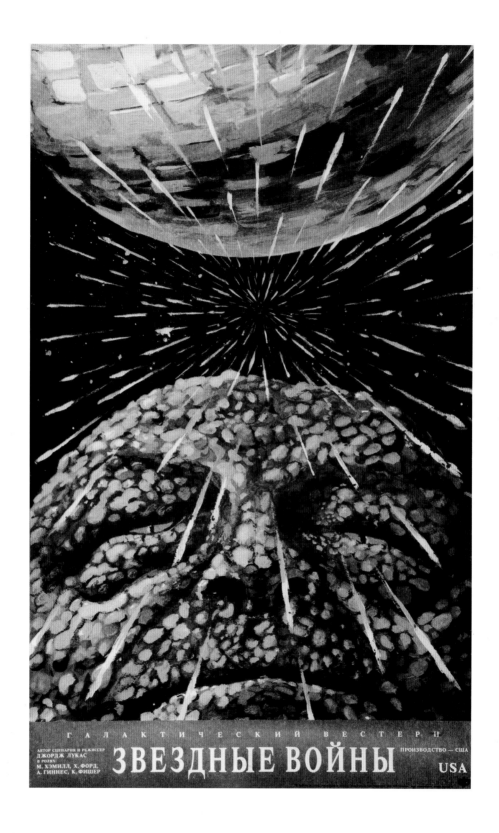

ГАЛАКТИЧЕСКИЙ ВЕСТЕРН

АВТОР СЦЕНАРИЯ И РЕЖИССЕР
ДЖОРДЖ ЛУКАС
В РОЛЯХ:
М. ХЭМИЛЛ, Х. ФОРД,
А. ГИННЕС, К. ФИШЕР

ЗВЕЗДНЫЕ ВОЙНЫ

ПРОИЗВОДСТВО — США

USA

303

STAR WARS LOBBY CARD

20TH CENTURY FOX
MEXICO, 1977

Lobby cards, usually in sets of eight, have gone the way of the dodo bird in the United States, although they are still printed—usually on thin paper—in some international territories that have sufficient numbers of one-screen movie theaters. To save money, lobby-card sets in Mexico all used the same full-color composite photo but were overprinted with different black-and-white publicity stills.

"NO PASSES" SIGN

UNKNOWN
UNITED STATES, 1983

Sorry! Hey, what passes?

PEWTER SCULPTURES

COMPULSION GALLERY
UNITED KINGDOM, 2001

(Left to right, top to bottom)
Darth Vader
Boba Fett
R2-D2
C-3PO

These oversize sculptures are made of a special high-density resin that is thermal-plated with lead-free pewter, lacquered, and then hand-polished. Vader is the tallest, at thirty-two inches high, and weighs about forty pounds. Brian May, the legendary guitarist and songwriter from Queen—and a huge *Star Wars* fan and collector—was presented with a set of the sculptures, all numbered 1,977 out of the total edition of 2,500 each. The statues range in price from about $980 to $1,050 each.

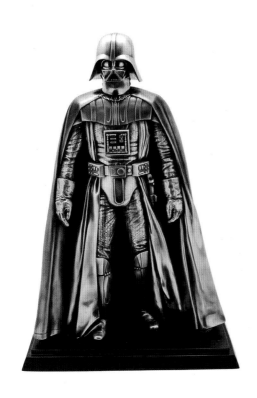

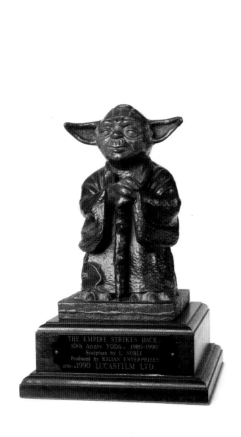

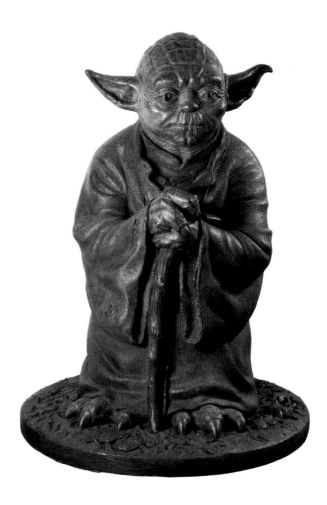

BRONZE YODA SCULPTURE

LAWRENCE NOBLE FOR KILIAN ENTERPRISES
UNITED STATES, 1990

This was the first sculpture licensed by Lucasfilm, created by an artist for whom the saga was a life-altering experience. Lawrence Noble had done drawings and paintings—he was even commissioned to do a concept poster for *The Empire Strikes Back*—but something about that film and the character of Yoda convinced him to try his hand at sculpture. He has since become almost exclusively a sculptor of massive bronzes, and he counts George Lucas and Lucasfilm among his clients. This eight-inch-high bronze was limited to fifty pieces, sold mostly through the Official *Star Wars* Fan Club at a cost of $500. It took several years to sell them out, but today their value has skyrocketed. A few years ago one changed hands in a private transaction for $5,000.

BRONZE YODA SCULPTURE

LAWRENCE NOBLE
UNITED STATES, 2005

Noble always had a hankering to do a full-size Yoda, and fifteen years after he made his small Yoda bronze, he was commissioned by five collectors (I was one of them) to produce this thirty-inch-tall, weighty masterpiece. The artist had six sculptures cast and gave one to George Lucas as a thank-you for the inspiration he provided. Later Lucasfilm licensed twenty-five additional Yoda sculptures for sale. They sold out fairly quickly at $15,000 each. There is one atop a fountain at Lucasfilm's headquarters at the Letterman Digital Arts Center in San Francisco and another at the Lucasfilm Animation campus in Marin County. There is also one missing. A flatbed truck was delivering four bolted-down Yoda sculptures, each weighing about 170 pounds, from the Northern California foundry to the Southern California distributor. It was parked overnight in a hotel parking lot, and when the driver got ready to leave the next morning he realized that one of his Yoda statues had flown the coop.

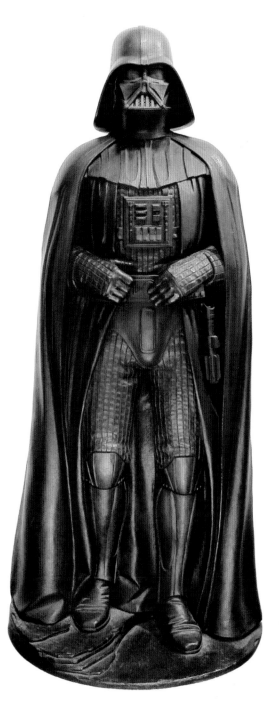

BRONZE DARTH VADER FINAL SCULPTURE

LAWRENCE NOBLE
UNITED STATES, 2008

BRONZE DARTH VADER SCULPTURE IN PROGRESS

LAWRENCE NOBLE
UNITED STATES, 2008

Part of the fun of commissioning a bronze is getting a chance to select the finish, or patina. It's applied at the foundry by bonding metal fragments to the sculpture with an acetylene torch. Various metals react differently, making it possible to select from a fairly wide range of colors and shades.

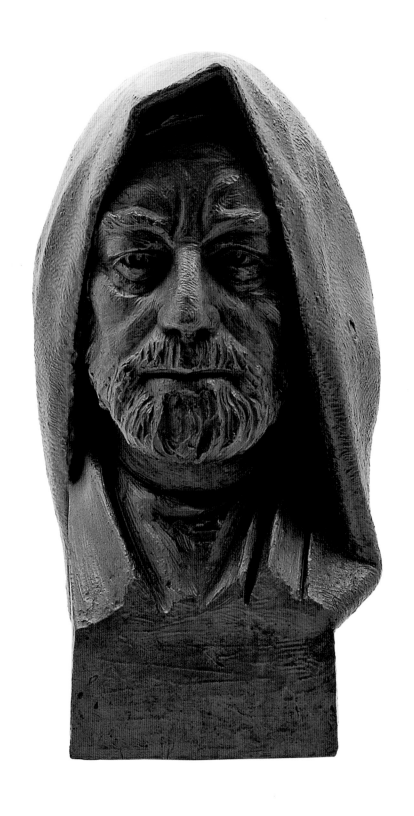

308

OBI-WAN KENOBI BUST

LAWRENCE NOBLE
UNITED STATES, 2007

Lawrence Noble was selected to sculpt these full-size busts out of lumps of clay in front of the attendees at the *Star Wars* Celebration thirtieth anniversary events in Los Angeles, London, and Tokyo. One fan was selected on the last day of each convention to receive a resin casting of the bust.

GRAND MOFF TARKIN BUST

LAWRENCE NOBLE
UNITED KINGDOM/UNITED STATES, 2007

LUKE SKYWALKER BUST

LAWRENCE NOBLE
JAPAN/UNITED STATES, 2008

HAND-CARVED EBONY YODA SCULPTURE

UNKNOWN
NORTH AFRICA, 2002

HAND-CARVED EBONY BOBA FETT SCULPTURE

UNKNOWN
NORTH AFRICA, 2002

I happened upon this black beauty at a fan convention in Paris.
The dealer was an Air France steward who flew routes from his
country to various capitals in North Africa. He spent enough
time there that he developed friendships, including one with
a local woodcarver. The steward was a *Star Wars* fan, but the
craftsman had never heard of the films. So the steward brought
a Boba Fett figure on one of his trips and asked the carver to
make a copy in ebony. This was the steward's personal sculp-
ture, but he said he was willing to take orders on a similar piece
and ship it. I was determined to leave Paris with this piece. After
substantial negotiations, I did. I later followed up and bought an
ebony Yoda sculpture, too.

LUKE SKYWALKER DRAWING

TOM JUNG
UNITED STATES, 1977

Artist Tom Jung, who painted theatrical posters used in the campaigns for all three original movies in the saga, did a lot of pencil sketches for possible marketing campaigns. This one features Luke Skywalker in one of the firing bays of the *Millennium Falcon*. It was purchased at auction in the late 1980s.

BOBA FETT CONCEPT ART BY JOE JOHNSTON

LUCASFILM LTD.
UNITED STATES, 1978

This hand-colored lithograph by concept artist Joe Johnston shows one of his early concept sketches for bounty hunter Boba Fett. When Jeremy Bulloch, the actor who portrayed Fett in the original trilogy, came to visit the collection, he signed the print with a typically gracious and funny comment.

STAR WARS COLLAGE STRING ART, MARKED JJK

UNKNOWN
UNITED STATES, C. 1984

A 1970s fad, string art is still popular today in some quarters. This astounding piece, using the standard small nails, velvet cloth covering wood, and a rainbow of colored thread, is even more amazing for its complexity when you realize there were no personal computers to help plot the points.

C-3PO MEXICAN FIESTA PAINTING

BUSTAMANTE
MEXICO, 2000

This fan-made painting of C-3PO at a Mexican fiesta inspired the actor who was inside the golden droid outfit, Anthony Daniels, to buy a giant sombrero at a hotel gift shop before leaving Mexico City after a fan convention.

STAR WARS PARODY OF MEXICAN LOTERÍA GAME CARDS

CHEPO PEÑA
UNITED STATES, 2009

Chepo Peña, a graphic designer and musician in Texas, has a love for both *Star Wars* and Mexican traditions. One of those traditions is Lotería, a form of Bingo that mainly uses pictures and words instead of numbers. In this clever parody, Peña picked twenty of the fifty-four cards in a standard Lotería deck, whose images have become iconic in Mexican culture. (The publisher first started printing them more than a century ago and operates in the United States under the name Don Clemente Inc.) So *el camarón* (the shrimp) becomes Yoda, *el diablito* (the little devil) is Darth Maul, Darth Vader holds up *el mundo* (the world), R2-D2 becomes *el barril* (the barrel), and one weapon—*las jaras* (the arrows)—is subbed for another, lightsabers.

LA MUERTE

EL APACHE

LA MANO

EL SOLDADO

EL PESCADO

GRAN FABRICA DE NAIPES
DE TODOS ESTILOS

EL GALLO
DON CLEMENTE

EL TAMBOR

EL CATRIN

EL MUNDO

EL VALIENTE

EL ALACRAN

LA DAMA

LAS JARAS

EL BARRIL

LA CORONA

EL BORRACHO

EL VENADO

EL DIABLITO

EL MUSICO

EL CAMARON

313

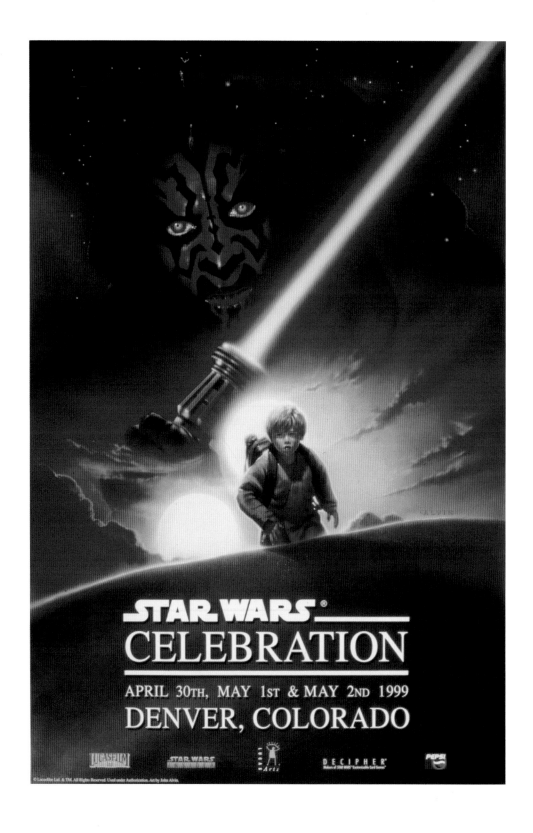

DARTH MAUL LOOMING OVER YOUNG ANAKIN SKYWALKER

JOHN ALVIN FOR *STAR WARS* CELEBRATION
UNITED STATES, 1999

John Alvin was one of the most famous contemporary poster artists until his sudden death from a heart attack in 2008 at the age of fifty-nine. Starting with Mel Brooks's *Blazing Saddles* in 1974, he painted posters for more than 135 films, ranging from *E.T. The Extra-Terrestrial* to *The Lion King* and many of Disney's other animated features. He was also a huge *Star Wars* fan. In 1977 he painted a well-known image of C-3PO and R2-D2 laden with instruments for a *Star Wars* concert tour that never took place. And in an incredible tenth-anniversary tribute poster he fit seventy-seven characters or vignettes inside a graphic rendition of the *Star Wars* logo. He was also chosen to do the art for the 1995 *Star Wars* international video campaign. Throughout the 1990s, John illustrated *Star Wars* book covers, and in 1999 he created this key art for the first *Star Wars* Celebration event in Denver.

John attracted friends like a magnet attracts iron filings. He loved to chat, and was passionate about his work and his family. He was proud to be a *Star Wars* fanboy, frequently signing his e-mails "Artboy" or "Your faithful Rebel Ally and resident geek." I had the privilege of working with John over a period of months on the key art for the thirtieth-anniversary convention in Los Angeles. Both dog lovers, we exchanged photos of his Milo and my Lucca. Six months before he died, John surprised me with the amazing portrait he called "Good Jedi Lucca."

"GOOD JEDI LUCCA" BY JOHN ALVIN

JOHN ALVIN
UNITED STATES, 2007

YODA PORTRAIT

JON J MUTH
UNITED STATES, 1995

Graphic artist John J Muth did this Zen-like Yoda sketch on commission at a convention, making brilliant use of negative space. A friend who saw the piece in my collection loved it so much that he had the image tattooed on his arm.

4-INCH-SQUARE GICLÉE PRINTS ON CANVAS

PLASTICGOD
UNITED STATES, 2008

Plasticgod is an underground artist in Los Angeles who specializes in painting caricatures of celebrity faces.

OBI-STEVE SANSWEET?

KEVIN DOYLE
UNITED STATES, 1996

I meet talented artists everywhere I go, and I try to help promote many of them. I met Kevin Doyle at a fan convention in the Midwest in my first year at Lucasfilm. He showed me some of his work, and I was very impressed. Kevin asked me my favorite character in the saga, and a few months later this piece arrived in the mail. I have fun telling visitors that this is proof that I was the original choice to play Obi-Wan Kenobi in *Star Wars*, but my Philadelphia accent did me in.

OBI-WAN KENOBI "KNIGHTS OF THE ROUND TABLE" PAINTING

MARK RAATS
AUSTRALIA, 2006

Mark Raats, a very talented artist and Web designer, lives on the distant west coast of Australia near Perth. His work centers on portraiture, often done in a combination of acrylic and colored pencil. He has done a series of sketches of the behind-the-camera luminaries at Lucasfilm and Industrial Light & Magic, ranging from director George Lucas and producer Rick McCallum to multi-Oscar-winning visual-effects artist Dennis Muren. This stunning painting of a young Obi-Wan Kenobi as portrayed by Ewan McGregor is based on Mark's comparison of the twelve members of the Jedi Council to the traditional Knights of the Round Table in Arthurian legend. As in the prequel films, the Jedi sit in a circle; but, in Mark's scheme, each has a tapestry of himself hanging on the wall behind his chair. Mark did another version with Luke Skywalker that was sold as a print at Celebration IV; the original was purchased by Lucasfilm.

RETIREMENT GICLÉE

AMY BETH CHRISTIANSON
UNITED STATES, 2008

Amy Beth Christianson, who works for the video-game division LucasArts Entertainment Co., submitted this giclée to the employee art show at Lucasfilm's annual holiday party. Titled *Retirement*, it shows Emperor Palpatine on a run-down farm feeding chickens in clone trooper helmets, while a black rooster wearing Darth Vader's helmet looks on from the top of a fence. Employees voted it best in show.

"CHE TROOPER" PAINTING

URBAN MEDIUM
UNITED STATES, 2003–2004

Derek and Heather Fridman, the husband-and-wife design team known as Urban Medium, created this instantly iconic mash-up of a stormtrooper and the revolutionary Che Guevara. It has appeared on stickers, on T-shirts, and as a vinyl maquette.

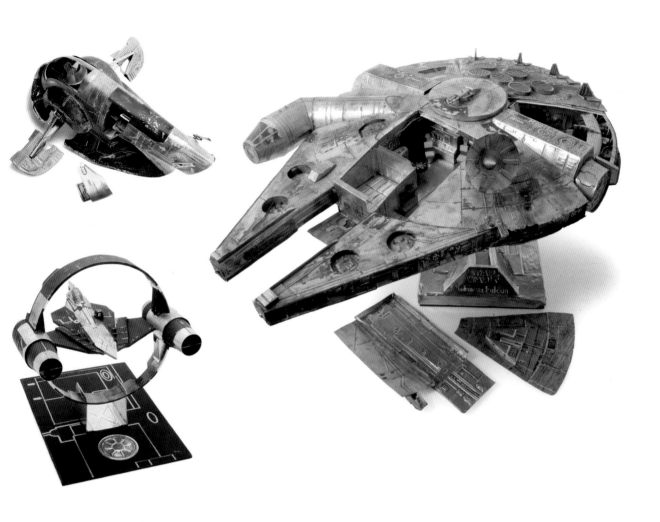

MILLENNIUM FALCON TIN-PLATE SCULPTURE

ANTONIO DIAZ
MEXICO, 2001

I first met Antonio Diaz at a collectors' show in Mexico City
about a decade ago. He is an actor-director-playwright with a
love for *Star Wars* and a skill at bending, crimping, hammering,
and cutting thin tin or aluminum sheets. He made intricate *Star
Wars* vehicles in miniature for himself, but had no desire to sell
any. I told him how much I truly admired his work, we talked for
a while, and he promised to keep in touch. The following year we
met again, and this time he was willing to let me have an incred-
ibly detailed R2-D2 sculpture. One thing led to another, and he
accepted commissions from me for several years. I now have
more than a dozen of his one-of-a-kind pieces in my collection,
but nothing tops his *Millennium Falcon*. Pieces of the hull can
be removed to see the detailed interior, parts that should move
do so, and the engine even lights up.

SLAVE I TIN SCULPTURE

ANTONIO DIAZ ALTAMIRANO
MEXICO, 2003

OBI-WAN'S JEDI STARFIGHTER TIN
SCULPTURE

ANTONIO DIAZ ALTAMIRANO
MEXICO, 2004

YODA SCULPTURE

JEFF McPEEK
UNITED STATES, 2001

Made out of Sculpey, this meditative Yoda was a gift from a fan I met while in Toledo, Ohio, to do a museum lecture. There is something about Yoda's expression—a sort of sublime concentration—that captivated me from the start.

R2-D2 BENTWOOD SCULPTURE

JAVIER VASQUEZ
MEXICO, 2005

An R2-D2 made from tongue depressors and bentwood, this piece from Javier Vasquez won first place in the model-building category at a crafts contest during a fan club convention in Mexico City. R2's wheels spin, his head turns, and his middle leg goes up and down.

REMAINS OF OBI-WAN KENOBI

FAN-MADE
JAPAN, 1998

When this resin piece first arrived, I wondered why my friend Eimei had sent me a petrified cow chip from Japan. Not until I discovered the small Obi-Wan lightsaber hilt at the bottom of the box did I realize it was a sculpture depicting the very poignant moment in *Star Wars* when Obi-Wan is cut down by Darth Vader and becomes one with the Force.

PACKING TAPE SALACIOUS CRUMB

FAN-MADE
MEXICO, 2004

A gift from a fan at a convention in Mexico City, this Salacious Crumb is made mainly from crushed newspaper and packing tape. I couldn't even begin to guess how it was done. It always bring smiles to visitors' faces.

BLOCKADE RUNNER RESIN MODEL

RANDY COOPER
UNITED STATES, 1985

Leave it to a fan model maker to produce an even more detailed version of the Rebel Blockade Runner than the one used in the filming of *Star Wars*. I first spotted this as a display at the *Star Wars* 10th Anniversary convention in Los Angeles. I engaged the model maker in a long conversation, but it was clear that he was very proud of the piece and had no desire to sell it. Still I left him my business card and told him to call if he ever changed his mind—a technique that has worked many times for me. Sure enough, about a year later Randy called, and we quickly negotiated a deal. A few years later, he asked to borrow the model back so he could make a cast of it for himself. I agreed without any hesitation; I couldn't imagine anyone taking better care of this baby than its creator.

***ATTACK OF THE CLONES* HAND-PAINTED NESTING DOLLS**

UNKNOWN
RUSSIA, 2003

DARTH VADER/ANAKIN SKYWALKER HAND-PAINTED NESTING DOLLS

UNKNOWN
UKRAINE, 2005

TANTIVE IV CORRIDOR "PLAY SET"

NICK MACARTY
UNITED KINGDOM, 2004

A British friend, Nick Macarty, is not only a *Star Wars* fan but also a creator of one-of-a-kind toys based on pieces that either only reached the prototype stage or were never made at all. Using a variety of not-quite-everyday household materials, this skillful builder has crafted many amazing pieces such as this imaginative play set or action-figure diorama of the *Tantive IV*, the Rebel ship that Darth Vader captured at the beginning of *Star Wars*. The *Millennium Falcon* play set has built-in moveable pegs to twirl your action figures around.

The *White Witch* (see following spread) was a ship in the animated *Droids* series, and it made it to the prototype stage at Kenner but was never produced. Nick also specializes in making miniatures, such as the chipboard Death Star play set, and in creating packaging, both produced and unproduced. He says he had great fun making a LEGO version of the famous Kenner "Early Bird Certificate" package, but, unlike Kenner's, Nick's came with the figures.

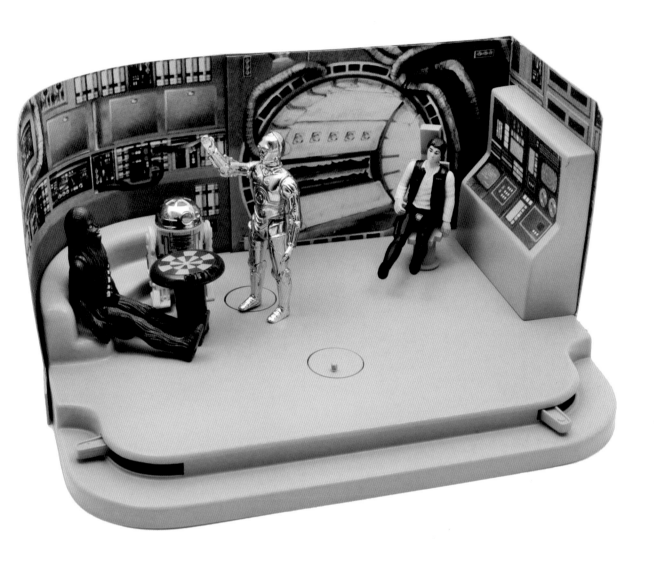

MILLENNIUM FALCON "PLAY SET"

NICK MACARTY
UNITED KINGDOM, 2007

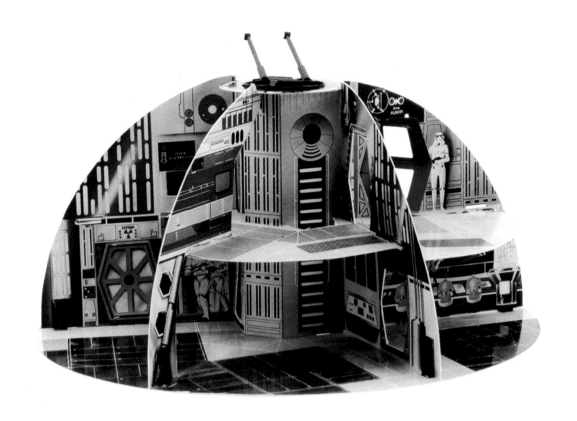

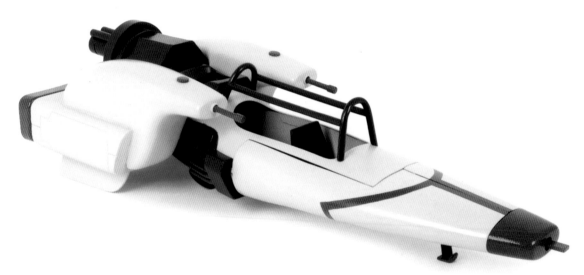

DEATH STAR PLAY SET MINIATURE REPLICA
NICK MACARTY
UNITED KINGDOM, 2008

WHITE WITCH UNPRODUCED TOY REPLICA
NICK MACARTY
UNITED KINGDOM, 2005

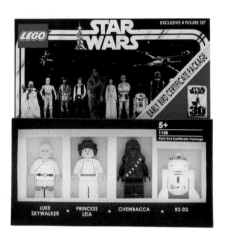

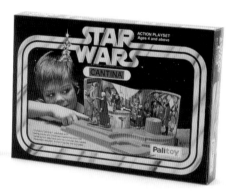

***STAR WARS: DROIDS* MINIATURE REPLICA
BOXES**

NICK MACARTY
UNITED KINGDOM, 2007

LEGO "EARLY BIRD CERTIFICATE PACKAGE"

NICK MACARTY
UNITED KINGDOM, 2007

PALITOY MINIATURE REPLICA BOXES

NICK MACARTY
UNITED KINGDOM, 2006

FELT MICE

THE HOUSE OF MOUSE
NETHERLANDS, 2008

(Left to right, top to bottom)
Emperor Palpatine
Yoda
Princess Leia
Chewbacca
Jabba the Hutt
R2-D2

Anna Greaves, who lives in the Netherlands, made this adorable set of *Star Wars* characters as mice for me by special request.

AD-AT VINYL FIGURE

BILL McMULLEN FOR SPAN OF SUNSET
UNITED STATES, 2003–2004

This limited-edition toy came near the beginning of the designer vinyl toy craze. Sold exclusively by a trendy shop in Los Angeles, it was designed by California-artist-turned-New-Yorker Bill McMullen and based on his painting *Attack of the Shelltoe AT-ATs*, a cross between Adidas sneakers and the All Terrain-Armored Transports from *The Empire Strikes Back*. A press release for a 2009 McMullen gallery show, featuring a fanciful construction of R2-D2 as a boombox, states that the artist's work "shows just how easy it is to be 'had' by misinterpreting capitalism's optical tools for cogent representations of unfeigned visual culture—and that the Ouroboros is actually all of us." Which is what I suspected all along.

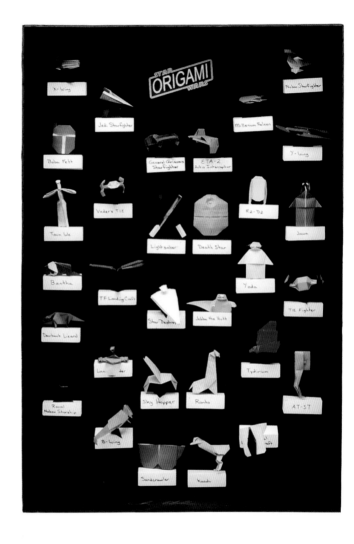

GIANT LEGO LIGHTSABER ACRYLIC SCULPTURES

GORO INOUE
JAPAN, 2008

As gifts for friends, Goro Inoue, a Japanese fan and prop maker by profession, built these life-size versions of lightsabers based on the ones that come with the small and blocky LEGO *Star Wars* figures boxed with building sets. Those are nearly two inches long. Goro's lightsabers are more than two feet tall.

CHARACTERS AND SHIPS ORIGAMI

CHRIS ALEXANDER
UNITED STATES, 2005

This display of more than thirty pieces of *Star Wars* origami was built by Chris Alexander and auctioned off for charity. Chris has demonstrated origami techniques at several Celebration events, once using audience members and gigantic sheets of colored paper to build a full-size Jabba the Hutt and a Jedi starfighter. He had volunteers come up on an elevated stage and remove their shoes before positioning them correctly. One mistake would have ended the demonstration because there wasn't any backup paper. The first fold on the starfighter took nearly an hour to bring off successfully.

**THE SIMPSONS AS *STAR WARS* CHARACTERS
PLASTER STATUES**

FAN-MADE
MEXICO, 2003

THE SIMPSONS PORCELAIN FIGURINES

FAN-MADE
UNITED KINGDOM, 2001

HAN AND LEIA "SKULL WARS" FIGURINE

SUMMIT INTERNATIONAL INC.
UNITED STATES, 2008

A friend found this in a local supermarket—and it wasn't related
to the Mexican observation of the Day of the Dead.

GREAT HOLOCRON

DON BIES FOR DK PUBLISHING
UNITED STATES, 2000

You never see Holocrons in a *Star Wars* movie, but they are
major story devices in the saga's comics, novels, and animated
television series *Star Wars: The Clone Wars*. They are the key
to unlocking ancient Jedi and Sith stories and wisdom. These
examples were specially built to be photographed for DK Pub-
lishing's *Attack of the Clones Visual Dictionary*.

SITH HOLOCRON

DON BIES FOR DK PUBLISHING
UNITED STATES, 2000

JEDI HOLOCRON

DON BIES FOR DK PUBLISHING
UNITED STATES, 2000

PIT DROID GIFT

MADE FOR LUCASFILM LTD.
UNITED STATES, 1999

Lucasfilm's Marketing and Licensing divisions had ILM model makers design special gifts to send to major partners after each prequel movie opened. The miniature pit droid from the Podrace arena was sent after the opening of Episode I.

STAR WARS FAN FILM AWARD

MADE FOR LUCASFILM LTD.
UNITED STATES, 2002

Lucasfilm has encouraged fans to make and submit their own short movies inspired by *Star Wars* and has awarded prizes at ceremonies every year since 2002. The gold-colored resin award, which features R2-D2 holding a soda cup with straw and C-3PO clutching a box of popcorn, was built originally by Don Bies based on modified Japanese model kits.

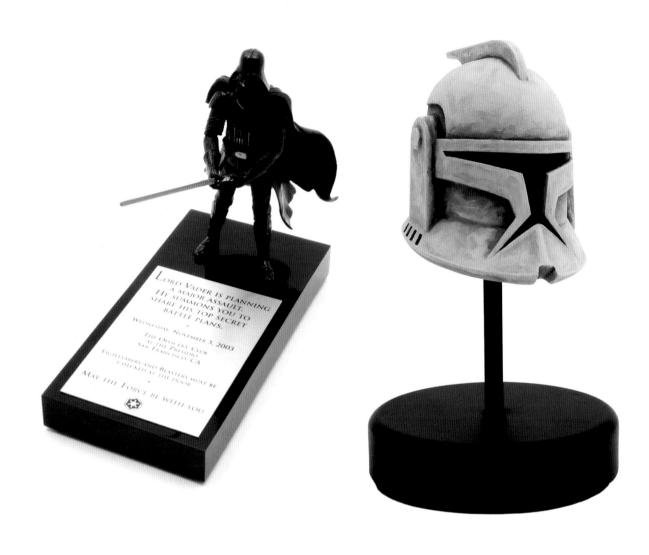

LICENSING EVENT INVITATION

MADE FOR LUCASFILM LTD.
UNITED STATES, 2003

LORD VADER IS PLANNING
A MAJOR ASSAULT.
HE SUMMONS YOU TO
SHARE HIS TOP SECRET
BATTLE PLANS.

·

WEDNESDAY, NOVEMBER 5, 2003

THE OFFICERS' CLUB
AT THE PRESIDIO
SAN FRANCISCO, CA

LIGHTSABERS AND BLASTERS MUST BE
CHECKED AT THE DOOR

MAY THE FORCE BE WITH YOU

STAR WARS: THE CLONE WARS CLONE TROOPER HELMET PAINTED MAQUETTE

MADE FOR LUCASFILM LTD.
UNITED STATES, 2009

Based on a one-year service award for Lucasfilm Animation employees, this seven-inch-tall resin clone trooper helmet was cast from an original made by crew sculptor Darren Marshall, hand-painted by texture artist Tim Brock, and signed by both artists as well as supervising director Dave Filoni and executive producer Cary Silver. It was auctioned for a charity event.

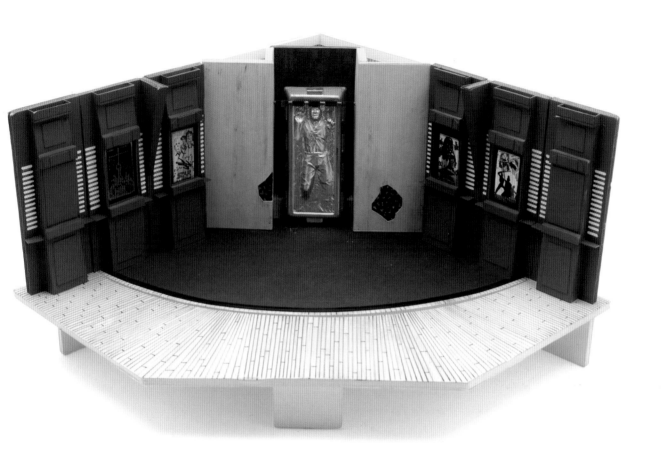

QVC SET DESIGN MINIATURE
LOU VENUTO
UNITED STATES, 1996

In the 1990s, I appeared as co-host on nearly thirty *Star Wars*
Collection shows on the QVC home shopping channel. My job
was to provide "entertainment" value, but in truth—because
I really liked nearly everything we sold—I provided a lot of
the sales push. For the first few years we did the show from
whatever set was available. I knew we were making good
money for QVC when I arrived for one show and was greeted by
a specially built set, which we used for several years. This is the
scale model from the set designer.

STAR WARS SOUNDTRACK GOLD ALBUM AWARD

RIAA
UNITED STATES, 1978

The Recording Industry Association of America started issuing Gold Album awards in 1958 to mark the sale of five hundred thousand copies; it created the Platinum Award (one million sold) in 1976. The awards are purchased and distributed by the record companies and have become hot collectibles, leading to bootlegs and look-alikes. When you combine two hot collecting areas, such as *Star Wars* and RIAA awards, prices can soar and provenance becomes important. I'm sure of the authenticity of this award, one of the first six issued for the double LP *Star Wars* soundtrack (and later followed by a Platinum Award). It hung for years in the office of a friend, a top official at 20th Century Fox. When he left the company, he took it with him and stored it in his garage. I told him I really wanted to buy it, but he kept me hanging, more for sport than anything else. Finally one day I presented an offer in writing: $100 to his favorite charity and half a bologna sandwich. He had a bit more to squeeze out of me: "Make it a whole bologna sandwich, and it's yours!" At our next get-together, he brought the framed record and I brought the money and a paper sack with his lunch for the next day.

EPISODE I PLATINUM AWARD

RIAA
UNITED STATES, 2000

BATTLE DROID LIFE-SIZE DISPLAY

MADE FOR FAO SCHWARZ
UNITED STATES, 1999

There were only a couple of full-size prop battle droids made for the shooting of Episode I *The Phantom Menace*. All the rest were digital. FAO Schwarz's display maker got the electronic files directly from Lucasfilm and made a number of these droids to populate the *Star Wars* department in a few of its major stores. This is one of two that were auctioned in FAO's bankruptcy sale in April 2004.

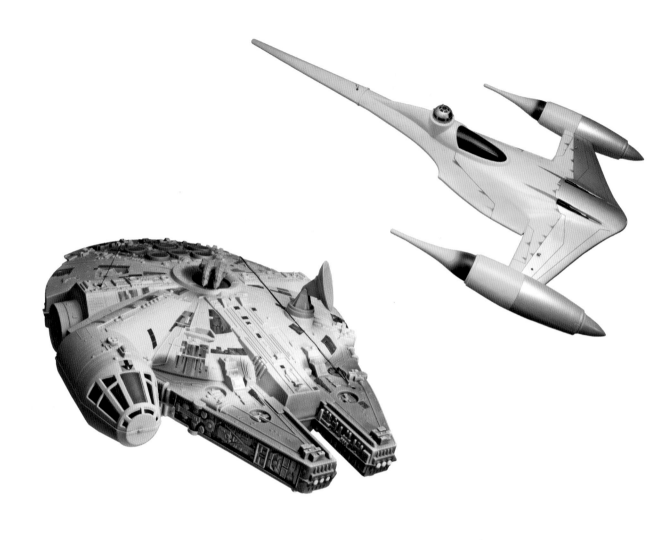

MILLENNIUM FALCON HANGING DISPLAY

MADE FOR HASBRO
UNITED STATES, 1997

This oversize *Millennium Falcon* display, about six feet long and
four and a half feet wide, was placed by Hasbro in hundreds of
Toys"R"Us stores. Just before the promotion was scheduled to
end, fans had a chance to win the display by buying $1 raffle
tickets to aid the Rosie's [O'Donnell] For All Kids Foundation.
One winning entry was selected at each store.

NABOO STARFIGHTER HANGING DISPLAY

MADE FOR HASBRO
UNITED STATES, 1999

Following the success of the *Millennium Falcon* display, Hasbro
provided a seven-foot-long Naboo starfighter to hang above
customers at Toys"R"Us stores, along with two enemy vulture
droid starfighters.

REAR PLATE OF X-WING FIGHTER TOURING REPLICA

MADE FOR LUCASFILM AND 20TH CENTURY FOX GERMANY, 1995

This is the rear plate from an X-wing starfighter that crashed. In Mexico. Really. First, a little back story. In 1995, 20th Century Fox Home Video and Lucasfilm decided to build nine nearly full-size X-wings in Germany to go on tour around Europe the following year for a major promotion of the enhanced video versions of the three original movies. Over the years, the fighters dispersed across the world, some faring better than others. One ended up on the front lawn of a New Jersey executive who paid $135,000 ($100,000 of which went to charity) in an auction from Neiman Marcus. Another made its way to Australia to become part of the Fox Australia studio tour. When the tour was abruptly closed, the ship was ordered to be destroyed. And one crashed while on tour in Mexico—or at least the truck that was carrying it was involved in an accident. Lucasfilm asked that the fighter be brought to Skywalker Ranch to determine if it could be fixed. It couldn't be, and the company brought in two

men to disassemble and destroy the craft. What Darth Vader couldn't accomplish Word spread as to what was transpiring and a colleague and I hastened to view the destruction ourselves. The workmen were great and shared our grief that this lovely piece—even though it wasn't a prop used in any filming—had to be put down. So we all agreed that a few of the nicest pieces would be temporarily put aside and we would seek our boss's permission to give them a new home. We asked. He looked at us like we were from another planet, but he said he'd think about it. Weeks passed; he was still thinking. The Archives, on whose property the pieces rested, was getting impatient. "Make them disappear!" the archivist insisted. We were only too happy to oblige.

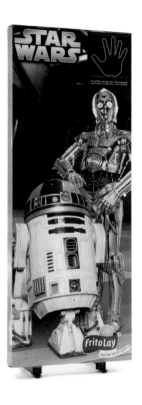

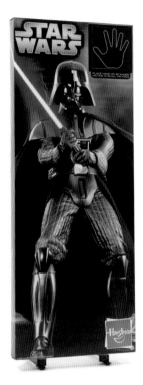

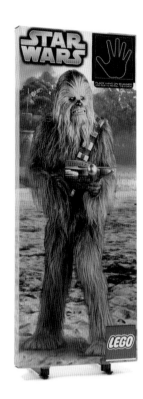

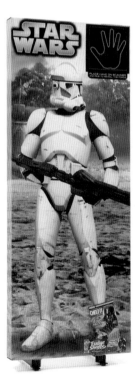

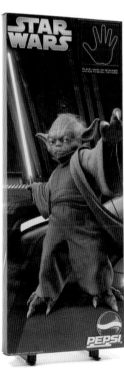

FLOOR DISPLAYS

MADE FOR WAL-MART
UNITED STATES, 2005

(Opposite, left to right)
Kellogg's
M&M'S

(Left to right, top to bottom)
Frito Lay
Hasbro
LEGO
Sunshine/Keebler
Pepsi

Wal-Mart had one of the largest promotions for the launch of toys for *Revenge of the Sith*. The chain called it "48 Hours of the Force" and set up large tents in the parking lots of four hundred stores nationwide. The larger licensees and marketing partners had these colorful standees placed around the tents, with a hand outlined at the top. A warm palm revealed a "secret" message: a URL for a Website to get more information on all the cool *Star Wars* goodies.

DARTH VADER AND LUKE SKYWALKER
CINEMACAST PROTOTYPES

KENNER PRODUCTS
UNITED STATES, 1995

These two hard plastic mold tests were made for a new Kenner product, which would be the first *Star Wars* merchandise the company would sell through mail-order only. It wasn't a very successful move, probably because many collectors never heard about the CinemaCast statue program. The Darth Vader figure was produced and sold, but the Luke Skywalker companion piece never made it to market before the series was canceled. Many collectors believe that blue plastic prototypes like these were made by Kenner vendors specifically to sell out the back door to collectors. They call the phenomenon "Blue Harvest," after the phony cover name Lucasfilm used to try to hide the filming of *Return of the Jedi* from fans and the media in Arizona and California.

DARTH VADER CINEMACAST AD

KENNER PRODUCTS
UNITED STATES, 1995

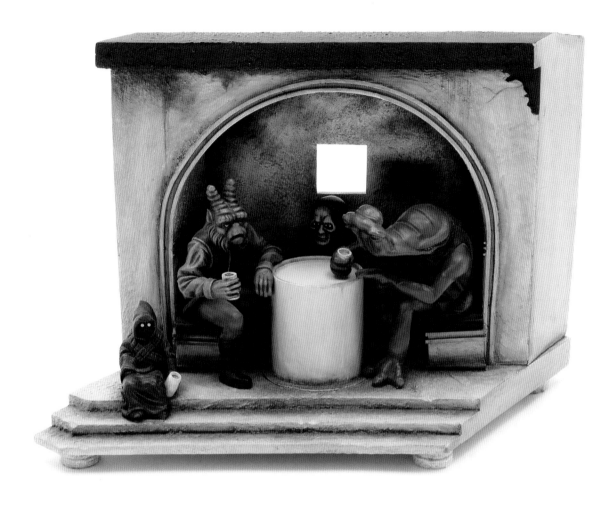

CANTINA SECTION, UNPRODUCED PROTOTYPE

GREG ARONOWITZ
UNITED STATES, 1996

This was the first piece of a proposed seven-section Mos Eisley
Cantina. You'd get one of these resin pieces every two months
or so until you could put together the entire interior of the
bar where Luke and Ben met up with Han and Chewie. There
would also be a lighted base for the entire collection. I was
jazzed when I saw the plans; the talented artist and sculptor
Greg Aronowitz, who had already sculpted beautiful character
maquettes for one Lucasfilm licensee, was jazzed that I was
jazzed. Alas, the project was not to be, but Greg signed the
back of one of the two existing prototypes made in China and
gave it to me.

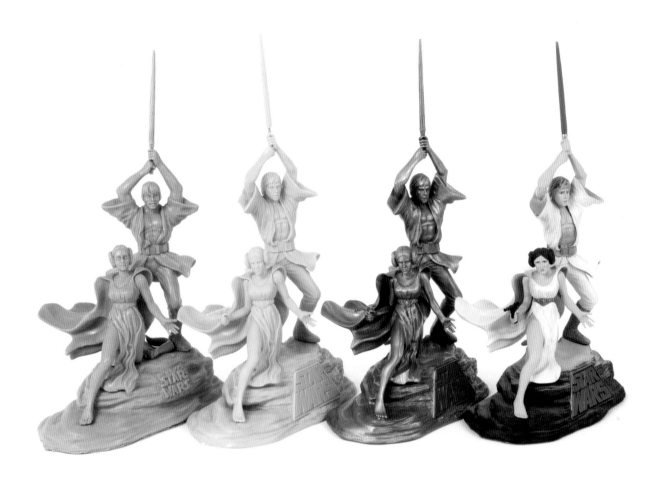

LUKE AND LEIA CINEMACAST

HASBRO
UNITED STATES, 1997

Taken from the iconic Luke and Leia poses on the main
theatrical poster for *Star Wars*, this small maquette went
through various stages. On the left is a plastic pull from a mold
of the original sculpt. It's very rough, and it underwent a major
resculpt of the characters' faces and positioning on the slab,
which also got a new version of the *Star Wars* logo, as seen in
the light blue plastic pull. The first version available for sale was
the pewter one, followed by a fully painted JC Penney exclusive.
There also is a bronze-colored one that was a Hasbro gift,
mainly to employees. I'm still looking for one.

DARTH MAUL UNPRODUCED CUT PAPER PROTOTYPE

ERIC WARD
UNITED STATES, 2000

Eric Ward can take a dollar bill and within about a minute turn it into a three-dimensional turkey. From his childhood, he's been passionate about paper engineering and has made a career out of it. He designed a series of full-size *Star Wars* droids that could be punched out and assembled. Some were used as point-of-purchase displays to promote *Star Wars* books; others were sold directly to the public. Eric really wanted to show that he could design full-size humanoids the same way, but it was six months after the opening of *The Phantom Menace*, and no licensee was interested. All that remains is this one-of-a-kind Darth Maul head prototype that Eric gave me. It looks down on me every day from a shelf in my home office.

STAR WARS CELEBRATION IV LOGO ENGRAVING EXAMPLE

CREATED FOR GEN CON
UNITED STATES, 2007

(Opposite)

R2-D2 (*DROIDS*) COIN

KENNER PRODUCTS
UNITED STATES, 1985

R2-D2 (*DROIDS*) COIN DIE AND ETCHING PLATE

KENNER PRODUCTS
UNITED STATES, 1985

Kenner came up with a new gimmick to try to entice fans to keep buying new action figures after *Return of the Jedi* completed its theatrical run: character coins included in each figure pack. These are the actual coin dies and etching plate for the R2-D2 figure in the animated *Droids* television series line.

BEN (OBI-WAN) KENOBI MEDALLION MOLDS

FOR THE *STAR WARS* CELEBRATION
COLLECTORS GROUP
UNITED STATES, 2007

As a bonus for attending panels about *Star Wars* collecting at recent official Celebration conventions, twelve different medallions were distributed randomly to audience members. There were five hundred of each and demand was high. A number of high-end collectors around the world subsidized the cost of producing the medallions for fellow collectors. They got to keep the molds and prototypes for the medallion they sponsored. In addition, sets of gold-colored medallions were made for the sponsors and panelists. Originally, Lucas Licensing turned down the concept. Hasbro's line of action figures in 2007 was going to come with collectible coins to commemorate the saga's thirtieth anniversary and to serve as a nostalgic reminder of similar coins released more than two decades earlier. Licensing managers didn't want fans to be confused. I felt there was room for compromise. So the collector giveaways grew in size, changed color, and, perhaps as important, changed their names from "coins" to "medallions." It worked.

(Right)

STAR WARS CELEBRATION IV GOLD MEDALLION SET

FOR THE *STAR WARS* CELEBRATION IV
COLLECTORS GROUP
UNITED STATES, 2007

STAR WARS CELEBRATION EUROPE GOLD MEDALLION SET

FOR THE *STAR WARS* CELEBRATION EUROPE
COLLECTORS GROUP
UNITED STATES, 2007

STAR WARS CELEBRATION JAPAN GOLD MEDALLION SET

FOR THE *STAR WARS* CELEBRATION JAPAN
COLLECTORS GROUP
UNITED STATES, 2008

(Opposite, left to right, top to bottom)

THE EPIC BEGINS 5 OZ. .999 SILVER COIN

RARITIES MINT INC.
UNITED STATES, 1987

The first authorized *Star Wars* coins were manufactured for the saga's tenth anniversary in 1987 by the private Rarities Mint. There were four types (five-ounce and one-ounce silver and one-ounce and quarter-ounce gold) in six different designs, ranging from the expected (Vader dueling Obi-Wan Kenobi) to the unexpected (three Cantina musicians). The coins were available only by advance purchase through coin dealers, and orders weren't helped by the fact that the price of both gold and silver had a decade-high peak that year. The one-ounce gold coins cost more than $1,000 each. Thus, it is little surprise that only fourteen complete sets of the coins can possibly exist because only fourteen of several of the one-ounce gold coins were minted, including Lucasfilm's samples. The high price of these extraordinarily scarce coins has kept most collectors away. One dealer tried for years to sell a complete set of twenty-four coins for $25,000.

MOS EISLEY CANTINA BAND
5 OZ. .999 SILVER COIN

RARITIES MINT INC.
UNITED STATES, 1987

IMPERIAL STORMTROOPERS
1 OZ. .999 SILVER COIN

RARITIES MINT INC.
UNITED STATES, 1987

R2-D2 AND C-3PO
.25 OZ. .999 GOLD COIN

RARITIES MINT INC.
UNITED STATES, 1987

DARTH VADER AND OBI-WAN KENOBI
.25 OZ. .999 GOLD COIN

RARITIES MINT INC.
UNITED STATES, 1987

HAN SOLO AND CHEWBACCA
1 OZ. .999 GOLD COIN

RARITIES MINT INC.
UNITED STATES, 1987

(Above)

POLISHED SILVER AND ENAMELED COINS

HELEVETISCHES MÜNZKONTOR
GERMANY, 2005

Although a small brochure accompanying each of the twenty-four coins in this set stated that the edition was limited to 9,999 sets, they are scarcely known inside Germany much less elsewhere. The 40 mm, 32 gram coins have the *Star Wars* logo on the polished silver reverse, but only the engraved Vader coin is also all silver on the obverse.

DARTH VADER 24K GOLD ON SILVER MEDAL
(OBVERSE AND REVERSE)

THE FRANKLIN MINT
UNITED STATES, 1997

This coin was one of the few products to specifically commemorate the twentieth anniversary of *Star Wars*. Aside from the lack of merchandising, the rerelease of all three original films in their restored and enhanced Special Editions at the beginning of 1997 made a huge impact on the public and paved the way for the first of the prequel films two years later.

BOTTLE-CAP COLLECTION

FOR THE *STAR WARS* CELEBRATION JAPAN STORE
JAPAN, 2008

To commemorate a well-loved premium from thirty years before—a set of fifty Coca-Cola caps with photos from *Star Wars* under the seal—the Celebration Japan store sold these caps. Two caps were packed randomly inside a white plastic egg, and there were thirty to collect. But there also was a mysterious thirty-first "chase" cap, which turned out to have art from the animated series *Star Wars: The Clone Wars*. Chase caps, cards, or anything else using that word are produced in lesser quantity than the base set, and more effort (and usually money) must be expended to collect them. Three friends together bought several hundred eggs but found not one chase cap. And when, after some delay, Lucasfilm Marketing got some product samples, there were no chase caps either. They were on their way, we were told. After many more inquiries, they finally arrived more than two months later, leaving me to wonder if anyone found a chase cap at the show.

354

STAR WARS TRADING CARDS SHELF DISPLAY BOXES

TOPPS COMPANY INC.
UNITED STATES, 1977

(Opposite)
Series One

(Left to right, top to bottom)
Series Two
Series Three
Series Four
Series Five

Among the first *Star Wars* licensees—and today one of the oldest—was Topps Co. Inc., purveyor of sports and entertainment trading cards. Originally known as bubble-gum cards when they were packed with a slab of cardboard-thin pink gum covered with a strange white powder, such cards were originally devised as a way to sell the gum, until the popularity of collecting full sets of cards far surpassed the perceived value of the candy. Topps's *Star Wars* cards were an immediate hit, selling out all over the United States. The first series was quickly followed by four others. Because so many millions of cards were produced, buying a full run of the 330 *Star Wars* cards and fifty-five stickers today is neither difficult nor very expensive. More difficult to find are sealed wax packs (the original wrapping was a waxed paper) with seven cards, one sticker, and very stale gum intact—and more elusive still are full shelf boxes with thirty-six sealed packs. In the rarefied land of advanced collecting are uncut sheets of each set's trading cards, as well as proof sheets from the printing process. Such treasures have been sold by Topps through auctions or its Topps Vault online store. Topps went on to produce four sets for *The Empire Strikes Back* and three for *Return of the Jedi*. Things were quiet on the trading-card front until 1993, when Topps came back with a huge hit, the first of its *Star Wars* Galaxy sets. In more than three decades, Topps has produced more than forty different card and sticker sets for the galactic saga.

STAR WARS WAX WRAPPERS

TOPPS COMPANY INC.
UNITED STATES, 1977

Series One
Series Two
Series Three
Series Four
Series Five

STAR WARS CARDS

TOPPS COMPANY INC.
UNITED STATES, 1977

Series One (Blue)
Series Two (Red)
Series Three (Yellow)
Series Four (Green)
Series Five (Orange)

UNCUT *STAR WARS* TRADING CARD SHEET

TOPPS COMPANY INC.
UNITED STATES, 1977

C-3PO "X-RATED" TRADING CARD #207

TOPPS COMPANY INC.
UNITED STATES, 1977

Topps *Star Wars* card number 207, a seemingly innocent set photo of the golden protocol droid C-3PO, has taken on a special significance and is highly sought by collectors. The first—and largest—printing of card 207 seems to show the mechanical man in an "excited" state, clearly something that was not planned and didn't happen on set. Once Topps was alerted to the perception problem, it rushed out an amended version of the card. The "clean" card was actually printed in lesser numbers and thus should command a higher value in the collector's market, but the novelty value of the "X-rated" or "obscene" trading card pushes it higher in price. For years, collectors have been trying to figure out how this card came to exist. There were stories that an angry employee or someone at the printing plant had changed it. But Topps officials denied knowledge of anyone at its company tampering with any assets received from Lucasfilm, claiming the unusual glitch was missed in the proofing process because no one was looking for

altered graphics. Lucasfilm speculated that perhaps a piece of Threepio's costume had come loose while the photo was being taken. A few years ago, while I was searching through Lucasfilm's near-endless file folders containing original slides and transparencies, I came up with a partial answer. There were two nearly identical transparencies, one that looked like the second printing and one that had the "aroused" golden droid. On close inspection, it became obvious that someone working with the original image had monkeyed with it, probably as a joke for some colleagues. It's highly doubtful that he or she meant that version to leave the company. So the mystery is partially resolved—and if and when the long-ago prankster comes forward, it will be a mystery no more.

C-3PO REPRINTED TRADING CARD #207

TOPPS COMPANY INC.
UNITED STATES, 1977

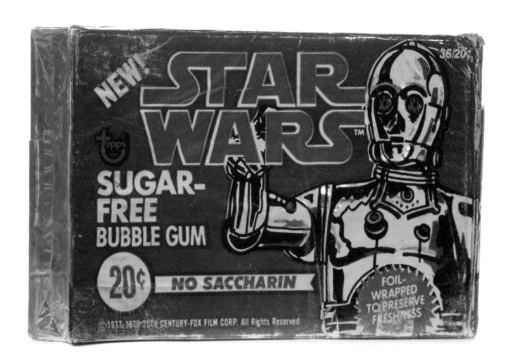

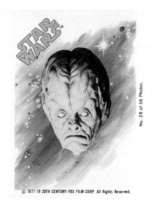

80 MOVIE PHOTO CARDS PLUS COLLECTING BOX

TOPPS COMPANY INC.
UNITED STATES, 1980

While most vintage trading cards were sold only in individual wax packs, there were a couple of exceptions, including this set of eighty cards and a thin cardboard box in which to keep them.

STAR WARS GALAXY SERIES ONE DISPLAY BOX

TOPPS COMPANY INC.
UNITED STATES, 1993

With the resumption of interest in *Star Wars*, original licensee Topps was one of the first to come back into the market, producing the first of a series of trading cards that promoted classic *Star Wars* art as well as imaginative new art from noted comic-book and illustration artists. The first three sets (for which I was the consulting editor, selecting the classic art and writing the copy for those cards) sold well, but Topps retired the concept before fans tired of it, only to come back to it for a new generation of collectors in 2009.

SUGAR-FREE BUBBLE GUM SHELF DISPLAY BOX AND WRAPPERS

TOPPS COMPANY INC.
UNITED STATES, 1978

Topps sugarless gum was sold only in a test market in the Southeast in relatively small quantities. Under this foil outer wrap is a cardboard shelf box, filled with thirty-six slabs of gum wrapped in paper. Four different designs for the outer wrap and a total of fifty-two photos on strange, often psychedelic backgrounds made up the full set. I first heard about these nine years after they were produced; if there had been an Internet in 1978, I probably would have heard in about nine minutes.

STAR WARS GALAXY SERIES TWO
PROMOTIONAL CARD

TOPPS COMPANY INC.
UNITED STATES, 1994

This artist-imagined scene of Ewoks attacking a scout trooper
during the Battle of Endor passed muster as a *Star Wars*
Galaxy promotional card. Once it was distributed, however,
someone at Lucas Licensing had a sensitivity attack and
decided that the Ewok clinging to the trooper's neck shouldn't
have an unsheathed knife in his hands. Explosions, spears, and
rocks, however, were apparently fine for the movie. Because
the card had already been distributed in small numbers as a
promo card, Lucas Licensing allowed Jim Starlin's art in the full
set—but with the knife carefully painted over.

STAR WARS GALAXY SERIES TWO
TRADING CARD

TOPPS COMPANY INC.
UNITED STATES, 1994

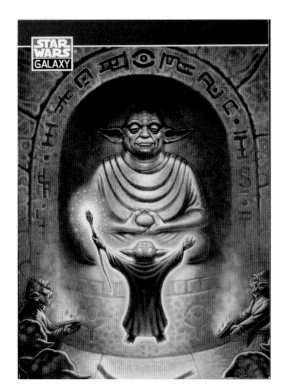

YODA *STAR WARS* GALAXY SERIES TWO
PROMOTIONAL CARD

TOPPS COMPANY INC.
UNITED STATES, 1994

This infamous promotional card, whose art had sprung from the imagination of the artist John Rheaume, was nixed by Lucasfilm before it could be distributed, but after it was printed. The company decided that George Lucas had never established any background for Yoda or even whether any other Yoda-like beings existed in his faraway galaxy. However, an unknown number of the so-called Yoda P-2 cards escaped shredding and were put up for sale. In an early auction, one sold for $2,755. But fifteen years later, even though Lucas hadn't established much more about Yoda's life, Lucasfilm let Topps put the art in its Galaxy 4 series as a numbered and limited collectible, along with an even more limited version signed by the artist.

YODA *STAR WARS* GALAXY FOUR CHASE CARD

TOPPS COMPANY INC.
UNITED STATES, 2009

TRADING CARD "GAMBLE PACKS"

TOPPS COMPANY INC.
JAPAN, 1978

Much like American trading cards, which come in sealed packs, thus forcing you to buy many duplicate cards before you can complete a full set, cheap paper sleeves held the Japanese versions of Topps *Star Wars* cards. The "gamble packs" had covers consisting of one of the cards and were held together with a small string. Kids just pulled a sleeve containing one of the cards out of the book if they didn't have the funds to buy the entire package. Some of the cards were stamped "winner" on the back and could be turned in for a much rarer and larger *Star Wars* card.

ALBUM STICKERS DISPLAY BOX

INTERNATIONAL TEAM FRANCE
FRANCE, 1987

GUM WITH STICKERS DISPLAY BOX

KENT
TURKEY, 1997

There's nothing quite like the taste of fruit-flavored Turkish bubble gum wrapped in *Star Wars* stickers, especially if you try to chew it a decade or so past its shelf expiration date.

GUM STICKERS

KENT
TURKEY, 1997

STAR WARS 3-D TRADING CARD DISPLAY BOXES

TOPPS COMPANY INC.
UNITED STATES, 1997

Each of these store shelf display boxes, which held thirty-two packs of cards, had a different *Star Wars* 3-D trading card firmly glued to its top. Because the cards were unprinted on the back, unlike the regular cards, they were a true variation for collectors, some of whom sought all twenty-one known variations.

LARGE LENTICULAR SAMPLE CARD

TOPPS COMPANY INC.
UNITED STATES, 1999

This is a prototype of Topps's large lenticular card, marked on the back in big type: SAMPLE ONLY. NOT FOR SALE.

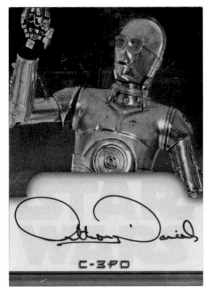

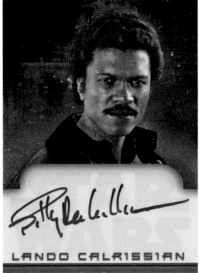

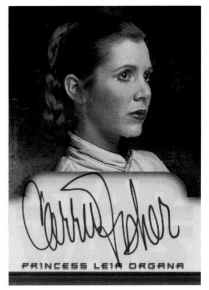

BILLY DEE WILLIAMS (LANDO CALRISSIAN) AUTOGRAPH CHASE CARD FROM THE EVOLUTION SERIES

TOPPS COMPANY INC.
UNITED STATES, 2001

Billy Dee Williams signed a Topps autograph card only once, for the 2001 Evolution series. One card could be found in every 2,452 packs.

CARRIE FISHER (PRINCESS LEIA ORGANA) AUTOGRAPH CHASE CARD FROM THE EVOLUTION SERIES

TOPPS COMPANY INC.
UNITED STATES, 2001

One Carrie Fisher card could be found in every 3,677 packs of *Star Wars* Evolution cards. Fisher has signed two other sets for Topps: the *Star Wars* Heritage set in 2004 and the *Star Wars* 30th Anniversary set in 2007. Her continued popularity with fans of all ages keeps the value of these cards high.

ANTHONY DANIELS (C-3PO) AUTOGRAPH CHASE CARD FROM THE EVOLUTION SERIES

TOPPS COMPANY INC.
UNITED STATES, 2001

Cards bearing autographs or artists' sketches have soared in popularity during this decade, due to both the relative scarcity of these chase cards and the idea of owning something that has been personalized "just for you"—that is, if you're lucky enough to find one randomly or have enough money to buy one from dealers. For example, one signed C-3PO card could be found in every 3,677 packs of the *Star Wars* Evolution series. Anthony Daniels signed again in 2007 for the *Star Wars* 30th Anniversary card set.

(Above)

NIEN NUNB PROMO CARD

TOPPS COMPANY INC.
UNITED STATES, 2001

This promotional card for the Evolution series was signed by Mike Quinn, the puppeteer who operated Lando Calrissian's copilot Nien Nunb in *Return of the Jedi*. Only 250 cards were signed.

DANIEL LOGAN AUTOGRAPH CHASE CARD

TOPPS COMPANY INC.
UNITED STATES, 2002

One Daniel Logan autograph card was found in every 570 packs of Topps's *Attack of the Clones* Widevision series. This was the only time Logan signed for Topps and his is the rarest of the twenty-six signed cards in this set.

SAMUEL L. JACKSON AUTOGRAPH CHASE CARD

TOPPS COMPANY INC.
UNITED STATES, 2005

One Samuel L. Jackson autograph could be found in every 2,795 packs of Topps's *Revenge of the Sith* Widevision cards. This was the only time he signed for Topps, and his is the rarest of the five signed cards in this set.

(Opposite)

MARK HAMILL AUTOGRAPH CHASE CARD

TOPPS COMPANY INC.
UNITED STATES, 2004

One Mark Hamill autographed card could be found in every 6,824 packs of the *Star Wars* Heritage series. This was the only time Mark Hamill signed for Topps.

JEREMY BULLOCH AUTOGRAPH CARD

OFFICIAL PIX
UNITED STATES, 2007

This card and autograph were available only to attendees of the Official *Star Wars* Fan Club Breakfast at *Star Wars* Fan Days in Dallas on October 20, 2007. Only about fifty exist. Scarcity, of course, factors into price, making a cheap piece of cardboard signed by a well-liked *Star Wars* actor a valuable commodity on auction sites like eBay. Even scarcer are uncut sheets signed by the celebrity attendees or filled with artists' sketches. There are only three of each.

HAYDEN CHRISTENSEN AUTOGRAPH CHASE CARD

TOPPS COMPANY INC.
UNITED STATES, 2006

This autograph card, from the Evolution Update series of trading cards, could be found only at the rate of one in every 2,005 packs of cards. Scarcity and star status helped the cards soar to more than $1,000 each in eBay auctions. That isn't the record, though. From a later set, Harrison Ford (Han Solo) autograph cards—limited to a total of ten—sold in eBay auctions for more than $6,000 each. There was only one Ford autograph in every 49,204 packs. You might have better odds in a state lottery.

JAMES EARL JONES AUTOGRAPH CHASE CARD

TOPPS COMPANY INC.
UNITED STATES, 2006

There was one James Earl Jones autograph card in every 2,005 packs of the *Star Wars* Evolution Update series. However, the set also included three "one of ones," which carried certified autographs cut from documents: George Lucas, Alec Guinness (Ben "Obi-Wan" Kenobi), and Peter Cushing (Grand Moff Tarkin). Not one of those has ever surfaced for sale, and it's possible that they will forever remain in some collector's sealed pack inside a sealed box.

LUKE SKYWALKER

JEREMY BULLOCH as BOBA FETT™

ANAKIN SKYWALKER

DARTH VADER

DAVE DORMAN *CLONE WARS* SKETCH CARD
(1 IN EVERY 1,945 PACKS)
TOPPS COMPANY INC.
UNITED STATES, 2004

RANDY MARTINEZ *STAR WARS* HERITAGE
SKETCH CARD
TOPPS COMPANY INC.
UNITED STATES, 2004

I'm still not sure how I feel about being portrayed as a bearded
Twi'lek with forehead lumps and head tails that are known
in-fantasy as "lekku." Twi'leks often are portrayed in the saga
as slaves or slavers, neither a very appetizing prospect. But at
least this Twi'lek appears to be in on the joke perpetrated by
artist Randy Martinez.

CLONE WARS "HOBBY EDITION" DISPLAY BOX
TOPPS COMPANY INC.
UNITED STATES, 2004

In recent years, Topps has shipped slightly different products
to various retail accounts. Hobby and comic shops usually got
card packs with hand-drawn artist-sketch cards while large re-
tailers got packs with easier-to-collect subsets of foil or other
specialty cards. For one recent *Star Wars* set, the company
made different specialty pieces for each of three large retailers
as well as for the hobby stores.

371

RANDY MARTINEZ SKETCH CARDS

TOPPS COMPANY INC.
UNITED STATES, 2005

This special six-panel series was included among the cards
that Topps let the individual sketch-card artists sell directly to
the public. The work by Randy Martinez is from the *Star Wars:
Revenge of the Sith* set.

RUSSELL WALKS SKETCH CARD
(1 IN EVERY 21,393 PACKS)

TOPPS COMPANY INC.
UNITED STATES, 2007

Russell Walks, well known for his amazing *Star Wars* art over the years, did very few sketch cards for the Topps *Star Wars* 30th Anniversary set. This beautiful portrait of Luke Skywalker was accidentally bent in half by Walks's daughter, but it was too nice to resist. The crease is not really noticeable unless pointed out. Sometimes a collector will eschew condition for rarity, and there's not much scarcer than one of one.

DAVE FILONI SKETCH CARD

TOPPS COMPANY INC.
UNITED STATES, 2008

Dave Filoni, supervising director of Lucasfilm's animated television series *Star Wars: The Clone Wars*, did just a handful of original sketches for the first series of Topps cards covering the show. This is the new character Ahsoka Tano, the young

Togrutan Padawan—or Learner—of the brash Anakin Skywalker. The small size of the canvas seems to inspire rather than limit most artists, proving what the wise Jedi Master Yoda once said: Size matters not!

DENNIS BUDD *THE CLONE WARS* SKETCH CARD, OBI-WAN KENOBI

TOPPS COMPANY INC.
UNITED STATES, 2008

DENNIS BUDD *THE CLONE WARS* SKETCH CARD, ANAKIN SKYWALKER

TOPPS COMPANY INC.
UNITED STATES, 2008

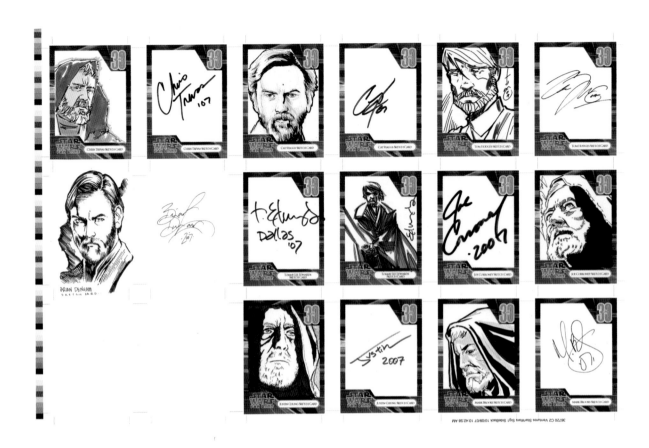

STAR WARS FAN DAYS SKETCH CARDS
UNCUT SHEET

OFFICIAL PIX
UNITED STATES, 2007

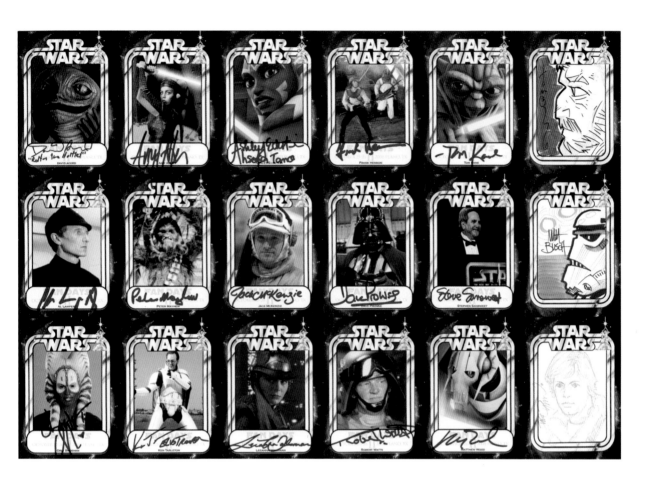

STAR WARS FAN DAYS II AUTOGRAPH CARDS
UNCUT SHEET

OFFICIAL PIX
UNITED STATES, 2008

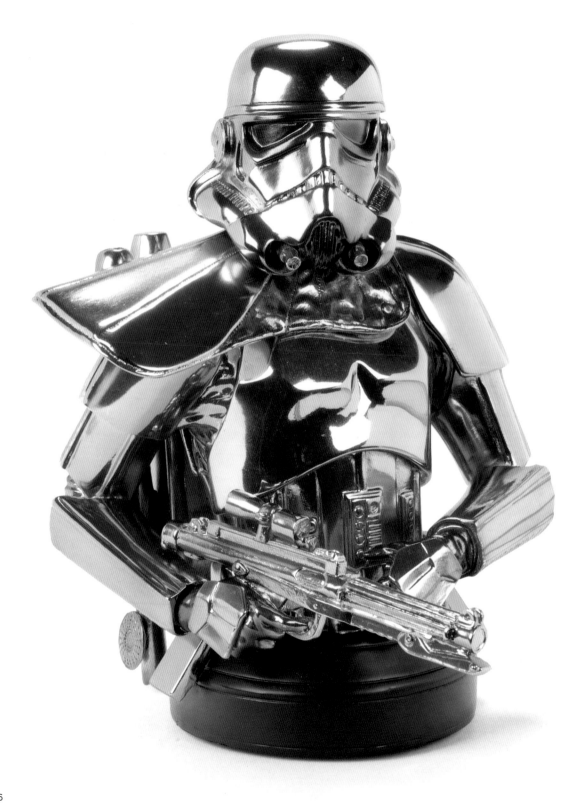

PADMÉ AMIDALA (*CLONE WARS*) ANIMATED MAQUETTE

GENTLE GIANT STUDIOS
UNITED STATES, 2005

With rare exception (perhaps Princess Leia in a gold bikini as Jabba the Hutt's slave), female images don't move *Star Wars* merchandise. This maquette is another, and unexpected, exception. It portrays Senator Amidala as she appeared in an episode of *Clone Wars*, journeying to the snowy planet Ilum. There was just something about the look of the character and the "snow-bunny" outfit that struck a chord. The white pompoms didn't hurt either. The figure quickly sold out, and its price rose to ten times the initial $80 in the aftermarket. A seller in early 2009 was seeking $1,200 for one.

YODA (*CLONE WARS*) MONUMENT

GENTLE GIANT STUDIOS
UNITED STATES, 2006

This three-foot-tall Yoda sculpture, based on the Jedi Master's look in the 2004–2005 Cartoon Network series *Clone Wars*, was originally produced by Gentle Giant in limited quantities as a store display for its mini-bust version. So many people asked about buying the display that the company produced its first large-scale "monument" for public sale. Others followed.

YODA (EPISODE III) MONUMENT
GENTLE GIANT STUDIOS
UNITED STATES, 2005

PRINCESS LEIA MONUMENT
GENTLE GIANT STUDIOS
UNITED STATES, 2007–2008

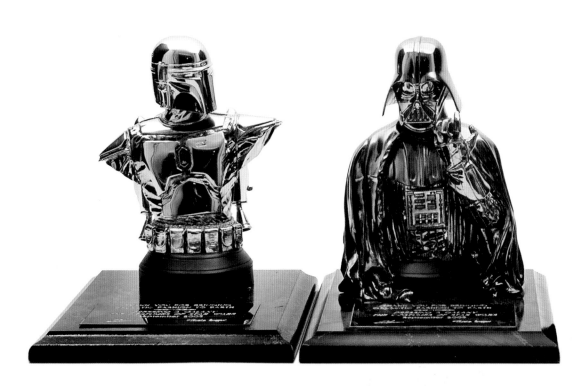

"DRESSING A GALAXY" EXHIBIT PLAQUES

GENTLE GIANT STUDIOS/LUCASFILM
UNITED STATES, 2005

These special chromed Gentle Giant figures were added to plaques to thank those responsible for putting on a dynamic special exhibition of *Star Wars* fashions at the Fashion Institute of Design and Merchandising in Los Angeles.

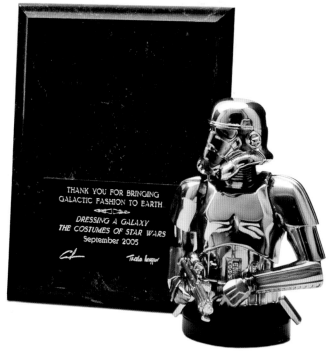

THANK YOU FOR BRINGING
GALACTIC FASHION TO EARTH.

DRESSING A GALAXY
THE COSTUMES OF STAR WARS
September 2005

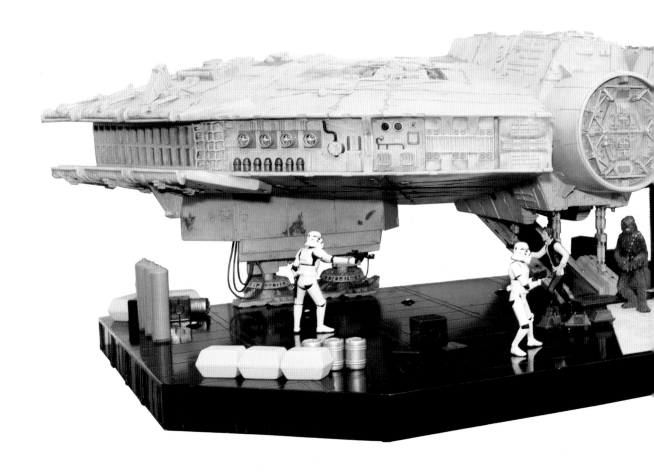

MILLENNIUM FALCON DIORAMA

ATTAKUS
FRANCE, 2005

One of the heaviest *Star Wars* collectibles ever made, this two-part diorama of a cutaway *Millennium Falcon* and the Death Star nook where Darth Vader confronts Obi-Wan Kenobi was also one of the most ambitious. Although it was limited to an edition of 400, it's doubtful that anywhere close to that number were produced because of its high price and the nearly as high shipping costs, which sent the total price soaring to more than $6,000. The figures, made of hand-painted metal, each were an additional $60 to $80. And although the diorama was shipped in three separate cartons, all attached to heavy wooden pallets, a mandible of the Falcon came severed and had to be fixed by a model-maker friend at an additional expense of several hundred dollars. Despite numerous follow-up emails over four years, none of which were answered, the company has yet to send me an exclusive metal figure that was a promised bonus with my purchase. My love affair with Attakus and its products thus came to an unhappy end.

JAWA, WICKET THE EWOK, AND YODA MAQUETTES

ATTAKUS
FRANCE, 2000

The French licensee Attakus was one of the first to sell meticulously sculpted small statues, or maquettes, that were made in limited editions. The name of the internal sculpting group was Bombyx. Each is named after a genus of silk moth. But that delightful derivation proved to be a problem when a large shipment of the company's *Star Wars* products arrived at an East Coast port a few months after the Sept. 11, 2001, terrorist attacks. A vigilant customs agent was alarmed by what looked like the words "ATTAK U.S." and "BOMB" printed on the cartons. Luckily, a quick call to Lucasfilm calmed the situation before the shipment was doused with water or exploded by the bomb squad.

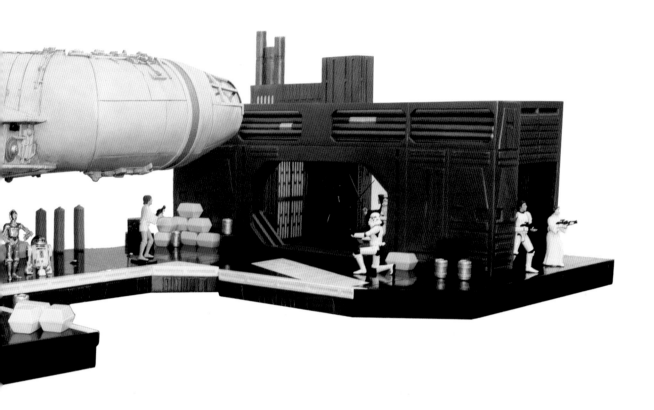

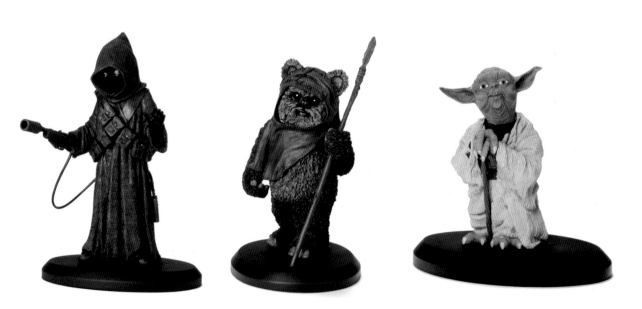

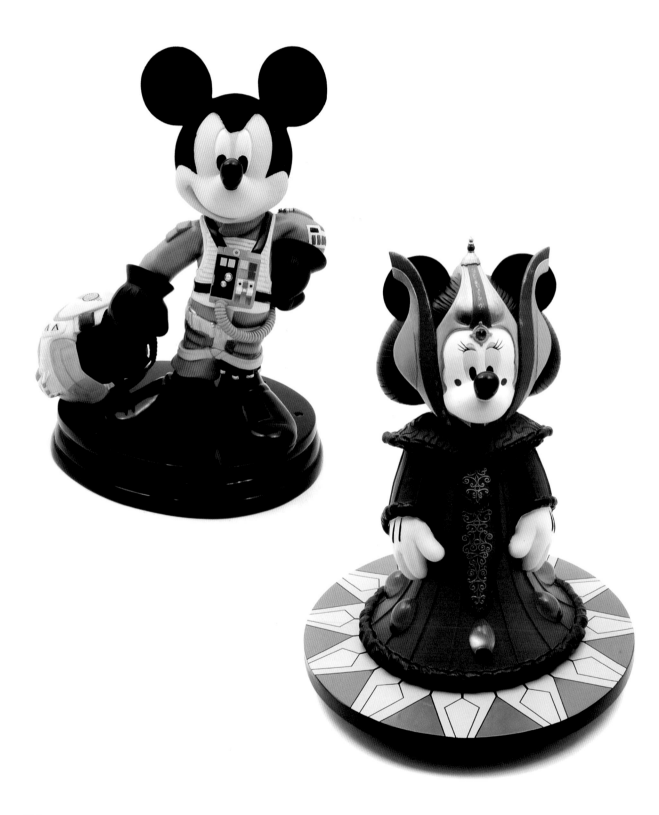

MICKEY MOUSE AS X-WING FIGHTER PILOT BIG FIG

WALT DISNEY COMPANY
UNITED STATES, 2007

With Walt Disney World putting on annual *Star Wars* Weekends every summer to tie in with its Star Tours ride, it's no wonder that there's been a bit of crossover between the two well-known family brands. These so-called Big Figs are among the best pieces available.

MINNIE MOUSE AS QUEEN AMIDALA BIG FIG

WALT DISNEY COMPANY
UNITED STATES, 2008

DONALD DUCK AS DARTH MAUL BIG FIG

WALT DISNEY COMPANY
UNITED STATES, 2008

DARTH VADER REVEALS ANAKIN SKYWALKER
LIFE-SIZE BUST AND HELMET

ILLUSIVE ORIGINALS
UNITED STATES, 1997

This unusual life-size resin and latex bust depicts the climactic
moment in *Return of the Jedi* when Luke Skywalker removes
his father's mask so that he and Anakin Skywalker can gaze
directly at each other for the first—and last—time. Mario
Chiodo, the sculptor and entrepreneur, was busy capturing
this moment of redemption in latex, fiberglass, leather, and
wool when I visited him for a story. "There was just something
about Darth Vader that I loved from the first time I saw *Star
Wars*, so this piece really holds special meaning for me," he told
me. Chiodo worked from copies of all the photo reference that
Lucasfilm had and played the brief scene in an endless loop
on a large-screen TV hanging from the ceiling as he sculpted
the head out of Plasticene clay covering an armature. The end
result is chillingly accurate.

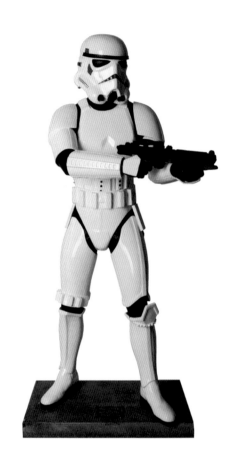

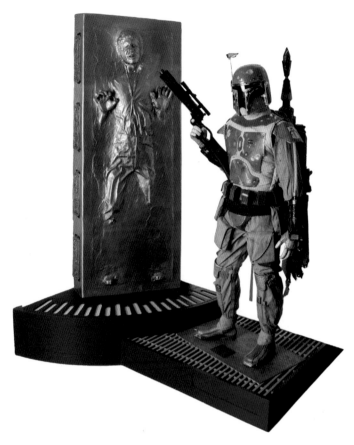

STORMTROOPER LIFE-SIZE REPLICA

DON POST STUDIOS
UNITED STATES, 1996

Don Post Studios, the venerable Southern California mask and helmet maker, was one of the earliest *Star Wars* licensees, and remained so for more than twenty years. There were always ads for Don Post *Star Wars* masks—the company started with Darth Vader, a stormtrooper, and Chewbacca—in pulp sci-fi, monster, and comic magazines. In the mid-1990s, Don Post got into the business of making high-end *Star Wars* mannequins that looked like they had just stepped off the set. Lucasfilm insisted that none of the costume pieces could be removable. The stormtrooper was first out the door. Although newly sculpted by Don Post artisans, it was a great amalgam of the different stormtrooper costumes made for each of the first three movies. The first sales were planned for a *Star Wars* Collection show that I cohosted on the QVC home shopping channel. There was an air of quiet apprehension as the show started; we had never before attempted to sell anything close to the $5,000 price point of the stormtrooper figure. We

shouldn't have worried. During the course of the two-hour show, we moved an amazing fifteen mannequins, and several more sold after the show went off the air. Don Post Studios was on its way to selling out the edition of five hundred.

HAN SOLO IN CARBONITE AND BOBA FETT LIFE-SIZE REPLICAS

ILLUSIVE ORIGINALS/DON POST STUDIOS
UNITED STATES, 1996–1997

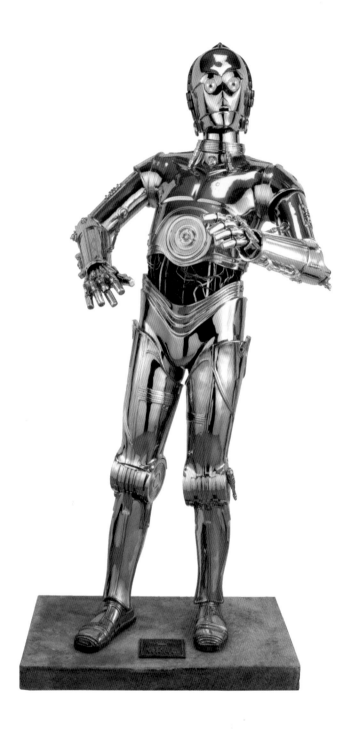

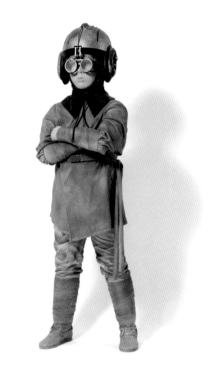

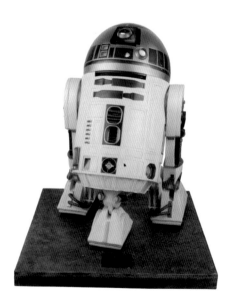

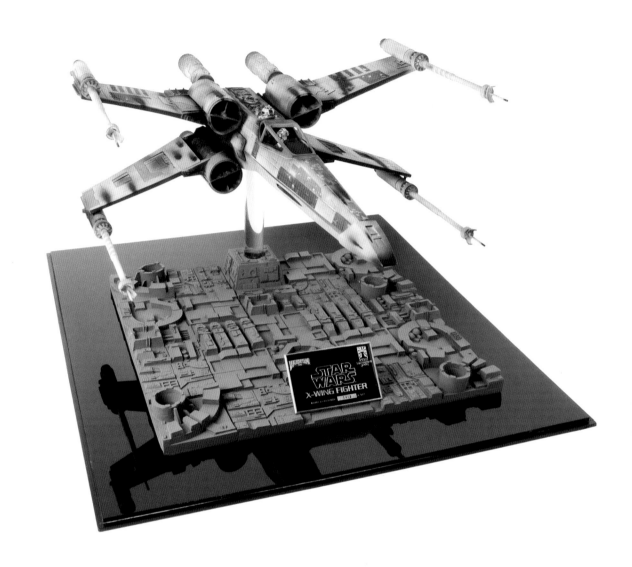

C-3PO LIFE-SIZE REPLICA

DON POST STUDIOS
UNITED STATES, 1997

ANAKIN SKYWALKER LIFE-SIZE REPLICA

DON POST STUDIOS
UNITED STATES, 1999

R2-D2 LIFE-SIZE REPLICA

DON POST STUDIOS
UNITED STATES, 1997

X-WING FIGHTER VEHICLE REPLICA

ICONS
UNITED STATES, 1997

JEFF GORDON #24 1999 *STAR WARS*/PEPSI CHEVROLET MONTE CARLO 1:24-SCALE STOCK CAR

ACTION PERFORMANCE COMPANIES INC.
UNITED STATES, 1999

With George Lucas being a huge racing fan (and also director of the ultimate movie about California car culture, *American Graffiti*), it seemed natural to pair the *Star Wars* prequels with that other American obsession, NASCAR. For Episode I there were more than sixty different miniature versions of the #24 Jeff Gordon car that was raced once—and finished in 33rd place. Gordon had a lot more success in 2005 before Episode III opened, coming in first at the Talladega Superspeedway with Yoda on the hood. While these cars can be played with, they are more of a big-boy's toy to be placed on the shelf and admired.

DALE JARRETT #88 2005 *STAR WARS*/M&M'S TAURUS 1:24-SCALE STOCK CAR

ACTION PERFORMANCE COMPANIES INC.
UNITED STATES, 2005

JOHN ANDRETTI #43 2002 *STAR WARS*/CHEERIOS DODGE INTREPID 1:64-SCALE STOCK CAR

TEAM CALIBER
UNITED STATES, 2002

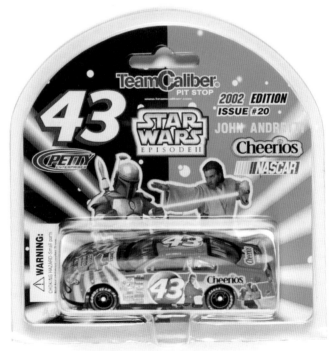

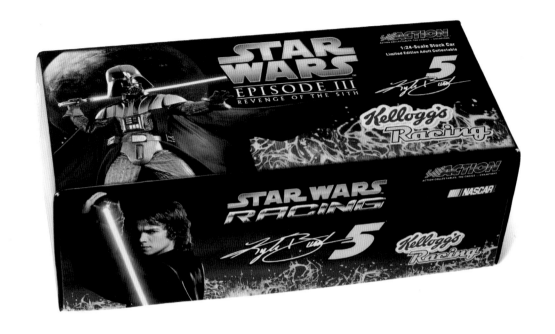

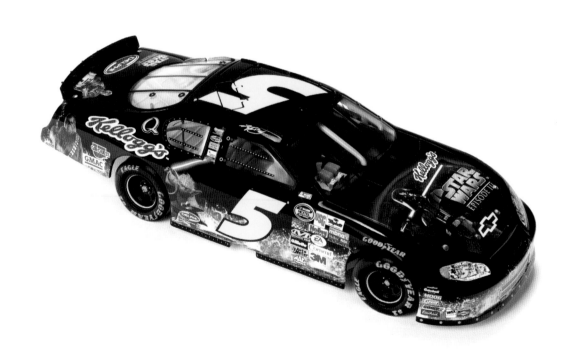

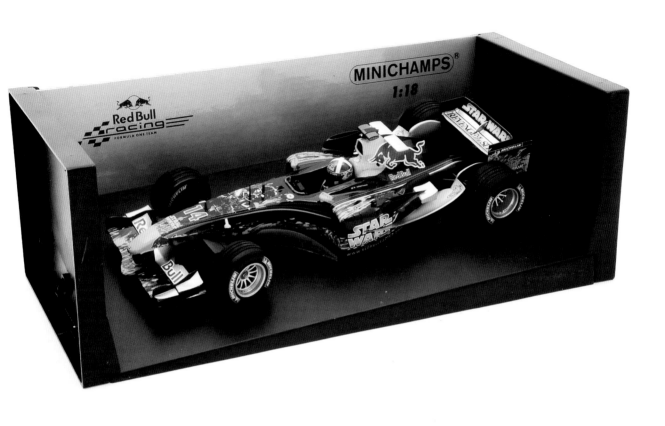

KYLE BUSCH #5 2005 *STAR WARS*/KELLOGG'S CHEVROLET MONTE CARLO 1:24-SCALE STOCK CAR WITH BOX
ACTION PERFORMANCE COMPANIES INC.
UNITED STATES, 2005

RED BULL RACING COSWORTH RB1 D. COULTHARD 2005 1:18-SCALE MINICHAMP
PAUL'S MODEL ART
UNITED KINGDOM, 2005

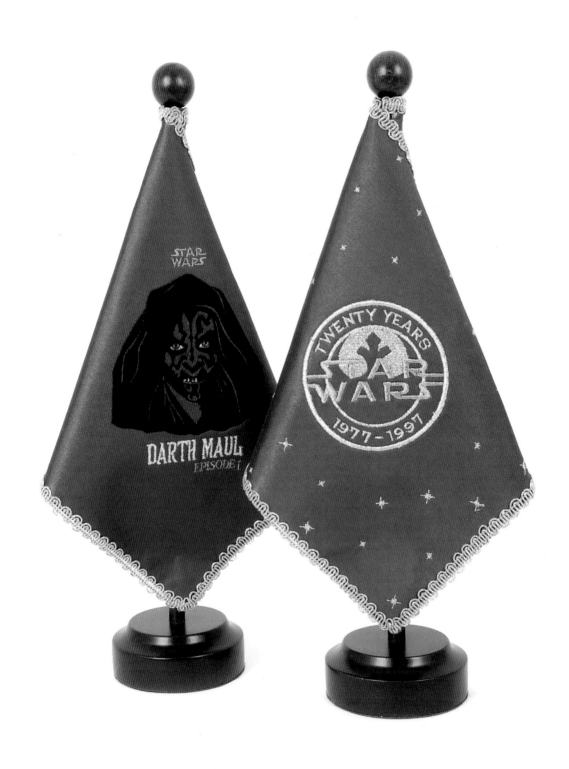

SLAVE I VS. JEDI STARFIGHTER GLOBE

NECA
UNITED STATES, 2002

STAR WARS LUKE AND LEIA GLOBE

ENCORE
UNITED STATES, 2005

YODA VS. DARTH SIDIOUS GLOBE

ENCORE
UNITED STATES, 2005

BATTLE OF HOTH GLOBE

ENCORE
UNITED STATES, 2005

BARNACON MINIATURE FLAGS

MADE FOR STAR WARS FAN CLUB SPAIN
SPAIN, 2000

Two sets of these miniature flags were made for this Spanish
fan convention, one of which was presented to me as a gift.

DARTH VADER SAMURAI SUIT OF ARMOR

YOSHITOKU
JAPAN, 2005

The Yoshitoku Company is Japan's oldest doll maker. Its president is the eleventh generation of a family that has owned the company for more than three hundred years. It has long produced small-scale versions of samurai armor for the traditional Japanese Boys' Day, when families place the suits outside their homes to wish their sons health, happiness, and prosperity. The company never licensed anything, until it came up with the idea of a Samurai Darth Vader. I love the fact that it was handmade by artisans with a passion for both quality and *Star Wars*. When all set up, it looks like a shrine—and it is: a tribute to the samurai of yore, to the great concept artist Ralph McQuarrie who based his incredible Vader design partially on samurai armor, and to Yoshitoku itself for readapting that design by linking it to its roots.

ACRYLIC DARTH VADER TRIPTYCH WITH AUTOGRAPHS

REBELSCUM.COM
UNITED STATES, 2005

This limited gift, made by Philip Wise, the Texas-based owner of the fan websites rebelscum.com and theforce.net, has the autographs of three Darth Vaders: David Prowse, who was inside the suit for the original three movies; James Earl Jones, who voiced Vader; and Hayden Christensen, the actor who got to don the suit at the end of *Revenge of the Sith*.

GEORGE LUCAS GRAND MARSHAL PIN
MADE FOR THE TOURNAMENT OF ROSES
UNITED STATES, 2007

It was a perfect kickoff to the thirtieth anniversary celebration of the original release of *Star Wars*. On January 1, 2007, the *"Star Wars* Spectacular" contingent in the 118-year-old Tournament of Roses Parade in Pasadena, California, rewrote records for the largest single unit ever in the parade's history. It was all George Lucas's idea, a way to honor the men and women of the 501st Legion, a fan costuming and service organization, whose members were on hand whenever Lucas showed up anywhere in the world for a *Star Wars* movie premiere or other event. At his request, Lucasfilm recruited more than two hundred costumers from around the world along with the high-stepping Grambling State University Tigers marching band. With a parade theme of "Our Good Nature," Lucasfilm created one float representing the lush Forest Moon of Endor and another the peaceful garden planet of Naboo. Five months into preparations, the organizing committee asked Lucas to be the parade's Grand Marshal, and he accepted. It was a truly amazing day that left all participants with lifelong memories and a few small souvenirs.

"STAR WARS SPECTACULAR"—
TOURNAMENT OF ROSES 2007 IDENTITY
PATCH FOR MARCHERS
MADE FOR LUCASFILM LTD.
UNITED STATES, 2007

GEORGE LUCAS HONORARY MEMBER CARD
501ST LEGION
UNITED STATES, 2006

BAGA FROM TOURNAMENT OF ROSES PARADE
FLOAT
FESTIVAL ARTISTS
UNITED STATES, 2006–2007

Baga was a young bordok who lived on the Forest Moon of Endor. A beast of burden built on a steel framework and covered totally by natural materials such as seeds and spices, the bordok "towed" an Ewok wagon at the front of the Endor float.

George Lucas - Creator of Star Wars
HONORARY MEMBER

PROGRAM TRIBUTE AD TO THE 501ST LEGION FROM GEORGE LUCAS AND LUCASFILM

TOURNAMENT OF ROSES/LUCASFILM LTD.
UNITED STATES, 2007

THE 118TH TOURNAMENT OF ROSES PROGRAM BOOK

TOURNAMENT OF ROSES
UNITED STATES, 2007

"*STAR WARS* SPECTACULAR" ROSE PARADE PIN

TOURNAMENT OF ROSES/LUCASFILM LTD.
UNITED STATES, 2007

***STAR WARS* LOGO DRUM HEAD FOR GRAMBLING STATE DRUMMERS IN TOURNAMENT OF ROSES PARADE**

REMO
UNITED STATES, 2007

BOBBLE HEADS: SHADOW STORMTROOPER PROTOTYPE, GAMORREAN GUARD, TUSKEN RAIDER, JANGO FETT, AND CHEWBACCA

FUNKO
UNITED STATES, 2007–2008

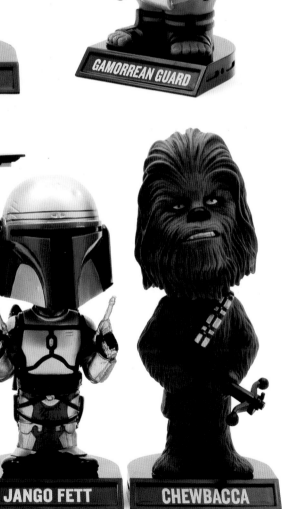

GAMORREAN GUARD

TUSKEN RAIDER JANGO FETT CHEWBACCA

CLONE TROOPER REPLICA HELMETS

MASTER REPLICAS
UNITED STATES, 2005–2007

(Left to right)
Clone Commander Gree
Imperial Shock Trooper
Special Ops Trooper

STARSPEEDER 3000 MINIATURE MODEL

INDUSTRIAL LIGHT & MAGIC
UNITED STATES, 1985

This miniature of the vehicle that appears in the ride film for
Star Tours at the Disney parks was cast in clear resin with
miniature lights inside. After it was painted, the areas where
the lights needed to shine through were scraped.

LIGHTSABER PROP REPLICAS (FROM LEFT):
YODA, ANAKIN SKYWALKER, DARTH SIDIOUS,
AND OBI-WAN KENOBI

MASTER REPLICAS
UNITED STATES, 2005

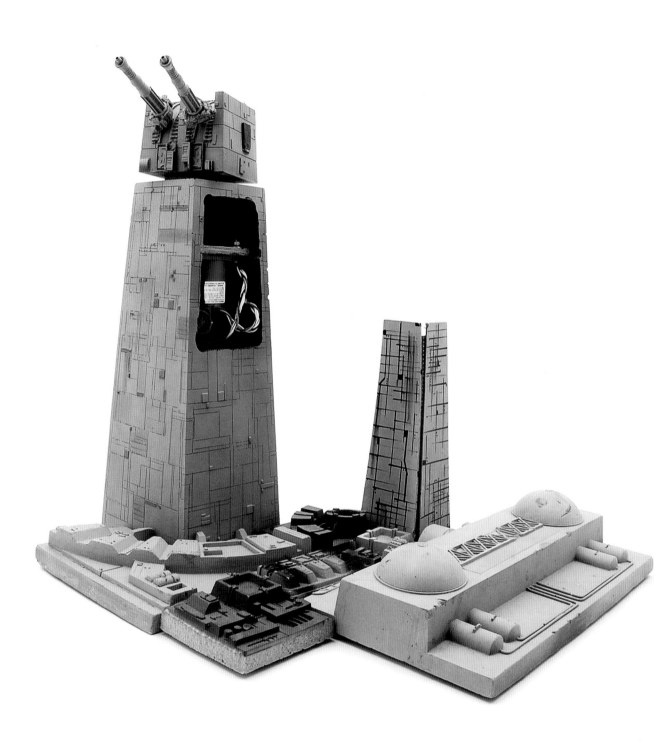

DEATH STAR PROP PIECES
LUCASFILM LTD.
UNITED STATES, 1976

The surface of the Death Star was made up of hundreds of cast-foam pieces in six basic designs and mainly in three different sizes. They were mixed and matched to provide variety and add a sense of reality to the Empire's main weapon of destruction. The tiles were assembled on a large, flat surface in the parking lot of ILM, then in Van Nuys, California, and a pickup truck–mounted camera sped by to capture shots of the surface as seen by speeding spacecraft. Some of the towers had motion-control motors to be able to exactly replicate their movements in shots that needed frequent exposures because of the number of models flying by. On the periphery of the shots, there were painted cardboard "gun towers." One day in the mid–1990s I got a call from a model-maker friend. "There's a guy I'm working with here in Hollywood whose friend once gave him a box full of Death Star pieces and he wants to sell them. Are you interested?" I already had a few pieces and I was interested, of course, but also deeply suspicious. After all, how often does someone call and offer you a box of used gold bullion? And for all I knew, that's how he might price it if it were real. When I arrived at the small model shop, the potential seller brought out an old cardboard box that was about three feet high. I reached deep inside and pulled out a plastic bag filled with green plastic Army men. Hmm . . . not a good sign. But when I carefully turned the box upside down, with permission, I knew instantly that this was the real deal. There were maybe fifteen to twenty good-sized chunks of the Death Star surface and other pieces that had served as the sides of the trench that Luke Skywalker flew down. Fantastic stuff, but could I afford it? "Make me an offer," the friendly guy said, something I really hate to hear as a collector. Where to start? I gulped and said quietly, "A thousand dollars?" "Oh no," the guy quickly responded. My heart sank. Then he added, "I only need eight hundred to make this month's rent payment, so you can have it all for that." Some days the Force truly is with you.

WAMPA CAVE "SNOW"
LUCASFILM LTD.
UNITED STATES, 1996

One of the few changes to the Special Edition version of *The Empire Strikes Back* was to extend the screen time of the wampa snow creature so you could actually see it onscreen. That meant constructing both a new costume (which its creator, ILM's Howie Weed, also wore on camera) and a small part of the ice cave. After the shoot, as the cave parts were being junked, I got a call from a colleague who was helping toss the trash. "Would you at all be interested in a small piece of the cave?" she asked. That was definitely the silliest question I had been asked in weeks.

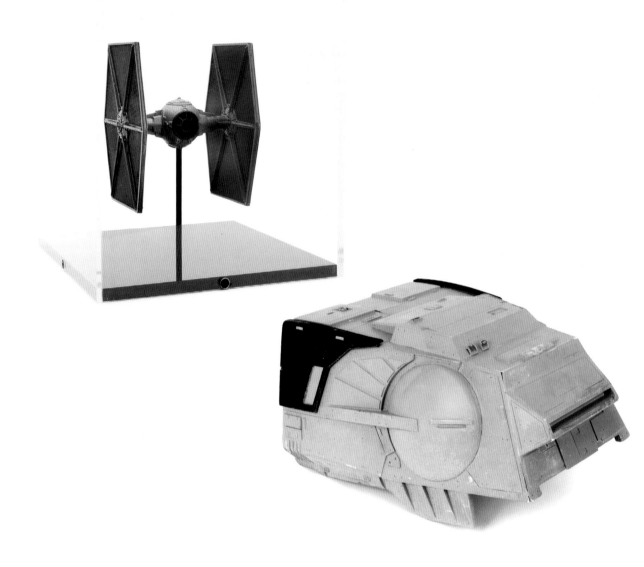

FOUR-FOOT AT-AT HEAD BUCK

LUCASFILM LTD.
UNITED STATES, 1979

This wooden "buck" was used to model the head of the four-foot-tall Imperial Walker, or AT-AT, for the Hoth ice planet battle sequence near the start of *The Empire Strikes Back*. Most of the AT-ATs, which were manipulated frame by frame to show movement, were two feet tall, although some were tiny to give perspective. The tall Walker made from this piece was the one that collapsed on center screen as its knees buckled.

TIE FIGHTER PROP

INDUSTRIAL LIGHT & MAGIC
UNITED STATES, 1978–1979

This small-scale TIE fighter is a filming model used in the making of *The Empire Strikes Back*.

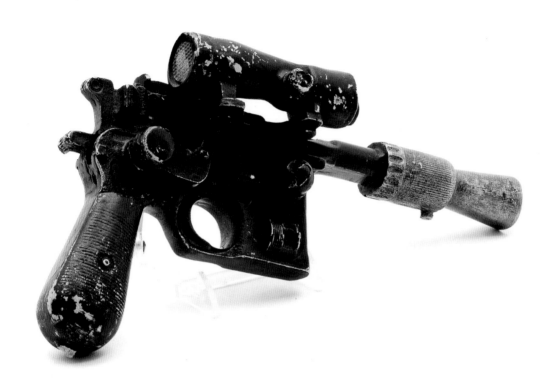

HAN SOLO "THROW DOWN" PISTOL

LUCASFILM LTD.
UNITED STATES, 1979

You couldn't prove it by me, but prop mavens, who study photo reference and watch scenes frame by frame in high definition on big-screen TVs, tell me that this is a screen-used stunt pistol—Han Solo's to be exact. Made out of lightweight resin, it was a lot lighter than the tricked-out old "Broomhandle" Mauser that served as the "hero" prop in close-ups. This prop apparently was made for *The Empire Strikes Back* but got its main use in *Return of the Jedi* as the gun Harrison Ford throws down when he is caught in the Imperial bunker on the Forest Moon of Endor.

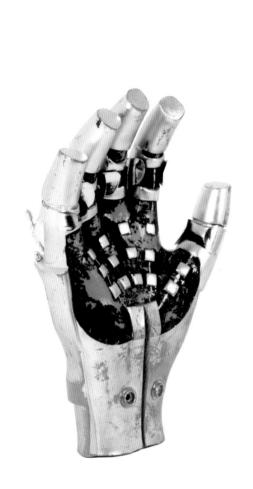
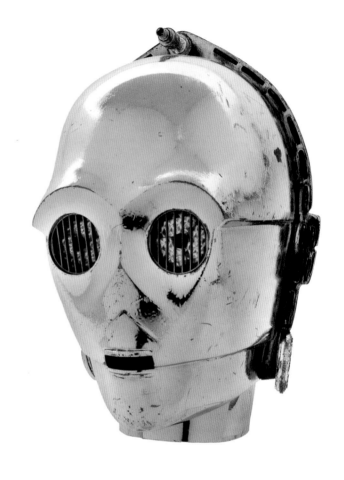

C-3PO COSTUME HEAD AND HAND

LUCASFILM LTD.
UNITED STATES, 1980

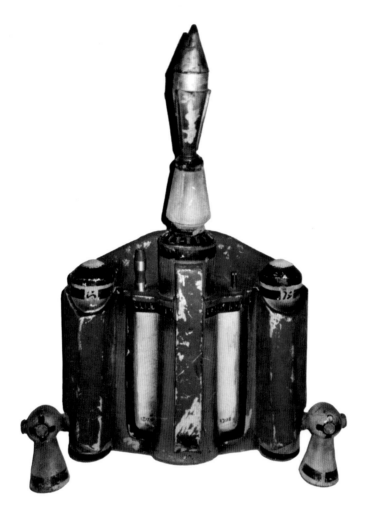

BOBA FETT STUNT ROCKET PACK

LUCASFILM LTD.
UNITED STATES, 1981

While some pieces have indeed gotten away from me, this is one that didn't, proving that persistence can pay off. In addition to the official *Star Wars* 10th Anniversary convention in Los Angeles in 1987, there were several less official ones. I flew to San Jose, California, for the day to attend one of these events. I got into the dealers' room an hour early thanks to good friends who were selling at the show. This piece hit me almost immediately. It was propped up on a chair, and as I approached my heart started going into arrhythmia, my face flushed, and my palms got sweaty. I walked around the chair, gently touched the piece, and faced the dealers. "Um, what is this?" "Well," said a guy who introduced himself as Rick, "we have a store in San Anselmo near ILM, and one day someone came in, said they worked there, and that they had rescued this from the trash. It was in a few pieces, he said, so he repaired it. He said it was a stunt rocket pack used for Boba Fett in *Return of the Jedi*, but of course, we can't vouch for that 100 percent." Maybe

not, but it looked awfully good to me; it was made mostly out of a rubbery foam, which would have cushioned any fall by the stunt man into the hole in the desert near Yuma, Arizona, which stood in for the Sarlacc pit. I was trying to play it cool. "Oh, really? How much do you want for it?" "Well, we really don't know," Rick said. "We're just going to leave it there for the whole show and consider offers." Darn! I had to leave early to catch my return flight, and I had no way of taking this large piece with me. I conferred with my dealer friends, Anne and Judy, and they said they'd be happy to transport the piece in their van back to Southern California if I could make it mine. For the next half hour I made myself a friendly nuisance at Rick's table. He was insistent; I was persistent. I glanced at my watch. The show was about to open to the public, and I somehow got him to state a price, although he did so reluctantly. It was reasonable—very reasonable. More than twenty years later, I'm still in touch with Rick, a prince of a guy. But he rarely forgets to remind me of what he once called my "deal of the century."

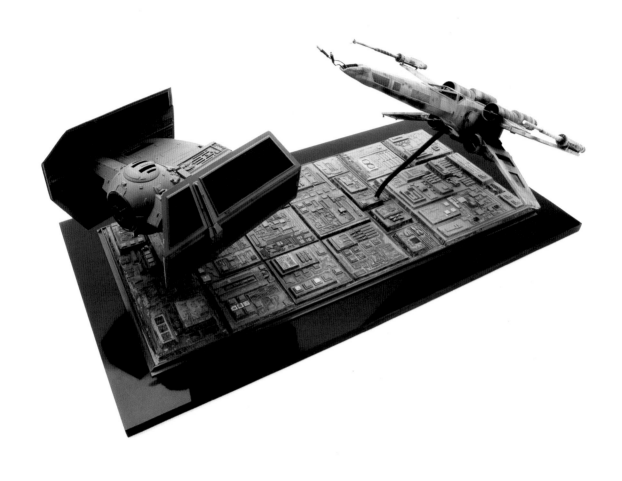

**DARTH VADER'S TIE FIGHTER AND X-WING
FIGHTER PROP MODELS**

INDUSTRIAL LIGHT & MAGIC
UNITED STATES, 1979

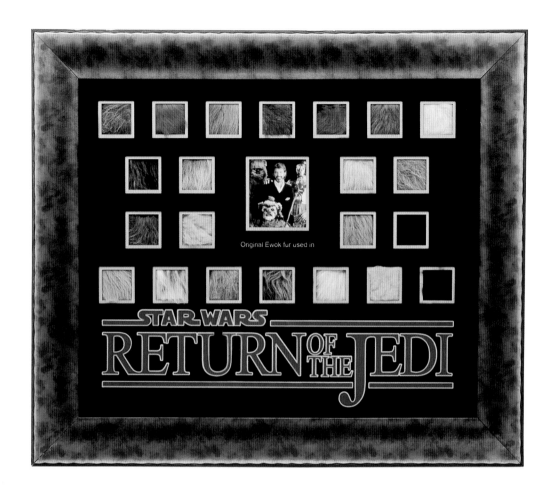

Original Ewok fur used in

EWOK "FUR" FROM STUART FREEBORN

PROP STORE OF LONDON
UNITED KINGDOM, 2007

Since it is a personal goal to pay the Ewoks the respect they are due for helping save the galaxy, I couldn't resist this beautifully framed memento from *Return of the Jedi*. Stuart Freeborn, the makeup designer on the film, still had pelts of artificial Ewok fur around his home workshop more than two decades after the movie's release. The Prop Store of London put them to good use by composing this framed sampling of nearly every Ewok variant on the Forest Moon of Endor.

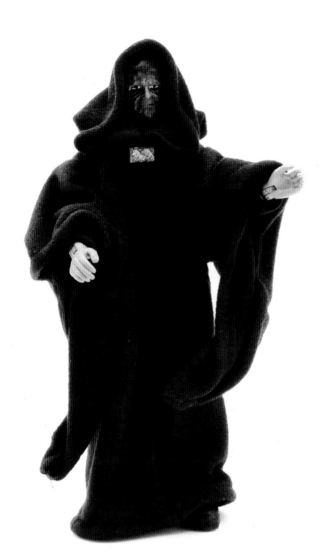

EMPEROR PUPPET FROM *ROBOT CHICKEN*

STOOPID MONKEY
UNITED STATES, 2007

Robot Chicken on the Cartoon Network's Adult Swim program block is one the funniest shows on television. Using stop-motion miniatures, it skewers pop culture and produces frequent belly laughs. Its creators, Seth Green and Matt Senreich, have become part of the extended family at Lucasfilm and have produced several half-hour all *Star Wars* specials. This is an eight-inch Emperor figure used in the production of one of the funniest sketches: The Emperor is having a meeting with his aides when Darth Vader calls to tell him that some kid has just blown up the Death Star. Furious, the Emperor listens as Vader spins his tale of woe, then utters a line that gained instant immortality among *Star Wars* fans: "What the hell is an Aluminum Falcon?" Seth and Matt contributed the figure to an auction to raise money for the AIDS and Breast Cancer Emergency Funds of San Francisco. Guess whose bid was highest?

ADMIRAL ACKBAR CEREAL BOX

CARTOON NETWORK/ADULT SWIM
UNITED KINGDOM, 2008

One short bit in a *Robot Chicken Star Wars* special had squid-faced Admiral Ackbar, leader of the Rebel fleet in *Return of the Jedi*, promote his eponymous cereal in a parody commercial. This mini-box, filled with real cereal and a mini DVD, was used to help promote the show in the United Kingdom.

501ST CHARITY PATCH QUILT

TERRI HODGES
UNITED STATES, 2008

This amazing quilt, in which each square contains a patch from a garrison, outpost, squad, or individual trooper of the 501st Legion, was sold at an auction to raise money for the Make-a-Wish Foundation.

413

USE IT

The actor-writer-director Kevin Smith (*Clerks*, *Mall-rats*, *Chasing Amy*) visited Rancho Obi-Wan one day a few years ago to tape a special for the Sci-Fi Channel on fan-made short films devoted to *Star Wars*. He's a fan, and as funny in person as his funniest moments on-screen or at conventions. During breaks in the set-ups, Kevin started asking me if I had particular toys from his childhood, so I would run to get them. It became a friendly challenge. "Well, I bet you don't have a *Star Wars* (fill in the blank)." I easily got through cake pans, trash cans, pencil sharpeners, and a lot more. "Well, I bet you don't have a real *Star Wars* fan on a shelf in here." Kevin, of course, meant a live one, but I made a beeline for a Japanese hand fan that was a promotional item for the airing of *The Empire Strikes Back* on television.

That got me to thinking. Even though toys are at the center of the *Star Wars* merchandising universe, there have been a lot of saga-related items that people use in their everyday lives. A child's bedroom, for example, can have *Star Wars* linens, curtains, and blinds; walls lined with *Star Wars* art or posters; and an R2-D2 and C-3PO throw rug on the floor. On the small *Star Wars* desk sits a "dark side" computer, and the

Star Wars bookcase houses, of course, saga books and comics. Move on down the hall to the bathroom, where you can brush your teeth, take a shower, and dry off using licensed products. And, as you'll see in this chapter, there is even *Star Wars* toilet paper, after a fashion, and an R2-D2 toilet-paper-roll cover.

We could continue the journey throughout the house, especially the kitchen. My one regret is that I can't show you my fantastic, but bootleg, giant Death Star Jell-O mold from Mexico. It disappeared during one of the many shifts and makeovers of Rancho Obi-Wan, and remains among the missing. I haven't had the temerity to tell my friend Emilio, who went to the ends of the earth—or at least the extremities of Mexico City—to find it for me many years ago.

All licensed products today ring up annual world-wide sales of around $108 billion. In 1976, the year before *Star Wars* opened, consumers around the globe

DARTH VADER/DEATH STAR UMBRELLA WITH LIGHTSABER HANDLE
HAPPINET
JAPAN, 2005

spent less than $5 billion on licensed goods. At least to some extent, licensed products let someone relive the happiness, excitement, buzz, or whatever it was that they took away from the entertainment behind the license. Partly, it's a small act of loyalty, or maybe an unexpressed hope that by making the creator of the brand happy and wealthy, he or she will produce more of what hooked you in the first place. Using licensed *Star Wars* products is also an act of self-identification backed by hard-earned income. And it fits in with the sense of community that binds fans together wherever they are. It says, "We are all members of the *Star Wars* tribe."

We're blocked by reality from getting some of the things we'd like to get from the *Star Wars* movies. Intergalactic peace. Unending adventure. A hot princess to rescue or a studly rascal for a boyfriend. Of these, none likely will you have. But *Star Wars* shampoo and bubble bath? Yes. A Jabba the Hutt cookie jar? Oh, yes. Special *Star Wars* equipment to make popcorn, shaped character cakes, and even toast? Yes, yes, yes! Is there a global financial meltdown? Just have the president ask George Lucas to make another live-action *Star Wars* movie with all the merchandise in its wake. That surely will end it. When our income is suffering, we first buy things we need, then things we love. But if we can get two hits for the price of one, why not?

A cautionary note. Occasionally when you buy licensed merchandise based on its look, you might be disappointed by its functionality. Lucas Licensing has been very good guarding against this problem. For example, there's a tale in this chapter about an outstanding-looking lunch pail that never went to market because of a critical design error. But sometimes something slips by. Take my licensed British barware set. The four pewter pieces look nice enough, even if they were a tad expensive. But the C-3PO knife to cut the seal on a bottle of wine is so short, awkwardly placed, and dull that your teeth would do a better job. Ditto the Darth Vader corkscrew, which might work if the cork were only a half-inch deep—which is exactly the problem with the Yoda-head cork. As for the R2-D2 bottle opener, I challenge anyone to use it to open a real-world, or even a fantasy-world, bottle. The company that foisted these on us is no longer a licensee.

There certainly has been a wide range of *Star Wars* items to shop for over the years, and at every price point. In Mexico, you could buy your daughter Avon's splash-on *colonia para niñas*, which came in a plastic bottle with a photo of Anakin Skywalker and Padmé Amidala about to kiss before their near-certain execution; if your daughter likes the smell of sunscreen lotion, she'd probably like this. For the more sophisticated, there was Yves Saint Laurent's "One Love" cosmetics line available at only the trendiest stores in a handful of the most fashion-conscious cities in the world. It may be telling that no *Star Wars* fan I know—male or female—ever reported seeing it for sale. And if you're looking for something totally upscale, the Finnish jewelry company that made the sterling silver necklace worn by Princess Leia at the end of *Star Wars* is still making it today (see page 180); it will set you back only about one thousand Euros. If you can pay for it with cash, that probably means you haven't touched your money since you started a *Star Wars* savings account in 1983 at the NSW (New South Wales) Building Society in Australia, but don't go looking for it under that name. A couple of years after the promotion, it turned itself into a bank.

Finally, you can use *Star Wars* products to relax or to exercise. Use your stormtrooper pick to strum a tune on your Darth Vader Retrorocket guitar from Japan. Or, if you still have a record player, spin the German 45 rpm single, "Bang Bang Robot Disco." Settle down with a friend over a *Star Wars* pewter chess set. If you feel energetic, get in a game of disc golf with your licensed flying discs, go bowling with your *Star Wars* ball and bag, or play at your saga foosball table. In *Star Wars* land, boredom has been banished.

"RUMPH" CERAMIC TANKARDS

JIM RUMPH FOR CALIFORNIA ORIGINALS
UNITED STATES, 1977

Obi-Wan Kenobi
Chewbacca
Darth Vader

When George Lucas was writing the screenplay for *Star Wars*, he says, he really wasn't thinking very much about possible merchandise. But once concept artist Ralph McQuarrie and he settled on a barrel shape for the hero droid R2-D2, it seemed natural to have an R2-D2 jar. And since mugs with dog breeds were (and remain) popular, it wasn't hard to think of one for Chewbacca, patterned after Lucas's faithful dog, Indiana. "When you're sitting and writing all day long, you ruminate," Lucas says. "It wasn't, 'Gee, I could turn Chewie into a Wookiee mug and R2-D2 into a cookie jar and make a lot of money'. It was simply that the design of R2 reminded me of a cookie jar, and I thought it would be funny to lift his top off and grab a cookie."

R2-D2, C-3PO, AND R4-P17 DRINKING
GLASSES IN THE ETCHED KIRIKO STYLE

KOTOBUKIYA
JAPAN, 2007

Kotobukiya makes amazing prepainted *Star Wars* model kits.
So it was surprising to see the company selling these intri-
cately carved drinking glasses at two United States fan events
in 2008. As the company explained it, "Kiriko is a traditional
Japanese glass-etching technique to make subtle alterations
to everyday glass tableware. As Kiriko developed during the
Meiji era (mid-nineteenth century), the craft went through
many revisions, such as utilizing new equipment introduced
from the West, while still retaining the time-honored Japanese
techniques utilized until this day." The *Star Wars* droid glasses
were hand-etched at different depths, producing complex
engravings.

PINE-SOL AND FLYING DISK PREMIUMS
PINE-SOL
UNITED STATES, 1977

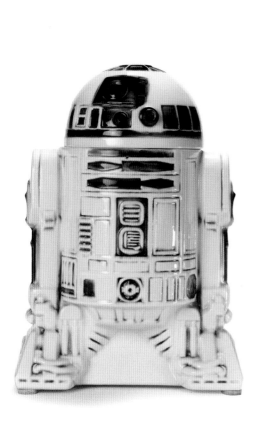

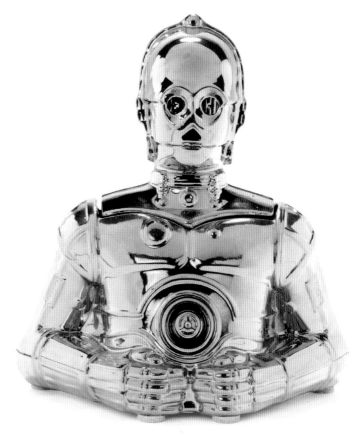

PITCHER AND GLASS SET FOR STAR TOURS STORES

WALT DISNEY COMPANY
UNITED STATES, 2005

The unusual curved design places this set in a galaxy far away.

R2-D2 CERAMIC COOKIE JAR

ROMAN CERAMICS CORP.
UNITED STATES, 1977

C-3PO CERAMIC COOKIE JAR

ROMAN CERAMICS CORP.
UNITED STATES, 1978

Possibly because the right look for the metallic glaze was difficult to achieve, this companion to the early R2-D2 cookie jar didn't arrive at stores until many months later. C-3PO was also made in smaller numbers than his droid partner and is more difficult to find today.

DARTH VADER EGG CUP PROTOTYPES

UNKNOWN
UNITED KINGDOM, 1996

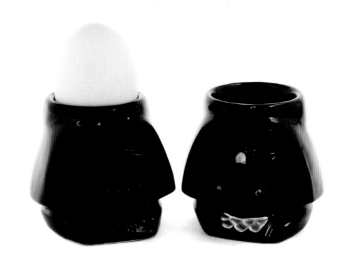

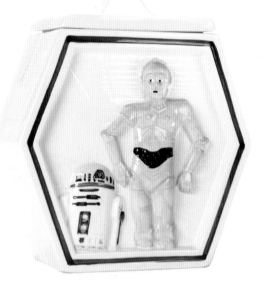

**C-3PO AND R2-D2/DARTH VADER CERAMIC
COOKIE JAR (BOTH SIDES)**

SIGMA
UNITED STATES, 1983

JABBA THE HUTT CERAMIC COOKIE JAR

STAR JARS
UNITED STATES, 1998

"Take a cookie at your own peril" this huge cookie jar seems to
shout. "Take a bunch and you'll start to look like me!" The latter
is even more frightening.

DEATH STAR CERAMIC COOKIE JAR

CARDS INC.
UNITED KINGDOM, 2006

LUKE ON A TAUNTAUN CERAMIC TEAPOT

SIGMA
UNITED STATES, 1981–1982

From 1981 to 1983, Sigma released dozens of ceramic *Star Wars* objects. Playful and almost childlike in their design, they have long since become favorites among collectors. Many of the items tried to be practical, such as a trinket box in the shape of a stormtrooper helmet. They included a snowspeeder toothbrush holder, a landspeeder soap dish, a Yoda candlestick, and an R2-D2 scissors holder and string dispenser. For *Return of the Jedi*, the company produced small ceramic figurines of the main characters, but gave them all faces that made them look like kids. Of course, there was that awkward C-3PO cellophane tape dispenser that forced a user to yank the tape from, well, you know.

JABBA THE HUTT CERAMIC BANK

SIGMA
UNITED STATES, 1983

C-3PO CERAMIC TAPE DISPENSER

SIGMA
UNITED STATES, 1981–1982

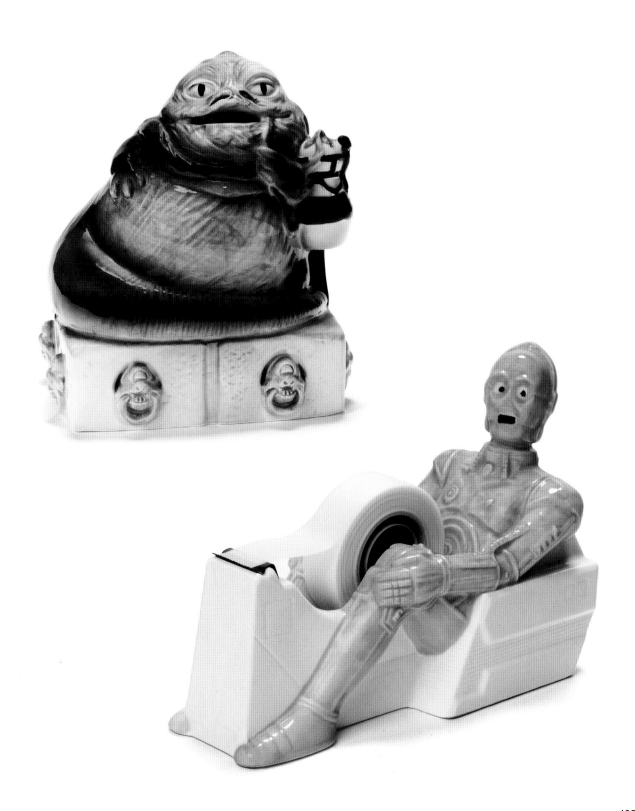

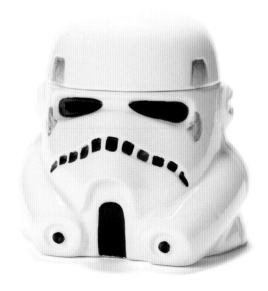

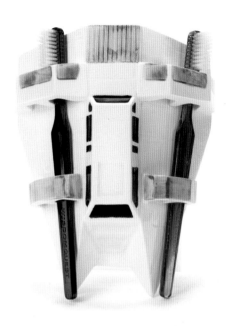

(Opposite)

**GUN TURRET WITH C-3PO CERAMIC
MUSIC BOX**

SIGMA
UNITED STATES, 1981–1982

DARTH VADER CERAMIC FRAMED MIRROR

SIGMA
UNITED STATES, 1981–1982

**R2-D2 CERAMIC STRING DISPENSER AND
SCISSORS HOLDER**

SIGMA
UNITED STATES, 1981–1982

**STORMTROOPER HELMET CERAMIC
TRINKET BOX**

SIGMA
UNITED STATES, 1981–1982

(This page)

**LANDSPEEDER CERAMIC SOAP DISH WITH
C-3PO AND OBI-WAN KENOBI**

SIGMA
UNITED STATES, 1981–1982

**REBEL SNOWSPEEDER CERAMIC
TOOTHBRUSH HOLDER**

SIGMA
UNITED STATES, 1981–1982

WICKET AND KNEESAA CERAMIC MUSIC BOX

SIGMA
UNITED STATES, 1983

STAR WARS 8 MM FILM

KEN FILMS UNDER LICENSE FROM
20TH CENTURY FOX
ITALY, 1978

An interim step between hand-cranked film in kids' toy projectors and video cassettes, 8 mm films showing short scenes from *Star Wars* were available in at least half a dozen countries. The nicest batch was released in Italy by United States licensee Ken Films. There were six different titles, each with multiple, if similar, short clips in color and with sound, and they were released in hard plastic cases with attractive graphics. The format basically died in the early 1980s as VHS and Beta movie tapes became widely available for sale or rental.

STORE DISPLAY FOR VIDEO RELEASE OF *DROIDS* TV SERIES

CBS FOX VIDEO
GERMANY, 1985

REVENGE OF THE SITH POPCORN MACHINE AND CART

SNAPPY POPCORN CO.
UNITED STATES, 2005

When you're watching a marathon of *Star Wars* movies on your big-screen TV, you definitely need more than a bag of microwave popcorn. This machine is the real deal. It comes in five different tops and five carts, and you can mix and match to your heart's content—as long as the sizes match.

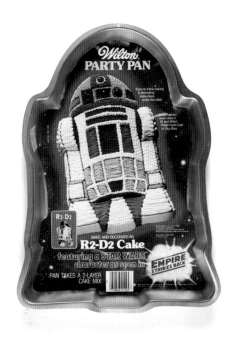

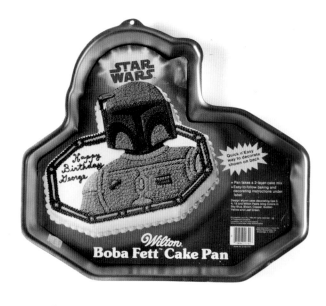

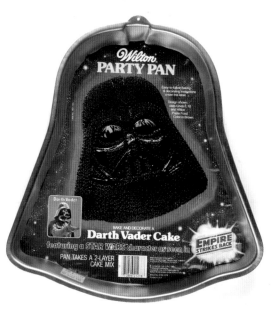

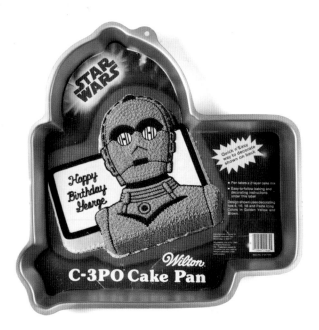

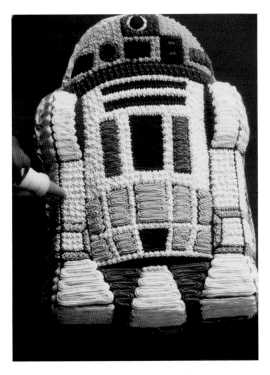

R2-D2 CAKE PAN

WILTON ENTERPRISES
UNITED STATES, 1980

Of all the "useful" *Star Wars* items no longer made, anecdotally the most requested have been the Wilton "party pans" that would let resourceful bakers make cakes in the shapes of R2-D2, C-3PO, Darth Vader, and Boba Fett. It certainly would be a challenge to get the icing to look as exquisite as it does in the photos, but who really cares after the first delicious forkful is eaten?

BOBA FETT CAKE PAN

WILTON ENTERPRISES
UNITED STATES, 1983

DARTH VADER CAKE PAN

WILTON ENTERPRISES
UNITED STATES, 1980

C-3PO CAKE PAN

WILTON ENTERPRISES
UNITED STATES, 1980

R2-D2 CAKE

WILTON ENTERPRISES
UNITED STATES, 1980

CELEBRATION SPONGE CAKE: VADER IN FLAMES

ELISABETH THE CHEF
UNITED KINGDOM, 2005

The box of this decorated cake proclaims: "Natural Coloured Sugarpaste." I actually cut up a fresh one while visiting the United Kingdom and shared it with friends. They are now all former friends.

METAL LUNCH BOXES

KING SEELEY THERMOS
UNITED STATES, 1977, 1980, 1983

A sign of the times? Any idea why most kids' lunch boxes these days are made of cloth or plastic? One reason is that too many schools— even grade schools—have metal detectors, and the numbers are growing.

PEWTER BARWARE: YODA WINE CORK, C-3PO KNIFE, R2-D2 BOTTLE OPENER, AND DARTH VADER CORKSCREW

CARDS INC.
UNITED STATES, 2005

Interesting-looking, but totally useless. Whoever designed this pewter barware clearly never served any alcoholic beverages at home.

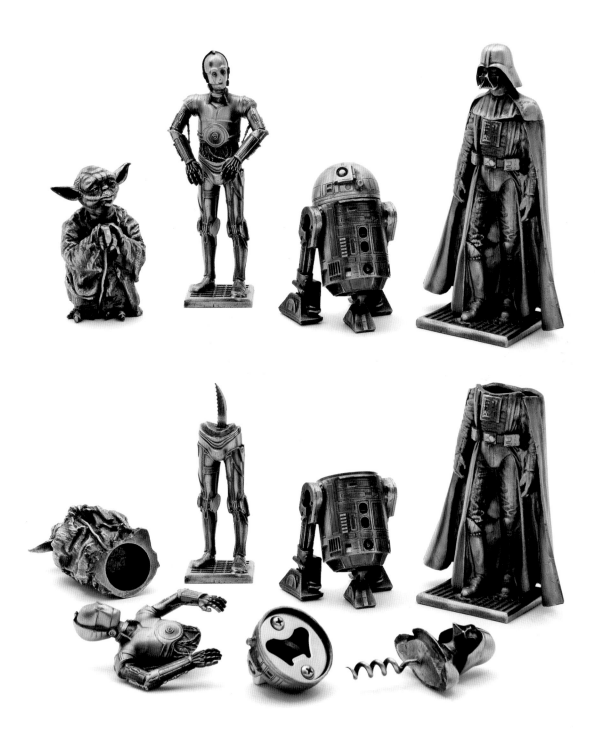

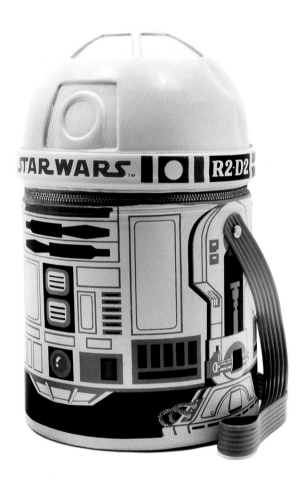

R2-D2 ZIPPERED LUNCH PAIL PROTOTYPE

THERMOS
UNITED STATES, 1977–1978

If there is one perfect example of never giving up on a quest, this is it. I picked up a 1977 black-and-white ad slick filled with clip art of various Thermos products to be used by retailers in newspaper ads. But there was one piece that was totally unfamiliar. It looked like a lunch box shaped like R2-D2. I filed the slick away, but that image kept haunting me. About two years later, around 1984, I went to a toy show where one of the country's largest dealers in old lunch boxes had a booth with hundreds of boxes dating back to the 1950s. I asked him about the box in the slick. "I've seen only one of those," he said. "They apparently produced a small number as salesmen's samples, but never went into production. I might be able to find one for you, but I don't know when. And it won't be cheap!" I gave him my business card, and that was that. I saw the dealer several times over the next few years; he hadn't forgotten. I met or contacted a half dozen or so other dealers across the country, too. Then, in 1994, I got a message on my answering machine from the original dealer. "I'm not sure you remember, but I've located that *Star Wars* lunch pail you were looking for," he said. "I need to hear back from you soon because I've also got another customer interested." I immediately returned his call and closed the deal for above $1,000. Yes, it was pricey, but I had been seeking this one rare piece for a decade. When I got it, I realized quickly why this vinyl lunch pail never went into production. It had a serious design flaw. The vinyl was so thin, and the vinyl hinge was so small, that opening and closing R2's lid—which was also made of extremely thin material that dented easily—would have broken the piece in just a few weeks. Thus the search had ended and the mystery was solved.

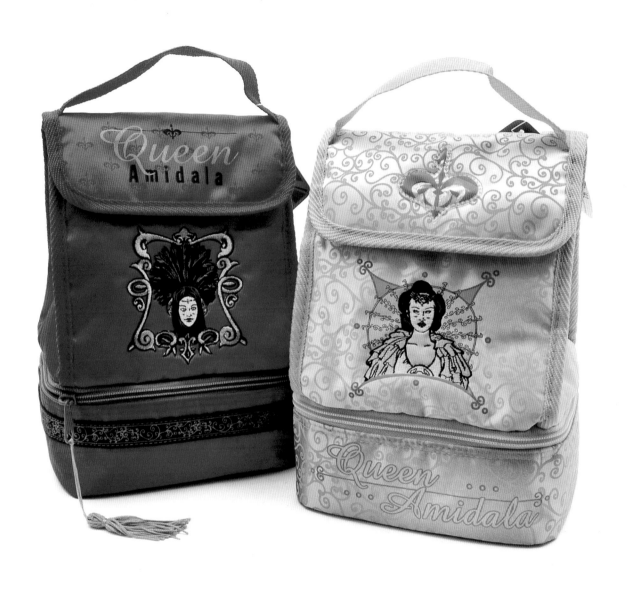

SOFT-SIDED QUEEN AMIDALA LUNCH BOXES

CALEGO
CANADA, 1999

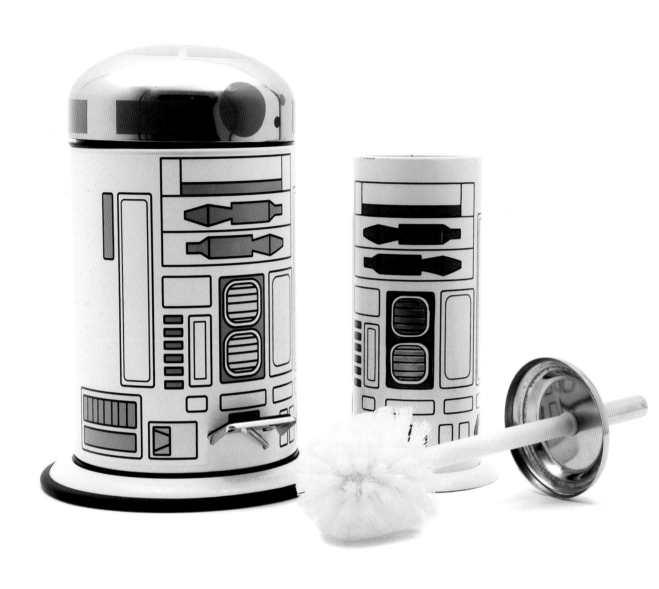

**R2-D2 MINI TRASH CAN AND
R2-M5 TOILET BOWL BRUSH**

DAVID SNEDIGAR
UNITED STATES, 2007–2008

SWITCHEROO LIGHT SWITCH COVERS

KENNER PRODUCTS
UNITED STATES, 1980

Darth Vader
R2-D2
C-3PO

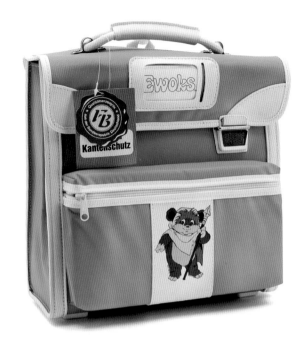

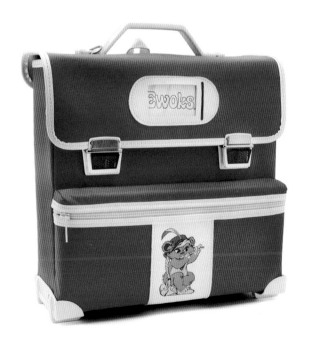

HAND-PAINTED AND CARVED WOOD CHAIR

SAMANTHA WINEGARNER AND TOM RICE FOR THE
TEEN INSPIRATION FOUNDATION
UNITED STATES, 1997

This amazing chair was carved and painted by teenagers
Samantha Winegarner and Tom Rice under the tutelage of the
Teen Inspiration Foundation in San Rafael, California, not far from
Skywalker Ranch. The foundation, which was active in the mid-
1990s, gave teens a creative place to spend their time after
classes. It had a work space where teenagers painted recycled
furniture, which they would then sell in a teen-managed gallery.

KNEESAA THE EWOK SCHOOLBAG

TRAMP
GERMANY, C. 1987

WICKET THE EWOK SCHOOLBAG

TRAMP
GERMANY, C. 1987

LATARA THE EWOK SCHOOLBAG

TRAMP
GERMANY, C. 1987

SAGA BEACH TOWELS

VARIOUS
UNITED STATES AND JAPAN, 1987–2007

C-3PO AND R2-D2 MAGIC WASHCLOTH

BASIC FUN
UNITED STATES, 2007

YODA MAGIC WASHCLOTH

BASIC FUN
UNITED STATES, 2007

C-3PO AND R2-D2 POP-UP COMB

ADAM JOSEPH
UNITED STATES, 1983

BATTERY-OPERATED TOOTHBRUSH

TAKARA
JAPAN, 1978

TOOTHPASTE WITH BIB FORTUNA ACTION-FIGURE PREMIUM

COLGATE
SPAIN, 1986

This may be the only existing example—or at least only one of a handful—from a Spanish promotion between Colgate and Kenner. The box notes there are seventy different figures and commands: "Collect them!" It's unclear how many different figures were included in the pack; perhaps it was only the slow sellers such as this Bib Fortuna figure. After I explained to one visitor how rare this piece was, he asked, "You mean you don't have all seventy boxes?" I just sighed and said, "Nope."

STAR WARS TOOTHBRUSHES SPECIAL OFFER THREE-PACK

ORAL-B/COOPER CARE
UNITED STATES, 1983

"Buy 2, Get a Jedimasters Toothbrush Free!" When the package proclaims "Recommended by more dentists than any other toothbrush," no doubt that means just the ones with *Star Wars* characters.

SHELF DISPLAY BOX FOR R2-D2 AND C-3PO
FIGURAL SOAP

CLIRO
UNITED KINGDOM, 1978

Many *Star Wars* characters have been turned into cakes of
soap or containers for bubble bath or shampoo—called soakies
by collectors. The low-cost category has included character-
shaped soap, glycerin soap with small toys inside, toothpaste,
flavored lip balm, talc, inexpensive cologne, hair gel, moisturizing
hand cream, and even an apple-scented roll-on liquid body soap.

ARTOO-DETOO BATH BUBBLES

CLIRO
UNITED KINGDOM, 1978

BUBBLE BATH

CLIRO
UNITED KINGDOM, 1978

See-Threepio
Chewbacca
Artoo-Detoo
Darth Vader

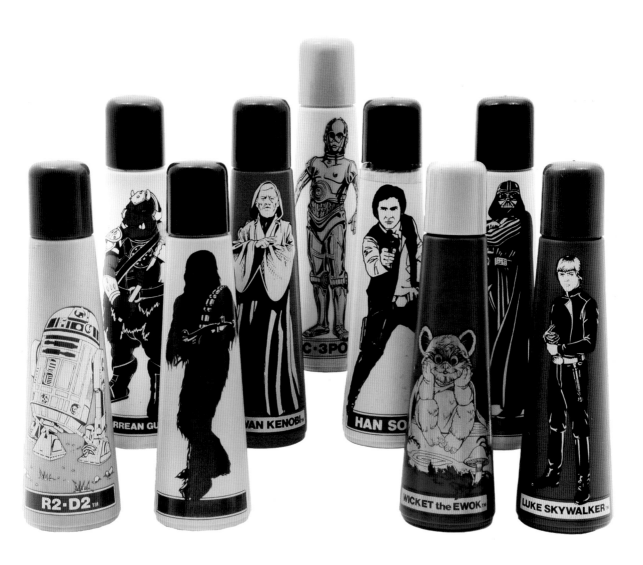

BUBBLE BATH

ADDIS LIMITED
UNITED KINGDOM, 1984

Because of the size, color, and quality of their art, these British bubble-bath containers are among the coolest personal products made for the saga. If any of you have the Princess Leia container that I'm missing, feel free to send it along to Rancho Obi-Wan.

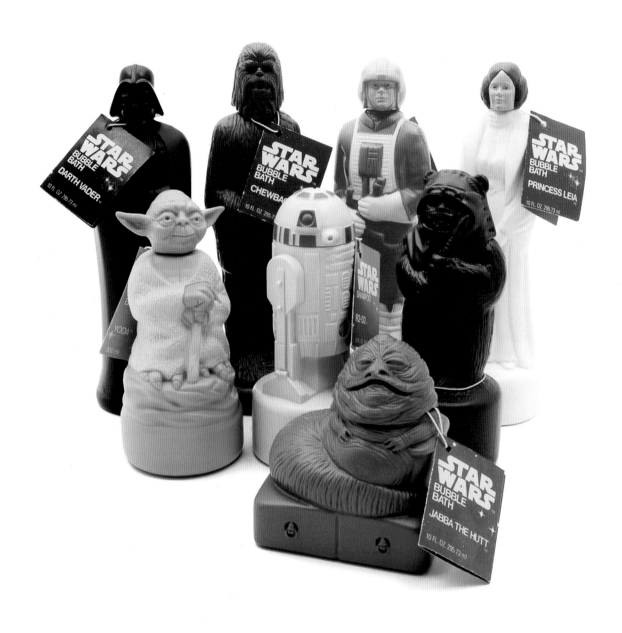

**SOAP COLLECTION WITH PRINCESS LEIA,
LUKE SKYWALKER, YODA, AND CHEWBACCA**

OMNI COSMETICS
UNITED STATES, 1982

BUBBLE BATH AND SHAMPOO SOAKIES

OMNI COSMETICS
UNITED STATES, 1981

**SOAP COLLECTION WITH R2-D2, C-3PO,
DARTH VADER, AND LANDO CALRISSIAN**

OMNI COSMETICS
UNITED STATES, 1982

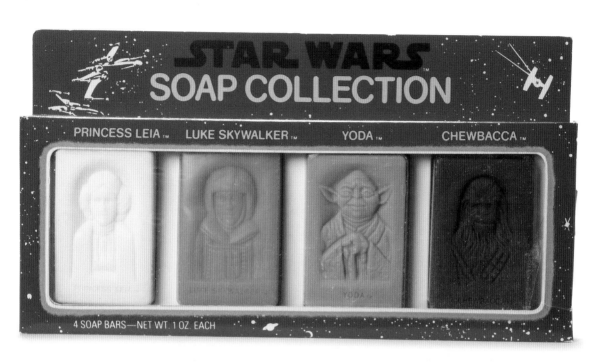

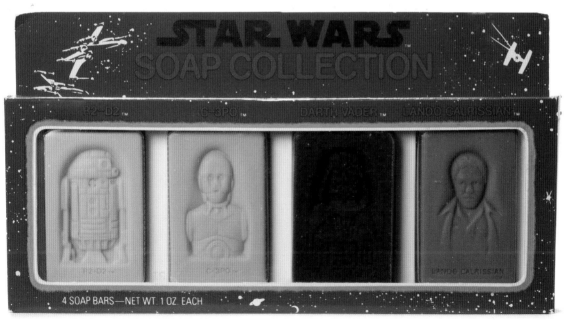

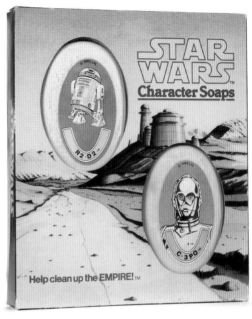

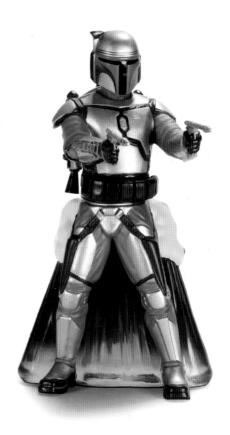

LUKE SKYWALKER AND DARTH VADER CHARACTER SOAPS

ADDIS LIMITED
UNITED KINGDOM, 1985

R2-D2 AND C-3PO CHARACTER SOAPS

ADDIS LIMITED
UNITED KINGDOM, 1985

WOKLINGS AND WICKET W. WARRICK CHARACTER SOAPS

ADDIS LIMITED
UNITED KINGDOM, 1985

SHOWER SET WITH LUKE SKYWALKER SHOWER GEL, DARTH VADER SPONGE, AND FATHER-AND-SON SOAPS

ADDIS LIMITED
UNITED KINGDOM, 1985

GUNGAN SUB BATH & SHOWER FOAM

GROSVENOR
UNITED KINGDOM, 1999

JANGO FETT BATH & SHOWER FOAM

GROSVENOR
UNITED KINGDOM, 2002

ANAKIN SKYWALKER ADHESIVE BANDAGES

LABORATOIRES MERCUROCHROME
FRANCE, 1999

PROTECTOR 3-D RAZOR BLADES EIGHT-PACK WITH COLLECTIBLE STICKERS AND SWEEPSTAKES

SCHICK
JAPAN, 1999

PUFFS TISSUE STORE DISPLAY

PROCTER & GAMBLE
UNITED STATES, 1980

This is one of the most visually striking store displays ever made for a *Star Wars* product tie-in. The three different Puffs Tissue boxes also had strong visual appeal, using beautiful photography and art from *The Empire Strikes Back*.

TOILET PAPER EIGHT-ROLL PACK

SCA HYGIENE PRODUCTS GMBH
GERMANY, 2005

There had never been licensed *Star Wars* toilet paper, the reason for which should be obvious. But when the contract from SCA Hygiene Products GmbH (using the brand name Zewa) came in, the new marketing project manager didn't give it a second thought—until the product plan and artwork arrived. Facial tissue in three different sizes and five different packaging variations. Check. Paper towels imprinted with *Star Wars* characters, sold in both a six-pack and a pack that included a box of facial tissues and a small, but ugly, Yoda plush toy. Check. Extra soft, five-star premium quality, four-layer bathroom tissue in eight-, sixteen-, and twenty-roll packs. All imprinted with *Star Wars* art. Um, wait a minute. That feels wrong. Maybe I'd better check. Let's see, they have an ad slogan they'd like to use with the imprinted toilet paper: "Wipe Out the Dark Side!" Uh-oh. As the manager expected, the boss wasn't too happy. He wanted to kill the toilet paper part of the promotion completely. But a compromise was reached. The TP with

Episode III promotional art on the packaging was approved, but no designs on the paper, and no separate advertising campaign. I learned something out of all this that I never knew before: The Germans have four-layer toilet paper. Wow!

PAPER TOWELS, TISSUE, FREE YODA PLUSH TOY

SCA HYGIENE PRODUCTS GMBH
GERMANY, 2005

R2-D2 TOILET-PAPER-ROLL COVER

ENSKY CO. LTD.
JAPAN, 2009

If you can't have *Star Wars* imprinted toilet paper, at least you can cover your shame with this zippered plush R2-D2 toilet-paper-roll cover, straight from the land of electronic toilets that heat the seat and spray warm jets of water.

COUNTER DISPLAY FOR YVES SAINT LAURENT *STAR WARS* "ONE LOVE" MAKEUP

YVES SAINT LAURENT
FRANCE, 1999

The Yves Saint Laurent promotional tie-in was an attempt to draw more than the usual male audience to a *Star Wars* movie. These were higher-end cosmetics, found mainly in a select number of stores in France, the United Kingdom, the United States, and Japan. Part of the publicity campaign for Episode I was also directed at fashion and architectural magazines. The YSL promotion produced among the most beautiful store displays and press material ever done for one of the *Star Wars* movies. The press kit came in a bright red box with product samples underneath the printed booklet. I'm not sure how well the products sold, but they garnered lots of publicity for Episode I in publications that otherwise would never have mentioned *Star Wars*.

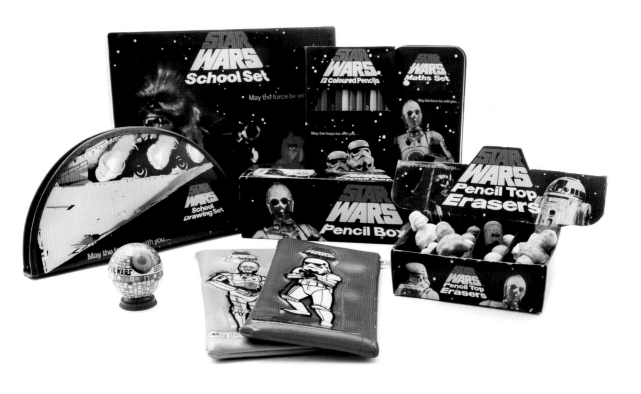

SCHOOL SUPPLIES

HELIX
UNITED KINGDOM, 1978

DEATH STAR PENCIL SHARPENER

HELIX
UNITED KINGDOM, 1978

When this small tin pencil sharpener was produced, it was the only three-dimensional Death Star object on the market. It remained so for nearly a decade, and even since then there haven't been many three-dimensional representations of the Empire's ultimate weapon.

C-3PO PAPER DECORATION AND R2-D2
PERPETUAL CALENDAR

EDICIONES MANANTIAL
SPAIN, 1978

C-3PO AND R2-D2 WIND-UP TALKING
ALARM CLOCK

BRADLEY TIME
UNITED STATES, 1978

FIGURAL ERASERS

TAKARA
JAPAN, 1978

LEGO WRITING SYSTEM COUNTER DISPLAY

CDM COMPANY
UNITED STATES, 2002

These pens featuring LEGO *Star Wars* character figures have various
pieces that can be added and switched to customize them. The store shelf
display is a nice add-on for a collector who has room for it.

DARTH VADER THEMED SCHOOL SUPPLIES

DONAU-DESIGN
AUSTRIA, 1997

STAR WARS PROTOTYPE PAPERWEIGHT

UNKNOWN
UNITED STATES, 1976

In addition to T-shirts and other apparel, the *Star Wars* movies have also produced a great number of three-dimensional items used as gifts for cast, crew, premiere benefit attendees, and licensing and marketing partners. The half-globe with an early version of the *Star Wars* logo, gold flecks, and an airplane was produced as a prototype for the film's producer, Gary Kurtz. It's not clear if the airplane was part of the design or just a placeholder for an X-wing or TIE fighter. A metal paperweight, two different drink coasters, and the topper—an intergalactic passport given to visitors to the set—were created for *The Empire Strikes Back*. An early "Revenge of the Jedi" paperweight was auctioned off years ago by one of Harrison Ford's sons. The rare, circular polished brass paperweight was a gift to Lucasfilm employees who had worked at the company at least ten years; and the square pewter piece commemorated the Special Edition films; this one is marked on the rear to show it was a gift at a preopening summit for licensees.

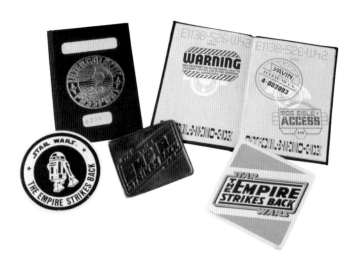

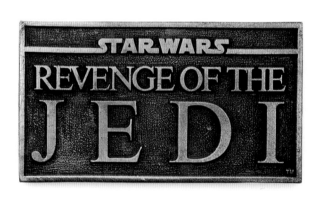

***THE EMPIRE STRIKES BACK* PAPERWEIGHT,
PASSPORT, AND COASTERS**

LUCASFILM LTD.
UNITED STATES, 1979

"REVENGE OF THE JEDI" PAPERWEIGHT

LUCASFILM LTD.
UNITED STATES, 1982

**"THE FIRST TEN YEARS 1977–1987"
PAPERWEIGHT**

LUCASFILM LTD.
UNITED STATES, 1987

**THE *STAR WARS* TRILOGY SPECIAL EDITION
PAPERWEIGHT FOR LUCAS LICENSING
SUMMIT**

LUCASFILM LTD.
UNITED STATES, 1996

STAR WARS TRILOGY ARCHIVAL RESTORATION TEAM PAPERWEIGHT

LUCASFILM LTD.
UNITED STATES, 1997

The ILM model shop hand-crafted fewer than thirty of these resin paperweights, certainly the rarest of all "crew" gifts. When George Lucas decided to rerelease *Star Wars* in theaters for the twentieth anniversary (and later added *Empire* and *Jedi*), no one realized how badly the original negatives and other materials needed to strike new prints had deteriorated. Lucas wanted to update the movies, especially the first one, and make them more the way he had planned to but couldn't because of time and technological restrictions. After an intensive multimillion-dollar restoration, during which Lucas created and upgraded shots, the Special Editions were declared theater-ready. The incredible box-office results for a twenty-year-old film had Hollywood agog. Lucas decided to give members of the core restoration team something to remember their effort. Each paperweight had an engraved, personalized brass plaque on the back. This particular one showed up on eBay with its brass plate removed.

APPA CONVENTION PAPERWEIGHT WITH SNOWSPEEDER

AUSTRALASIAN PROMOTIONAL PRODUCTS ASSOCIATION
AUSTRALIA, 1999

DEATH STAR CRYSTAL PAPERWEIGHT

WATERFORD CRYSTAL FOR NEIMAN MARCUS
UNITED STATES, 1996

STAR WARS ACRYLIC STAR PAPERWEIGHT

TWO'S COMPANY
UNITED STATES, 1977

Three different acrylic stars were used at different benefit premieres as souvenir gifts, placed around tables in clear plastic boxes wrapped with "ribbon" made of film or in a velvet pouch. Because of their simplicity, these have been bootlegged for sale to unsuspecting fans. Paying homage to the stars, the collecting track at Celebrations II and III used versions of them as gifts to people who put on presentations.

"MAY THE FORCE BE WITH YOU" ACRYLIC STAR PAPERWEIGHT

TWO'S COMPANY
UNITED STATES, 1977

THE EMPIRE STRIKES BACK ACRYLIC STAR PAPERWEIGHT

TWO'S COMPANY
UNITED STATES, 1980

STAR WARS CELEBRATION II STAR COLLECTOR ACRYLIC STAR PAPERWEIGHT

FOR THE *STAR WARS* CELEBRATION COLLECTORS GROUP
UNITED STATES, 2002

STAR WARS CELEBRATION III COLLECTING PANEL ACRYLIC STAR PAPERWEIGHT

FOR THE *STAR WARS* CELEBRATION COLLECTORS GROUP
UNITED STATES, 2005

MILLENNIUM FALCON CANCELED FIRST-DAY COVER FROM LOS ANGELES, FIRST DAY OF ISSUE

UNITED STATES POSTAL SERVICE
UNITED STATES, 2007

On May 25, 2007, the United States Postal Service released the first-ever sheet of fifteen different _Star Wars_ postage stamps and a slew of related products. It also announced that Americans had voted to place Yoda on a single-character sheet of stamps that came out later in the year.

THE EMPEROR CANCELED FIRST-DAY COVER FROM GOODYEAR, ARIZONA

UNITED STATES POSTAL SERVICE
UNITED STATES, 2007

C-3PO CANCELED FIRST-DAY COVER FROM LOS ANGELES

UNITED STATES POSTAL SERVICE
UNITED STATES, 2007

DARTH VADER CANCELED FIRST-DAY COVER FROM ARLINGTON HEIGHTS, ILLINOIS

UNITED STATES POSTAL SERVICE
UNITED STATES, 2007

YODA CANCELED FIRST-DAY COVER FROM NEW YORK CITY

UNITED STATES POSTAL SERVICE
UNITED STATES, 2007

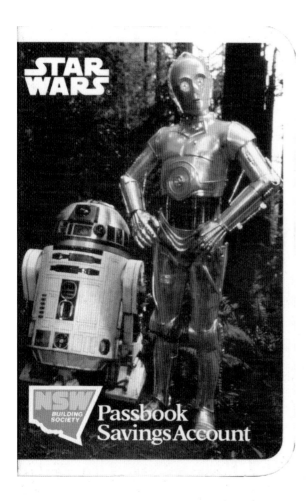

STAR WARS

Passbook
Savings Account

NSW BUILDING SOCIETY

NSW BUILDING SOCIETY

ACCOUNT NUMBER

STA BRANCH STAMP DATE

APPLICATION FOR STAR WARS® SAVINGS ACCOUNT

APPLICANTS

FIRST NAMES SURNAMES

1 _____ _____
2 _____ _____
3 _____ _____

ADDRESS

No. _____ STREET _____
SUBURB / TOWN _____ POSTCODE _____
HOME TELEPHONE _____ WORK TELEPHONE _____

AMOUNT

I/WE ENCLOSE THE SUM OF $ _____ BEING FOR FULLY PAID
SHARES OF $1.00 EACH.

FOR STATISTICAL PURPOSES ONLY

YEAR OF BIRTH _____
DO YOU HAVE ANY OTHER ACCOUNTS
WITH NSW BUILDING SOCIETY? ☐ YES ☐ NO

I/We apply for the above Account and declare that I/We agree with the conditions set out overleaf.

SIGNATURE OF 1 _____
EACH APPLICANT 2 _____
NAMED ABOVE 3 _____

FOR JOINT ACCOUNTS ONLY. Please act on withdrawals signed by:-
(✔) ☐ EITHER/ANY ONE OF US ☐ BOTH/ALL OF US ☐ ANY OF US (State No.)

OFFICE USE ONLY

I.D. PARTICULARS _____

SIG | W-T | INT. | A | C

TM & © LUCASFILM LTD (LFL) 1983. ALL RIGHTS RESERVED. N.S.W. BUILDING SOCIETY LIMITED. AUTHORISED USER.

STAR WARS SAVINGS ACCOUNT PASSBOOK

NSW BUILDING SOCIETY
AUSTRALIA, 1983

APPLICATION FOR STAR WARS SAVINGS ACCOUNT

NSW BUILDING SOCIETY
AUSTRALIA, 1983

STAR WARS SAVINGS ACCOUNT COMPETITION ENTRY FORMS

NSW BUILDING SOCIETY
AUSTRALIA, 1983 (LEFT), 1985 (RIGHT)

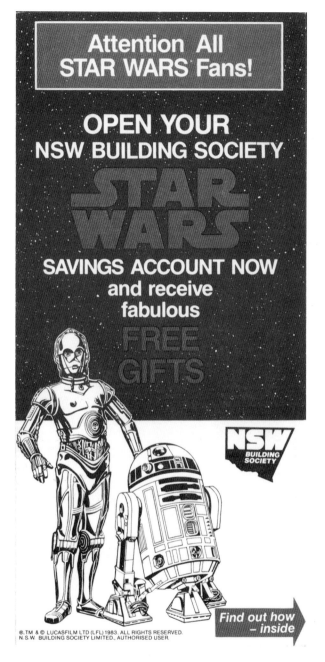

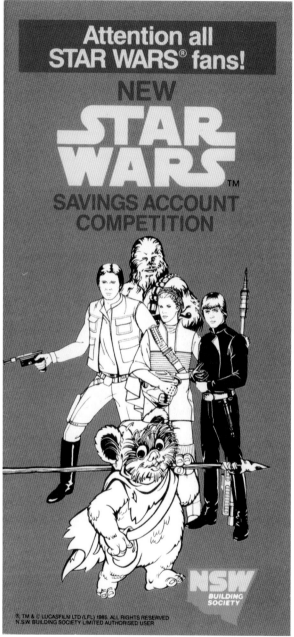

CHECKBOOK COVERS

ANTHONY GRANDIO
UNITED STATES, 2002–2007

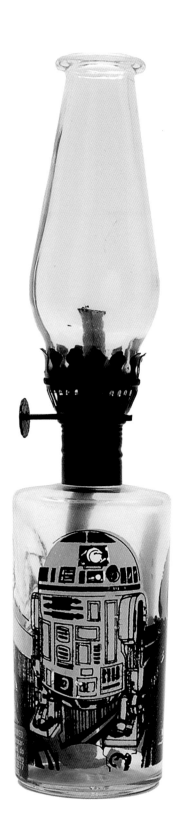

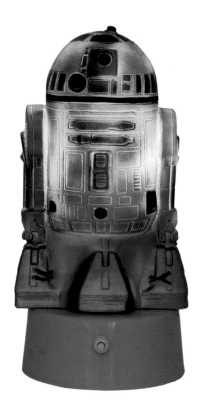

R2-D2, C-3PO, AND DARTH VADER OIL LAMP

LAMPLIGHT FARMS
UNITED STATES, C. 1978

Because of the funky art, the lack of any Lucasfilm or 20th Century Fox copyright, and the potentially dangerous nature of the product (*DANGER: HARMFUL OR FATAL IF SWALLOWED. COMBUSTIBLE*, screams a label on the back), I assume this is a bootleg. No contract for the company exists in the Lucas Licensing archives. Yet, according to the company's Website, it owns the trademark "Tiki" for a variety of outdoor lamps and torches and "will enforce its intellectual property rights to the fullest extent of the law." Go figure.

R2-D2 OVERSIZED NIGHTLIGHT

NORTHLIGHT PRODUCTIONS LTD.
UNITED KINGDOM, 1978

Another funky-looking lamp, but this one is licensed. Seeing it turned off, you'd never guess that you'd be able to see any illumination from inside the fully painted, hard-vinyl droid. But it still works fine, with its original six-volt bulb, more than three decades after its manufacture. Although it predates "Energy Star" ratings by many years, the lamp "uses only 1 unit of electricity (about 3p) every 70 hours," according to an instruction sheet. However, the cost of a kilowatt-hour of electricity in the United Kingdom today is likely a bit higher than three pence per seventy hours.

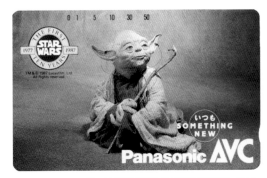

(Clockwise from top left)

PANASONIC GEORGE LUCAS AND C-3PO PHONE CARD

KDD
JAPAN, 1987

Telephone calling cards were very popular throughout Asia and in many European countries until cell phones became widespread. Many of them were used as promotional or advertising items, and they spawned a fairly active collectors' market somewhat akin to that for trading cards and stamps. Panasonic cards using George Lucas and *Star Wars* characters were part of a five-year promotional campaign in Japan only.

PANASONIC YODA PHONE CARD

KDD
JAPAN, 1987

This Yoda card supposedly was limited to Panasonic executives only.

PANASONIC SPARKY PHONE CARD

KDD
JAPAN, 1990

Sparky was a new character created by ILM specifically for the multiyear Panasonic campaign in Japan.

PANASONIC MACLORD GEORGE LUCAS PHONE CARD

KDD
JAPAN, 1989

「スター・ウォーズ／新たなる希望」公開から25周年記念にあたる2002年、4半世紀の時を経て、ついに、「エピソード2／クローンの攻撃」で、サーガ全体の"核心"となる物語が明かされる！

エピソードⅠから10年後、銀河共和国では今まさに動乱が始まろうとしていた。19歳の若者に成長したジェダイの騎士アナキン・スカイウォーカーは、女王の座を退き元老院議員となったパドメ・アミダラの護衛を命じられる。共和国が戦争に向けて準備を進めるさなか、ふたりは恋に落ちていく。しかし、ジェダイの誓いを立てたアナキンには怒りや憎しみばかりでなく、愛さえも許されなかった…。

7月13日(土)、日劇1ほか全国〈夏休み〉ロードショー

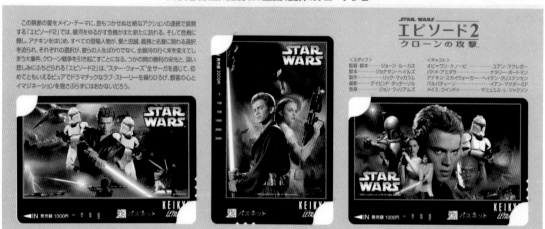

この禁断の愛をメイン・テーマに、息もつかせぬ壮絶なアクションの連続で展開する「エピソード2」では、銀河をゆるがす危機がまた新たに訪れる。そして危機に際し、アナキンをはじめ、すべての登場人物が、愛と忠誠、義務と名誉に関わる選択を迫られ、それぞれの選択が、彼らの人生行く末を変えてしまう大事件、クローン戦争を引き起こすことになる。つかの間の勝利の栄光と、深い悲しみにふちどられる「エピソード2」は、"スター・ウォーズ"全サーガを通じて、初めてともいえるピュアでドラマチックなラブ・ストーリーを繰りひろげ、観客の心とイマジネーションを揺さぶらずにはおかないだろう。

STAR WARS
エピソード2
クローンの攻撃

〈スタッフ〉
監督・脚本……ジョージ・ルーカス
脚本……ジョナサン・ヘイルズ
製作……リック・マッカラム
撮影……デイビッド・タッターサル
音楽……ジョン・ウィリアムズ

〈キャスト〉
オビ＝ワン・ケノービ……ユアン・マクレガー
パドメ・アミダラ……ナタリー・ポートマン
アナキン・スカイウォーカー……ヘイデン・クリステンセン
パルパティーン……イアン・マクダーミド
メイス・ウインドゥ……サミュエル・L・ジャクソン

ATTACK OF THE CLONES SET OF THREE
TRANSIT CARDS
KEIKYU
JAPAN, 2002

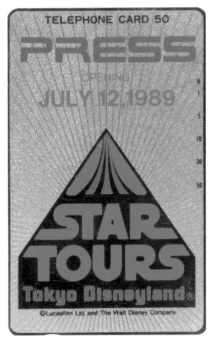

STAR TOURS TOKYO DISNEYLAND FIRST-ANNIVERSARY PHONE CARD

TELECA
JAPAN, 1990

MITSUBISHI STAR CARS PROMOTIONAL PHONE CARD

TELECA
JAPAN, 1996

R2-D2 PHONE CARD

TELECA
JAPAN, 1997

STAR TOURS PRESS OPENING PHONE CARD

TELECA
JAPAN, 1989

"LIGHT SIDE" AND "DARK SIDE" *STAR WARS* EDITION PERSONAL COMPUTERS

ALIENWARE HIGH-PERFORMANCE SYSTEMS
UNITED STATES, 2005

As the company's full name suggests, it makes high-powered, high-performance computers heavily used by gamers. Because many *Star Wars* fans are inveterate gamers, it made sense to produce "light side" and "dark side" PCs.

CHEWBACCA CELL-PHONE CASE

ORANGE
UNITED KINGDOM, 2005

Many Wookiees have died for these cases. No, not really.
Because there are no real-world Wookiees, the makers of
this very clever cell-phone case used polyester to create a
convincing reminder of the loyal, hardworking Chewbacca.

COMPUTER DISKETTES WITH *STAR WARS* SCREENSAVER

BOEDER
GERMANY, 1997

How quickly technology changes these days. Does anyone still have a computer that uses diskettes? Merchandise like this reminds us that *Star Wars* was launched before the era of personal computers, the Internet, and even home video and video games.

STORMTROOPER COMPUTER MOUSE

AMERICAN COVERS
UNITED STATES, 1996–1997

X-WING FIGHTER ON DEATH STAR RUN MOUSEPAD WITH CALCULATOR

LONG ISLAND DISTRIBUTING CO.
CANADA, 1997

YODA SHIELDZ FOR IPOD SHUFFLE

XTREMEMAC
UNITED STATES, 2005

B-WING FIGHTERS 3-D "MOUSE MAT"

MOUSEPAD (MPC LTD.)
UNITED KINGDOM, 1997

SKITTLES GRAND-PRIZE DARTH VADER ENGRAVED IPOD AND COVER

APPLE COMPUTER
UNITED STATES, 2005

HAN SOLO IN CARBONITE USB 256MB MEMORY KEY

I-O DATA
JAPAN, 2005

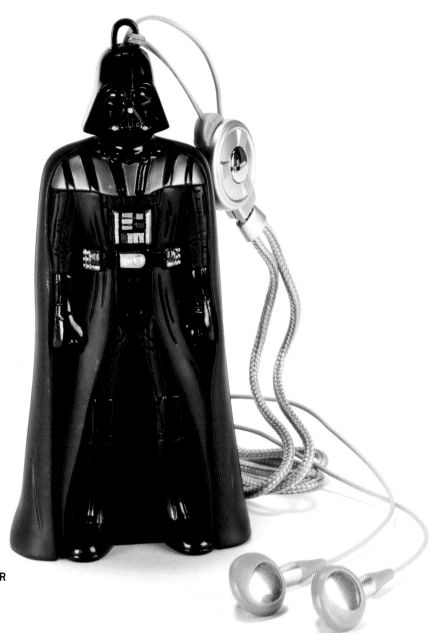

LIGHTSABER MP3 PLAYER
IS MUSIC
JAPAN, 2005

YODA MP3 PLAYER
IS MUSIC
JAPAN, 2005

R2-D2 MP3 PLAYER
IS MUSIC
JAPAN, 2005

EMPEROR PALPATINE MP3 PLAYER
IS MUSIC
JAPAN, 2005

DARTH VADER MP3 PLAYER
IS MUSIC
JAPAN, 2005

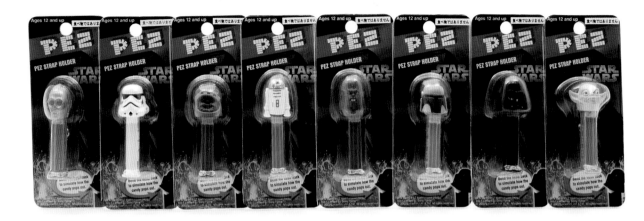

**MINIATURE PEZ CELL-PHONE STRAP
HOLDERS**

SONY PLAZA/PEZ INTERNATIONAL
JAPAN, 2005

**NOKIA 3410 JEDI STARFIGHTER COUNTER
DISPLAY**

NOKIA
UNITED STATES, 2002

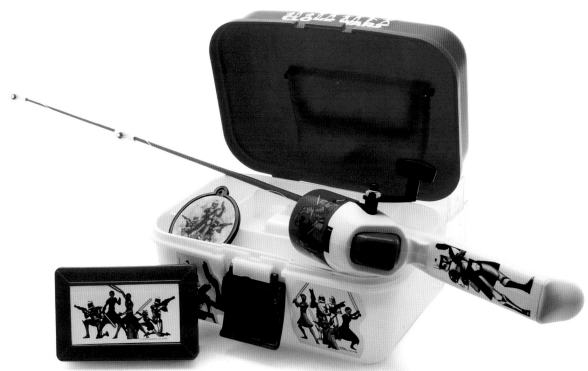

FUN CASTING COMBO

BIMINI BAY OUTFITTERS LTD.
UNITED STATES, 2009

What could be more relaxing during *The Clone Wars* than to take a break and go fishing with your very own *Clone Wars* fishing outfit—a "tangle resistant" fishing rod, a "magic image changing" casting plug, and bait and tackle boxes. Just don't hook any Mon Calamari; we need them for the war effort.

R2-D2 "SSPD WARS" FISHING LURE

SHOP MODIFIED/HEDDON LURE CO.
JAPAN/UNITED STATES, C. 2002

Where's R2-D2? Gone fishin'! And you'd think that after tumbling into the Dagobah swamp and being swallowed and spit out by a dragonsnake, he'd have had his fill of water. This unlicensed fishing lure came from an eBay seller in Japan, where it was made in a limited edition of about 300. SSPD WARS apparently stands for "suspend wars." The lure came in a carefully opened and resealed "Big Bud" package from Heddon Lure Co. Big Bud, as the name implies, was decorated as a can of Budweiser in its original form, but it has been modified in scores of variations, including that of a certain droid from a distant galaxy.

STAR WARS QUESTION AND ANSWER BOOK ABOUT SPACE

RANDOM HOUSE
UNITED STATES, 1979

Many kids saw *Star Wars*, read this book, and decided they wanted to be astronauts. We're not sure how many actually made it that far, but with the Space Shuttle carrying a lightsaber into space, we'll wager at least a few.

RETURN OF THE JEDI STORYBOOK

RANDOM HOUSE
ISRAEL, 1983

DROIDI COLORING BOOK

FORUM MARKETPRINT
YUGOSLAVIA, 1989

PRINCESS KNEESAA BOOK

PLAZA JOVEN
SPAIN, 1986

Ewoks

Kinesa
y los
korrinas

PLAZA JOVEN
EDICIONES

THE RISING FORCE YOUNG ADULT BOOK

SCHOLASTIC INC.
RUSSIA, 1999

JAR JAR'S MISTAKE CHILDREN'S BOOK

PATAKIS
GREECE, 1999

THE LAST COMMAND

Star Wars
Book 3

by

TIMOTHY ZAHN

In Ten Volumes
Volume 9

By Kind Permission
of the Author and Publishers

National Library for the Blind
Far Cromwell Road
Bredbury
Stockport SK6 2SG

Tel: 0161 494 0217
(24 hour answering service)
Fax: 0161 406 6728
Charity Registration Number 213212

PATRON: HER MAJESTY THE QUEEN
1997

VOLUME 3 OF *THE LAST COMMAND* IN BRAILLE

NATIONAL LIBRARY FOR THE BLIND WITH
PERMISSION FROM BANTAM PRESS
UNITED KINGDOM, 1997

It took ten large Braille volumes to tell the story of *The Last
Command*, the final novel in Timothy Zahn's three-book series
that relaunched *Star Wars* publishing in 1991. The project was
undertaken by the British National Library for the Blind. The
darker brown sheets are Braille corrections.

THE HUNT BEGINS, STAR WARS NO. 7
COMIC BOOK

MARVEL COMICS
DENMARK, 1984

STAR WARS NO. 2 COMIC BOOK

MARVEL COMICS
NORWAY, 1984

RETURN OF THE JEDI WEEKLY NO. 28
COMIC BOOK

MARVEL COMICS
UNITED KINGDOM, 1983

STAR WARS

RETURN OF THE JEDI

Nº 28 DEC 28 1983

25p

FROM UNCLE DARTH

FROM DAD

BOB WAKELIN '83

CHRISTMAS QUIZ INSIDE!

YODA GUITAR

FERNANDES GUITARS
JAPAN, 2002

Japan's Fernandes issued a series of eight different guitars; the smaller ones, such as this Japan-exclusive Yoda, had a tiny battery-powered speaker and came with a cloth carrying case.

DARTH VADER RETROROCKET GUITAR AND CASE

FERNANDES GUITARS
JAPAN, 2002

This Darth Vader "Retrorocket" guitar was the largest in the Fernandes line and had an output for an external amp. It came with a hard case that had an embossed *Star Wars* logo. In addition to the eight guitars and three straps, Fernandes produced four different metal guitar knobs and a couple dozen *Star Wars* guitar picks.

STAR WARS COMIC BOOK, OVERSIZED EDITION NO. 1, IN LIBRARY BINDING

MARVEL COMICS
UNITED STATES, 1977

STAR WARS COMIC BOOK, OVERSIZED EDITION NO. 2, IN LIBRARY BINDING

MARVEL COMICS
UNITED STATES, 1977

GUITAR PICK PROTOTYPES

FERNANDES GUITARS
JAPAN, 2002

(Opposite)
Imperial logo
Darth Vader
Stormtrooper

(Above)
Boba Fett
Darth Maul

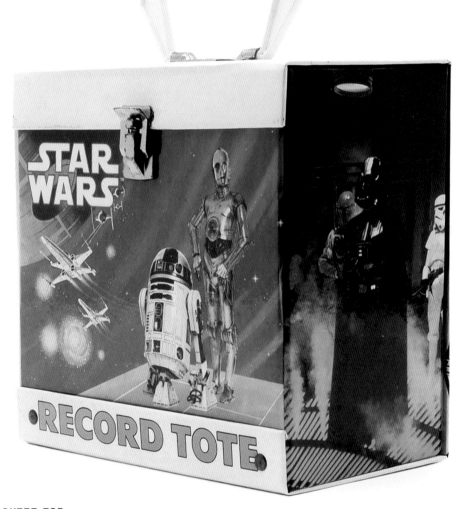

45 RPM RECORD TOTE

BUENA VISTA
UNITED STATES, 1980–1981

"WHAT CAN YOU GET A WOOKIEE FOR CHRISTMAS (WHEN HE ALREADY OWNS A COMB?)," 45 RPM SINGLE

RSO RECORDS
UNITED STATES, 1980

This is one of the highlights of the *Star Wars* Christmas album, *Christmas in the Stars*. Really. Of course, there's also the lilting lyrics and marvelous melody of "R2-D2 We Wish You a Merry Christmas."

"*STAR WARS* BANG BANG ROBOT DISCO," 45 RPM SINGLE

20TH CENTURY RECORDS
GERMANY, 1977

MECO *STAR WARS* THEME/CANTINA BAND 45 RPM SINGLE

RCA VICTOR
MEXICO, 1977

CHESS BOARD AND PEWTER PIECES

THE DANBURY MINT
UNITED STATES, 1994

Because of numerous production delays, this set took nearly two years to produce and distribute, supposedly at the rate of two chess pieces a month. The full set ended up costing around $700.

STARBLES LIMITED-EDITION BOXED SET

MARBLE VISIONS INC.
CANADA, 1997

Among the more useless items released in conjunction with the *Star Wars* Trilogy Special Edition films were Starbles—nothing more than soft plastic globes with small cards inserted in the middle portraying characters from the saga. These were available one by one from vending machines at Canadian movie theaters, but to get the full set of twelve in a limited edition of only one hundred, nestled inside a cheap plastic case with egg-crate foam—that would only set you back $100. Yes, there is one born every minute.

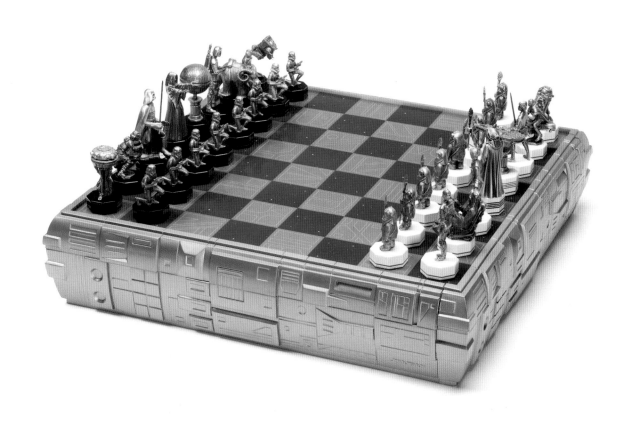

493

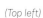

(Top left)

GEORGE LUCAS SUPER LIVE ADVENTURE COUNTDOWN CLOCK

MADE FOR NHK
JAPAN, 1993

This one-of-a-kind countdown clock was on the reception counter at NHK, Japan's public broadcasting network. NHK was a promotional partner for the George Lucas Super Live Adventure, a fanciful arena show that toured Japan.

(Bottom left)

GEORGE LUCAS SUPER LIVE ADVENTURE WATCH

MADE FOR FELD PRODUCTIONS
JAPAN, 1993

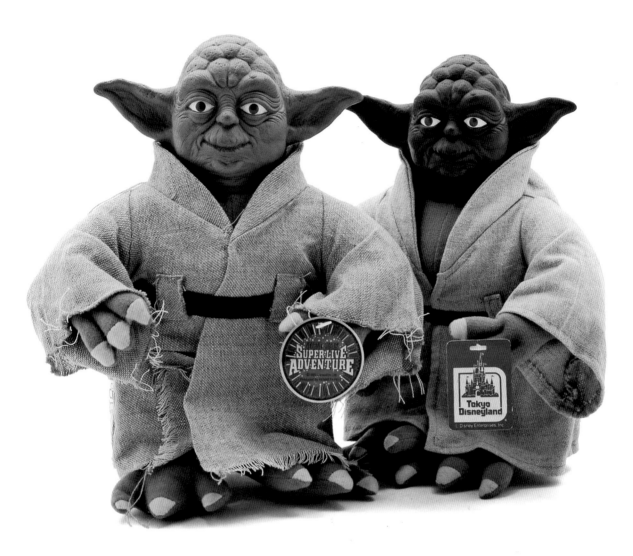

(Opposite, right)

GEORGE LUCAS SUPER LIVE ADVENTURE GLITTER WAND, NOISE MAKER, VOICE CHANGER, AND STROBE LIGHT

MADE FOR FELD PRODUCTIONS
JAPAN, 1993

A plethora of merchandise enticed young children at the numerous souvenir stands around the arenas where the Super Live Adventure played. (The show itself was a corny trip through some of the movies George Lucas made as a director or producer, including *Indiana Jones*, *Tucker*, *Willow*, *American Graffiti*, and, of course, *Star Wars*.) A friend who attended told me that an announcer, with annoying regularity, would get on the sound system and say something like, "Attention Japanese parents! In ten minutes all children will wave their magic glitter wands to help poor Willow." There would then be a stampede to the merchandise kiosks to make sure no child felt left out.

(Above)

YODA PLUSH DOLLS FROM GEORGE LUCAS SUPER LIVE ADVENTURE AND TOKYO DISNEYLAND

FELD ENTERTAINMENT/TOKYO DISNEYLAND
JAPAN, 1993

STAR TOURS TOKYO DISNEYLAND SOUVENIRS

WALT DISNEY COMPANY/ORIENTAL LAND CO.
JAPAN, 1990s

What would a theme-park attraction be without attendant merchandise? You want to remember all the fun you had, of course. This is some of the merchandise available at the store connected with the Star Tours ride at Tokyo Disneyland, which opened in 1989. From left, there's a small mirror, a tin bank, a wind-up music box (it plays the *Star Wars* main theme, naturally) in the shape of the Starspeeder 3000 that takes you on your intergalactic journey, a coffee cup, and pencils topped by spinning starspeeders.

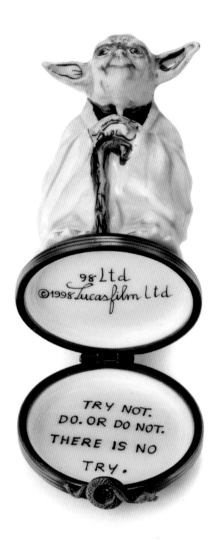

YODA LIMOGES PORCELAIN BOX

ATELIER DE LIMOGES
FRANCE, 1998

The Yoda and Queen Amidala Limoges "boxes" from France's
Atelier de Limoges are just a couple of the *Star Wars* products
made or sold by high-end manufacturers and retailers, such as
Waterford crystal and Yves Saint Laurent cosmetics.

QUEEN AMIDALA LIMOGES PORCELAIN BOX

ATELIER DE LIMOGES
FRANCE, 1999

SANKYO *STAR WARS* FEVER *PACHINKO* PARLOR
CHAIR COVERS

SANKYO
JAPAN, 2008

Imperial Citation

Trooper ID: _____

Time: __:__ Date: __/__/__

Location: _____

INFRACTION

Transportation Violations
- Coming out of hyperspace too close to a system ☐
- Resisting the Tractor Beam ☐
- Illegal modifications to a Class 5 Corellian Freighter ☐
- Expired Operator's License ☐

Force Violations
- Improper use of "The Force" ☐
- Attempted use of "Jedi Mind Trick" on an Imperial Officer ☐

Bounty Hunting Violations
- Firing a jetpack in a restricted area ☐
- Unauthorized possession of short range blasters ☐
- Disintegrating without permission ☐

General Violations
- Improper use of the "Too Short for a Stormtrooper" joke ☐
- Unauthorized touching of a Stormtrooper's Firearm ☐
- Unauthorized photography of Imperial Operations ☐
- Confusing Star Wars with Star Trek ☐
- Improper use of the "I AM Your Father" quote ☐
- Pretending not to notice a group of Stormtroopers as you casually pass by. ☐
- Improperly touching a Trooper ☐
- Asking too many questions ☐
- Improper use of spoons ☐

To view pictures of your arrest and other Garrison Titan events Visit this web address:

www.seattlestarwars.com/titan

WARNING:
Failure to report to The Seattle Star Wars Society's Website will result in a loss of fun.

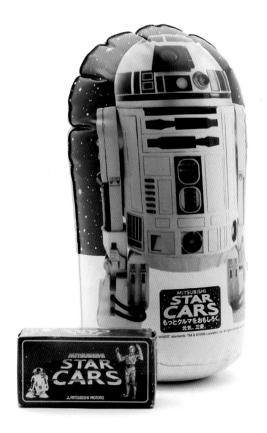

IMPERIAL "CITATION" PAD

501ST LEGION
UNITED STATES, 2001

I'll admit it. I was cited for both attempting to use a Jedi Mind Trick on an Imperial officer and improper use of the "Too short for a stormtrooper" joke. I was frozen in a carbonite block, never to be seen again.

MITSUBISHI STAR CARS PROMOTIONAL MINI BOP BAG AND TISSUE BOX

MITSUBISHI
JAPAN, 1995

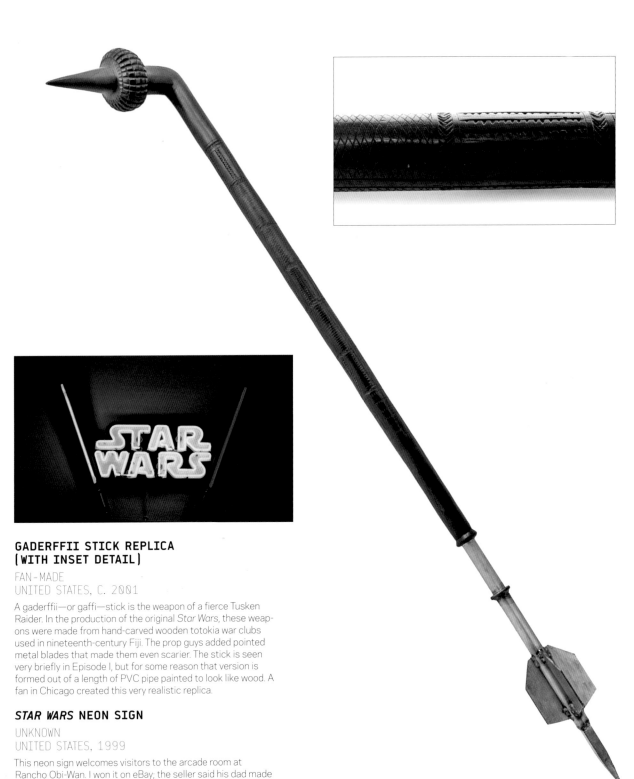

GADERFFII STICK REPLICA
(WITH INSET DETAIL)

FAN-MADE
UNITED STATES, C. 2001

A gaderffii—or gaffi—stick is the weapon of a fierce Tusken Raider. In the production of the original *Star Wars*, these weapons were made from hand-carved wooden totokia war clubs used in nineteenth-century Fiji. The prop guys added pointed metal blades that made them even scarier. The stick is seen very briefly in Episode I, but for some reason that version is formed out of a length of PVC pipe painted to look like wood. A fan in Chicago created this very realistic replica.

STAR WARS NEON SIGN

UNKNOWN
UNITED STATES, 1999

This neon sign welcomes visitors to the arcade room at Rancho Obi-Wan. I won it on eBay; the seller said his dad made it. It arrived broken and had to be fixed not once, not twice, but three times. After that, the seller paid me to fix it locally.

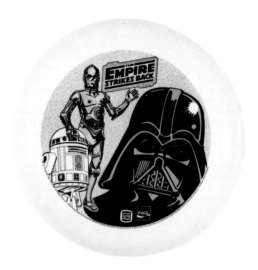

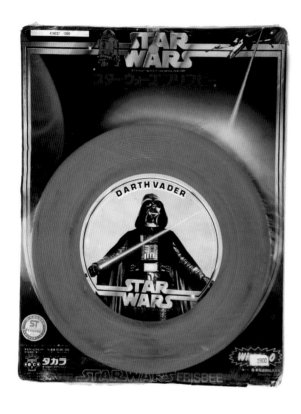

DARTH VADER FRISBEE

WHAM-O
JAPAN, 1978

**DARTH VADER, C-3PO, AND R2-D2
PROMOTIONAL FLYING DISC**

BURGER KING
UNITED STATES, 1980

DARTH MAUL E.PIX FLYING DISC

WORLDS APART
UNITED KINGDOM, 1999

REVENGE OF THE SITH BOWLING BALL

LEADING EDGE PROMOTIONS
UNITED STATES, 2005

Leading Edge instituted a *Star Wars* bowling league and had
seven different bowling balls available for sale—one for each
of the *Star Wars* movies, and a pink one for the girls. Is that PC
or un-PC?

WOMEN OF *STAR WARS* BOWLING BALL

LEADING EDGE PROMOTIONS
UNITED STATES, 2005

BOWLING BALL BAG

LEADING EDGE PROMOTIONS
UNITED STATES, 2005

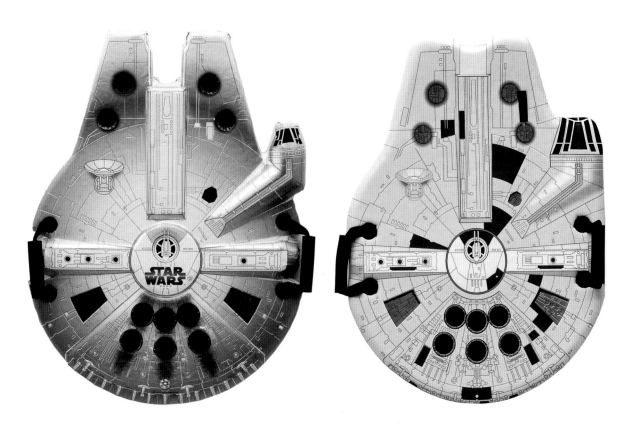

FOOSBALL TABLE GAME

SPORTCRAFT
UNITED STATES, 2005

In a world that has a *Star Wars* everything, of course there would be a *Star Wars* foosball game with *Revenge of the Sith* graphics. It's clone troopers (before they turned into Imperials) versus super battle droids. What a kick!

STAR WARS INFLATABLE POOL RING

TAKARA
JAPAN, 1978

MILLENNIUM FALCON SNOWBOARD PROTOTYPE

DYNATECH ACTION INC.
CANADA, 2008

MILLENNIUM FALCON SNOWBOARD

DYNATECH ACTION INC.
CANADA, 2008

BOBA FETT "PAT DUFFY" SKATEBOARD DECK

UNKNOWN
UNITED STATES, 1994–1995

While scores of *Star Wars* skateboards have been made since 1997, none were available commercially when these limited-edition bootleg decks were allegedly commissioned and used by top skateboarders earlier in the 1990s. They could be fitted out with TIE fighter wheels. This is one of several examples of the pop culture getting ahead of the merchandisers and producing something that the public wanted, one way or another.

HAN SOLO "RICK HOWARD" SKATEBOARD DECK

UNKNOWN
UNITED STATES, 1994–1995

SLAVE LEIA "MIKE CARROLL" SKATEBOARD DECK

UNKNOWN
UNITED STATES, 1994–1995

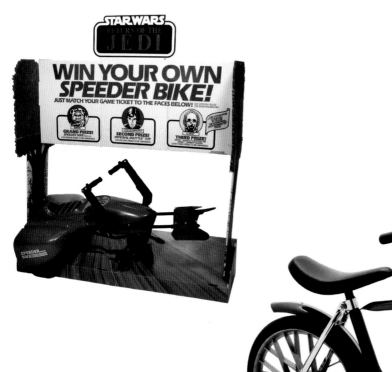

"BOYS FIRST BIKE" WITH TRAINING WHEELS

HUFFY
UNITED STATES, 1983

This bike became an object lesson in several ways. First, I passed on it when I saw it in boxed, pristine condition at Toys"R"Us in 1983, probably for around $50. I later regretted my decision, but the bike had sold out by the time I went looking for it. Then I made a bigger mistake a decade later in one of the first interviews I gave about my Star Wars collection to Starlog magazine. The reporter asked me if I had a holy grail and I mentioned this Huffy bicycle. Within two weeks after the magazine came out, I received calls from two different dealers, one on the East Coast and one in the Midwest, both of whom offered me the boxed bike in mint, unassembled condition. And they each offered it at the same price: $2,000. I passed. I found it years later for considerably less. I guess that's lesson number three.

"WIN YOUR OWN SPEEDER BIKE" FLOOR DISPLAY

HUFFY FOR KENNER
UNITED STATES, 1983

About two thousand of these ride-on speeder bikes were produced, but none were sold. The only way to get one was to win a sweepstakes at your local Kmart or Toys"R"Us store. They later became a hot commodity on the collectors' market, especially if the bike was in mint condition (it cracked easily during play) and was accompanied by one of the two different store displays.

DARTH VADER KIDS RIDE-ON MOTORCYCLE

MADE FOR TARGET
AUSTRALIA, 2005

Of course you remember that scene in *Attack of the Clones* when Anakin Skywalker returns to Tatooine, discovers that his mother has been captured by Tusken Raiders, and hops on a nearby battery-operated Darth Vader "hog" to rescue her. No? Better watch the DVD again.

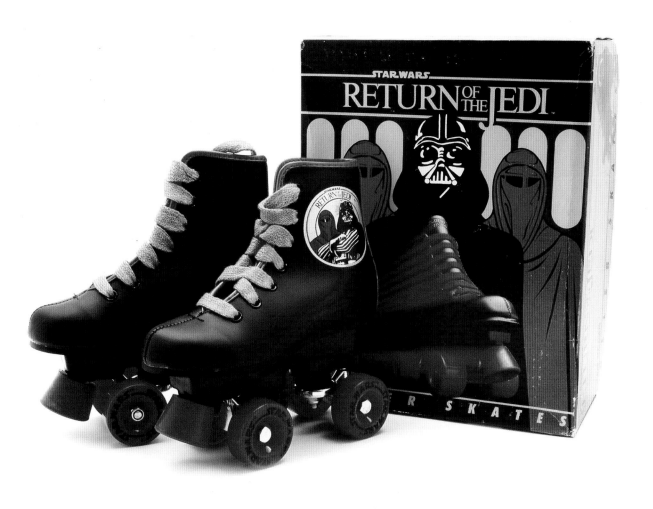

STAP ELECTRIC SCOOTER

ZAP WORLD
UNITED STATES, 1999

Zap made this thirteen-miles-per-hour electric scooter tricked out like a STAP (or Single Trooper Aerial Platform) used by battle droids in Episode I. They were available only from FAO Schwarz. Lucasfilm shipped two of them to the crew filming Episode II at Fox Studios Australia, and stunt coordinator Nick Gillard commandeered one. He had the prop shop fit it out with a high-powered toy water cannon and proceeded to terrorize the backlot—all in fun, of course.

DARTH VADER AND IMPERIAL GUARD ROLLER SKATES

BROOKFIELD ATHLETIC SHOE CO.
UNITED STATES, 1983

DARTH VADER AND STORMTROOPER GOLF BAGS

BRIDGESTONE
JAPAN, 2007

Many Japanese, as they will themselves attest, are *gorufu kureji*—golf crazy. Many Japanese are also huge *Star Wars* fans. Bridgestone combined both passions into two amazing golf bags that have the look and feel of the saga—and the look of Darth Vader and a stormtrooper's mask, respectively. These aren't inexpensive kids' toys; the limited-edition bags sold for fifty thousand yen, or around $500 each. The designs and logos are either embroidered or silkscreened. Each bag has ten zippered pockets with a total of thirteen two-sided *Star Wars* logo zipper pulls and a separate "hood" that buckles and zippers onto the top in case of a sudden downpour. (The stormtrooper bag hood has a large embroidered *Star Wars* logo while the Darth Vader bag hood sports a silkscreened Death Star.) The top six inches of the interiors of the bags have a black velvet lining. Solidly made, with sleek lines . . . Wait a second—I think I'm falling in love with a couple of golf bags.

BRAVO SQUADRON AUTO SEAT CUSHION PROTOTYPE

UNKNOWN
UNITED STATES, 1999

JAR JAR BINKS CAR SUNSHADE

SIEPA
FRANCE, 1999

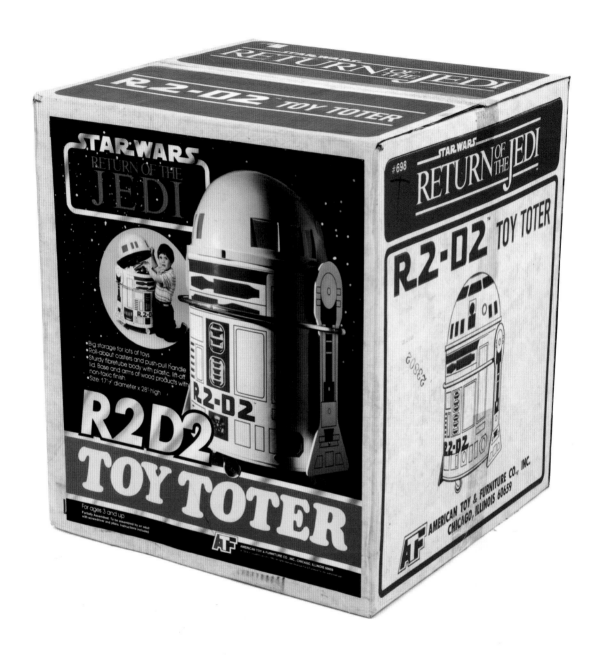

R2-D2 TOY TOTER

AMERICAN TOY & FURNITURE
UNITED STATES, 1983

With so many *Star Wars* toys out there, it's a wonder no one
came up with a fantasy toy chest before 1983. This is the best!
A "toy toter" on wheels in the shape of R2-D2 can hold a pretty
large number of action figures, LEGO bricks, and a lot more.

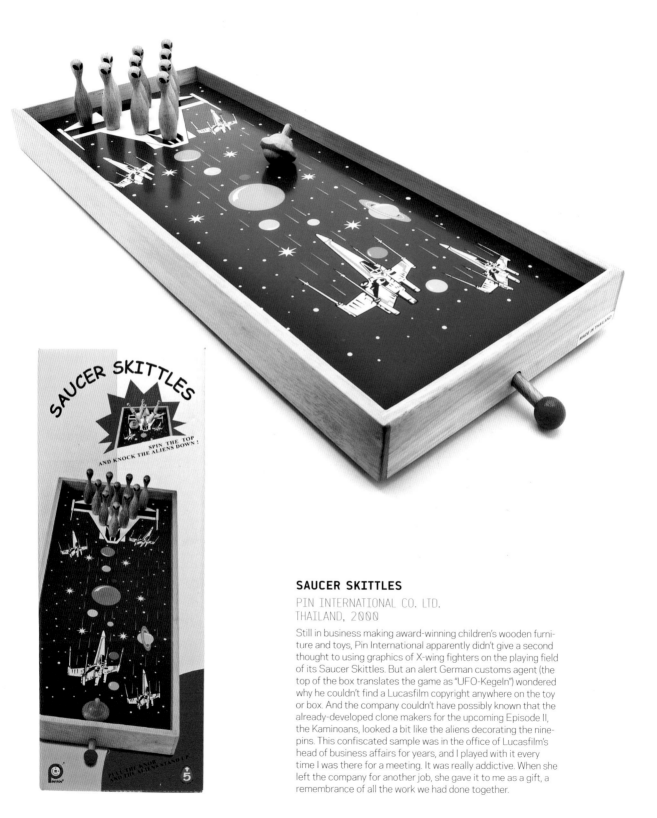

SAUCER SKITTLES

PIN INTERNATIONAL CO. LTD.
THAILAND, 2000

Still in business making award-winning children's wooden furniture and toys, Pin International apparently didn't give a second thought to using graphics of X-wing fighters on the playing field of its Saucer Skittles. But an alert German customs agent (the top of the box translates the game as "UFO-Kegeln") wondered why he couldn't find a Lucasfilm copyright anywhere on the toy or box. And the company couldn't have possibly known that the already-developed clone makers for the upcoming Episode II, the Kaminoans, looked a bit like the aliens decorating the nine-pins. This confiscated sample was in the office of Lucasfilm's head of business affairs for years, and I played with it every time I was there for a meeting. It was really addictive. When she left the company for another job, she gave it to me as a gift, a remembrance of all the work we had done together.

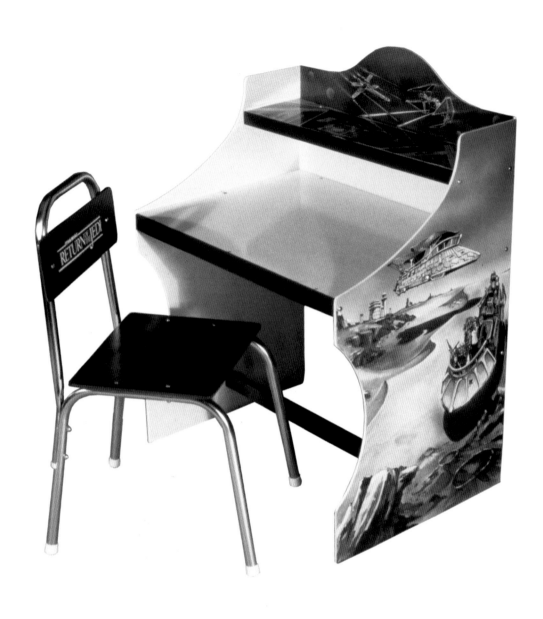

RETURN OF THE JEDI DESK AND CHAIR SET

AMERICAN TOY & FURNITURE
UNITED STATES, 1983

RETURN OF THE JEDI BOOKCASE

AMERICAN TOY & FURNITURE
UNITED STATES, 1983

CAN YOU BELIEVE IT?

You've already seen the *Star Wars* toilet paper. What else could there possibly be that would have you scratching your head or breaking out in a smile of disbelief? Plenty. And there was even more that I let slip away.

I can distinctly remember going to an outdoor arts and crafts festival in Los Angeles in the summer of 1983. It wasn't the kind of show where I expected to find any *Star Wars* collectibles. Rounding a turn, though, I saw what looked like a bunch of framed art. From a distance, one of the artworks had the unmistakable look of the lead character in *E.T. The Extra-Terrestrial*, a movie that I loved and also collected at the time. As I got closer, I blinked. Could it be? Yes, there also was a portrait of Chewbacca. As I got really close, the art looked somewhat three-dimensional, even a little fuzzy. And all the pieces were in muted shades of brown, yellow, and black, with a little red showing up here and there. "Excuse me," I asked the young man I assumed to be the artist. "What exactly are these?" "They're hair portraits," he told me. "My buddy has a barber shop. And when he sweeps up he saves the cuttings for me." My stomach started churning involuntarily. As I started to quickly walk away, he kept talking. "Well, I clean the hair first, of course, and then I" I heard no more.

That was the first, and so far the only, time a potential *Star Wars* collectible made me physically ill.

Of course, today I regret not buying Hairbacca. I also missed out on a particularly tacky C-3PO velvet painting, and I've never seen one since that matched its sheer tastelessness. Things like these are collection builders as well, especially when you want visitors to know that you don't take it all too seriously. In the early days of the Internet, there was a thread going around on a forum: What happens to Sansweet's

"QUEEN AMIDALA AND HER HANDMAIDENS GO VEGAS" PARODY
LYNANNE SCHWEIGHOFER FOR CLUB JADE
UNITED STATES, 1999

No, that's not Barbie. It's "Queen Amidala and Her Handmaidens Go Vegas!" At least that's what this lovely trio was called in a 1999 charity auction sponsored by a great group called Club Jade. These twenty- to fifty-something professional women share their love of *Star Wars* online and get together in person once a year to party and geek out. The clothes were handmade. Later that year, I received as a holiday gift chic disco capes and Christmas party outfits for twelve-inch figures of Jedi Master Qui-Gon Jinn and his Padawan, Obi-Wan Kenobi—although you might not remember them looking like that in *The Phantom Menace*.

collection when he dies? I thought it was a hoot. And since I didn't post to forums myself, I had my then-assistant Josh post the following: "This is official, and Steve told me I could post it. When he dies, he's going to be placed in the exact center of the museum and have the entire building imploded around him." Some people actually believed that, since it was probably as rational an answer as some of the guesses: open it up to a mob of fans who could take away whatever they could carry, or give it all to a museum. Actually, a curator at the Smithsonian National Air and Space Museum told me that the facility would be happy to "accept" the collection when I was "through with it." She was careful not to use the words "buy" or "die."

When it comes to some of the items in this chapter, the fact that they even exist today is remarkable. There is no good reason why one of the prop doors from the Mos Eisley cantina exterior in Tunisia should have survived. But how it did, and how it ended up at Rancho Obi-Wan, is a story I love to tell. On the other hand, how a disparate group of licensees decided that Jar Jar Binks's tongue should be the featured part of his anatomy in products ranging from toothbrush holders to watches—and including one truly gross novelty candy—is something that is inexplicable.

TOTALLY WANTON JEDI GEAR "PARTY LIKE IT'S 1999" PARODY
LYNANNE SCHWEIGHOFER FOR CLUB JADE
UNITED STATES, 1999

TOTALLY WANTON KNIT GEAR "THE JINGLE BELL ROCK" PARODY
NANCY LUTZ FOR CLUB JADE
UNITED STATES, 1999

TOTALLY WANTON KNIT GEAR "STAR OF HOTH" PARODY
NANCY LUTZ FOR CLUB JADE
UNITED STATES, 1999

TOTALLY WANTON JEDI GEAR "MASTER OF CEREMONIES" PARODY
LYNANNE SCHWEIGHOFER FOR CLUB JADE
UNITED STATES, 1999

TOTALLY WANTON
JEDI GEAR

**Master and Padawan Party Pack
Series AA:**
WHAT ARE YOU DOING NEW YEAR'S EVE?
M1. *Master of Ceremonies*

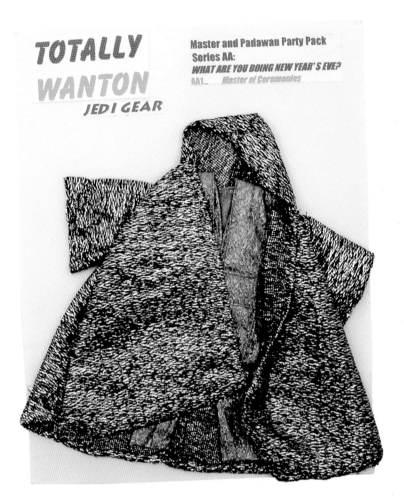

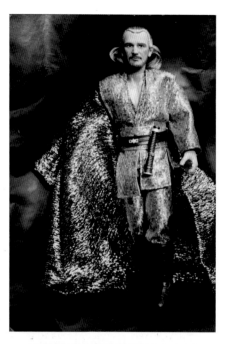

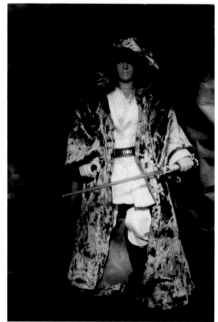

THE LAST REMAINS OF QUI-GON JINN

JAK PRODUCTIONS
UNITED KINGDOM, 1997

How about a stuntman's plaster cast, carefully cut open and preserved for more than a quarter of a century? It certainly meant something to him, since he kept it for most of those years. But why would I be interested in something both mundane and strange? Because of the story it tells with the help of a bunch of related material, and because of the look on guests' faces when they first spot it in the collection.

Over the years, I've come to the realization that, for me at least, the real purpose of collecting—of having a collection—is to share it with others. It gives me a chance to put things in context, to explain why or how, to offer up a funny anecdote. No, most five-year-olds aren't interested in the stories, just the stuff. But aging just a few years brings with it an intense inquisitiveness and, I suspect in many cases, the planting of a seed that might sprout into a future collector. And I get great joy out of showing Rancho Obi-Wan to people who don't consider themselves either *Star Wars* fans or collectors. I'd call their first expression one of bemused awe, then most of these folks pick up on my passion and excitement and often begin to feel it themselves.

Over the past few years, I've donated a number of tours to various charitable groups in the area; their fund-raising auctions for a guided tour of my collection can bring them several hundred to several thousand dollars. The adults who bid often bring a bunch of kids along to celebrate someone's birthday. It may be more expensive than Chuck E. Cheese's, but it's nowhere near as noisy or fattening. Of course, there are a few things that are off limits depending on the make-up of the party.

Then there are the items that just aren't photogenic. I was on the set at Leavesden Studios in the United Kingdom, helping to squire a group of our licensed fan-magazine editors for a behind-the-scenes look at the making of Episode I *The Phantom Menace*. On this particular day, the cast and crew were shooting a scene near the end of the movie in which the great Jedi Qui-Gon Jinn, having been killed by an evil Sith Lord, is being cremated. Actor Liam Neeson's stand-in was a beautifully made hard-wax effigy that could be reused if the scene needed to be reshot. His costume, however, could not be. When George Lucas called "Cut!" some crew members in the proper gear grabbed the wax dummy, laid it on the ground, and hosed it down thoroughly to make sure there were no live flames or sparks. They removed the dummy and the upper part of the boots because they hadn't burned, leaving a sodden pile of burnt rags and a couple of leather buckles. I stumbled upon the mess, which to me represented something very special: the last remains of Qui-Gon Jinn! I had no bag with me, so I picked up a few of the least tattered pieces, squeezed them out, and stuck them into my pocket.

Then I spied another treasure: the soles of Qui-Gon's boots. I could see it so clearly; I'd be able to make a display and tell people that I had captured "the soul of Qui-Gon Jinn" after his death. Alas, that urge to pun was never satisfied. As I started to pick up the soles, they crumbled into tiny granules. Then, just last year, as I was reorganizing my garage, I came across a small plastic bag filled with what looked like some dirt. Puzzled, I opened it and picked up the faint aroma of smoke. Holy cow! I guess I had put a bunch of the crumbled sole/soul into my other pocket, packed it up, and forgotten about it for nearly a decade. I should have thrown away the bag right there and then. Do you really think I did?

ORIGINAL BANNER FOR FAN CONVENTIONS

LUCASFILM LTD.
UNITED STATES, 1976

This hand-painted canvas banner shows up in photos taken at a few fan conventions that Lucasfilm attended in 1976. Charlie Lippincott, who was head of marketing, merchandising, and publicity for Lucasfilm, was frustrated that some marketing executives at 20th Century Fox just didn't understand the space fantasy that George Lucas was making. The film had been put up for bidding from theater owners to play it, and there were very few takers. (When it finally opened in May 1977, it was on only thirty-two screens.) So Lippincott, who was a self-acknowledged science-fiction and comic geek at a time when geeks were considered sideshow performers who bit the heads off live chickens, decided to take the movie to "his" people. The strategy worked beautifully, and Hollywood eventually started catching on—about twenty years later. *Star Wars* concept artist Ralph McQuarrie says he remembers painting the letters on the banner, based on his early design of a *Star Wars* logo. The art, also his, is silkscreened and glued on.

"3PO IS HUMAN" MATCHBOOK

MATCHMAKERS
UNITED KINGDOM, 1976

Playing the role of an always-masked character in a movie
is never great fun. Imagine being screwed and bolted into a
plastic, resin, and metal outfit all day, every day, when you were
on the set. Such was the fate of C-3PO's alter ego, Anthony
Daniels, who couldn't even sit in the costume during breaks;
instead, he was leaned back onto a large slanted board. Daniels
started to feel that crew members were forgetting there was a
human inside the stiff costume. So he had these matchbooks
printed and left batches on the crew's catering table. They
helped a little, Daniels said. "At least they said, 'Thanks Tony,'
when they passed by."

MILLENNIUM FALCON 3-D "BLUEPRINT"

INDUSTRIAL LIGHT & MAGIC
UNITED STATES, 1978

When the production decided it needed a "full-size" *Millennium Falcon* for *The Empire Strikes Back*, ILM built this plastic miniature "blueprint" to guide the builders, who undertook the project at a former Royal Navy shipbuilding yard in Wales. Using this and paper blueprints, the crew built the *Falcon* with a steel superstructure covered in MDF, an engineered wood product, and then sliced it into sections that were transported by truck to Elstree Studios for filming. A local newspaper, picking up stories of strange happenings in the windowless hangar at the shipyard, reported that a "flying saucer" was being built under great secrecy.

4-LOM'S CROTCH

LUCASFILM LTD.
UNITED STATES, 1979

This piece of costume from the bounty hunter 4-LOM (a name derived by ILM wags from "For the Love of Money") in *The Empire Strikes Back* has caused me some grief. It was offered to me years ago and I turned it down—$1,000 for a crotch? No thanks. The guy came after me for months—like I was the only one in the world who was meant to have it—and kept lowering his price. Finally, I gave in when he said he desperately needed rent money. The piece has been sitting in a display case for years. Few people pay it any attention. Then one day I was doing an interview with a British newspaper and the reporter asked me what the strangest item was in my collection. I've given various answers over the years, but for some reason my mind drifted to this piece. After I told him the story, we both laughed. As a former journalist I should have realized that I had stepped right in it. I don't have the clipping handy, so let me paraphrase: *Steve Sansweet has the genitals of a* Star Wars *bounty hunter. No, he hasn't undergone reconstructive surgery . . .*

DOOR TO THE MOS EISLEY CANTINA
LUCASFILM LTD.
TUNISIA, 1976

This is the actual door from the Mos Eisley cantina, the one that three drunk Jawas were snoozing in front of when all of that action was taking place inside. It's the actual set piece, to be more exact, and the fact that it has survived all these years is a miracle. My buddy David West Reynolds, who discovered the door, is an archeologist in the Indiana Jones style and was the first full-time editor of starwars.com. In the mid-1990s he agreed to be a tour guide to *Star Wars* filming sites in Tunisia for the winner of a Decipher Collectible Card Game *Star Wars* tournament. One of the locations was Ajim, a port city in the southwest of Djerba, an island off Tunisia's west coast, which had stood in for that wretched hive of scum and villainy, Mos Eisley. David quickly found the building used for the exterior of the cantina and chatted up the friendly owner, who still remembered the filming and didn't seem disturbed by yet another interruption from a few *Star Wars* fanatics. He said there really wasn't much left from the filming two decades before. As David and his party continued walking around, they came face to face with The Door. It was very weathered but there was no mistaking it. The owner had been using it as the door to his chicken coop for twenty years. David went back to the owner and said he wanted to buy the door. He thought he might be able to get it for $5 or $10, but the owner quickly came back with a price of $100. "But that's a lot of money for a chicken coop door," David said. "Perhaps," responded the owner, "but that door's been very good to me." The deal done, and with darkness descending, David decided he had to find an all-night carpentry shop to saw the door in half so he could get it onto the plane the next day. The driver who was squiring the party thought that would be impossible. "But as we were driving around the desert under pitch-black skies I saw a light and heard an unmistakable sound," David said. "It was a carpentry shop with a table saw, and they were happy to slice the door for $5." Back home, David and his dad mounted the two halves on another board, restored the door to its original color—and it eventually came to rest in a former chicken coop, Rancho Obi-Wan.

KRAYT DRAGON "BONES" PROP

LUCASFILM LTD.
UNITED KINGDOM, 1976

There's a very noticeable, large skeleton of a fearsome "krayt dragon" in the Tatooine dunes where C-3PO and R2-D2 land after fleeing the Imperial invasion of the Rebel Blockade runner. The production team had found a leftover fiberglass prop dinosaur skeleton at the studio in the United Kingdom, brought it to Tunisia as set dressing, and left it on the Grand Dune. Over the years, locals picked over the remains, and many other pieces were buried in sand drifts—only to be dug out years later by adventurous fans. The area is now pretty well picked clean.

CANTINA INSTRUMENTS

MADE FOR DK PUBLISHING'S *STAR WARS VISUAL DICTIONARY*
UNITED STATES, 1997

Among the most iconic props in the original *Star Wars* movie are the instruments played by the cantina band. Like a lot of other elements from the first movie, these didn't end up in Lucasfilm's hands. So when it came time to publish DK's photo-real *Visual Dictionary*, the instruments were built anew by ILM model makers. Like the original props, these use many identifiable found pieces, such as automotive tubing and garden sprinkler-can heads.

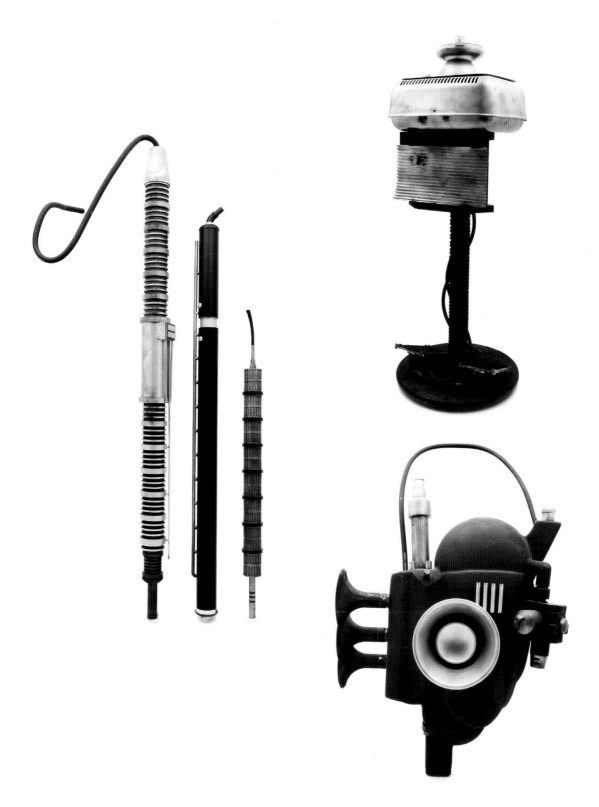

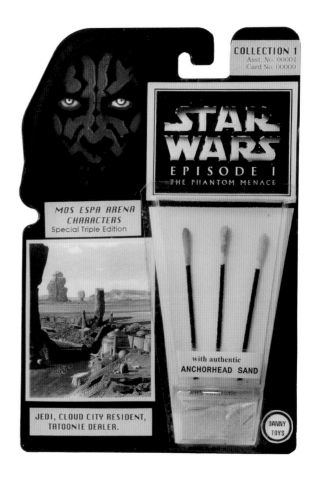

YODA IN DRIFTWOOD SCULPTURE

UNKNOWN
UNITED STATES, 1998

I found this at the San Diego County Fair in Del Mar, California. I asked the sculptor how she came to carve Yoda in this particular piece of driftwood. "I stumbled on this piece on the beach, and Yoda just talked to me from it." When I realized she was being literal, I paid my money and quickly walked away. I must admit that I've never heard it speak.

MOS ESPA ARENA CHARACTERS ON CARD

DANNY WAGNER
UNITED STATES, 1999

The Mos Espa Podrace Arena in *The Phantom Menace* was a large model built by the craftsmen at ILM. To achieve the visual effect of cheering spectators, they built a wire grid into the grandstands and filled it with long cotton swabs painted the colors of the rainbow. An air blower from beneath moved the "spectators" in a random pattern. Danny Wagner, one of the model makers, made up ten sets of "Mos Espa Arena Characters—Special Triple Edition" action figures as a fun reminder of the segment.

GEORGE LUCAS FAMOUSTYPE FIGURE

HOT TOYS
CHINA, 2000

In *Star Wars*, the golden droid C-3PO has a simple line when he dips into a much-needed hot oil bath: "Thank the maker!" (Little did we know at the time that the "maker" was Anakin Skywalker/Darth Vader.) Fans have taken to calling the *Star Wars* creator "the maker" as an in-fantasy homage. A Chinese toy company, Hot Toys, tried to take that homage one step further by making a twelve-inch scale George Lucas doll, called out on the box only as "FamousType Figure." One cease-and-desist order later, the toy was taken off the market, but not before collectors snapped up several hundred of them. Over the past three decades, Lucas has occasionally let his visage be used as a fan surprise on a few figures: a TIE fighter pilot microfigure, a Rebel pilot, and a stormtrooper action figure. There's also an action figure of him—covered with blue paint—as Baron Papanoida, the cameo character he played in *Revenge of the Sith*. Hot Toys, after patching things up with Lucasfilm, got a license to produce a series of *Star Wars* "chubbies."

TATAOUINE TOURS LOCATION SAND

— JEREMY BECKETT
TUNISIA/UNITED KINGDOM, 2000

Jeremy Beckett, a British friend, toured the filming locations
in Tunisia and picked up sand along the way for souvenirs. The
sand for each site actually has its own unique look. Jeremy
also wrote a self-published tour guide to the sites. Some film-
ing took place near the town of Tataouine, which, of course,
provided inspiration for the name of the desert planet Tatooine.

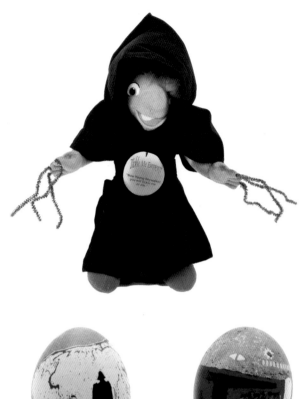

DISPOSABLE CAMERA WITH *STAR WARS* YO-YO

AGFA
SPAIN, 1999

FAN-MADE "TICKLE ME EMPEROR"

CHRIS CASSIDY FOR CLUB JADE
UNITED STATES, 2001

Take one Hunchback of Notre Dame plush toy, add one Tickle Me Elmo voice box with a shaking mechanism, stir in some glistening blue pipe cleaners, cover with a dark cloak, and surprise! You've got a fan-made Tickle Me Emperor doll. "Now young Skywalker," says the tag on the ersatz Palpatine, "you will tickle me or die!"

EPISODE I AND BOBA FETT EASTER EGGS

VERA WILLIAMS
CANADA, 2000

My friend Vera Williams is of Ukrainian descent. When she and her collector husband, Hugh, paid a visit from Winnipeg, she brought along these hand-painted eggs, one depicting bounty hunter Boba Fett and the other based on the Episode I advance teaser poster, which shows an innocent, young Anakin Skywalker casting the shadow of the monster he will become: Darth Vader.

MEATY BEEF FLAVOUR DOG CHOW BAG

ARNOTT HARPER PTY. LTD.
AUSTRALIA, 1983

Star Wars dog food? Well, yes and no. Harper's Dog Chow in Australia did a promotion for *Return of the Jedi* with Darth Vader on the bag and twelve different character stickers randomly placed inside. If you had only one small puppy, how many nine-pound bags of dog food would you buy a month? If the promotion lasted the normal two or three months, what are the odds that you'd complete a full set of twelve? Even if you're not great at math, it's not difficult to figure out why this is one of the toughest small sets of cards or stickers for a *Star Wars* collector to put together. In fact, while there are most likely more, we know of only one existing full set in excellent condition.

DOG CHOW STICKERS

ARNOTT HARPER PTY. LTD.
AUSTRALIA, 1983

AA DURACELL BATTERIES WITH LEGO ARC-170 STARFIGHTER

LEGO SYSTEMS INC.
SOUTH KOREA, 2005

UHU GLUE STICKS WITH EWOK ACTION FIGURE

PALITOY
ITALY, 1983

Of all the strange combinations, Ewoks and glue sticks may just be the strangest.

MINI CARBONITE BLOCKS, INCLUDING A FROG, HAN SOLO, GEORGE LUCAS, AND JAR JAR BINKS

VARIOUS
UNITED STATES AND JAPAN, 2001–2006

We all know Han in carbonite. Meet Jar Jar, George Lucas, and a frog. The first three were made by fans. The frog comes from the very creative San Francisco office of Frog Design. It slid open to reveal a disk with the company's proposal for the redesign of starwars.com.

GEORGE LUCAS FANDANGO-STYLE PAPER BAG PUPPET

DAVID ISKRA FOR LUCASFILM LTD.
UNITED STATES, 2007

Paper-bag puppets of most of Lucasfilm's top executives were made for a proposed short film for the company's annual meeting. The direction changed after the George Lucas puppet had been made, and it was a shame to let it go to waste. George was out of the country and couldn't attend Celebration IV, so his paper-bag puppet made an appearance on the big screen in his place.

"KERMIT SKYWALKER" PHOTO PUPPET

MASTER REPLICAS WITH FAN-MADE COSTUME
UNITED STATES, 2007

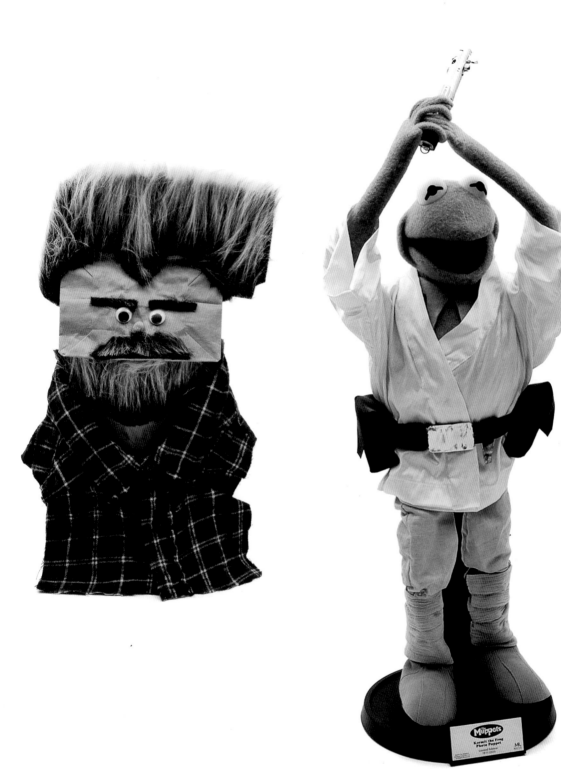

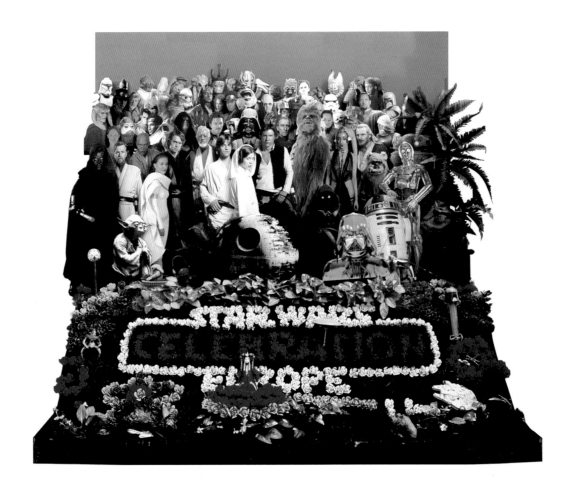

SGT. LUCAS *STAR WARS* CELEBRATION EUROPE PROGRAM COVER ART

RANDY MARTINEZ
UNITED STATES, 2007

When artist Randy Martinez realized that the thirtieth anniversary of *Star Wars* coincided with the fortieth anniversary of the great Beatles album *Sgt. Pepper's Lonely Hearts Club Band*, the inspiration was born for this construction, which was made into the cover of the *Star Wars* Celebration Europe program book and a print. Sgt. Pepper's drum became the Death Star, a French horn became Max Rebo's red ball jet organ, and the British actress Diana Dors in a slinky gold-lamé gown morphed into C-3PO.

CHILDREN'S EYEGLASS FRAMES AND CASE FOR DISPLAY

INTERNATIONAL EYEWEAR
UNITED KINGDOM, 2008

MILLENNIUM FALCON TATTOO GUN

ADAM HAYS
UNITED STATES, 2008

It's called the "Scoundrel," and it was made by Adam Hays of Red Rocket Tattoo in New York City. Hays, a much-admired tattoo artist, gets called on to do a lot of *Star Wars* tattoos. He built this particular tattoo gun to make those particular clients even happier.

CHAINSAW C-3PO

FAN-MADE
CANADA, C. 1998

This chainsaw-and-chisel wooden C-3PO is made in only three pieces: the two arms and the rest. An Alabama fireman and part-time antiques dealer purchased it on a trip to Canada. The sculpture is based on the Kenner action-figure version of the protocol droid, not the movie version. It had a long, strange journey before it made it to Rancho Obi-Wan.

R2-D2 FISH TANK

PLANET PETS
UNITED STATES, 2008

STAR WARS "TREE OF LIFE" SCULPTURE

STAR WARS FAN CLUB TOLUCA
MEXICO, C. 1999

The "Tree of Life" is a familiar symbol in many cultures. But no rendition has quite the panache of this *Star Wars* ceramic version from the *Star Wars* Fan Club in the state of Toluca, Mexico.

STAR WARS TOOTH CAPS

JORGE ARIAS
MEXICO, C. 1999

My friend Jorge Arias and his wife, Bertha, are both dentists in Mexico City. Jorge was just fooling around when he made these, but he's offered to make the real things the next time I visit.

STEVE AS YODA PARODY

KENNER, MODIFIED FOR SUSAN GROSS
UNITED STATES, C. 2001

For some reason, friends (and even strangers who usually become friends) have this urge to place my countenance into the fantasy world of *Star Wars*. From big-eared Yoda (note that I'm fully posable) to animated Obi-Steve to my incarnation as an Ewok at Celebration IV, it's all for fun and deeply appreciated.

OBI-STEVE SANSWEET "ANIMATED" PARODY

NICK MACARTY
UNITED KINGDOM, 2005

STEVE SANSWEET *STAR WARS* CELEBRATION IV EWOK PARODY

RICK SNIJDER
THE NETHERLANDS, 2007

OBI-STEVE KENOBI ACTION FIGURE

GENTLE GIANT STUDIOS
UNITED STATES, 2000–2001

Gentle Giant took its scanning equipment to the United King-dom and later to Australia during the filming of Episodes I and II in order to capture the three-dimensional visages of some of the actors and even a few props. Just before they packed up Down Under they did a "mercy scan" of me—and a few months later Obi-Steve came as close to action-figure status as he's going to get.

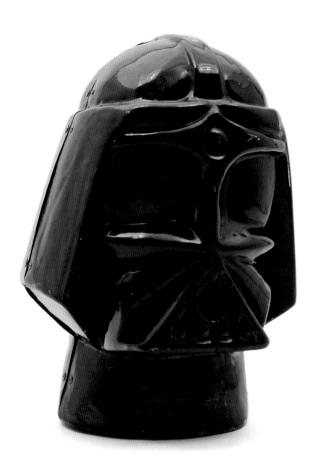

DARTH VADER AND C-3PO KNOCKOFF WATER GAME HEADS

UNKNOWN
UNITED STATES, 1990s

These strange C-3PO and Darth Vader plastic heads came off
an arcade game at the New Jersey Shore. Squirt water into
their mouths and see whose balloon blows up and bursts first.

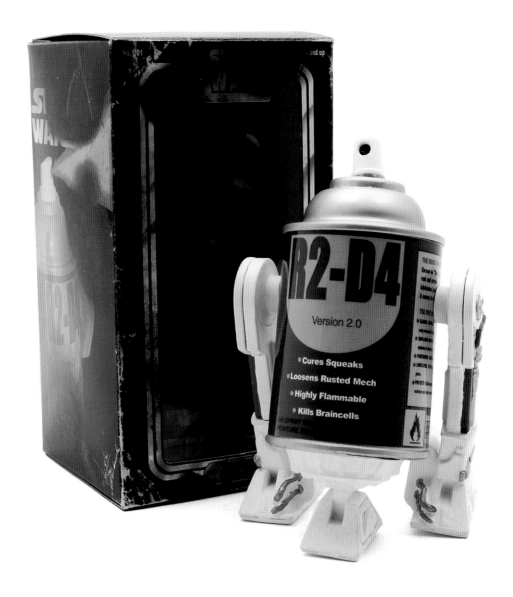

CHEW-BUDDHA THE HUTT RESIN SCULPTURE

UNKNOWN
UNITED STATES, 2007–2008

ICE CREAM MARKERS

UNKNOWN
SPAIN, C. 1983

The idea was that these sticks bearing heads from *Return of the Jedi* would be placed in open tubs of ice cream in parlors, so kids could order flavors by character name. The idea was never approved, leaving only a few prototype sets of these markers.

R2-D4 (WD-40) PARODY

NATHAN CABRERA FOR SPAN OF SUNSET
UNITED STATES, 2003–2004

This limited-edition parody, the love child of R2-D2 and a can of WD-40, is a serious sociopolitical commentary on . . . Nah. It's just funny. The box is imaginatively printed to look like it had already survived a few close calls with a match.

JAR JAR BINKS MONSTER MOUTH CANDY TONGUE

CAP CANDY
UNITED STATES, 1999

Hands down, this wins the award for the grossest *Star Wars* product ever licensed. Sure, kids are into gross, but pushing a lever and having Jar Jar's dimpled, cherry-flavored tongue pop out for a licking? Ugh! The Gungan's tongue was a popular totem for licensed merchandise in 1999: an action figure, a drinking glass, a toothbrush holder, a talking plush figure, a wristwatch, a necktie, and a sticky tongue toy that you throw at a window or mirror and watch as it slowly dribbles down.

JAR JAR BINKS MONSTER MOUTH CANDY TONGUE DISPLAY

CAP CANDY
UNITED STATES, 1999

JAR JAR BINKS (TATOOINE) ACTION FIGURE

HASBRO
UNITED STATES, 2001

JAR JAR BINKS DRINKING GLASS

DOWNPACE LTD.
UNITED KINGDOM, 1999

JAR JAR BINKS TOOTHBRUSH HOLDER

GROSVENOR
EUROPE, 1999

TALKIN' HUNGRY HERO JAR JAR PLUSH DOLL

HASBRO
UNITED STATES, 1999

JAR JAR BINKS ROTATING TONGUE
CHARACTER WATCH

NELSONIC
UNITED STATES, 1999

TRY ME!

AGES 3 AND UP
NO. 84416

SQUEEZE
MY BELLY
TO SEE
MY TONGUE
EXTEND!

SQUEEZE HAND TO HEAR
8 MOVIE PHRASES!

STAR WARS
EPISODE I

TALKIN'
HUNGRY HERO JAR JAR™

USES 3 "AAA" BATTERIES (INCLUDED)

JAR JAR™ BINKS

ROTATING TOUNGE CHARACTER WATCH

STAR WARS
EPISODE I

JAR JAR BINKS NECKTIE

RALPH MARLIN
UNITED STATES, 1999

**JAR JAR BINKS PUNCH-OUT FIGURES AND
FLAPS BOOK**

RANDOM HOUSE
UNITED STATES, 1999

JAR JAR BINKS TWO-YEAR MONTHLY PLANNER

DAYRUNNER
UNITED STATES, 1999

JAR JAR STICKY TONGUE TOYS

WALKER'S, SMITH'S
UNITED KINGDOM AND THE NETHERLANDS, 1999

JAR JAR BINKS BEACH TOWEL

TEX UK LIMITED
UNITED KINGDOM, 1999

KNOW YOUR LIGHTSABER

The lightsaber is an elegant weapon. Not nearly as clumsy or random as a blaster, it has been carried by Jedi Knights for over a thousand years. It is respected and feared, as are those who wield it. However, if you've never taken a lightsaber into combat it can be a little tricky. Please take time to familiarize yourself with the weapon.

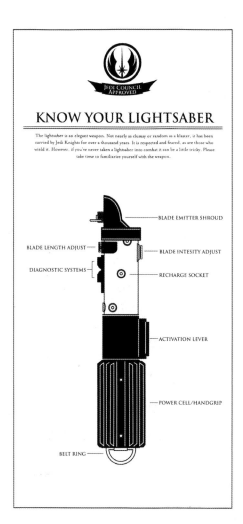

BLADE EMITTER SHROUD

BLADE LENGTH ADJUST

BLADE INTESITY ADJUST

DIAGNOSTIC SYSTEMS

RECHARGE SOCKET

ACTIVATION LEVER

POWER CELL/HANDGRIP

BELT RING

LIGHTSABER ETIQUETTE

ALWAYS POINT THE HILT AWAY FROM YOU.

Powered by the energy field of rare crystals, the lightsaber is capable of easily cutting through any material, including you. Make sure you have it pointed the right way before you power on.

LET THE BLADE DO THE WORK.

Nothing can stop the power of a lightsaber blade, save another lightsaber.
Therefore it is not necessary to exert a lot of force when swinging the blade.
Simply follow through with your natural movement, and let the blade do the work.

GO FOR THE NECK.

When disposing of droids the "weak spot" is the neck. You will find you can effortlessly mow down 10-20 droids in a matter of minutes if you follow this simple rule.

AIR-SICKNESS BAGS

LUCASARTS/VIRGIN ATLANTIC AIRLINES
UNITED STATES, 2005

A clever if unusual campaign for the Episode III game from LucasArts used the front (shown right) and backs (four shown above) of Virgin Atlantic air sickness bags. They drew a lot of comments. It's not every day that you find a "limited-edition" barf bag in your seat pocket.

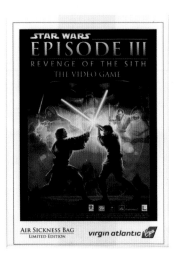

THE ART OF JEDI COMBAT

The art of Jedi combat is not something that should be entered in to lightly. Often severely outnumbered and outgunned, the Jedi are renowned for their ability to quickly and efficiently dispatch multiple enemies at once. Before you throw yourself into a combat situation, please review the following.

HOW TO TURN A DOZEN BATTLE DROIDS IN TO A HARDWARE YARD SALE.

Throw in a Force power or two. A well-timed dose of force push can buy you valuable seconds to face other opponents or catch your breath.

WHY "NO" ACTUALLY MEANS "YES".

The Jedi mind trick isn't just for seedy bars and weak-minded people, it also works well in combat. A simple Jedi mind trick can distract your opponent long enough for you to land a well-placed blow. All you'll need is one.

WHAT TIME IS THE RIGHT TIME FOR FORCE LIGHTNING?

Force lightning, although often associated with the dark side, is one of the deadliest and disabling force powers. Thousands of volts of electricity fry your adversary into submission. The rule of thumb has always been, if you really need it, use it.

SEATING JEDI AND SITH

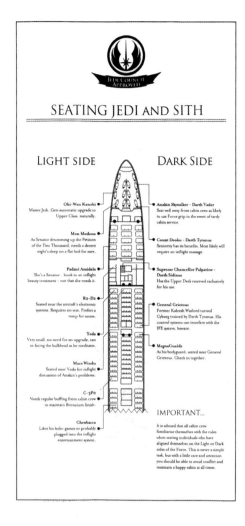

LIGHT SIDE

Obi-Wan Kenobi
Master Jedi. Gets automatic upgrade to Upper Class, naturally.

Mon Mothma
As Senator drumming up the Petition of the Two Thousand, needs a decent night's sleep on a flat bed for sure.

Padmé Amidala
She's a Senator - book in an inflight beauty treatment - not that she needs it.

R2-D2
Seated near the aircraft's electronic systems. Requires no seat. Prefers a ramp for access.

Yoda
Very small, no need for an upgrade, can sit facing the bulkhead as he meditates.

Mace Windu
Seated near Yoda for inflight discussion of Anakin's problems.

C-3PO
Needs regular buffing from cabin crew to maintain Bronzium finish.

Chewbacca
Likes his holo-games so probably plugged into the inflight entertainment system.

DARK SIDE

Anakin Skywalker - Darth Vader
Seat well away from cabin crew as likely to use Force grip in the event of tardy cabin service.

Count Dooku - Darth Tyranus
Seniority has its benefits. Most likely will require an inflight massage.

Supreme Chancellor Palpatine - Darth Sidious
Has the Upper Deck reserved exclusively for his use.

General Grievous
Former Kaleesh Warlord turned Cyborg trained by Darth Tyranus. His control systems can interfere with the IFE system, beware.

MagnaGuards
As his bodyguard, seated near General Grievous. Check in together.

IMPORTANT...

It is advised that all cabin crew familiarise themselves with the rules when seating individuals who have aligned themselves on the Light or Dark sides of the Force. This is never a simple task, but with a little care and attention you should be able to avoid conflict and maintain a happy cabin at all times.

C-3PO CERAMIC LAMP AND UNPAINTED WHITEWARE

UNKNOWN
UNITED STATES, C. 1978–1980

When *Star Wars* took the country by storm, it's not surprising that it swept many aspects of popular culture and commerce along with it. One of these was the "homemade" ceramics business. Even small towns had at least one shop where you could buy whiteware—undecorated but once-fired clay castings— that you glazed yourself, returned to the shop for firing in its kiln, and then possibly decorated with faux jewels or other frippery. These pieces often could be turned into allegedly useful things, such as lamps. It was not long before the shelves of many shops were filled with some fairly ugly takes on *Star Wars* characters. This strange before-and-after C-3PO bust is actually one of the more handsome ones in my collection.

STAR WARS THIMBLES

UNKNOWN
UNITED KINGDOM, 1999–2005

If you were going to sew a Jedi robe, of course you'd use a *Star Wars* thimble. Although I'm passable at sewing buttons back on to shirts, I have never quite understood the utility of a thimble. But when these often ugly "bone china" thimbles— some of them featuring comic-book characters of such minor importance that even the most diehard fans wouldn't recognize them—started showing up on eBay from a few British dealers, how could I resist? Especially because there was rarely anyone bidding against me.

MARDI GRAS BEADS AND COINS

UNKNOWN
UNITED STATES, 1979–2008

New Orleans's big outdoor party and *Star Wars* have been linked since the late 1970s when *Star Wars* imagery began appearing on the lightweight metal doubloons that Mardi Gras krewes (or clubs) toss from their floats like confetti. And why not? Having fun, wearing strange-looking clothing, occasionally acting bigger than life, sometimes getting into a bit of trouble—it all sounds a little like a galaxy far, far away. Costumed *Star Wars* fans march and ride tricked-out floats as part of large krewes or by themselves. Special *Star Wars*-themed beads are usually abundant. The purple Darth Vader doubloon shown here was tossed by the Bards of Bohemia krewe in 1979; the silver X-wing fighter dates from 1982. The parade's 1986 theme was outer space, and at least four krewes had *Star Wars* imagery on their doubloons, three of them Yoda and one R2-D2.

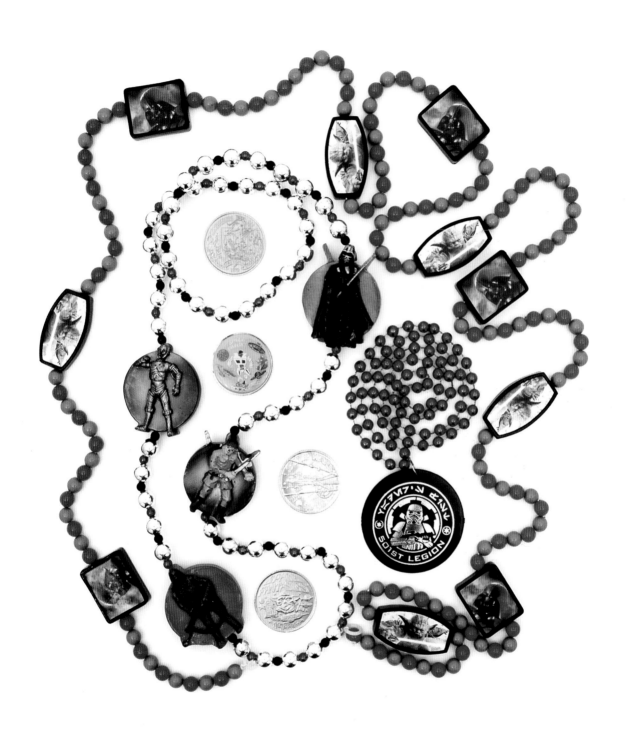

EPISODE I STAR WARRIOR FRICTION-POWERED TRUCK

UNKNOWN
CHINA, 1999

If Episode I had been an arena show moving from city to city, this might have been the truck hauling scenery, props, and costumes. Or not. I bought this from an eBay dealer in South Korea just because of its absurdity. Stickers on the top and front of the trailer say Episode I.

DARTH VADER BOXER

UNKNOWN
TAIWAN, C. 1983

Boxing hand puppets have long been a favorite item of bootleggers, who slap new heads, hands, and an accessory (if necessary) onto the basic, cheap spring-and-rubber-band mechanism. How could I resist this big-eyed Darth Vader in his striking gray and aqua-striped tunic, wielding his tiny red saber?

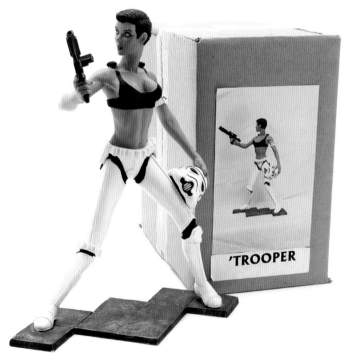

'TROOPER BABE GARAGE KIT

UNKNOWN
JAPAN, C. 1988

Produced by hobbyists in very limited editions in places like
garages, resin kits such as this one are made by model-making
fans who can't find licensed kits of subjects they want to
build. My friend Eimei Takeda has found and bought dozens of
Japanese *Star Wars* resin kits for me over the years, although
the flow has slowed considerably because licensed kit makers
such as Fine Molds are doing a great job making the kind of
detailed models that fans want. Eimei stumbled on 'Trooper
Babe at a toy show. He knew that it would take me forever to
assemble the piece, so he also bought the kit maker's sales
model at the end of the event.

BLUE HARVEST

MOVEMENT ORDER LONDON/YUMA
APRIL 1982

I. MOVEMENT DETAILS
As per attached.

Individuals will receive their own 'Mini Movement Orders' with
details of car pick-up times, hotels for overnight stops, etc.

II. PLEASE NOTE THAT THE PRODUCTION OFFICE AT ELSTREE STUDIOS WILL BE
OPEN ON SATURDAY, 3RD APRIL and SUNDAY, 4TH APRIL, SO IF YOU HAVE
ANY QUERIES AT ALL, PLEASE RING PAT OR GAIL ON 953.1784 or 207.0453.

III. TICKETS ATTACHED.

IV. PLEASE MAKE SURE THAT YOU HAVE ALL FILLED IN A BAYLY, MARTIN
& FAY INSURANCE FORM. IF NOT PLEASE ASK THE PRODUCTION OFFICE
FOR ONE.

V. DETAILS OF YUMA LOCATION

1. HOTEL ADDRESS FOR CREW IS AS FOLLOWS:
The Stardust Motor Resort Inn
2350 4th Avenue
Yuma, Arizona 85364.
Tel: (602) 783-8861. (Dialling from London = 0101.602.783.8861.)

2. YUMA PRODUCTION OFFICE ADDRESS IS:
"BLUE HARVEST" PRODUCTION OFFICE
2372 4th Avenue
Yuma, Arizona 85364.
Tel: (602) 782-5124/5/6/7/8 > > > > > Contacts: LATA RYAN
Telex: 255-910-953-1637. & LOUIS FRIEDMAN

BUTTERCUP VALLEY LOCATION SITE: (714) 339-5071
and
(714) 352-4434 & ask for mobile unit
number 4707 - maximum conversation
time for mobile is 4 minutes.

The hotel is approximately 20-25 mins. drive from the location.

** Note: Arizona is one hour ahead of California time, which
means that Yuma time is 8 hours behind London.

.../contd.

"BLUE HARVEST" MOVING ORDERS

PAUL WESTON
UNITED STATES, 1982

"BLUE HARVEST" LUGGAGE TAG

PAUL WESTON
UNITED STATES, 1982

"BLUE HARVEST" NAME BADGE

PAUL WESTON
UNITED STATES, 1982

BROKEN LEG CAST

PAUL WESTON
UNITED STATES, 1982

I will grant that this is a very strange item—but it is history, after a fashion. Paul Weston, a very talented stuntman on *Return of the Jedi*, was with the crew in Yuma, Arizona, filming under the cover name of "Blue Harvest." Dressed in a mask and costume as a member of Jabba the Hutt's crew aboard the sail skiff, ready to make Luke Skywalker walk the plank, Weston's character finds the tables turned and falls into the terrible Sarlacc pit. Apparently the stunt came off fine the first time around; on the second take, however, Weston hit the side of the wooden skiff and shattered his leg. But what memories, to have your plaster cast signed by wags who write things like, "Don't lose your sense of Yuma!" Mark Hamill drew a scoreboard: Sarlacc 1, Stuntmen 5. And there's even a note from Princess Leia: "What? & give up show business? Your loving nurse (day shift) Carrie Fisher."

INDEX

ACKNOWLEDGMENTS

Principal photography was by Anne Neumann, collection manager at Rancho Obi-Wan, who also developed an indispensable database that took much of the complexity out of organizing a large book like this. Anne also came up with lots of great ideas to help make this fun to do and, hopefully, to read. Additional photography was provided by Alex Ivanov, Steve Essig, Victoria Webb, Terry Hankins, Bob Canning, and Stacey Leong. Thanks to my editor Elisa Urbanelli for being an excellent wordsmith and for coming up with super suggestions. A big thank you to Abrams editor-in-chief Eric Himmel, who embraced the concept behind the book, came up with a game plan, and then was willing to be extremely flexible on a publication date when a previous project interfered. At Lucasfilm, my thanks to LucasBooks executive editor Jonathan Rinzler and art director Troy Alders for their contributions. To fellow collectors Duncan Jenkins and Gus Lopez goes a big shout-out for their book *Gus and Duncan's Comprehensive Guide to Star Wars Collectibles*, which was an invaluable resource for fact-checking. Finally, special thanks to the earliest *Star Wars* dealers with whom I shared a singular bond: Tom Kennedy of TKRP, Sunnie Ballard, Ann Young and Judy Hovey, and Mike Stannard. What a ride!
—S.J.S.

For Abrams:
Editor: Elisa Urbanelli
Designers: Seth Labenz and Roy Rub of Topos Graphics
Production Manager: Anet Sirna-Bruder with Ankur Ghosh

For Lucasfilm:
Executive Editor: Jonathan W. Rinzler
Art Director: Troy Alders
Director of Publishing: Carol Roeder

Library of Congress Cataloging-in-Publication Data

Sansweet, Stephen J., 1945-
Star wars : 1,000 collectibles : memorabilia and stories from a galaxy far, far away / by Stephen J. Sansweet with Anne Neumann.
 p. cm.
ISBN 978-0-8109-7291-9 (Harry N. Abrams, Inc.)
1. Star Wars films—Collectibles. 2. Star Wars films—History and criticism. I. Neumann, Anne. II. Title. III. Title: Star wars, 1,000 collectibles.
PN1995.9.S695S215 2009
791.43'75075--dc22

 2009017584

Printed and bound in China
10 9 8 7 6 5 4 3 2 1

Abrams books are available at special discounts when purchased in quantity for premiums and promotions as well as fundraising or educational use. Special editions can also be created to specification. For details, contact specialmarkets@abrmasbooks.com, or the address below.

THE ART OF BOOKS SINCE 1949

115 West 18th Street
New York, NY 10011
www.abramsbooks.com

www.starwars.com